Women in Management Worldwide

Women in Management Worldwide

Nancy J. Adler
Dafna N. Izraeli
Editors

M. E. Sharpe Inc.
Armonk, New York
London, England

Available in the United Kingdom and Europe from M. E. Sharpe,
Publishers, 3 Henrietta Street, London WC2E 8LU.

Library of Congress Cataloging-in-Publication Data

Women in management worldwide.

 Includes bibliographies and index.
 1. Women executives. I. Adler, Nancy J. II. Izraeli, Dafna N.
HD6054.3.W66 1988 331.4'81658 88-4520
ISBN 0-87332-417-X

Printed in the United States of America

Dedicated to the memory of Linda Keller Brown,
pioneer in the study of women in management,
valued colleague and friend.

Contents

Acknowledgments

Many hours from many creative people went into the preparation of this book. We should especially like to thank Professor Jean Boddewyn, who, as editor of *International Studies of Management & Organization*, originally suggested that the book be written, and Betty Appelbaum, who did an excellent job of making the disparate styles of writing into one cohesive whole. Without both Jean and Betty, this book could not have become a reality.

Beyond expressing our gratitude to the individual contributors to this work, all of whom dealt successfully with a network of international communications, sometimes against considerable odds, we should like particularly to acknowledge the important role of Dr. Linda Keller Brown. Linda was studying women in international management and publishing excellent research before most of us had even begun to formulate our questions. Her untimely death is a great loss to all of us, personally and professionally.

Contributors

Nancy J. Adler is an associate professor of organizational behavior and cross-cultural management at McGill University, Montreal, Quebec, Canada. She received her M.B.A. and Ph.D. from the University of California, Los Angeles (UCLA). Her research focuses on international management issues, including human resource management (entry, cultural shock, cultural adaptation, and reentry) and cross-cultural management (negotiations, culturally synergistic problem-solving, and organizational development in multicultural organizations). She has published numerous articles; produced a film, *A Portable Life*, on the role of the spouse in overseas moves; and written a book entitled *International Dimenions of Organizational Behavior* (Boston, MA: Kent Publishing Co., 1986). Dr. Adler has taught at the American Graduate School of International Management, regularly conducts executive seminars at INSEAD, in France, and has consulted with governments and private corporations on projects in North and South America, Asia, Africa, the Middle East, and Europe.

Dafna N. Izraeli is associate professor and chair of the Department of Sociology and Anthropology at Bar-Ilan University, Ramat Gan, Israel. She received her M.S.W. from McGill University, Montreal, Quebec, Canada, and her Ph.D. from Manchester University, England, and has done postdoctoral work at the University of California, Berkeley. She is a member of the National Council on the Status of Women and the Advisory Committee to the Commander of the Women's Army in Israel. Dr. Izraeli's research focuses on the interface of women, work, organizations, and power in Israel. She is currently researching dual-career couples and the perception of the status of women as a social problem. She has published numerous articles on sex differences in

persistence behavior, in influence, and in attributions for success; the impact of proportions on union committees; issues related to sex segregation of occupations; and the management of refusals in organizations. She is co-author of the book *The Double Bind: Women in Israel* (Hebrew). Tel-Aviv: Kubbutz Hameuchad, 1982.

Jeff Hearn is Lecturer in Public and Social Policy, School of Applied Social Studies, University of Bradford, United Kingdom. He has published widely on organizations, gender, and social policy, including *Birth and Afterbirth* (1983), *Sexuality and Organisational Life* (with Wendy Parkin as co-author), and *The Gender of Oppression* (1987).

P. Wendy Parkin is Lecturer in Social Work and Sociology, Department of Behavioural Sciences, Huddersfield Polytechnic, and Social Worker, Kirlees Metropolitan Council, United Kingdom. She has published in *Organization Studies*, *Planned Parenthood in Europe*, and *The Handbook of Leadership*. She is co-author, with Jeff Hearn, of a forthcoming book, *Sexuality and Organisational Life*.

Gladys L. Symons received her B.A. from Queen's University, Kingston, Ontario; Maîtrise, from the University of Grenoble, France; and Ph.D., from York University, Toronto; she has also studied at l'Ecole des Hautes Etudes Commerciales, in Montreal, Quebec. She is an associate professor of sociology at l'Ecole Nationale d'Administration Publique, a part of the University of Quebec network, in Montreal. She has also taught at the University of Calgary, Alberta, and has served as a visiting professor at the Hebrew University in Jerusalem. Dr. Symons has published work on professional socialization and graduate education, the work/family interface, managerial women, and organizational culture. She is currently editing an anthology entitled *La culture des organizations au Québec*.

Audrey Chan is a Lecturer at the School of Management, National University of Singapore. She received her Ph.D. from Texas A & M University. Dr. Chan has held administrative positions in higher-education institutions in the United States and Hong Kong, and was a research associate on two U.S. federal projects. Her current research interests include human resource development, organizational communication, and social/cultural consequences of nation building.

Virginia R. Crockett is Associate Director of the Pacific Asian Management Institute (PAMI) at the University of Hawaii. She received her B.A. in Asian Studies from the University of California, Berkeley, and her M.A. from the University of Hawaii, under the auspices of the East-West Center's Population Institute, and she holds a certificate in advanced Indonesian from Malang Teachers College in Indonesia. She is responsible for the administration of the PAMI's programs in international business with a Pacific-Asian focus and for coordination of funded research projects on business and international education. Her most recent research is centered on Indonesian women and management-development issues.

Patricia G. Steinhoff is Professor of Sociology and Director of the Center for Japanese Studies at the University of Hawaii. She holds a B.A. in Japanese Language and Literature from the University of Michigan and a Ph.D. in Sociology from Harvard University. Her books include *Abortion Politics. The Hawaii Experience* and *Conflict in Japan* (co-edited with Ellis Krauss and Thomas Rohlen). She has also published nearly fifty articles on women's reproductive issues in the United states and on protest, social control, and social movements in Japan.

Kazuko Tanaka holds degrees in Sociology from Tokyo Metropolitan University and the University of Hawaii. She is Assistant Professor of sociology in the Faculty of Law, Kokugakuin University, Tokyo, Japan, and is an active participant in the Ochanomizu Women's University Women's Studies Group. She is the co-editor of three books (in Japanese): *Toward a Sociology of Women* (1981), *Creating Women's Studies* (1981), and *Concise Dictionary of International Women's History* (1986).

Jean R. Renshaw is Professor of Organizational Behavior and International Business in Pepperdine University's M.B.A. program (in California), a consultant to Hawaii Loa College, and a principal in the consulting firm AJR International Associates, San Diego, California. She has lived and worked internationally in the Middle East, India, Europe, and the Pacific, most recently at the University of the South Pacific in Fiji. She has been an economist at the RAND Corporation and a consultant to corporations, small businesses, and government, educational, and nonprofit organizations. As Chair of the Business and

Economics Department at Eastern Oregon State College, she developed the Small Business Institute to bring students and small business owners together to consult and learn from each other. Her publications include articles on the interaction of work and family life, strategic thinking and systems planning, women and achievement, international business, culture and communication, and gender roles and alternative futures.

Ariane Berthoin Antal is a Fellow in the Research Policy and Planning Unit of the Wissenschaftszentrum Berlin für Sozialforschung (WZB). She was educated at Pomona College and the Monterey Institute of International Studies, California, and Boston University, Massachusetts, USA. Her research interests are internationally comparative in perspective, and her publications deal with the interaction between business and society, environmental policy, and women in management. She is currently vice-president of the European Women's Management Development Network.

Camilla Krebsbach-Gnath, a sociologist, is manager of the Technology Assessment Department at the Battelle Institute in Frankfurt a.M. Her recent research has focused on the societal impacts of new technologies and their particular effects on women's employment.

Anne Blochet-Bardet (M.A., University of Geneva) is currently working on a research project on middle age. Her main interests focus on the sociology of women. She has published articles on middle age.

Lucienne Gillioz (M.A., University of Geneva) is a sociologist working in the Sociological Research Unit of the Institutions Universitaires de Psychiatrie de Genève. She has published several articles in the area of medical sociology. Her research interests include the situation of women in Swiss society, and she has conducted a study of women in academic and scientific life in Switzerland.

Danielle Goerg (M.A., University of Geneva) is a sociologist working in the Sociological Research Unit of the Institutions Universitaires de Psychiatrie de Genève. She has done research on mental illness and studied the careers of mental patients. She has also researched the role of women in academic and scientific life in Switzerland.

Maryvonne Gognalons-Nicolet (Ph.D., the Sorbonne, Paris; M.A., State University of New York, Fullbright Fellow) has worked in France on subjects that include aging, the sociology of health, the sociology of the life cycle, and the sociology of gender. As a senior research scientist with the Unité d'Investigation Clinique, Institutions Universitaires de Psychiatrie de Genève, she has extended her research interests to middle age and the sociology of psychiatry. She has published several books on aging and health and many articles on middle age and aging women.

Valerie Hammond is Director of Research at Ashridge Management College, having joined the College in 1980. She has researched women and management issues since 1975; currently her research interests include management for the future, cultural and organizational change, and women in management. She has also researched the effects of information technology and has written two books on this subject: *The Computer in Personal Work* (with Edgar Wille) and *Tomorrow's Office Today* (with David Birchall). Other publications include "Employee Potential Issues in the Development of Women" (London: Manpower Services Commission and Institute of Personnel Management, 1980); "Men and Women in Organisations" (editor, with Tom Boydell), *Management Education and Development*, 1985, *16*, Part 2; and "What Is Self-development?" in D. Clutterbuck and M. Devine, *Businesswomen Present and Future*—among many papers on women's management development. Before joining Ashridge, Ms. Hammond worked in line management and training in industry. She is currently president of the European Women's Management Development Network.

Ronel Erwee is a registered counseling psychologist. She obtained B.A. (Hons), M.A., and D.Phil. degrees from the University of Pretoria. She completed part of her doctoral work at Michigan State University, in the United States. At present she is engaged in research on career development and is Associate Professor in Organizational Behaviour at the Graduate School of Management of the University of Pretoria. She received a merit award for her involvement in an organizational development project for the South African Defence Force. She has published many articles in scientific journals. As a consultant, she focuses on career-development issues. She has been nominated to the Third National Manpower Commission, and serves on the Board of Directors of

the Women's Bureau in Pretoria, South Africa.

Caroline Andrew is Associate Professor of Political Science at the University of Ottawa and currently Vice Dean of the Faculty of Social Sciences and Coordinator of the Women's Studies Programme of the university. Her publications have been in the areas of urban development, municipal politics, and women and politics. Her current research interests include women in management, women in municipal politics, and neighborhood planning in Ottawa.

Cécile Coderre is Assistant Professor of Sociology at the University of Ottawa. She has published in the areas of women and management, feminist theory, and pornography. Her present research interests are the development of the women's movement in Western Québec, women and management, and employment equity.

Ann Denis is Associate Professor of Sociology at the University of Ottawa, and was the first Coordinator (1983–1985) of the university's interdisciplinary Women's Studies Programme. She has published on gender, ethnicity, and postsecondary education. Her current research interests center on women and employment, with particular reference to women in management, to ethnic variations in women's employment, and to the interrelations among higher education, women's employment, and their unpaid activities, both domestic and in the community.

Linda Keller Brown (1943–1984) was a noted research authority on corporate sociology and women in management. She did her undergraduate work at Muhlenberg College, in Pennsylvania, and received her Ph.D. from the University of Pennsylvania. She served on the faculties of the City University of New York, Rutgers University, and Columbia University. In 1974 she held a Fulbright-Hayes Senior Lectureship in American Studies at Hiroshima University in Japan.

As a consultant to the Fulbright Commission of Japan and a resident scholar and academic policy officer for the United States Information Agency (USIA), Dr. Keller Brown developed projects, primarily in improving American Studies in foreign universities, in 20 countries. From 1981 to 1983, she served as Deputy Associate Director for Educational and Cultural Affairs of the USIA. At the time of her death, she was Council Associate, Division of Academic Affairs and Institu-

tional Relations, American Council on Education. Her consulting and other professional activities brought her numerous honors and awards.

Dr. Keller Brown's teaching and research interests included American Studies (interdisciplinary social science), the development and impact of business in American society, social statistics of contemporary American life, cross-cultural communication, and comparative culture studies—subjects on which she published many articles and a number of books. Among the latter was *The Woman Manager in the United States: A Research Analysis*, published in 1981 by the Business and Professional Women's Foundation, Washington, DC.

Women in Management Worldwide

1

Nancy J. Adler and Dafna N. Izraeli

Women in Management Worldwide

> One of the richest underutilized resources in America is the talent of its women. And this nation has for many years squandered this talent in a shameful fashion.
>
> —Hubert Humphrey

The global environment has become exceedingly competitive, and good employees enable corporations to compete. A top-quality human resources system provides strategic advantages,[1] yet companies worldwide draw from a restricted pool of potential managers. Although women constitute over fifty percent of the world's population, in no country do they represent half, or even close to half, of the corporate managers. In recognizing the strategic importance of female managers, *Fortune* claims that their greater number in U.S. corporations is one of the country's few remaining competitive advantages [2].

The last decade has been filled with stories describing the role of women in society. The United Nations Decade for Women, completed in 1985, focused world attention on the many changes needed for women to achieve equality. Within this context of change, we shall review the role women do and can play as managers worldwide. What has prevented women's movement into management and, especially, into the executive suite? What have countries, companies, and women themselves done to increase women's representation in management? Is the next decade predicted to be a replication of the past? If so, why? If not, why not?

Unlike the many articles and books written about American women in management (see, for example, [3–7], among many others), in this book we shall attempt to take a global perspective and go beyond the parochial determinism of each individual country's cultural, social, legal, economic, and political history.

Assumptions about Women's Role in Management

Assumptions	Equity model	Complementary contribution model
Fundamental assumptions		
• Men's and women's contributions	Similarity	Difference
• Fairness based on	Identical Equity	Complementary Valuing difference
Strategic goal		
• Assessment	Equal access Quantitative	Recognizing and valuing difference Qualitative
• Measured by	Statistical proportion of women at each hierarchical level	Assessing women's contribution to organization's goals
• Process	Counting women	Assessing women's contribution
Measurement of effectiveness:		
• Women's contribution	Identical to men's	Complementary to men's
• Norms	Identical for men and women	Unique to men and women
• Based on	Historical "male" norms	Women's own contribution
• Referent	Men	Women
Acculturation Process		
• Expected behavior	Assimilation	Synergy
• Based on	Standardized	Differentiated
• Essence	Male norms	Female norms
	"Dress for success" business suit	Elegant, feminine attire
Example	United States: "The melting pot"	France: "Vive la différence!"

Fundamental assumptions

In reviewing the situation female managers face across a wide range of countries, one can clearly see that many of the constraints are quite similar; nevertheless, the relative importance of each varies markedly from society to society. Both the possibility for increased representation and impact of women in management and the selection of potentially more effective strategies to bring about such change depend fundamentally on each culture's perception of the dominant constraints. Women in Japan and Saudi Arabia, for example, may focus on cultural patterns when explaining the situation with regard to female managers, whereas American women may look primarily to the legal structure, and Chinese women in Singapore and the People's Republic of China may emphasize current economic conditions and political leadership.

Although generally implicit, and underlying each of the nation-based explanations, one of two fundamentally different assumptions about the ideal role of women in management is being made. As shown in the table, the first defines an equity model based on assumed similarity, and the second defines a complementary contribution model based on assumed difference.

The first, the equity model, based on assumed similarity, is most pervasive in the United States. In this model, women are assumed to be identical, as professionals, with men, and therefore equally capable of contributing in ways similar to those of men. From the perspective of this model, the primary question is one of access. Are women given the opportunity to demonstrate their competence? Primary change variables include legal requirements—e.g., affirmative action programs and the Equal Rights Amendment in the United States—and structural change—i.e., avoiding tokenism, and training women in management skills traditionally neglected during their formal and informal education.

Given the emphasis on access (to the previously and currently male-dominated management world), the process for women entering management becomes one of assimilation: women are expected to act, dress, and think like the men who currently hold the aspired-to management positions. Effectiveness is then, understandably, measured against male norms: "Can she do what he has been doing as well as he has been doing it?" The potential for women to make a unique, different, but equivalent contribution remains outside the logic of the equity

model, and therefore invisible.

The second model, most articulately expressed in Steen's description of Swedish managers,[2] but pervasive throughout Europe and evident in many other areas of the world, is based on the assumption of difference, not similarity. In this complementary contribution model, men and women are assumed to differ and therefore to be capable of making different, but equally valuable, contributions to the organization. Unlike in the equity model, fair treatment is assumed to be a question not of statistical representation, but rather of equivalent recognition of men's and women's different patterns and styles of contribution.

From this second perspective, change strategies revolve around (1) identifying the unique contributions of men and women, (2) creating enabling conditions for both types of contribution to be made and rewarded within the organization, and (3) looking for synergy—ways in which men's and women's contributions can be combined to form new and more powerful managerial processes and solutions to the organization's problems. Under this second set of assumptions, female managers are expected to act, dress, and think "like women" (see Loden [8] for an American version of this model). Their behavior, though similar in some ways to that of their male colleagues, differs in many important respects.

Progress as measured by the equity model tends to be quantitative— a statistical accounting of the relative number of women in the organization by rank, salary, and status. Progress as measured by the complementary contribution model tends to be qualitative—an assessment of the extent to which the organization allows, encourages, and rewards men and women for making unique contributions and for building synergistic combinations of those contributions based on their very uniqueness.

Interestingly, each model tends to be labeled heresy when viewed through the eyes of the other. From the perspective of the equity model, seeing women (or blacks, Hispanics, francophones, or older managers, for that matter) as different is tantamount to seeing them as inferior. From this point of view, there is one best way to manage, and women should be given equal access to that way. By contrast, from the perspective of the complementary contribution model, there are many equally valid, yet different, ways to manage, the best way being based on recognizing, valuing, and combining the differences. From this second point of view, not to see women's uniqueness is to negate their identity

and, consequently, to negate their contribution to the organization.

In reading individual country descriptions, it is important to reflect on the underlying assumptions being made in each about women's role in management. To what extent is difference discussed as heresy or as a potential resource? To what extent is uniqueness viewed as a constraint rather than a valuable asset?

The common themes

Although the number of women who work outside the home is substantial in many countries, the number in management remains negligible almost everywhere. According to Management Centre Europe's [9] 1982 survey of 420 companies in 9 Western European countries[3]— Belgium, France, Germany, Italy, the Netherlands, Portugal, Spain, Switzerland, and the United Kingdom—fewer than half (49 percent) had ever employed a female manager. Of the remaining 51 percent, 15 percent claimed they would never consider promoting a woman into management. Among the countries surveyed, the United Kingdom (83 percent), France (74 percent), and Portugal (67 percent) reported the most companies with female managers, and Italy, the least (12 percent). Companies in the Netherlands, Germany, and Italy reported no women in top management. But even these figures create an illusion, since the percent of female managers in each company is considerably lower than the percent of companies having at least one female manager. According to the Management Centre Europe study, only 8 percent of British managers, 9 percent of French managers, and 13 percent of Portugese managers are women. Notwithstanding most respondents' (91 percent) personal belief that women could manage effectively in their company, "hardly any companies had or intended to have specific programs designed to introduce women into management" [9,10].[4] The situation in Asia and South Africa, although culturally distinct, is also far from remarkable.

In country after country, the proportion of women holding managerial positions falls short of that of men. Corporations, it appears, have systematically ignored women as a potential resource. In all countries, the higher the rank within the organization, the fewer the women found there. In some countries, the percentages, though small, have increased over the last decade; but in none have they approached equality. This pattern prevails in oriental and occidental cultures, communist, socialist, and capitalist systems, and both economically developed and devel-

oping countries. The question is: Why? Why are so few women in management, and why do their numbers remain so small?

The paucity of women in management appears neither coincidental nor random. There is no systematic evidence proving women ineffective as managers. In entry- and middle-level management positions, which sizable numbers of women now hold in some countries, experience confirms their effectiveness. In upper-level management, the scarcity of women to date precludes judgment for or against their effectiveness. If proven ineffectiveness is not the reason, why, then, are there so few female managers worldwide? The barriers are both structural—legal, educational, cultural, social, and historical—and psychological.

This book about women in management covers 11 countries scattered across 4 continents that differ considerably in history, culture, level of economic and technological development, and available material and human resources. Despite the variations, as editors we have been struck by the similarities in the factors that relate to women in management: similar factors shape the likelihood of women's entry into managerial positions, their career patterns, and their access to organizational power, although the relative impact of each factor varies from culture to culture. Against a background of diversity, common threads weave through the multicultural fabric, creating distinctive and recognizable forms that enable us to extract the following generalizations.

Management as a masculine domain

Everywhere, leadership in general and management in particular are a masculine domain (see Hearn and Parkin in this collection*). Managerial roles are filled by men, popular beliefs about the requisites of management are socially constructed from stereotypically masculine traits, and the social codes that govern interaction in the managerial arena are forged from the collective experience and interests of men. Women, relative newcomers to the managerial race, seem to be running on a foreign track, according to a set of rules with which they are not fully familiar, and under conditions of an initial handicap. Reading the contributions to this book can make the reader wonder how women have made the gains they have.

In all the countries represented here, women fill only a minority of managerial positions and, in most cases, are virtually invisible in senior

*All unnumbered references to authors are to contributions to this book.

positions. Yet there is considerable variance from place to place in the proportion of women in management and in their prospects for entry and promotion into such positions. The factors that explain this variance may be analyzed in terms of cultural traditions and social norms, level and form of economic development, social policy, access to education, and organizational processes.

Cultural constraints

The cultural tradition in each country defines the normative predispositions or ground rules. Customs and religious laws vary in the rights they grant women to enter the public domain and in their recognition of women's independent status. In the Pacific Islands, for example (see Renshaw), Melanesian women have traditionally derived their status from men, whereas Polynesian and Micronesian women have had varying degrees of direct access to status and land. This difference is reflected in the significantly greater proportion of Polynesian and Micronesian women in the labor force, particularly in professional, technical, and clerical work. Tradition in Japan (see Steinhoff and Tanaka) requires that women withdraw from the labor force upon marriage, a social norm that impacts on managerial assignment policies. In traditionally stratified societies, women from the elite class often enjoy privileges not available to other women, including socialization for leadership and access to education. In Fiji, for instance (see Renshaw), both men and women who belong to the chiefly families are socialized to recognize their leadership role.

The domestic sphere

The centrality of family life is a major variable, in any society, in determining the cost for women, but not for men, of selecting a managerial career and, consequently, the likelihood of achieving that position. In societies in which the marital and birth rates are high, the divorce rate is low, the family is the major locus for ceremonial and other social events, the parenting role is gender specific, and the ideology of motherhood requires that the mother be eminently available to her children, women are less likely to be able to "afford" the social and psychological costs of entering a "time-greedy" occupation such as management.

As the contributors to this book report, the proportion of nonmarried

managers is significantly higher for women than for men, and the proportion of nonmarried women is greater in management than in other occupations. Blochet-Bardet and her colleagues suggest that being single or divorced is the price that many Swiss women pay for their entry into the world of power. In Japan (see Steinhoff and Tanaka) this is the case primarily for women in large corporations and less so for those in small and medium-size businesses. Similarly, Izraeli implies that in Israel the centrality of family life and the expectations regarding women's roles in the family discourage qualified women from embarking upon managerial careers.

There are indications, however (see, for example, Andrew, Coderre, and Denis), that the younger, more highly educated generation of female managers experiences greater compatibility between family and work responsibilities than than do their older peers. These women are more likely to be married and to report receiving moral support from their husbands than is true of the older generation. Younger married women are hence more apt to begin their managerial careers earlier in life. Andrew and co-authors point out, nevertheless, that the role conflict between the demands of motherhood and management persists, as reflected in the relatively small number of women managers with children at home.

Economic development

Economic developments affect women's opportunity structure in general and their access to managerial positions in particular. The demand for labor that occurred in many countries during the 1960s and 1970s resulted in an increase in the female labor force. In industrialized countries, opportunities for women were greater where expansion took place in the financial, business, or community and public service branches of the economy. Where growth was largely in the industrial sector, foreign male labor more often was used to meet the need for human resources, e.g., in the Federal Republic of Germany (see Antal and Krebsbach-Gnath). Economic expansion and technological innovation increased the demand for managers in certain sectors of the economy more than in others. Where there was a growth in the proportion of women managers, it was most notable in economic branches in which an increase in the proportion of women in the labor force and an expansion of managerial roles were greatest. A case in point is Singapore's rapid economic

growth earlier in this decade (see Chan's description in this collection).

Social policy

Social policy, as reflected in either specific legislation or the allocation of resources in general, has an indirect but significant impact on women's careers in management. The countries covered here vary greatly in the extent to which social policy promotes or hinders women's careers. In the United States (see Keller Brown), affirmative action legislation proactively seeks to alter the structure of women's opportunities. In Singapore (see Chan), government development policies encourage women's participation in the labor force.

Legislation in some countries aims to free women from lingering traces of patriarchal control over women's economic activities. In the Federal Republic of Germany, for example, a law giving husbands the right to prohibit their wives from working outside the home was changed just in 1977 (see Antal and Kresbach-Gnath). In South Africa, a husband's control over his wife's right to negotiate and undertake contractual agreements was annulled by a provision of the Matrimonial Property Act passed in 1984; this provision does not, however, apply to black women, who are still subject to traditional laws (see Erwee).

The length of the school day and year, the availability of child care and other services, and maternity (or parental) leave rights and benefits are other social-policy variables that affect a family's cost-benefit calculations relative to a woman's employment in general and her entry into highly demanding occupations such as management in particular.

Higher education

Education is understandably an important prerequisite for women's access to managerial positions in most countries, particularly at the middle and upper levels. Formal education plays a more important role where managers are recruited directly from universities, as in the United States (Keller Brown), Canada (Symons), and Israel (Izraeli). Where managers are also recruited through in-firm training programs or through other channels, as is the case in England (see Hammond), a university degree is less significant. Keller Brown notes that in the absence of an academic credentials system, European women must surmount a double hurdle: first, they must be hired by the company,

and then they must be selected for the training programs intended for potential executives. Where higher education is important for entry into management, it may be so differentially for different levels of the managerial hierarchy: Antal and Kresbach-Gnath point out, for example, that the higher the position, the less is significance attached to such objective qualifications.

Organizational context

Organizations differ in the opportunities they offer women; they vary in this respect by sector and economic branch as well as individually. A number of contributions to this book support the finding that women fare better in public-sector than in private-sector organizations. This phenomenon has been explained by the former's greater use of universalistic employment criteria, their greater exposure to public control, and their lower competitive power in the educated-labor market. Blochet-Bardet and her colleagues claim that in Switzerland, the more prestigious and powerful the economic branch, the less accessible it is to women. And, as we have mentioned earlier, women's achievements are greatest in expanding economic branches and in those that employ a large proportion of women at lower levels.

Individual organizational policies often discriminate against women, either overtly or inadvertently. In Japan (see Steinhoff and Tanaka), the importance that large corporations attribute to seniority and career continuity and the frequency of geographic transfers to branch offices place women who attempt to juggle family and career responsibilities at a disadvantage. About two-thirds of the surveyed Japanese firms exclude women from the transfer system, thus depriving them of the opportunity to gain sufficient experience to advance in their careers.

Unresearched issues

We stress, again, that the reasons for the paucity of women in management are fairly similar worldwide—cultural sanctions, educational barriers, legal restrictions, corporate obstacles, and women's disinterest in pursuing traditional managerial careers—though the relative importance of each and the dynamics involved vary from one country to another. Given the dominance of American assumptions and United States-based research, however, a number of factors have tended to be overlooked or underresearched.

For example, what are the noncorporate career paths of women in management? What percentage of entrepreneurs are women? What is the distribution of female managers by size of firm (small, medium, and large), type of industry, and type of ownership (public corporations versus family-owned enterprises)? Symons's study in this collection describes four alternative career paths for female managers in Canada and France, but much more work is needed in this area.

Another underresearched area is that of ascribed status: To what extent do women worldwide gain access to managerial positions by being born into the "right" family, the "right" socioeconomic class, the "right" tribe, or the "right" ethnic group? Whereas much research, especially in North America, has focused on achieved status (i.e., general education, M.B.A. degrees, in-house training), far less research has dealt with the importance of ascribed status.

As suggested in the examination of assumptions at the beginning of this overview, paucity (i.e., as reflected in actual numbers) is only one way of viewing the issue of women in management. Another, equally important, dimension is assessment of women's effectiveness as managers. What do women contribute to the organization once they become managers? Is that contribution distinct or indistinguishable from that of men? Should women's effectiveness as managers be assessed relative to men's (the equity model), relative to other women's, or relative to some measurement of their net contribution to the organization (the complementary contribution model)?

To date we have made assumptions and created models, but have developed no real history of international research addressing the question of effectiveness. As the number of women in management begins to increase, research can begin to expand from its previous focus on barriers to entry to a needed focus on performance once on the job (effectiveness).

A look to the future

Most contributions to this collection identify gender differences in career behavior as important in explaining women's small numbers in management. These, however, are treated not only as differences between individuals who have been socialized differently but as differences emanating from the social structures in which each gender operates [6]. As Risman [11] has recently argued, "Material conditions, situational constraints, opportunity structures, socially organized inter-

actional expectations and actors' positions within social networks all operate to create and sustain cultural definitions of gender over and above gender-typed training or personality development.''

The implication, evident in almost all of the contributions to this book, is that significant changes in the number and positioning of women in management depend on restructuring the social environment [12]. This would require a more egalitarian division of labor in the home and family, greater gender desegregation of occupations, affirmative action programs that would make discriminatory behavior economically inefficient, and other social policies designed to create structures for equal opportunities.

Recognition of these requirements is currently reflected in the social policies of some governments. For example, two decades ago the Swedish government made a formal commitment to provide equal employment opportunity and equal participation in family life for both men and women. Sweden boldly attempted to change the very nature of society and the place of work within it [13]:

> A policy which attempts to give women an equal place with men in economic life while at the same time confirming woman's traditional responsibility for care of the home and children has no prospect of filling the first of these aims. . . . The subdivision of functions between the sexes must be changed in such a way that both the man and the woman in a family are afforded the same practical opportunities of participating in both active parenthood and gainful employment.

National governments, through legislation, and private corporations, through policy, are changing the role of women in management. The progress is slow, sometimes seemingly nonexistent; but there is progress. It may be that multinational corporations, faced with intense global competition, will assume the leadership in hiring and promoting women to top management. Can multinational corporations risk not choosing the best person just because her gender does not fit the traditional profile? Needs for competitive advantage, not an all-consuming social conscience, may answer the question, if not in fact define it. Already today,

> All over Europe, many of the top female executives are with North American—particularly U.S.—companies. Americans' acceptance of women managers, in turn, is influencing European companies. For a decade in Britain, for instance, merchant banks have increasingly hired

women for key posts, partly because they have seen their successful performance in rival U.S. banks.[14]

Many questions remain: Will society create new ways of balancing work and family demands, of men and women's working together, of experimenting with risk—the risk of promoting women into positions heretofore held by men, positions requiring major corporate or governmental responsibility? The reality is that some women are assuming top positions, and we predict that this trend will continue.

Will the trend greatly alter the gender structure of organizations? Although most of our authors end their contributions on a note of optimism concerning the future of women in management in their respective countries, we think that such optimism is still premature. It is unlikely that even the most favorable economic conditions would be sufficient to bring significant numbers of women into positions of true economic power. A significant increase in women in senior managerial positions would both require and reflect a basic restructuring of the distribution of power in society. "For categories of people to be equal, a social order must be restructured for equality of outcome" [12]. Such restructuring, however, is ultimately achieved through the accumulated daily negotiations for social change occurring in the various arenas of society. These negotiations take many forms: the investments women managers make in their education and training, their commitment to the world of work, their attempts to break through the "glass ceiling" of opportunity hierarchies. The women managers described in this book are visible evidence that the negotiation process is well under way.

Acknowledgments

Nancy J. Adler would like to thank the Social Sciences and Humanities Research Council of Canada for its support of her research on women in international management, and Ellen Bessner, for her excellent and insightful research assistance in preparing this paper.

Notes

1. P. Evans and P. Lorange (1986) "The Two Logics Behind Human Resources Management." Unpublished paper. Fontainebleau, France: INSEAD.

2. G. M. Steen (1986) "Male and Female Culture: A View from Sweden." Unpublished manuscript. Stockholm: Kontura Gruppen. Presented at the International Federation of Training and Development Organizations' annual meeting in Stockholm in 1985.

3. The 1982 Management Centre Europe survey included large and small companies, across industries, in the nine listed Western European countries. Since the selected companies all had some contact with Management Centre Europe, the sample cannot be considered random.

4. Management Centre Europe (1985) "Women Executives in Europe: Their Attitudes to Business." Executive Report. Brussels: Management Centre Europe.

References

1. Caulkin, S. (1977) "Women in Management." *Management Today*, September, pp. 58–63.

2. Taylor, A., III (1986) "Why Women Managers Are Bailing Out." *Fortune, 14*(4), 16–23.

3. Bird, C. (1976) *Enterprising Women*. New York: Norton.

4. Brown, L. K. (1979) "Women and Business Management." *Signs: Journal of Women in Culture and Society, 5*, 267–88.

5. Hennig, M., and Jardim, A. (1977) *The Managerial Woman*. New York: Pocket Books.

6. Kanter, R. M. (1976) *Men and Women of the Corporation*. New York: Basic Books.

7. Terborg, J. (1977) "Women in Management: A Research Review." *Journal of Applied Psychology, 63*, 647–64.

8. Loden, M. (1985) *Feminine Leadership, or How to Succeed in Business without Being One of the Boys*. New York: Times Books.

9. Management Centre Europe (1982) "An Upward Climb for Women in Europe" (Executive Report). Summarized in "An Upward Climb for Career Women in Europe." *Management Review, 71*(9), 56–57.

10. Burrow, M. G. (1976) *Women: A Worldwide View of Their Management Development Needs*. New York: AMACOM.

11. Risman, B. J. (1987) "Intimate Relationships from a Microstructural Perspective: Men Who Mother." *Gender & Society, 1*(1), 6–32.

12. Lorber, J. (1986) "Dismantling Noah's Ark." *Sex Roles, 14* (11/12), 567–80.

13. Barrett, N. S. (1973) "Have Swedish Women Achieved Equality?" *Challenge, 16*(November/December), 14–20.

14. Ross-Skinner, J. (1976) "European Women: Heading for the Executive Suite." *Dun's Review, 108*(4), 80–82, 131.

2

JEFF HEARN AND P. WENDY PARKIN

Women, Men, and Leadership: A Critical Review of Assumptions, Practices, and Change in the Industrialized Nations[1]

As the title indicates, assumptions, practices, and change in the relationship of leadership to women and men in the industrialized nations are critically reviewed. Organizations and organizational leadership are considered within a broad social and economic context, including the divisions that exist between women and men within, across, and beyond organizations. Major forms of leadership, in the literature and in practice—traditional male leadership, women in management, a process approach, and power perspectives—are analyzed in terms of their assumptions about gender. These are subjected to further examination through focuses on the critique of men, sexuality, the public and private domans, comparative studies, and political leadership. In conclusion, the authors draw on feminist critiques that challenge the whole concept of leadership and hierarchy.

Our purpose here is to review critically the roles of women and men as leaders, with particular reference to the assumptions that have been promoted, but are changing, within the literature and practice of leadership in the industrialized nations. In discussing this we are concerned not with women and men in biological terms, but rather with the social construction of women and men as genders. Thus, although the social and biological demands on women are different from those on men (for example, in their functions as mothers), we do not assume that women's and men's roles are fixed and not subject to change. "Women" and "men" and femininity and masculinity are socially and culturally produced and vary with the society and the social context.

Women may be more publicly visible now than in the past, but it is misleading to assume that there is a specific form of leadership practiced by "women as leaders" or "women in management." To label managers or leaders as special because they are women is itself part of the problem of the unequal social conditions of the sexes.

The social and economic context

The distribution of women and men in organizations takes a wide range of historical and cultural forms [1]. In many societies women have been, and are, the predominant producers of food, although their proportion of the community's wealth is small and they have less access to literacy and other sources and signs of public power. Historically, women have frequently had multiple responsibilities and therefore leadership roles, including home production of goods, teaching, healing, and agriculture. Novarra [2] identifies the following major tasks that have traditionally constituted "women's work" in Western society: bearing children, providing and preparing food, providing clothing, tending the sick and frail, early education, organizing the house, and emotional support work. In recent centuries such activities have become incorporated into public organizations, factories, schools, hospitals, and other male-dominated bureaucracies [3]. Women still continue in their traditional family and caring roles, but no longer have control over them.

Abundant evidence is now available to confirm that women tend to occupy less-powerful, lower-paid, and lower-status organizational positions than men. This not only can be seen in a mass of census and other official sources, including the various state "equal opportunity" agencies, but is analyzed in great detail in a large number of texts focusing on such topics as "the sexual division of labor," "women and work," and "the sexual structuring of organizations."[2]

The broad and pronounced tendency for men to occupy official leadership positions—in terms of *organizational role* at least—results from many factors and forces both outside and inside organizations. These include the domination of the public over the private domain, production over reproduction, and paid work over domestic and unpaid work. In addition, some commentators consider that women and men are a part of a dual labor market [11], women being part of a "reserve army of labor" [12,13], performing "dual roles" as paid workers and domestic child-carers, and even "triple roles" as carers also of the

elderly and infirm. Within organizations, relevant factors and forces include the valuation of men as intellectual workers over women as manual workers [14], of men as professionals over women as semi- or paraprofessionals [15], of men as manual workers in "nondomestic" trades—for example, engineering—over women as manual workers in "domestic" trades—for example, in clothing industries [16,17]—of men as full-time workers over women as part-time workers [18], and even of men as registered unemployed workers over women who are not registered as unemployed. Such divisions between women and men in the official organizational designation of leaders and leadership are frequently reflected in informal relations between women and men [19]. Leadership as a process between women and men has both formal and informal elements.

Divisions between women and men within organizations apply not only vertically, in terms of authority and types of labor, but also laterally, horizontally or spatially. Leadership roles can be conceptualized as part of the center or core of organizational activity, while other roles can be seen as part of the periphery, as boundary roles. Frequently this "spatial" distance between center and periphery in organizational structuring and in leadership involves clear divisions between men and women. In some organizations part of the leadership role of men comprises the direction of women into boundary roles that the men do not consider leadership roles. Ironically, such boundary roles may demand considerable initiative from workers and even involve high degrees of autonomy [20], qualities that might elsewhere be labeled those of leadership.

Furthermore, just as there may often be divisions between men at the center of organizations and women at the boundary, there may be similar divisions between those within and those outside organizations, as customers, clients, or other members of the public. Although it is, of course, difficult to generalize about the various clienteles of organizations, many organizations are characterized by clear differences between the distribution of women and men on and around the "front line." This can occur between male professionals and female clients, for example, in gynecological settings, or between female receptionists and male customers. When jobs as secretaries, receptionists, or salespersons in boutiques are allocated to women as a matter of course, they may involve women's being employed to sell their sexuality as part of their labor power [21].

The essential point is that the conceptualization and evaluation of

leadership *within* organizations and management often parallel or accompany *inverse* conceptualizations and evaluations of what is seen as nonleadership at or around the organizational boundary. In this way divisions between women and men—as, say, receptionists and clients— may reinforce leadership patterns, especially when the selling of sexuality is viewed as indicating the opposite of leadership. In contrast, leadership is usually understood as "asexual," "neutral," or, above all, male.

Traditional leadership

It is within the above-described general social and economic context that dominant traditional forms and notions of leadership have developed, both theoretically and practically. Characteristically, leadership has been performed by men; and characteristically, notions of leadership have implicitly assumed that leaders are to be men. Hence, leadership may be assumed to imply maleness, and maleness may be assumed to carry with it inherent qualities of leadership that women lack. These particular shortcomings of prevailing notions are obscured by a general lack of attention to the study of women and men within organizations [22].

A major example of these assumptions is Weber's three ideal-typical forms of authority [23]. First, leadership may be seen as arising from the traditional authority that comes from a socially accepted status, as, for example, that of fathers. Second, leadership may be understood as the product of the qualities and charisma of "great men." Third, leadership may be taken for granted as the usual complement of rational-legal authority within bureaucracies.

Although these interpretations are distinct within Weber's theorizing, elements of all three can be discerned in many mainstream studies of, and prescriptions for, leadership—for example, Taylor's "management of men" [24]. Subsequent work within organizational psychology attempted to identify the most significant traits in the selection and performance of leaders [25]. The major synthesis of these approaches is to be found in the social systems theories of Parsons, Bales, and colleagues [26,27] in terms of types of behavior. Such studies not only presumed the importance of role differentiation between women and men but frequently noted the pro-active competence of men over and against women [28]. Although much of this research was conducted in small-group contexts [29. Pp. 208–210], the impact of its assumptions

on organization theory and management theory has been lasting.

Even studies that are critical of the traits approach (e.g., Bavelas [30]) or are at pains to point out the dysfunction and incompetence of rigid leadership (e.g., Dixon [31], on the British army) often convey the assumption that leaders are to be men. The accompanying observations concerning women at the bottom of, at the boundaries of, or beyond organizations often bear the implicit assumption that women have inherent qualities of submissiveness that necessitate their being led by men. Classic studies in which such divisions of men as leaders and women as subordinates are not seen as problematic include Mayo's investigation of the Western Electric Company [32] and Crozier's analysis of French bureaucracy [33].

Variations in leadership style, from authoritarian to more participatory stances [34], are subtle variations on a masculine theme. Within many models of leadership, the necessary and desirable qualities are assumed to be masculine. This assumption is deeply entrenched in thinking and language, so that the language of leadership often equates with the language of masculinity to include qualities such as aggression, assertiveness, abrasiveness, and competitiveness. When women demonstrate such qualities and become leaders, a distortion of the language often occurs: aggressive becomes "overdomineering," and assertive is viewed as bossy and strident. Even more pejorative terms are used to describe men who demonstrate a different style of leadership, one that may be seen as more flexible and cooperative: they may be subject to derogatory comments ascribing supposedly feminine attributes to their leadership. In such an ideological perspective, leadership is not considered a female occupation, a female leader is regarded as an aberration, and women who become leaders are often offered the presumed accolade of being described as being like men.

The entry of women into management

The growth of hierarchical bureaucracies has produced a situation in which, it can be argued, there is little distinction between formal leadership and management. Males continue to dominate in such organizations, women seldom gaining top management posts and being grossly underrepresented even in lower management positions. This applies not only to technological and engineering organizations but also to educational and welfare organizations, in which women often predominate in numerical terms.

The slow increase in the number of women in management, or attempting to become part of management, has produced a considerable literature, particularly in the United States, offering both theoretical interpretations and practical advice (e.g., Gordon and Strober [35], Fenn [36], Stead [37]). Excellent bibliographies on "women in management" are contained in Stead and in Leavitt [38].

In much of this literature there is a concern with the entry of women into management. For example, Hennig and Jardim's [39] advice for the aspiring careerist woman in management is to bear in mind that she is ". . . going to a foreign country for an extended stay." In a foreign country one has to learn, or at least try to use, a foreign language and understand different norms and standards. In the case of management, women are entering a well-established male preserve with well-established rules and language. These circumstances can be important determinants of female behavior. An interesting variant on these *corporate* dynamics is provided by the managerial experiences of women as *entrepreneurs*. Goffee and Scase [40] have recently surveyed British women proprietors and concluded, from the variety of their experiences, that they can be "innovative entrepreneurs," "conventional businesswomen," "radical co-owners," or "domestic traders."

In contrast, the entry of men into management is taken for granted: they are already there; some may even assume that it is an inherent attribute of men that they should be there. Thus, in subtle ways the conceptualization of the entry of women into management can reinforce the equation of leadership with masculinity.

The phenomenon of women in management raises the further question of whether those women, once they have "entered" management, have a different style of leadership, stemming from the supposedly inherent qualities of women. The "sex differences" approach to women in management assumes that women possess characteristic qualities which result in a form of leadership different from that of men. Women's qualities in leadership can then be used or exploited in an organization, perhaps in an attempt to "soften" its image [41]. Another "sex differences" approach argues that women who achieve leadership have denied or repressed the attributes of their sex and have become like men.

Jacklin and Maccoby [42] have looked critically at sex differences and their implications for management. Their research provides little evidence for substantiating a "sex differences" approach, pointing out, for example, that "The male potential for empathic and sympathet-

ic emotional reactions and male potential for kindly helpful behavior towards others (including children) is seriously underrated'' (P. 31). They also put the issue in a broader context, noting: ''. . . dominance or leadership appears to be achieved primarily by aggressive means among apes and little boys. Among human beings, the linkage weakens with increasing maturity and there appears to be no intrinsic reason why the more aggressive sex should be the dominant one in adult relations'' (P. 34). No evidence of sex differences was found in achievement motivation, risk-taking, task persistence, or other, related skills. Jacklin and Maccoby conclude that women are not psychologically handicapped for management, but are blocked by recruitment, hiring, and promotion policies.

Meeker and Weitzel-O'Neill [43] have also comprehensively argued against the sex differences approach and instead propose an analysis of sex roles that is more specifically context based. This may help to describe (though not explain) how status and power are still bestowed on male professionals and managers, whereas status and negative connotations are given to the leadership role of women in the family. Yet, when management courses were set up for women within the University of Aston's Women and Work Programme in England, women came with trepidation, but were amazed to discover that many of the tasks they had been performing might be defined as management functions, though they lacked the social and economic status [44].

Women who seek to enter management clearly face a number of problems. These include coping with additional family and domestic roles [45,46], managing conflicts between paid work and unpaid work, and fighting against a variety of myths that persist about women's ''management potential.'' The tensions and conflicts women managers face have been a major focus of recent British research on women in management. This work represents an important contribution to the literature and a rather different emphasis from the often more organization-focused American research.

In what is the most sophisticated analysis yet of women in management, Marshall [47. Chap. 2] effectively demystifies and counters the following six such misapprehensions, drawing on published research evidence:

 (1) Women are different from men, so they do not make good managers.

 (2) Women do not have the same motivations towards work as men.

(3) Stereotypes of women mean companies are reluctant to employ them as managers.

(4) Women believe the stereotypes too, and behave accordingly.

(5) Other people will not work for or with women, or make life difficult for them if they do.

(6) When women go out to work their children and husbands and homes suffer, and society suffers as a result. (P. 13)

It is not surprising that in this social context, women managers experience considerable pressures and stress [48–50]. More positively, it can be argued that the dual roles and multiple responsibilities of women mean that they are *more* eminently suited for the multiple responsibilities of management, as they have wider experience of complexity and decision making in different settings. Furthermore, these complications and potentialities have important consequences for the training of women—and, indeed, men—managers. Recent discussions of such issues are to be found in an Irish study of the problems of women and men working together [51] and Dutch experience of women-only training in the face of some women's isolation and difficulty in entering into open conflict in a constructive manner [52].

Although most of the literature dealing with the entry of women into management stands in clear opposition to traditional assumptions about leadership and its domination by males, it can itself be criticized as limited in certain respects. The literature on women in management is predominantly business oriented, American in origin and in cultural assumptions, often unduly optimistic about the immediate possibilities for change, and devoted to what remains an issue for a relative minority of women. It seems to obscure various issues that affect most women, such as whether the presence of more women managers would improve the lot of women workers. The literature is often psychological in orientation, stressing the "managerial qualities" of particular women and rarely considering the larger questions of social structure and power. It does not necessarily provide a general, critical reformulation of the relationship of gender and leadership, as management is usually assumed to involve a relatively fixed set of powers and practices that women may assume and apply.

Leadership as processes between women and men

In contrast to viewing management and leadership as something performed by managers or leaders *upon* others who are managed or led,

one may conceptualize them as processes *between* people, in this context, women and men. If management and leadership are processes as well as practices, this means that it is equally important to consider the effects of leaders upon the led and the led upon leaders—and indeed, the relations between the two groups. It may even be necessary to question the usefulness of the terms *leaders* and *led*. For example, Whyte's [53] classic study of the social structure of the restaurant suggests that leadership roles of male kitchen staff are based on taking responsibility for originating initiatives *for* women. The male kitchen staff has much to gain by containing orders (both for food and in general) from female waitresses by physical barriers, use of written slips, and generally setting their own pace of work.

The interesting point is that leadership is no longer the province of one set of (male) leaders, but involves all organizational members, with reciprocal yet partial attempts to influence and control overtures made by others, both women and men, in the organization. This occurs within a more general process that cannot be determined by any one group or set of leaders.

Subsequent American studies of women's and men's leadership in a variety of group situations also emphasize the importance of looking at the reciprocal behavior of "leaders" and "nonleaders," superordinates and subordinates, women and men, at the same time [54. Chap. 30]. The research in this area is complex, but a number of examples will give some idea of the type of questions that have been addressed.

Bartol [55] has noted the adverse effects of male leaders on female group members' satisfaction with task structure, compared with the mildly positive effect on task situations of female leaders for female followers in mixed groups. It is no longer possible to consider the evaluation of female or male leaders in isolation. Another study, by Bartol and Wortman [56], takes the analysis of these processes further in concluding that although leaders' sex may be a significant factor in determining, *inter alia*, perceived leader behavior or job satisfaction, the nonleader's sex may be significant in determining how the leader is perceived and the nonleader's own job satisfaction. A more recent, critical study, by Mayes [57], has examined the differences in the reactions of women and men nonleaders within female- and male-led groups. The reactions were found to be to the whole group process, not just to the leader. Men's reactions to female-led groups were particularly interesting: they included feelings of hostility, dependency, confusion, and, above all, uncomfortableness.

Authority and power relations

A process approach to leadership may emphasize informal relations, but has clear implications for formal structuring. Simpson and Simpson [15], for example, postulate that the differences in work orientation of women and men may be a major factor in the tendency of numerically female-dominated organizations, such as in the "semiprofessions" of teaching, nursing, social work, and librarianship, to become more bureaucratic and more centralized. Sexual divisions can account for a particular type of formal process of authority and leadership. Although their work has subsequently been criticized, not least on empirical grounds [58,59], the Simpsons' contribution is a lasting one. They have raised issues and questions on the need to understand patterns and processes of leadership as but one part of a system of authority and power relations between women and men, both inside and outside a given organization.

Thus, as noted above, we may usefully reinterpret aspects of Crozier's [33,60] classic study of power in the French bureaucracy, and even the Hawthorne Experiments in the Relay Assembly Testing Room [32], as being products of the power relations between men superordinates and women subordinates, as well as of control over uncertainty and informal dynamics.

Kanter [61] has analyzed the distribution of power within organizations as a central issue in determining the distribution of work attitudes and behavior, including leadership, between women and men. She sees the location of a person in the organizational structure as a more significant determinant of leadership behavior than sex differences per se. Many women and some men are in disadvantaged positions in society and in organizations, but women are the more disadvantaged. The structure of power within organizations rather than gender attributes explains the concentration of women at the bottom of the hierarchy.

Wells [62] argues, similarly, that women have been "late entries" into organizations, whose structure and power relations were already determined by masculine values and male prerogatives. Accordingly, women may often find that the covert power of men, reinforced by the hierarchical power structure of organizations, influences the way in which women experience power. Reducing hierarchical power within hierarchical organizations can thus assist both women and men, but has greater potential for changing the lot of women.

This approach to leadership and its change raises a more subtle issue: that power in organizational settings is itself understood and experienced as essentially male [63]. According to this formulation, not only do men dominate within organizations but they dominate the currency by which domination is maintained. Kanter [64] maintains that subordinates often prefer to work for the "powerful," which in practical evaluations tends to mean men: as she puts it, "preference for men = preference for power." Men's continuing domination of leadership roles, particularly as formal leaders, is only part of the male domination of leadership: in addition, the process of leadership, what counts as leadership, the means of gaining legitimacy in leadership, and so on, are male dominated in most organizations.

The critique of men

The development of the power perspective on leadership necessarily leads to consideration of the power of men. This perspective from within organization theory links with more broadly based feminist and other critiques. Hence, there is a dual reason for exploring the critique of men.

Feminist and other radical critiques have addressed men's leadership in a number of different ways. First, and most obviously, critiques have been developed in relation to the behavior of particular men leaders. Pollert [19], for example, in her study of a tobacco factory in Bristol, England, discusses the way in which the authority of male supervisory staff over women workers is maintained and reinforced by sexist language, jokes, and innuendo. Similarly, Kanter [64] and Korda [65] explore the frequent sexism in managers' behavior. This is particularly crucial for women, such as secretaries, who work closely with managers [66]. More generally still, management, and therefore predominantly male management, can be analyzed as a distinct class-grouping. Management by men can be understood as an important contributory factor to the maintenance of a "capitalist patriarchy" [67].

A second approach to the critique of men is not directed specifically at men who are employed as leaders, but rather at other sources of men's power and leadership at work. Most important of these are the power and leadership that accrue from men's labor power. As Cockburn [68. P. 134], in her study of the British printing industry, puts it: "The solidarity forged between men as a group of males is part of the

organised craft's defence against the employer.'' This process is important in the development of dominant forms of masculinity among working-class men, which, in turn, has several implications for leadership: perpetuation of the pattern of men as leaders of working-class women, the occasional alliance of male workers with male management, and the general male domination of many organizational cultures.

Third, there are critiques that treat men as a class, and thus represent critiques of men's leadership. The roots of men's being regarded as a class may lie in either biology [69] or the economy, or both. Delphy [70,71], the French feminist theorist, for example, emphasizes the divisions between women and men in marriage and the family as a mode of production. In such views, ''. . . every. . . relationship [between a woman and a man] is a *class* relationship, and the conflicts between individual men and women are political conflicts that can only be resolved collectively'' [72]. The relationship between an individual man superordinate and women subordinates, or indeed between a woman superordinate and men subordinates, has, from this perspective, to be understood strictly as an instance in a broader class relationship.

Leadership and sexuality

One specific aspect of leadership that concerns relations between women and men, indeed, between people of the same sex, is sexuality. Men's domination of leadership—in formal, public terms at least—means that many models of masculinity are based on some form of power. Similarly, dominant models of men's sexuality frequently include elements of domination and ''mastery.'' There are numerous detailed ways in which sexuality, power, and leadership can become intertwined [73], in both social and psychological terms [74,75].

Those in formal positions of leadership may also have either the responsibility for, or an interest in, controlling the sexual behavior and attitudes of subordinates [76]. This may include taking punitive action against those, particularly women, who engage in sexual liaisons in the organization [77]. Moreover, men managers frequently evaluate women workers not only on the grounds of work done but also of appearance and sexual presentation [78].

Such interest in others' sexual behavior on the part of leaders may be particularly acute in ''total institutions,'' in which responsibility extends over both staff and inmates. In most organizations, management

of sexuality usually involves assumptions of "normality" and, gener-
ally, heterosexuality [79]. This can have a wide range of subtle effects
on the selection and promotion of leaders and managers—for example,
in the evaluation of male executives' wives, and in discrimination
against, and thus maintenance of, secrecy concerning homosexuality.
According to reports from both Britain [80. Pp. 78,79] and Germany
[81], the persecution of homosexuality is particularly severe in the
armed forces. The implications for leadership styles and the leadership
prospects of homosexuals are clear.

These general tendencies within management and leadership some-
times have a greater and more directly oppressive impact on women in
the form of sexual harassment. There are now numerous reports of the
occurrence of harassment, including that by men managers of subordi-
nate women, and even of women managers and professionals [46,82].
Surveys in both Britain and the United States have recorded very high
rates of sexual harassment of women entering work in jobs not tradi-
tionally defined as "women's work" and therefore in relative isolation
from other women [83,84]. Such conditions apply to many women in
management and other leadership roles, and this raises the question of
how men in positions of power may collude with other, less-powerful
men in the process of harassment of women.

The significance of sexuality, and indeed of sexual harassment, in
leadership is that it represents an incursion of the private into the public
domain. It is to this general theme of the public and the private that we
now turn.

The public and the private

Organizations, and therefore leadership in organizational settings, are
distributed in a very distinctive way throughout society. Although
organizations exist for and across all economic classes and within all
spheres of human activity, they are especially prominent in the public
domain, which includes most workplaces where people work for pay-
ment, political organizations, and public places. Inasmuch as private
life does sometimes take place in organizations, e.g., in kibbutzim, and
public life does sometimes take place outside organizations, e.g., in
crowds and street groups, there is a considerable overlap between the
"public" and the "organizational" in most, and particularly Western,
societies.

The theme of the public–private divide has been dealt with in recent

years by a number of feminist writers, among them O'Brien [85], Elshtain [86], and Stacey and Price [87] at a somewhat theoretical level, and Nowotny [88] and Skard [89] in empirical studies of Austrian and Norwegian women, respectively. O'Brien [90], in particular, has explored the theoretical significance of this divide, arguing that "The opposition of public and private is to the social relations of reproduction what the opposition of economic classes is to the social relations of production" (P. 236).

This perspective is important in understanding both organizations and organizational leadership. It implies that leadership, in organizations at least, usually involves *two* levels of activity and action: first, in the organization concerned, and second, in the public sphere over the private sphere. Not only do women and men tend to occupy positions of leadership unequally in most organizations but there is a further inequality between women and men in terms of the power of the public over the private. Therefore, men usually lead and dominate women not just in particular organizations but also in the way those organizations form part of public life, which is dominated and led by men. For example, male managers may be directly powerful in public, organizational settings and indirectly powerful in the private sphere, both with regard to consumers and clients (frequently women) in general and in their own domestic realm.

Several implications follow from this kind of analysis of organizations and leadership. One is that particular organizations, and therefore their leadership, can be understood as part of the process of production and/or reproduction. Production and reproduction have very different significance for women and men. This may be a secondary matter within production, even though production taking place in the public sphere may be part of men's domination of women. Within reproduction, the division between women and men is clearly a primary matter. Thus, for example, leadership, usually by men, in a maternity hospital involves several interrelated elements: the domination of the public over the private, the domination of men over women's reproductive labor [91], and the more specific intraorganizational domination through hierarchy.

Another area of importance in considering the interrelation of women, men, and leadership is in activity on and across the public–private divide. In particular, there are a number of studies stressing the leadership roles of women in moving private experiences, often of other women, into the public, and therefore explicitly political, sphere [92].

Often such pioneering activity is immensely difficult, subject to rapid change and conflicting pressures, and perceived as a threat within male-dominated organizations in the state and elsewhere. A recent British example is the development of the national and local women's aid organizations providing shelter and support for women who have suffered violence from men [93]. Many such initiatives of leadership by women across the public–private divide subsequently encounter attempts by men, often as professionals, to take over or incorporate them [94].

Considerable analytical care needs to be taken in the interpretation of the location of such "peripheral" organizations that stand on or across the public–private divide. Some may represent attempts to establish an autonomous public sphere for women; others may act as subsidiaries of male-dominated organizations, even though they are led by women and perhaps are limited to women members [95]; still others may represent the development of exchange relationships between women in the performance of domestic tasks, such as "baby-sitting" [96]. Together, such organizational and leadership initiatives, frequently by women, are means of renegotiating the public–private divide.

Comparative studies

It has been noted at several points in this paper that the dominant tradition in leadership research has been derived from studies in the United States, particularly from American management theory. Accordingly, much of this work is liable to charges of ethnocentrism, especially in the study of gender and leadership. An important development from purely organizational studies of women in management and leadership, reflecting a broadening of questions such as those discussed above, has been an increasing interest in comparative studies of the economic and social positions of women, and thus of men. For example, recent Norwegian studies have noted both wide variations in the cultural forms of, and relation of gender to, leadership [97] and possible variations in conceptions of sex roles even within a particular culture [98]. Cross-cultural and comparative studies are particularly difficult to perform [54. Chap. 32], and may indeed fail to yield very firm conclusions [99].

Although most forms of business and managerial leadership are still patriarchal, the precise mechanism for maintaining patriarchal leader-

ship varies considerably. Not only broadly cultural and narrowly orga-
nizational factors but also more structural and societal causes of vari-
ation must be recognized. Perhaps most important is the impact of past
or present feudal structures on industrial and capitalist organizations,
as in the Middle East or Japan. For example, Rohlen's study [100] of a
large Japanese bank, performed in 1968–1969, pointed out that "wom-
en must resign on marriage, and there are no exceptions!'' (P. 78). In
order to achieve senior positions, the few women concerned therefore
had to be the appropriate age and unmarried. Although there have been
some changes for women since that time, the Japanese system remains
paternalistic and patriarchal [101].[3]

Political leadership

The major contribution of recent comparative studies, and of non-
Anglo-American research, has been in analysis of the state of women's
participation and representation, or lack of it, in politics and public life
rather than specifically in management or business leadership (*pace*
Silver [102] and Whitley [103]). This theme is dominant in the impor-
tant collections edited by Epstein and Coser [104] on elites, Loven-
duski and Hills [105] on political participation, and Siltanen and Stan-
worth [106] on politics in the public sphere. Perhaps the most
important point is that what is regarded as "politics" is concerned
primarily with men's activities and is generally considered the domain
of men, not women, as has been emphasized by the Norwegian com-
mentators Skard [89] and Albrektsen [107].

The Lovenduski and Hills [105] collection, for example, includes
surveys of women's public participation in political life in, *inter alia*,
Spain (Matsell), Italy (Weber), Sweden (Eduards), Finland (Haavio-
Mannila), Eastern Europe (Wolchik), the USSR (Lovenduski), and
Japan (Hargadine). These and similar studies consider the extent of
women's participation in voting, political party membership and lead-
ership, candidacy and electoral success, and representation in legisla-
tures, governments, and ministerial offices. Sanzone [108], for in-
stance, reviews the changing representation of women in power
positions of central government, particularly their general absence
(*pace* Thatcher) from the more prestigious ministeries, in France, West
Germany, and the United Kingdom.

Although there are gross imbalances in formal political leadership
between women and men, it would be a mistake to overgeneralize about

their nature, extent, and even causes among different countries and cultures. For example, in the Soviet Union about three-fourths of the doctors are women, but there is not one woman in the Politburo. Even within Scandinavia there is considerable cultural variation between the traditionalism of Norway [89] and the relative political activism of Finnish women [109]. A further complication is the impact of various "equal opportunities" and civil rights legislation upon the legal status of women and how this interrelates with leadership practices. The studies we have cited, however, focus on the political leadership of women within male-dominated definitions of politics and organization.

Further feminist approaches

Radical feminists such as Siren/Black Rose [110], Farrow [111], Kornegger [112], and Ehrlich [113] go further than this in urging attention to the ideological underpinnings of modern organizations, which they claim are dominated by men. Women's increasing awareness of male supremacy has evoked a variety of responses. Some women have "entered" management and leadership and have demonstrated an ability to perform equally with men in their organizational roles. Far from bringing a "softer" approach, based on supposedly inherent female characteristics of submissiveness, passivity, and caring, to leadership positions, they have demonstrated that women as well as men can be competitive and assertive. This would seem to confirm Kanter's view that organizational position is a more powerful determinant of behavior and attitude than supposedly inherent sex differences.

Having said that, we have to argue that society does impose on women and men gender roles that inevitably follow them into organizational roles. Thus, women continue to predominate in lower-paid, lower-status, caring roles, often at the bottom of career structures, despite the apparent success of women whose response to male domination has been to campaign for a change in the law that will assure them equal pay and opportunities. Women continue to experience oppression, discrimination, and harassment, and their "entry" into leadership and management and changes in the law have evoked only token responses.

It is not surprising, in view of this, that Charlton [114], in England, and Gould [115], in the United States, draw attention to feminist organizations with "nonpatriarchal and nonhierarchical" structures that are considered alternatives to the existing male-dominated hierar-

chies and are not dependent on them. This can imply a "sex differences" approach in which women intrinsically organize themselves cooperatively and nonhierarchically. We have repeatedly argued, however, that the "sex differences" approach is a misleading oversimplification of a complex situation that has its roots in history, tradition, and religion. It ignores women who have successfully risen in hierarchies and men who seek cooperative alternatives. Yet this anti-organizational stance is frequently taken by feminists, who use it not as a statement about the nature of women, but as an illustration of how the sex role assigned to women in our society can be used in a political challenge. This challenge to male power, domination, and leadership can be seen more clearly as a political statement when it is compared with the unwillingness of some black people to reinforce white supremacy by "entering" white organizations and their preference for establishing their own radical alternatives.

A striking example of this sort of political statement in action is the creation of the women's peace movement and the setting-up of peace camps in Britain, and the way they have attracted considerable male hostility and harassment [116]. This reaction suggests that these radical, anti-organization, feminist movements are presenting a stronger challenge to the present male order than does women's joining male-dominated organizations. The former movements represent a double threat to the *status quo* in that they challenge the whole concept of leadership and hierarchy as a form of power and, with it, the long-held view, bound up in all our languages, that leadership, masculinity, and power are inextricably linked. Power becomes "empowerment," "power to" or "power for," not "power *over*," energy, not domination [117], and thus goes "beyond leadership" [118].

It is therefore appropriate that we conclude with comments from a feminist peace campaigner [119]:

> The male cosmology based on separation and hierarchy gives rise to strategies for peace based on building barriers and creating fear. The result is a never-ending arms spiral. The alternative, a positive peace built on mutual support and co-operation. . . . It is our vision and our practice of a new way to peace that makes women such an important force in the peace movement—not any "natural pacifism" attributed to women. The common belief that women are by nature non-aggressive is itself part of the female stereotype of passivity, the complement of the idea that violence and war are "natural" to men. . . . Men are not inherently

violent; they are traditionally and structurally dominant and retain that dominance through the cultivation of toughness and violence. (Pp. 26–27).

Leadership, as usually understood, is not a natural phenomenon or process; neither is it a natural attribute or possession of women or men; nor is it salvation for either. Leadership needs deconstruction: it is as gendered as it is problematic.

Notes

1. This is a revised and extended version of the paper P. W. Parkin and J. Hearn (1987) "Frauen, Männer, und Führung." In A. Kieser, G. Reber, and R. Wunderer (Eds.), *Handwörtbuch der Führung*. Stuttgart: C. E. Poeschel.

2. British material is surveyed by Davies [4] and Mackie and Pattullo [5]; Australian material, by Game and Pringle [6]. Lewenhak [7] takes an admirably international and historical approach, considering the experience of China, France, the United States, and many other countries. Invaluable bibliographies on this material have been prepared by the International Labour Office [8], Winship [9], and Clarricoates, Cooper, and Allen [10].

3. See also the Steinhoff and Tanaka contribution to this volume.

References

1. Sanday, P. R. (1981) *Female Power and Male Dominance*. London: Cambridge University Press.

2. Novarra, V. (1980) *Women's Work, Men's Work*. London: Marion Boyars.

3. Ehrenreich, B., and English, D. (1978) *For Her Own Good. 150 Years of Experts' Advice to Women*. New York: Anchor/Doubleday.

4. Davies, R. (1975) *Women and Work*. London: Arrow.

5. Mackie, L., and Pattullo, P. *Women at Work*. London: Tavistock.

6. Game, A., and Pringle, R. (1983) *Gender at Work*. North Sydney: Allen & Unwin.

7. Lewenhak, S. (1980) *Women and Work*. London: Fontana.

8. International Labour Office (1970) *Bibliographie sur le Travail des Femmes*. Geneva: International Labour Office.

9. Winship, J. (1978) *Women at Work Bibliography*. Birmingham: Centre for Contemporary Cultural Studies, University of Birmingham.

10. Clarricoates, K., Cooper, A., and Allen, S. (1980) *Women in Local Labour Markets*. London: Social Science Research Council.

11. Barron, R., and Norris, G. (1976) "Sexual Division and the Dual Labour Market." In D. Barker and S. Allen (Eds.), *Dependence and Exploitation in Work and Marriage*. London: Tavistock. Pp. 47–69.

12. Braverman, H. (1974) *Labor and Monopoly Capital*. New York: Monthly Review Press.

13. Bruegel, I. (1974) "Women as a Reserve Army of Labour: A Note on Recent British Experience." *Feminist Review, 3*, 12–23.

14. Willis, P. (1977) *Learning to Labour*. Farnborough: Saxon House.

15. Simpson, R. L., and Simpson, I. H. (1969) "Women and Bureaucracy in the Semi-professions." In A. Etzioni (Ed.), *The Semi-professions and Their Organization*. New York: The Free Press. Pp. 196–265.

16. Cunnison, S. (1966) *Wages and Work Allocation*. London: Tavistock.

17. Lupton, T. (1963) *On the Shopfloor*. Oxford: Pergamon.

18. Beynon, H., and Blackburn, R. (1972) *Perceptions of Work. Perceptions within a Factory*. London: Cambridge University Press.

19. Pollert, A. (1981) *Girls, Wives, Factory Lives*. London: Macmillan.

20. Miles, R. (1980) "Organization Boundary Roles." In C. Cooper (Ed.), *Current Issues in Occupational Stress*. Chichester: Wiley. Pp. 61–96.

21. Bland, L., Brunsdon, C., Hobson, D., and Winship, J. (1978) "Women 'Inside and Outside' the Relations of Production." In Women's Studies Group, Centre for Contemporary Cultural Studies, University of Birmingham, *Women Take Issue*. London: Hutchinson. Pp. 35–78.

22. Hearn, J., and Parkin, P. W. (1983) "Gender and Organizations: A Selective Review and a Critique of a Neglected Area." *Organization Studies, 4*(3), 219–42.

23. Weber, M. (1947) *The Theory of Social and Economic Organization*. Glencoe, IL: The Free Press.

24. Taylor, F. (1947) *Scientific Management*. New York: Harper. Section reprinted from Testimony to the House of Representatives Committee, 1912.

25. Stogdill, R. (1948) "Personal Factors Associated with Leadership." *Journal of Psychology, 25,* 35–71.

26. Parsons, T., Bales, R. L., and Shils, E. A. (1951) *Working Papers in the Theory of Action*. Glencoe, IL: The Free Press.

27. Parsons, T., and Bales, R. F. (Eds.) (1955) *Family, Socialization and Interaction*. New York: The Free Press.

28. Strodtbeck, F. L., and Mann, R. D. (1956) "Sex Role Differentiation in Jury Deliberations." *Sociometry, 19,* 3–11.

29. Hare, A. P. (1962) *Handbook of Small Group Research*. Glencoe, IL: The Free Press.

30. Bavelas, A. (1960) "Leadership: Man and Function." *Administrative Science Quarterly, 4,* 491–98.

31. Dixon, N. (1976) *On the Psychology of Military Incompetence*. London: Cape.

32. Mayo, E. (1933) *The Human Problems of an Industrial Civilization*. New York: Viking.

33. Crozier, M. (1963) *Le Phénomène Bureaucratique*. Paris: Editions du Seuil.

34. Likert, R. (1961) *New Patterns of Management*. New York: McGraw-Hill.

35. Gordon, F., and Strober, M. (Eds.) (1975) *Bringing Women into Management*. New York: McGraw-Hill.

36. Fenn. M. (1978) *Making It in Management*. Englewood Cliffs, NJ: Prentice-Hall.

37. Stead, B. A. (Ed.) (1978) *Women in Management*. Englewood Cliffs, NJ: Prentice-Hall. (2nd ed., 1985).

38. Leavitt, J. A. (1982) *Women in Management: An Annotated Bibliography and Sourcelist*. Phoenix, AZ: Oryx.

39. Hennig, M., and Jardim, A. (1978) *The Managerial Woman*. London: Marion Boyars.

40. Goffee, R., and Scase, R. (1985) *Women in Charge. The Experiences of Female Entrepreneurs*. London: Allen & Unwin.

41. McLane, H. S. (1980) *Selecting, Developing and Retaining Women Executives.* New York: Van Nostrand.

42. Jacklin, C. N., and Maccoby, E. E. (1975) "Sex Differences and Their Implications for Management." In F. Gordon and M. Strober (Eds.), *Bringing Women into Management.* New York: McGraw-Hill. Pp. 23–38.

43. Meeker, B. F., and Weitzel-O'Neill, P. A. (1977) "Sex Roles and Interpersonal Behavior in Task-orientated Groups." *American Sociological Review, 42*(1), 91–105.

44. Coyle, A. (1984) "Power Point." *The Guardian,* 8 December.

45. Fogarty, M., Rapoport, R., and Rapoport, R. N. (1971) *Sex, Career and Family.* London: Allen & Unwin.

46. Cooper, C., and Davidson, M. J. (1982) *High Pressure. Working Lives of Women Managers.* Glasgow: Fontana.

47. Marshall, J. (1984) *Women Managers. Travellers in a Male World.* Chichester: Wiley.

48. Davidson, M. J., and Cooper, C. L. (1983) *Stress and the Woman Manager.* Oxford: Martin Robertson.

49. Davidson, M. J., and Cooper, C. L. (1984) "Occupational Stress in Female Managers. A Comparative Study." *Journal of Management Studies, 21*(2), 185–205.

50. Davidson, M. J., and Cooper, C. L. (1984) "She Needs a Wife: Problems of Women Managers." *Leadership and Organization Development Journal, 5*(3), 1–30.

51. Donleavy, M. R. (1985) "Antidote to Babel: Organisational and Personal Renewal through Women and Men Working Together." *Management Education and Development, 16*(2), 230–37.

52. Fischer, M. L. (1985) "On Social Equality and Difference—A View from the Netherlands." *Management Education and Development, 16*(2), 201–210.

53. Whyte, W. F. (1949) "The Social Structure of the Restaurant." *American Journal of Sociology, 54,* 302–310.

54. Bass, B. M. (1981) *Stogdill's Handbook of Leadership. A Survey of Research.* New York: The Free Press.

55. Bartol, K. (1975) "The Effect of Male Versus Female Leaders on Follower Satisfaction and Performance." *Journal of Business Research, 3,* 31–42,

56. Bartol, K., and Wortman, M. (1975) "Male Versus Female Leaders: Effects on Perceived Leader Behavior and Satisfaction in Hospitals." *Personnel Psychology, 28*(4), 533–47.

57. Mayes, S. S. (1979) "Women in Positions of Authority." *Signs: Journal of Women in Society and Culture, 4*(3), 556–68.

58. Marrett, C. M. (1972) "Centralization in Female Organizations: Reassessing the Evidence." *Social Problems, 19,* 348–57.

59. Grandjean, B. D., and Bernal, H. H. (1979) "Sex and Centralization in a Semi-profession." *Sociology of Work and Occupation, 6,* 84–102.

60. Sheriff, P., and Campbell, E. J. (1981) "La Place des Femmes: Un Dossier sur la Sociologie des Organisations." *Sociologie et Sociétés, 13,* 113–30.

61. Kanter, R. M. (1975) "The Impact of Hierarchical Structures on the Work Behavior of Women and Men." *Social Problems, 23,* 415–30.

62. Wells, T. (1973) "The Covert Power of Gender in Organizations." *Journal of Contemporary Business, 2* (Summer), 53–68.

63. Korda, M. (1976) *Power!* London: Coronet.

64. Kanter, R. M. (1977) *Men and Women of the Corporation.* New York: Basic Books.

65. Korda, M. (1972) *Male Chauvinism! How It Works.* New York: Random House.

66. Vinnicombe, S. (1980) *Secretaries, Management and Organization.* London: Heinemann.

67. Eisenstein, Z. R. (Ed.) (1979) *Capitalist Patriarchy and the Case of Socialist Feminism.* New York: Monthly Review Press.

68. Cockburn, C. (1983) *Brothers. Male Dominance and Technological Change.* London: Pluto.

69. Firestone, S. (1970) *The Dialectic of Sex: The Case for Feminist Revolution.* New York: Morrow.

70. Delphy, C. (as Dupont, C.) (1970) "Liberation des Femmes: Année Zéro." *Partisans,* No. 54–55. Reprinted as *The Main Enemy.* London: Women's Research and Resources Centre, 1977.

71. Delphy, C. (1984) *Close to Home. A Materialist Analysis of Women's Oppression.* London: Hutchinson.

72. Redstockings (1969) *Manifesto.* Quoted in A. Coote and B. Campbell (1982) *Sweet Freedom.* London: Blackwell.

73. Zetterberg, H. L. (1966) "The Secret Ranking." *Journal of Marriage and the Family, 28,* 134–42.

74. Bradford, D., Sargent, A., and Sprague, M. (1975) "Executive Man and Woman: The Issue of Sexuality." In F. Gordon and M. Strober (Eds.), *Bringing Women into Management.* New York: McGraw-Hill.

75. Hearn, J., and Parkin, W. (1987) *"Sex" at "Work." The Power and Paradox of Organisation Sexuality.* Brighton: Wheatsheaf; New York: St. Martin's.

76. Burrell, G. (1984) "Sex and Organizational Analysis." *Organization Studies, 5*(2), 97–118.

77. Quinn, R. (1977) "Coping with Cupid: The Formation, Impact and Management of Romantic Relationships in Organizations." *Administrative Science Quarterly, 22*(1), 30–45.

78. MacKinnon, C. (1979) *The Sexual Harassment of Working Women.* New Haven: Yale University Press.

79. Rich, A. (1980) "Compulsory Heterosexuality and Lesbian Existence." *Signs: Journal of Women in Society and Culture, 5*(4), 631–60.

80. Tatchell, P. (1985) *Democratic Defence.* London: GMP.

81. Kentler, H. (1985) "Still Despised and Persecuted. On the Position of Homosexuals in the World of Work." *Planned Parenthood in Europe (Familienplanung in Europe), 14*(1), 32–35.

82. McIntosh, J. (1982) "Sexual Harassment. You Tell Us It's *Not* a Joke." *Cosmopolitan,* October.

83. Leeds Trade Union and Community Resource and Information Centre (1983) *Sexual Harassment of Women at Work.* Leeds: TUCRIC.

84. Gutek, B. A., and Morasch, B. (1982) "Sex-Ratios, Sex-Role Spillover, and Sexual Harassment of Women at Work." *Journal of Social Issues, 38*(4), 55–74.

85. O'Brien, M. (1981) *The Politics of Reproduction.* London: Routledge and Kegan Paul.

86. Elshtain, J. B. (1981) *Public Man, Private Woman.* Oxford: Martin Robertson.

87. Stacey, M., and Price, M. (1981) *Women, Power and Politics.* London: Tavistock.

88. Nowotny, H. (1981) "Women in Public Life in Austria." In C. F. Epstein and R. L. Coser (Eds.), *Access to Power. Cross-national Studies of Women*

and Elites. London: Allen & Unwin. Pp. 147–56.

89. Skard, T., with Hernes, H. (1981) "Progress for Women: Increased Female Representation in Political Elites in Norway." In C. F. Epstein and R. L. Coser (Eds.), *Access to Power. Cross-national Studies of Women and Elites.* London: Allen & Unwin. Pp. 76–89.

90. O'Brien, M. (1978) "The Dialectics of Reproduction." *Women's Studies International Quarterly, 1*(3), 233–39.

91. Stacey, M. (1981) "The Division of Labour Revisited or Overcoming the Two Adams." In P. Abrams, R. Deem, J. Finch, and P. Rock (Eds.), *Practice and Progress. British Sociology 1950-1980.* London: Allen & Unwin. Pp. 172–90.

92. Gordon, L. (1975) "The Politics of Birth Control, 1920–1940. The Impact of Professionals." *International Journal of Health Services, 5*(2), 253–77.

93. Hanmer, J. (1977) "Community Action, Women's Aid and the Women's Liberation Movement." In M. Mayo (Ed.), *Women in the Community.* London: Routledge and Kegan Paul. Pp. 91–108.

94. Hearn. J. (1982) "Notes on Patriarchy, Professionalization and the Semi-professions." *Sociology, 16*(2), 184–202.

95. Cohen, G. (1979) "Symbiotic Relations: Male Decision-makers and Female Support Groups in Britain and the United States." *Women's Studies International Quarterly, 2*(4), 391–406.

96. Cole, J., and Brintnall, D. (1975) "The Decline of a Babysitting Cooperative in a Non-cooperative American Economy." *Urban Life and Culture, 3*(4), 456–63.

97. Joynt, P. (1983) *Cross Cultural Management.* Oslo: Norwegian School of Management.

98. Klykken, A. J., Klepper, U., and Joynt, P. (1982) *Presence and Potential of Women in Management.* Oslo: Norwegian School of Management.

99. Hisrich, R. D. (1984) "The Woman Entrepreneur in the United States and Puerto Rico: A Comparative Study." *Leadership and Organization Development Journal, 5*(5), 3–8.

100. Rohlen, T. P. (1974) *For Harmony and Strength. Japanese White-collar Organization in Anthropological Perspective.* Berkeley, CA: University of California Press.

101. Trevor, M. (1983) *Japan's Reluctant Multinationals.* London: Frances Pinter.

102. Silver, C. B. (1981) "Public Bureaucracy and Private Enterprise in the U.S. and France: Contexts for the Attainment of Executive Positions by Women." In C. F. Epstein and R. L. Coser (Eds.), *Access to Power. Cross-national Studies of Women and Elites.* London: Allen & Unwin. Pp. 219–36.

103. Whitley, R. (1981) "Women, Business Schools and the Social Reproduction of Business Elites." In C. F. Epstein and R. L. Coser (Eds.), *Access to Power. Cross-national Studies of Women and Elites.* London: Allen & Unwin. Pp. 185–92.

104. Epstein, C. F., and Coser, R. L. (Eds.) (1981) *Access to Power. Cross-national Studies of Women and Elites.* London: Allen & Unwin.

105. Lovenduski, J., and Hills, J. (Eds.) (1981) *The Politics of the Second Electorate.* London: Routledge and Kegan Paul.

106. Siltanen, J., and Stanworth, M. (Eds.) (1984) *Women and the Public Sphere. A Critique of Sociology and Politics.* London: Hutchinson.

107. Albrektsen, B. H. (1977) *Kvinner og Politisk Deltakelse* [Women and Political Participation]. Oslo: Pax. Cited by T. Skard, with H. Hernes (1981) "Progress for Women: Increased Female Representation in Political Elites in Nor-

way." In C. F. Epstein and R. L. Coser (Eds.), *Access to Power. Cross-national Studies of Women and Elites*. London: Allen & Unwin. Pp. 76–89.

108. Sanzone, D. S. (1981) "Women in Politics. A Study of Political Leadership in the United Kingdom, France and the Federal Republic of Germany." In C. F. Epstein and R. L. Coser (Eds.), *Access to Power. Cross-national Studies of Women and Elites*. London: Allen & Unwin. Pp. 37–52.

109. Haavio-Mannila, E. (1981) "Women in the Economic, Political and Cultural Elites in Finland." In C. F. Epstein and R. L. Coser (Eds.), *Access to Power. Cross-national Studies of Women and Elites*. London: Allen & Unwin. Pp. 53–75.

110. Siren/Black Rose (1971) *Anarcho-Feminism*. Chicago; Siren.

111. Farrow, L. (1974) *Feminism as Anarchism*. New York: Aurora.

112. Kornegger, P. (1975) *Anarchism: The Feminist Connection*. Cambridge, MA: Second Wave.

113. Ehrlich, C. (1978) *Socialism, Anarchism and Feminism*. Baltimore: Research Group One.

114. Charlton, V. (1977) "Lesson in Day Care." In M. Mayo (Ed.), *Women in the Community*. London: Routledge and Kegan Paul. Pp. 31–44.

115. Gould, M. (1980) "When Women Create an Organization: The Ideological Imperatives of Feminism." In D. Dunkerley and G. Salaman (Eds.), *The International Yearbook of Organization Studies, 1979*. London: Routledge and Kegan Paul. Pp. 237–52.

116. Jones, L. (Ed.) (1983) *Keeping the Peace*. London: Quartet.

117. Carroll, S. J. (1984) "Feminist Scholarship on Political Leadership." In B. Kellerman (Ed.), *Leadership—Multidisciplinary Perspectives*. Englewood Cliffs, NJ: Prentice-Hall.

118. Wainwright, H. (1984) "Beyond Leadership." In J. Siltanen and M. Stanworth (Eds.), *Women and the Public Sphere. A Critique of Sociology and Politics*. London: Hutchinson. Pp. 176–82. Reprinted from S. Rowbotham, L. Segal, and H. Wainwright (1979) *Beyond the Fragments*. London: Merlin.

119. Strange, P. (1983) *It'll Make a Man of You. A Feminist View of the Arms Race*. Nottingham: Mushroom.

3

Gladys L. Symons

Women's Occupational Careers in Business: Managers and Entrepreneurs in France and in Canada

This is a qualitative study of women's experiences in managerial careers viewed from a cross-cultural perspective. One hundred businesswomen were interviewed in France, Quebec (Francophone Canada), and Anglophone Canada. Four career profiles are described: two types of managers (self-made women and professionals) and two types of entrepreneurs (heirs and founders/owners). Cross-cultural comparisons reveal differences in the operation of the sponsorship system in France and in Canada, and linguistic differences in the Canadian context. The study provides data-rich case material on women's careers and demonstrates, among other things, that the concept of an occupational career based on a male model is not entirely applicable to women's working lives.

The world of business management has long been the domain of men. With increasing numbers of women embarking on careers in management, we are witnessing an important change in the sexual division of labor in postindustrial societies. To understand the transformations taking place in the organization of work, we need to turn our attention to the careers of managerial women.

The concept of the occupational career has, for the most part, been conceived in the context of the male experience. A career involves a sequence of jobs leading to upward mobility and greater power, privilege, and prestige. It implies involvement in, and commitment to, the occupation [1–3]. In this paper I shall use a more general definition of "occupational career" as a series of stages through which a person passes throughout her working life. I include the notion of "internal careers," that is, "the stages and tasks as seen and experienced by the

person'' [3. P. 36] as well as both subjective and objective aspects of ''career'' [2], that is, both attitudinal and behavioral aspects of one's working life.

A cross-cultural study

Aspects of women's managerial careers from a cross-cultural perspective are here explored. France and Canada are studied, Canada being subdivided into Quebec (the French-speaking province) and English Canada. Both highly industrialized nations, France and Canada have similar rates of female participation in the labor force. In 1981, 51.8 percent of Canadian women worked for wages, 4.2 percent of them in managerial or administrative occupations. The female participation rate in Quebec was lower, at 39.7 percent, 4.9 percent of them working in management [4,5]. In 1980, 54.7 percent of French women were in the labor force, 5.4 percent being in senior management or liberal professions [6,7].[1]

Comparing these two countries is of added interest given Quebec's cultural and linguistic ties with France. Moreover, juxtaposing countries on either side of the Atlantic takes us beyond a strictly North American focus on managerial women's careers.

The sample

Between 1978 and 1980, 100 businesswomen were contacted through a technique of snowball sampling.[2] Intensive interviewing was undertaken, using a semistructured interview schedule. Conversations (one to four hours long) were tape-recorded, transcribed, and analyzed. Forty-three of the women were French; 19, Quebecoises; and 38, Anglo-Canadian. They lived in Paris, France; or Montreal (Quebec), Calgary, or Toronto, Canada. They worked in a number of industries, including manufacturing, service, communications, finance, retail, research, energy, food, advertising, wholesale, personnel, and consulting.[3]

The study began as a comparison of two types of businesswomen: managers and entrepreneurs. The managers worked as salaried employees in mainly large corporations: over one-half worked in firms of 500 or more employees. Upon analysis, two distinct types of managers emerged: ''self-made women'' and ''professional managers.'' The entrepreneurs owned and managed a company, commonly a small concern. Three of 4 owned companies with 100 or fewer employees, and 6

of 10 employed 20 or fewer workers. Data analysis revealed two types of entrepreneurs: "heirs" and "founders/owners."[4]

The ages of the women ranged from 25 to 69 years, the vast majority being between 31 and 50. The average ages were 41 years for self-made women, 36 for professional managers, 40 for heirs, and 48 for founders/owners. Self-made women were the least well educated of all 4 groups: 53 percent had no formal training beyond high school, and only 19 percent had a university degree or diploma from a university-level "grande école."[5] All professional managers had at least one university degree or technical diploma.[6] Labor-force experience varied by career profile: the average number of years at work was 19 for self-made women, 13 for the professional managers, 15 for the heirs, and 22 for the founders/owners.

Career profiles of business women

Managers: self-made women

> I started out as a secretary working for the credit manager. Actually my duties became much more involved in a short space of time. . . . In addition to secretarial work, I was reviewing files, establishing lines of credit, handling accounts receivable and cash—a multitude of things. I could literally just step in and run it, but I didn't have the authority to do so. . . . Had I been a man, I probably would have been credit manager, given my background, knowledge, and ability. When people had questions, they came to me, not to the man I was working for.

Grace is a 44-year-old manager in Calgary, whose account gives us some idea of the career of the self-made woman. Typically, this type of manager left school in her teens for a traditionally feminine occupation, such as secretary or file clerk. Early labor-market entry was an economic necessity for these young women, who were mainly from working-class backgrounds. Initially, they had few thoughts of a career.

For self-made women, the key to success is plain hard work and the willingness to do all kinds of jobs. Accepting additional responsibilities is seen as important on-the-job training that compensates for little formal education. However, an increased work load and long hours do not readily translate into higher salaries and status. In fact, blocked mobility and slow career progress are typical characteristics of this group's profile.

Careers of self-made women are often company dependent: their

slow climb up the company ladder has depended on dedication to the organization and inside knowledge gained through long years of experience within the firm. Many are pessimistic about finding a comparable position elsewhere. Moreover, self-made women often have had difficulty establishing credibility and convincing their superiors of their potential as managers. Nicole, a product manager in Montreal, described the problem:

> I started here as a managerial assistant. It was difficult to advance, because I had to continually change people's opinions about the work I do now and what I did before. It's difficult to convince them that I can take charge. This is especially true for a woman, because we are attributed a service or helping role. Before having responsibility, women must prove themselves many times over.

Here we see the subtle interplay of stereotypical attitudes toward women and "women's work" in organizations. The job of assistant seems fitting, as a service role with little responsibility. When women attempt to act authoritatively and assume positions of power, they encounter roadblocks.

Careers of self-made women are "downwardly anchored" [8] and are viewed as movement *from* an occupational starting point. Self-made women define success in terms of where they have come from, rather than where they are going. Few envisage future promotions, and only one in three predicts her chances for advancement to be fair or better. But self-made women are proud of their accomplishments, for long years of hard work and dedication to the company have taken them out of the secretarial ghetto.

Managers: professionals

> I plan to be successful, and everything else based on that kind of head trip just falls into place. . . . Some people have a lot of misgivings about their qualifications, but it never entered my mind that I would not be successful.

This statement by Shirley, a senior group manager in Toronto, captures the orientation of professional managers. They are young, dynamic, well educated, and "on the move." They have prepared for the work force by obtaining advanced education and have sought jobs in promotional managerial streams.

Nevertheless, these young women have often had difficulty finding a job that corresponds to their education and occupational aspirations. Recruitment problems are exacerbated by youth and lack of experience, as age and gender combine to produce a multiplier effect for women, making them less attractive as management material. For many, when they have received an offer, salary and/or entry level have been major deterrents to accepting the job.

Entry problems have seasoned the professional managers early. They are assertive and ready to defend their rights. Self-confident and politically wise, they are not willing to do just any job. Hard work is in order, but quality is more important than quantity. Their careers are generally not company dependent. If treated fairly, they willingly commit themselves to the organization; if not, they are prepared to move on.

Roselyn, a 33-year-old Québecoise vice-president, describes her experience in a former job. An organizational shuffle occurred in the company, and she approached the president, to seek promotion:

> He told me that I was ready for a promotion, but that I was too young. He said, "As a woman in an excessively technical environment, you will never be capable of controlling those men." What can you say? I told him I was going to look for something else. I found my present job and quit the company, just like that. Advancing up the hierarchy is difficult for both men and women, and it's pointless to add another barrier like resistance to women. I would have had nothing to gain fighting for a position in a place that was against me from the start. It's useless to associate with people who don't have confidence in you.

Careers of professional managers are likely to be "upwardly anchored." Most women are future oriented, aspiring for promotions within or outside their present company. Whereas only one-half of self-made women would consider leaving the firm, seven of ten female professional managers foresee a possible company change in their career.

Entrepreneurs: heirs

As entrepreneurs, heirs are action-oriented, risk-taking, independent individualists. The heir inherited the company from her father or late husband. Two basic patterns were found to characterize the heirs' career beginnings. "Early starters" [9] began working in the company when they were young and learned the trade from their paternal mentor.

The apprenticeship process was demanding, and many found themselves thrown into management positions at a young age.

Sophie, a 29-year-old French heir to a publishing company, went to work for her father at 20:

> I worked relatively little with my father, but he allowed me to get all kinds of technical training in all the crafts of the publishing business. In 1973, my father took sick, and I replaced him at a moment's notice, with absolutely no experience. I was 23 years old when I began to manage this business all by myself. . . . I struggled as well as I could, with all the problems you can imagine. After a year, my father returned, and we co-managed the company for four years. In 1978, he died, and I found myself definitely alone with the responsibility not only for the business but also for the people who work here.

Other heirs had taken over family businesses later in life, upon the death of a father or husband. Faced with the decision to become president or sell, the heirs accepted the challenge. Heirs profited from anticipatory socialization, the process of advance career preparation. Early starters grew up with the family business, and heard it discussed at home. As one woman described it, "I learned by osmosis." Daughters often visited the premises with their fathers and watched them perform. Others married into the business and experienced the anticipatory socialization process during their adult life. When the time came to take over, heirs had a certain degree of familiarity with the working of the firm and knew many employees.

For heirs, self-concept, work identity, and company commitment are strongly intertwined. Making a success of the business is a constant preoccupation and provides major satisfactions. They also enjoy the independence and power typical of entrepreneurs. The company is a family heritage to be protected. Eve, a Québecoise heir with two grown children of her own, talks of succession:

> I hope that the company will continue to progress. My father established a certain base, and I took over and developed the company further. I hope my children will develop it even more. I am often asked if I want to sell. I say "No," and so do my children. They would like to continue it.

All is not clear sailing for the heirs, however, and credibility problems arise. Employees may doubt the daughter's ability to step into her father's shoes. People outside the company may question the wife's

ability to take over. As Eve explained, "When I decided to change careers and go into business, people said, 'She won't succeed. It won't work. She doesn't have what it takes, and she won't make it.'" Fighting against negative reactions, heirs become even more determined to succeed.

Entrepreneurs: founders/owners

Women founders/owners are self-starters, highly independent and achievement oriented. Usually they began the company with little capital, either starting from scratch or buying out a company on the brink of bankruptcy. A few had financial backing from husbands or family, but most did not. Founders/owners are innovators, risk-takers, and individualists.

Many of these women link their desire to "be their own boss" to events in their childhood or early adult life. Three of the four in Calgary came from pioneering families and explained that their parents' struggle for survival taught them the values and fortitude necessary to start their own business. Indeed, women founders/owners are themselves a type of pioneer. Two women mentioned war experiences, and another, the depression. Hard times imbued them with a fighting, entrepreneurial spirit.

Early career histories of some founders/owners sound like those of self-made women: By founding their own company, they escaped the occupational segregation and blocked mobility they faced as women in the business world. For example, Paulette, owner of a personnel agency in Paris, who had spent her early working life as a secretary, explained:

> I had problems as a secretary and hoped for a more interesting job. I hated to admit that it was because I was a woman, and this gave me the desire to take control of a company. It was the only way to avoid being blocked by men.

Founders/owners describe their job satisfaction in terms of creation. They have made their mark and have left a legacy. But although the achievement of founding a business may be traditionally masculine, the imagery is typically feminine. Some women compared the development of their company to the experience of giving birth and nurturing a child.

The challenges, risks, and sacrifices that women founders/owners assume are in many ways similar to those of men; but women face

additional hurdles, not the least of which is establishing credibility. Maria, owner of a Montreal travel agency, described some of the difficulties she encountered:

> In the beginning, nobody thought I'd ever make it. You have got to stick it out, take the knocks. People tend to look at you strangely—with less trust than they would give a man. People walk in here, and they want to see the manager. I say, "Yes, may I help you?" "Is your husband here?" "No, I don't have a husband." "Is your father here?" "What does my father have to do with this?" This type of exchange has happened more than once. Now I laugh about it, but I used to get very upset. Can't they realize that this is mine and that I am perfectly capable of running a business?

People are often hesitant to believe that a woman can actually build a business on her own. A frequent assumption is that her male advisors are really running the show. Moreover, founders/owners struggle against stereotypes of women as dilettantes. Indeed, establishing credibility is the Achilles' heel of businesswomen in general.

Cross-cultural comparisons

All four career profiles are found in the three cultural settings: France, Quebec, and English Canada. The samples differ in terms of age, education, and social class. The French women interviewed were slightly older than the Canadians: the average age was 41 for the French and 38 for both Québecoises and English Canadians. The Canadian women had more university training than the French: 68 percent had at least one degree, compared with 58 percent of the French. In contrast, the French women in the sample came from higher social classes than the Canadians: 73 percent of the former group and 55 percent of the latter came from middle-class or upper-class families.

Space limits discussion of the many cross-cultural differences found in this research (see Symons [10–12]), so I shall focus on two issues: sponsorship, and the language question in Quebec.

Sponsorship

Participation in the sponsorship system is an important activity for career development [13–16]. A powerful and influential person assists the newcomer, initiates her into the organizational culture, gives her

advice, opens doors, and helps advance her career. The operation of this system differs by both career profile[7] and cultural milieu.

Fifty-seven of the 100 women interviewed mentioned people (mostly men)—supervisors, former bosses, and company presidents—who had played the sponsor role for them. Canadians benefit most from the system, for 66 percent of the Anglophones and 63 percent of the Québecoises, compared with only 48 percent of the French women, reported having a sponsor.

The individualism of the culture has been suggested as a reason for lower sponsorship rates among the French. However, it is also important to examine the role of education and its relationship to occupational mobility. The key to occupational success in France is a diploma from the most prestigious "grandes écoles," and sponsorship operates through the process of recruiting others with the same diplomas. Hence, the old-boy network grants privileges to young men with the right credentials. Until recently, the "grandes écoles" were segregated by sex, putting women at an obvious disadvantage. A diploma from the École des Hautes Études Commerciales Jeunes Filles (HECJF), for example, did not carry the same prestige as a diploma from the École des Hautes Études Commerciales (HEC), the male equivalent. As one woman explained, "For many employers, HECJF is HEC at a discount."

Women professional managers are at a disadvantage because of this system, but the self-made women in France were found to suffer most of all, for only one-third of them had enjoyed the support of a sponsor. In Canada, professional managers and self-made women reported similar experiences with the sponsorship system.

Linguistic differences in the Canadian context

The historical development of private industry in Quebec is characterized not only by a sexual division of labor but also by ethnic and linguistic divisions. Anglophones have traditionally dominated the commercial sector, and it is difficult for Francophones to avoid the English-speaking business world of North America.

In addition to difficulties created by the sex structure, Québecois women also face a linguistic barrier, one most acutely felt by self-made women. Many learned to speak English on the job, and working in a second language put them at a disadvantage from the start. Their confidence was eroded as they battled with feelings of inadequacy and

frustration from learning and working in English. Nicole, a product manager in Montreal, described her experience:

> When I began to speak English almost every day, I would come home practically in tears. I had been working for nearly ten years, but I had the impression of being a ten-year-old child. My intellectual level had deteriorated to words. It's been a very frustrating experience.

Since most professional managers learn English in school and entrepreneurs inherit or establish Francophone businesses, the language issue does not affect them with such acuity as it does the self-made women.

Conclusion

This study demonstrates that the concept of an occupational career based on a male model is not entirely applicable to women's working lives. Although there are no doubt similarities between men's and women's experiences as both managers and entrepreneurs, it is inappropriate to ignore women's particular experience by subsuming it within the male model.

For example, the self-made man who has worked his way up the company ladder did not start out in the pink-collar ghetto. Professional male managers surely encounter difficulties, but not the recruitment problems faced by women. Recent studies have shown female entrepreneurs to have qualities similar to those of male entrepreneurs [17–19]. Nevertheless, the male heir who faces the challenge of filling his father's shoes (but rarely those of his wife) does not have to contend with queries about his right to try, nor do male founders/owners have their competence called into question because of their gender.

Women's careers in business are tempered by blocked mobility, credibility problems, and a constant battle against disparaging stereotypes of women as workers who lack commitment to and involvement in their occupation. Women are constantly called upon to manage their gender identity in a masculine world of work [20]. Huppert-Laufer [21] has pointed to a fundamental difference between male and female managerial careers in France, a difference I believe to be equally true for Canada. To pursue a career in business, she notes, women must first and foremost situate themselves with respect to men. Men, on the other hand, develop their careers by positioning themselves in relation to the organization.

This study of women's career profiles affords a more detailed picture of the world of work, organizations, and occupational careers. Women in business have been both hidden and silenced by male models of career and masculine stereotypes of managers and entrepreneurs. The present analysis reveals the presence and potential of women and the unfolding of their careers in the corporate world. I think the future of business points to sexual desegregation of managerial and entrepreneurial careers, and I trust that this study provides some insight into the nature of the transformations that are taking place.

Acknowledgments

I should like to thank all the businesswomen who kindly gave of their time to participate in this study. I also wish to express my appreciation to Jean Ross, who assisted in coding the data, and to Francine Pilon, who typed the manuscript.

The research upon which this paper is based was supported by three operating grants from the University of Calgary, a France-Canada Cultural Exchange Fellowship, and a sabbatical leave from the Social Sciences and Humanities Research Council of Canada. I am most grateful for this assistance.

Notes

1. French data on the proportions of women managers are not strictly comparable, because of the classification system of the French census. For example, the category of "cadres supérieurs" (senior administrators) also includes members of the liberal professions. The category "cadres moyens" includes not only middle-level management but also teachers, other intellectual professions, and medical and social services and technicians.

2. This sampling technique is used when the population under study is not known. Initial informants were identified and asked to nominate women managers and entrepreneurs. Each woman interviewed was asked to supply names of other candidates for inclusion in the sample. Since the technique is not random, I can make few claims about the generalizability of the sample. This, however, is not the purpose of a qualitative study, which instead seeks to collect data-rich case material, to discover categories, and to refine concepts, and thus to probe in detail the complex nature of social phenomena.

3. Most of the self-made women are employed in manufacturing, communications, finance, energy, and advertising. Professional managers work primarily in manufacturing, finance, and energy industries. Most of the heirs own retail and service companies, and the founders/owners have developed their enterprises mainly in the service and consulting sectors. Given the wide variety of industries represented, the sample size is too small to permit a cross-cultural analysis by industry.

4. In the sample there are 21 self-made women (9 French, 6 Québecoises, and 6 Anglo-Canadians), 46 professional managers (18 French, 9 Québecoises, and 19

Anglo-Canadians), 14 heirs (9 French, 3 Québecoises, and 2 Anglo-Canadians), and 19 founders/owners (7 French, 1 Québecoise, and 11 Anglo-Canadians).

5. A diploma from a "grand école" is generally considered more prestigious than a university degree.

6. Most degrees are in commerce, administration, and economics; but only five of the women (two French, one Québecoise, and two Anglo-Canadians) have an M.B.A. degree.

7. Differences by career profile indicate that managers are more likely than entrepreneurs to benefit from sponsorship: 64 percent of the managers studied, compared with 45 percent of the entrepreneurs, name people who assisted them in developing their careers. Professional managers benefit to a somewhat greater extent than do self-made women: 65 percent of the former group, compared with 58 percent of the latter group, named a sponsor. Among the entrepreneurs, two-thirds of heirs and only one-third of founders/owners claimed to have received this kind of assistance.

References

1. Hall, R. (1975) *Occupations and Social Structure*. Englewood Cliffs, NJ: Prentice-Hall.

2. Hall, D. T. (1976) *Careers in Organizations*. Glenview, IL: Scott, Foresman.

3. Schein, E. H. (1978) *Career Dynamics*. Reading, MA: Addison-Wesley.

4. Statistics Canada (1981) *Labour Force Activity* (Cat. 92–915). Ottawa. Table 1.

5. Statistics Canada (1983) *Labour Force-Occupation Trends*. Ottawa. Table 1.

6. Levy, M. L. (1981) "La carrière des femmes." *Population et Sociétés*, No. 146, pp. 1–3.

7. Levy, M. L. (1981) "Actualité." *Population et Sociétés*, No. 146, p. 4.

8. Tausky, C., and Dubin, R. (1965) "Career Anchorage: Managerial Mobility Motivations." *American Sociological Review, 30*, 725–35.

9. Toulouse, J. M. (1980) *Les réussites québecoises: Défis des hommes d'affaires*. Montréal: Les éditions Agence d'Arc.

10. Symons, G. L. (1984) "Career Lives of Women in France and Canada: The Case of Managerial Women." *Work and Occupations, 11*(3) (August), 331–52.

11. Symons, G. L. (1984) "Le rôle du conjoint dans la carrière de la femme gestionnaire." *Gestion, 9*(2) (Avril), 50–52.

12. Symons, G. L. (1986) "Careers and Self-concepts: Managerial Women in French and English Canada." In K. Lundy and B. Warme (Eds.), *Work in the Canadian Context* (2nd ed.). Toronto: Butterworths. Pp. 282–94.

13. Clawson, J. G. (1980) "Mentoring in Managerial Careers." In C. B. Derr (Ed.), *Work, Family and the Career*. New York: Praeger. Pp. 144–65.

14. Hennig, M., and Jardim, A. (1977) *The Managerial Woman*. Garden City, NY: Anchor.

15. Kanter, R. M. (1977) *Men and Women of the Corporation*. New York: Basic Books.

16. Zey, M. G. (1984) *The Mentor Connection*. Homewood, IL: Dow Jones-Irwin.

17. Gouvernement du Québec (1985) *Portrait de la femme d'affaires au Québec*. Québec: Ministère de l'Industrie et du Commerce.

18. Schreier, J. W. (1976) "Is the female entrepreneur different?" *M.B.A. Master of Business Administration*, 10 March, pp. 40–43.

19. White, J. (1984) "The Rise of Female Capitalism—Women as Entrepreneurs." *Business Quarterly*, *49*(1) (Spring), 133–35.

20. Symons, G. L. (1986) "Coping with the Corporate Tribe: How Women in Different Cultures Experience the Managerial Role." *Journal of Management*, *12*(3), 379–90.

21. Huppert-Laufer, J. (1982) *La féminité neutralisée? Les femmes cadres dans l'entreprise*. Paris: Flammarion. P. 206.

4

AUDREY CHAN

Women Managers in Singapore: Citizens for Tomorrow's Economy

Singapore, as one of the most rapidly developing newly industrialized countries in the Pacific Basin, presents a special case of female participation in an expanding economy. This paper describes the changing roles of women in the Singapore economy. Societal and individual factors that have helped or hindered women's joining the managerial ranks are discussed, and strategies for their future career success are suggested.

Singapore's population consists mainly of immigrants and descendants of immigrants from the world's two major agrarian societies, China and India. The great majority of early migrants to South East Asia (the Nanyang) during the nineteenth and early twentieth centuries were men. They came in search of opportunities to earn a living for themselves and the families they left back home, and most of them initially had no plans to settle in the region.

In 1836, only 7,229 women lived in Singapore, whereas the male population had reached 22,755. Up to 1920s, only a very small number of women had migrated to the Nanyang, in part because of the ban the Chinese government placed on female emigration. More women began to arrive in the late 1920s and in the 1930s. Singapore's passage of the Aliens Ordinance in 1933, which regulated alien admission to the island by imposing a more expensive passage for men, facilitated this change. Women from Canton and other parts of China came by the shipload, many to work as domestic servants; others were kidnapped and sold to brothels as prostitutes. Whatever their position, they belonged to a generation imbued with a strong work ethic, which they applied to "pursuing material gain" [1. Pp. 2–7].

**Changing roles of women
in the Singapore economy**

Women's participation in Singapore's economy may be analyzed in terms of three chronological stages.

Stage I: 1959–1965

In 1959, after Singapore became a self-governing state within the Federation of Malaysia, the governing People's Action Party (PAP) began to use the liberation of women as a prelude to liberating the country politically. Emancipation of Singaporean women was endorsed through passage of the Women's Charter, a monogamous marriage law; legitimization of married women's rights to engage in trade and the professions; and a policy, from 1965 on, of equal pay for equal work in the civil service.[1]

Unfortunately, postwar Singapore was burdened with a high rate of unemployment and social instability, and few job opportunities were available. Consequently, there were few women in full-time paid employment. Between 1957 and 1966, the female labor-force participation rate increased only marginally, from 19.3 percent to 21.2 percent [2]. Significant changes in that rate did not occur until the late sixties.

Stage II: 1966–1978

After independence in 1965, the leadership of Singapore shifted its attention from political development to economic growth. The government was highly committed to creating an environment and building an infrastructure that would attract labor-intensive, multinational corporate investment. From 1960 to 1980, Singapore experienced an annual growth rate of 9.2 percent in gross domestic product (GDP) and an annual 13.3 percent growth in total trade [3. P. 10]. In the same period, the labor force increased at an annual average of 6.0 percent. Increases in female and foreign workers strongly contributed to this high growth rate.

With economic prosperity creating new job opportunities for women, Singapore recorded its highest increase in the number of working women during this period. However, most working women were employed in low-income jobs, with the largest proportion (31.3 percent of the female work force in 1970) in the labor-intensive manufacturing

industries, predominantly as electronics and textile workers. The second major job category for women was commerce and trade, which employed up to 18.8 percent of the female work force in 1970 [2]. Women in these economic branches generally worked as secretaries, clerks, saleswomen, or service personnel. The third dominant sector was professional and technical staff, accounting for 14.2 percent of all employed females in 1970. Most female professionals were teachers or nurses, but increasing numbers were becoming lawyers or doctors [4. Pp. 31–32].

Despite the increase in female workers, labor shortages still existed in a number of sectors of the economy. Consequently, Singapore pursued a policy of selectively admitting foreign workers, mainly from the ASEAN countries, for jobs in the manufacturing and construction industries. Between 1970 and 1980, the citizen and noncitizen labor forces increased by 54.5 and 46.7 percent, respectively [5. P. 4]. Foreign labor contributed greatly to expanding Singapore's economy; it also formed a hedge against massive layoffs of Singaporeans during the recent recession.

Stage III: 1980 to the present

In 1980, the government launched a "second industrial revolution," in an effort to restructure the economy from low-wage, low-capital, business activities to investment in high-tech, capital-intensive, and service industries [6,7]. It adopted this new economic development strategy to counteract the challenge of other countries in the region that are rich in natural resources and cheap labor. To accomplish this new mission, the government has offered very attractive financial incentives (e.g., tax relief and special grants) to encourage factory automation. Statutory boards such as the National Wage Council and the National Productivity Board were given greater responsibility in monitoring wage increases and promoting productivity of the work force. There were also attempts to reduce Singapore's overreliance on foreign workers. In 1980–1984, Singapore's real GDP grew by an average of 8.5 percent per annum. The government attributed this high growth of GDP to the increase in international services, namely, transport, communications, banking, finance, and business services [8. P. 23].

By 1983, women constituted 35.5 percent of the total employed population. Nevertheless, to cope with the shortage of human resources in Singapore, the government launched a major campaign to

attract nonemployed Singaporean women, estimated at 124,000 [9], back into the labor force. Most of these economically inactive women were over 30 years old, and married with young children. A task force on female labor-force participation [10. Pp. ii-iii] identified supporting infrastructures, such as quality child-care services, flexible work scheduling and work incentives, training and retraining programs, and improving the society's attitude toward career women, as important means of facilitating women's entering and/or remaining in the work force. Yet, more drastic institutional and attitudinal changes seemed necessary, as a National Survey of Married Women [11] indicated that most Singaporean women who had left their work to establish families did not return to the work force even after their children reached school age.

In the mid-eighties, the economy took an adverse turn. The Economic Committee reported that between the first quarter of 1984 and the last quarter of 1985, Singapore experienced a dramatic decline in quarterly GDP growth rate, from a positive 10 percent to a minus 4.5 percent. In 1985 alone, there was a loss of 90,000 jobs, leading to the repatriation of 60,000 foreign workers [8. P. 39]. Most of the losses were in construction and manufacturing, followed by commerce, transportation, and communication.

The employment rate of 1984 university graduates 6 months after graduation was 90.6 percent, a significant drop from the 97.5 percent average since 1973 [12]. Graduates holding B.A., B.Sc., B.Acc., and B.B.A. degrees were the hardest hit by the ailing economy, accounting for two-thirds of the graduate unemployment in 1984 [12]. Ironically, these were the programs with the largest numbers of female students. An overall comparison of the employment situation for male and female graduates from 1981 to 1984 shows that, in general, women were more disadvantaged than their male counterparts: not only was the women's employment rate lower but they also had to wait longer for their first job, were paid a lower starting salary, and received fewer job offers within six months after graduation [12].

Female managers in Singapore

An emerging profile

In 1983, women constituted 17.8 percent of the total administrative and managerial work force, compared with 7 percent in 1970. Between

1970 and 1983, the number of female administrators and managers grew from 645 to 11,093. According to Ling [13], of the 8,126 female executives in 1980, 49.7 percent were employed as managers; 46.8 percent, as executive officers; and the remaining 3.5 percent, as government officials or administrators. Most of these women managers were of Chinese descent, and younger than their male counterparts (over four-fifths were between 20 and 39 years old). Sixty-four percent of them were married. However, the percentage of the unmarried among women (31 percent) was twice that among men (14 percent). Among female officers in the public sector, such as executive officers, legislative officials, and other government administrators, over half were unmarried [13].

In 1980, most female managers held positions in personnel, employee relations, corporate relations, marketing, sales, accounting, or general management. They worked in manufacturing, banking and finance, commerce, retailing, communication, advertising, and the hotel industry as well as in the civil service. In 1974, only 534 female professionals and managers earned S$1,500 or more per month, forming only 6 percent of this top-income group. In November 1984, almost 3,000 female managers earned at least S$3,000 a month, accounting for approximately 9 percent of the managers in this top 5 percent of wage earners.

The statistics reveal support for two trends. First, most female managers are concentrated in "female enclaves" such as personnel, administrative services, consumer affairs, and public relations—areas perceived to be especially suited for women. Second, only 16 percent of the female executives are entrepreneurs. The majority—those who have risen to administrative levels in companies not owned by them or their families—are concentrated in lower- and middle-management positions. Singson[2] has observed that women hold 1 percent or less of the senior posts in the largest corporations in Southeast Asia. The paucity of women in senior positions may be explained partly by the fact that they are newcomers to most corporations. Their potential for climbing the corporate ladder appears much greater than their current representation would suggest.

A growing corps

What has contributed to the large increase in the number of Singapore's female managers during the past decade? Three factors appear most

important: (*1*) economic conditions, (*2*) development policies, and (*3*) women's career aspirations.

1. Economic conditions and environmental challenges

Singapore's separation from Malaysia in 1965 marked a new era for the nation's economic development. Deprived of a resource-rich hinterland for its entrepot trade, Singapore moved quickly to develop a new strategy emphasizing the export of labor-intensive manufactured goods. This development strategy proved successful, partly because of its excellent timing. During the late sixties and early seventies, the world economy was booming, and multinational firms needed cheap labor for their assembly production. Within a decade, a diversified economic structure, based on manufacturing, trade, finance, and transportation activities, was established in Singapore [3. Pp. 4–5]. This influx of "female-intensive" industries was a decisive factor in the sharp rise in female labor-force participation, from 21.2 percent of the work force in 1966 to 31.6 percent in 1974 [14. P. 11]. These women constituted a reservoir for the recruitment of future managers.

Environmental changes in recent years have led Singapore to revise its economic policies. The global economic downturn at the end of the seventies resulted in a mounting protectionist sentiment among many developed nations. In addition, Singapore's rapid industrialization and its successful family-planning programs have produced a growing shortage of cheap labor. It was predicted that this, together with an anticipated aging of the labor force, would put Singapore at a disadvantage in competing with her neighbors, many of whom are richly endowed with both human and natural resources. In 1979, the Singapore government launched a Second Industrial Revolution designed to push Singapore out of labor-intensive operations and toward more sophisticated, knowledge-intensive, technological industries and high-skilled brain services.

The government strongly believes that Singapore's future competitive advantage will lie in the export of services. The government identified finance and banking, computer and information systems, transportation and communication, biotechnology, and medical services, together with management consultancy, as the sunrise industries. As shown in Table 1, these growing industries have provided, and will continue to provide, new opportunities for Singaporean women. They are likely to become the largest industrial employers of women manag-

ers. On the basis of the above observations, a first generalization is proposed:

> *Generalization 1*: In a newly industrialized country such as Singapore, any increase in female managers will occur predominantly in the growing sectors of the economy.

2. Specific development policies

Two development policies introduced in the past decade have facilitated women's entry into management. The first was a compulsory military service for all male citizens and the second, changes in university admission criteria.

Since independence in 1965, Singapore has placed high priority on rapidly building a credible national defense. Starting in 1967, a mandatory two-and-a-half-year National Service (NS) was imposed on all Singapore males at age 18. The political leaders saw this as the most efficient way to establish a citizens' army and, at the same time, to integrate young Singaporeans of different religions and language groups [15. Pp. 40–41]. In the late sixties and early seventies, the government permitted male university students to defer National Service until after graduation. Consequently, a large proportion of men were summoned to National Service upon graduation, which gave their female counterparts a smoother and less competitive start in their careers. It was not until 1975, when most men began to complete their National Service before attending university, that a substantial number of college men entered the labor force immediately after graduation. Of course, even under this new arrangement, men generally begin their professional career at a later age than women.

Another policy contributing to women's career advancement was the change in university admission criteria in the early eighties. In 1980, the National University of Singapore (NUS) was formed by merging the University of Singapore and Nanyang University, and became the only university in the city-state. In 1981, to upgrade the quality of students, admission criteria were revised by increasing the emphasis on the language components (English, the official language, plus a choice of a second language: Chinese, Malay, or Tamil) of the GCE "A" Level Examination. Unfortunately, this change apparently discouraged a number of top students from applying to NUS [16,17]. The majority

Table 1

Distribution of Employed Females by Industry

Industry	1974 Females as % of total women employed	1983 Females as % of total women employed
Agriculture, hunting, forestry, fishing	2.4	0.6
Mining and quarrying	0.1	0.1
Manufacturing	40.0	34.0
Electricity, water, & gas	0.4	0.3
Construction	1.5	1.8
Commerce	19.1	24.4
Transport, storage, and communication	4.3	5.9
Financing, insurance, real estate	6.1	10.9
Community, social, and personal services	25.8	22.0
Activities not adequately defined	0.3	0.0
Total	100	100

Sources: These rates are calculated from data in Table 2.6 (P. 14) of *Report on the Labour Force Survey of Singapore 1974*. Singapore: Ministry of Labour and National Statistical Commission; and Table 35 (P. 52) of *Report on the Labour Force Survey of Singapore 1983*. Singapore: Ministry of Labour, Research and Statistics Division.

of these students were males, who traditionally have had more difficulty with language studies. Thus, this change in admission criteria inadvertently discouraged male applicants and resulted in a sharp increase in the proportion of female students, from 44.2 percent in 1980/81 to 55.3 percent in 1983/84 [18].

University admission criteria have subsequently been revised to counteract the unanticipated consequences of the new policy, the revision being implemented in the 1986/87 academic year.

3. Improved educational attainments and heightened career aspirations

Labor-force surveys over the years have clearly indicated that female economic activity rates are much higher for women who have obtained at least a secondary-level education. Table 2 compares female economic activity rates by education for 1974 and 1983. Many female

Table 2

Female Labor-force Participation Rates by Education

Education	1974, %	1983, %
No education	20.5	26.4
Primary	29.2	44.0
Postprimary	52.9	—
Secondary	67.5	67.6
Postsecondary	67.5	62.8
Tertiary	76.1	91.4
Not classifiable	21.5	—

Source: These rates are calculated from data in Table 17 (P. 37) of *Report on the Labour Force Survey of Singapore 1974*. Singapore: Ministry of Labour and National Statistical Commission; and Table 15 (P. 33) of *Report on the Labour Force Survey of Singapore 1983*. Singapore: Ministry of Labour, Research and Statistical Division.

managers today in their thirties and forties see themselves as "the first generation of Singapore women to benefit from greater parental awareness of the importance of education"[19]. More women have entered universities and colleges in the last ten years than previously; and most, upon graduation, have had ample job opportunities, thanks to the booming economy.

Table 3 highlights the general upgrading of Singaporean women's educational attainment. Table 4 compares the status of female graduates in selected occupations in 1975 and 1984. The public sector (government departments and statutory boards) continued to be the main employer in 1984, hiring up to 60 percent of all female graduates (compared with 50 percent of male graduates). In a society committed to meritocracy in which only 5 percent of the population completes tertiary education, a university degree virtually guarantees a solid start in one's career. These observations lead to a second proposed generalization:

> *Generalization 2*: The number of female managers in a society is positively related to the number of female university graduates joining the labor force.

Remaining barriers

Numerous factors, internal and external, inhibit women's career advancement in professional management. The following section de-

Table 3

Economically Active Persons Classified by Highest Education Attained

Education	1974 Females as % of total women employed	1983 Females as % of total women employed
No education	36.7	22.3
Primary	23.0	22.3
Postprimary	4.7	25.7
Secondary	26.9	37.1
Postsecondary	6.8	11.0
Tertiary	1.7	3.7
Not classifiable	0.1	0.3

Sources: See Table 2.

Table 4

Working Female Graduates in Selected Occupations

Occupational status	Graduate women as % of total graduates employed in the specified occupation	
	1975	1984
Teachers, cadet teachers, lecturers	85.7	73.7
Accountants/auditors	57.3	85.1
Bank officers, financial analysts	44.8	36.4
Engineers	9.2	15.9
Medical professionals, doctors, dentists	38.9	47.6
System analysts/programmers, statisticians	70.0	74.8
Managers, executive officers (nongovernment)	58.3	71.4
Administrative officers (government)	86.0	67.6
Marketing/sales representative	—	43.9
Journalists, editors, reporters	—	87.5
Clerical & related workers	91.7	—

Sources: References 20 (Appendix, Table 8) and 12 (Appendix, Table 7).

scribes some of the corporate barriers, including employers' prejudicial attitudes and unfair company policies. Psychological barriers to women's career advancement will also be discussed, including most female managers' comparatively lower power needs, their relative lack of political/influence skills within the corporation, and their frequently inadequate coping mechanisms for managing unrealistic social expectations.

Corporate barriers to career advancement

In spite of the growing representation of women in managerial and professional positions, a number of social and cultural factors still constrain them from competing equally with their male counterparts. Perlita Tiro, director and chief executive of PA Consulting Service—a reputable executive search firm—observed the following to be some of employers' more common reservations (reported in [21]):

1. Married women are considered unsuitable for jobs that require frequent travel.

2. Companies are reluctant to hire a woman to head a department staffed by men.

3. Companies seldom recruit female managers from outside, preferring to promote female staff who have proven track records within the company

4. Companies hesitate to employ women to supervise plants, shipyards, or construction sites, places labeled "off limits" to women.

5. Employers often doubt whether women (especially working mothers) will take their careers seriously and be willing or able to work the long hours necessary to succeed.

6. Employers commonly believe that women will have a much more difficult time gaining the trust and respect of customers.

Many Singaporean women managers encounter male discomfort, resistance, and, sometimes, open hostility—both inside and outside the office—from clients, colleagues, and subordinates. During a course on "Women and Excellence" recently organized by the Singapore Business and Professional Women's Association, a number of junior and middle-level female executives were reported to express their frustration because of a common perceptual bias among Singaporean men regarding women's physiological and emotional constraints, which they believed affect women's capability. Other participants, however, claimed that their major problem was gaining support from their female colleagues or subordinates [22].

Another stressful consequence of upward mobility is "the loneliness at the top," particularly for women. This is reflected in the statement of a 36-year-old divisional manager of corporate relations: "At times, the hostility was so depressing that I wanted to resign. . . . I had no close friends in the office, no one to lunch with, so I buried myself in my work" [19]. Feelings of inadequate support, poor career prospects, and lack of authority on the job have forced many women managers to defend their positional power. This might partially explain why female Singaporean managers are frequently perceived to be poor delegators [13].

In addition to these unfavorable attitudes held by employers, colleagues, and subordinates, recent female university graduates have also reported unfair company policies. In general, female graduates wait longer to secure their first job, receive fewer job offers within the first six months after graduation, receive lower pay, and are less satisfied with their starting salary than are males graduating at the same time.

Tables 5 and 6 compare the starting salaries and waiting times for male and female graduates' first jobs in 1975 and 1984, the two years directly affected by the unanticipated decline in the Singapore economy. These data substantiate the common claim that equal opportunities for women can be truly tested only in hard times, when employers become more discriminating. These findings may represent another set of organizational obstacles to women's establishing managerial careers. A third generalization is thus proposed:

> *Generalization 3*: Female graduates and junior women managers/administrators are more likely to be discriminated against during times of economic retrenchment.

Initial prejudice often results in a slow climb for women. In a recent survey conducted by *The Straits Times*, Arasu and Ooi [19] interviewed 20 women executives holding top management positions. They found that, on average, the women required between eight to ten years to reach senior management, compared with about five years for men. The majority of these female executives anticipated that it would take another generation for women to become common figures in the boardroom.

Women's underrepresentation at top levels may be explained, in part, by their relative naivety about organizational politics and

Table 5

Working Female Graduates by Gross Monthly Salary

Gross monthly salary (Singapore dollars)*	% of all employees in the salary range	
	1975	1984
Less than $600	30.2	66.7
$600– $799	69.0	73.7
$800– $999	58.1	85.1
$1,000–$1,199	44.1	85.6
$1,200–$1,299	30.9	68.9
$1,300–$1,399	—	—
$1,400–$1,499	14.3	60.6
$1,500 & above	—	—
$1,600–$1,799	—	32.7
$1,800–$1,999	—	29.8
$2,000–$2,199	—	19.0
$2,200–$2,399	—	9.0
$2,400–$2,599	—	20.0
$2,600–$2,799	—	23.1
$2,800 & above	—	15.4
Not stated	—	55.5

Sources: References 20 (Appendix, Table 10) and 12 (Appendix, Table 10).

*1 U.S. dollar = 2.13 Singapore dollars.

the lack of support they receive from informal groups [13. P. 49]. Many female managers in Singapore, often because of their upbringing and social pressure, appear handicapped in the use of direct, overt power. They shy away from major managerial responsibilities and decision making, fail to make strategic moves to expand their scope of influence, and are usually shortsighted in setting their career goals and shaping their career paths [19].

Besides having to climb a more circuitous path to reach the top, women managers receive lower salaries. 1980 census data indicated that whereas the average monthly earnings for all administrators and managers were S$2,222, the mean income for female managers was S$1,313, falling far below the mean income of S$2,406 for their male counterparts. Sex differences in the appointment to different functional groups and level of management explain part of this earnings gap, but another potential explanation is employers' reported reluctance to offer equivalent executive training to their female employees.

Table 6

Working Female Graduates by Waiting Time for First Job

Length of time taken to find first job	% of total graduates who have waited for the specified time before locating first job	
	1975	1984
Did not have to wait		51.4
Less than 1 month	51.5	44.2
1 to less than 3 months		48.8
3 to less than 6 months	71.9	58.4
6 months or more	100.0	68.7
Not stated	20.0	—
Not applicable (self-employed or further study)	—	56.1

Sources: References 20 and 12 (Appendix, Tables 3 and 4).

Psychological hurdles

Two major psychological hurdles appear to have impeded women's career success: their difficulty in coping with different role expectations, and their relative lack of the high power needs and political skills required for moving up.

Unless they marry or have a steady dating partner before their mid-twenties, women professionals and managers in Singapore often fail to find compatible marital partners. In a recent talk before National University of Singapore students, Prime Minister Lee Kuan Yew expressed concern about the imbalance in educational qualifications of brides and grooms registered under the Women's Charter in 1985 and 1986.[3] The figures indicated that fewer than one-half of the male graduates chose to marry women with tertiary education, and fewer than one in ten of the women graduates decided to "marry down." Mr. Lee cautioned that if the trend continued, around 40 percent of women graduates and over 25 percent of women with upper-secondary (GCE "A" levels) qualification might remain unmarried in the years to come. He further asserted that one main reason for this problem was that the majority of the Singaporean men still preferred "wives who are seen to be controllable"—they preferred to marry women who were academically and professionally their inferior. On the other hand, few highly educated Singaporean women are willing to marry men of lower status than

themselves. The tendency of women managers to marry men with at least the same level of educational attainment has also been reported in a recent survey of Singapore women managers conducted by the Asian Institute of Management (AIM) [23].

While encouraging high levels of female participation in education and employment, the government would also like to enhance women's fulfillment of their traditional roles as wives and mothers. A Social Department Unit has been established to organize social activities for matchmaking and marrying single men and women with university or upper-secondary education. Starting in 1984, home economics became a compulsory course for all lower-secondary girls. The Education Ministry's explicit purpose in requiring the home economics course was "ensuring that at least one member of a future family would know something about managing a home." Needless to say, this "one member" is assumed to be the woman [24].

This strong sex-role stereotyping, reinforced by the socialization process, has resulted in frustration and confusion among professional and managerial women. On the one hand, many of the professionally trained women want to challenge this discriminatory attitude of sexual inequality [25]. On the other hand, a large number also feel apologetic about their career commitment and guilty about neglecting child-care and other family responsibilities [13].

Such psychological pressures may well explain the apparently limited ambitions of female managers. Many female managers and professionals claim not to have worked out a career path or set specific career goals. AIM's study of 69 senior and middle-level women managers in Singapore found that more than half of these fairly well-established female corporate managers had had, at the age of 18, no clear idea concerning what profession or career they wanted to pursue, and only one-third were doing exactly what they had wanted to do since their youth [23]. They work for financial independence, pleasure in job accomplishment, and justification of self-worth. The job is not seen as a stepping-stone to advancement and power. One senior bank manager, a mother of two, asserted, "The status, perks and power are not worth the sacrifices and hassle" [19].

Working mothers are usually challenged by the additional responsibility of maintaining an acceptable balance between their family and career lives. The burden is especially heavy for women who head single-parent families. In Singapore the number of divorces trebled

from 730 in 1975 to 2,313 in 1984. Within stable marriages, 80 percent of the married Singapore respondents in AIM's study reported the help of their husbands in family duties, but mostly to a limited extent [23]. One alternative arrangement is the employment of domestic help, mainly foreign maids from the Philippines, Indonesia, Malaysia, or mainland China. A survey conducted by the Labour Ministry in 1982 revealed that three of four foreign maids were employed by working married women employed as professionals, managers, executives, or administrative or technical workers. Most maids took care of children in addition to performing household chores [26]. "Behind every successful working mother are two women," the maid and Mum, who often lives close to the family. Despite the available assistance, high-earning women still feel they should bear primary responsibility for the care and socialization of their children. Although most married working women in Singapore think there are substantial advantages in working, they believe that a mother should bear primary responsibility for taking care of young children. The women themselves believe that nonworking women are better mothers than those who work, and that women should be willing to sacrifice their career for a number of years to bring up their children properly [14,27].

The mother role, although made easier by machines, is expanded by the great demands made on child performance. In Singapore the educational system is highly competitive. Streaming, an exercise in placing students in different classes according to their academic performance, occurs as early as in grade three. Mothers often play a more active role than fathers in helping push their very young children to gain a "head start." They assist their children with homework, hire private tutors for core academic subjects, and enroll their children in piano, art, swimming, ballet, and other classes. Parents who can afford it travel abroad with their children during school vacations.

In paying the "pioneer's price" of balancing career and family responsibilities, many working mothers have to "put in incredibly long hours, give up almost all leisure and personal time, and feel guilty for not getting everything done in time."[4] Over half the Singapore women managers surveyed in the AIM study considered the dearest prices they had to pay for their career success were the quality of relationships and/or time spent with their husbands and children. Personally, they had to compromise with less time for leisure and sports, as well as for other job-unrelated responsibilities. Some 13 percent of the respon-

dents even felt that they missed the chance to marry because of their work [23].

Unfavorable social attitudes and unwelcoming structures in many organizations further prevent women managers from realizing their potential. For instance, cultural values still restrain female managers from entertaining their business associates in private clubs and on the golf course, places well known among the Singaporeans as congenial to establishing networks and to "learning from the grapevine." Ling [13] further indicates that problems also arise because of the ambivalence women in authority feel over "their lack of assertiveness in behaviour, weak supportive network among women themselves, poor career planning, limited access to training and fewer challenging assignments, an inability to delegate work and inexperience in recognizing the importance of acquiring mentors in career success."

To eliminate this socially indoctrinated sexual bias, an enlightening movement to assert women's status is gaining momentum in Singapore. Several women's associations are taking a more active role in generating public awareness of women's contribution to the Singapore economy and of the problems inherent in occupational and societal sex stereotyping. The Singapore Association of Women Lawyers, for example, has recently compiled a booklet entitled *The Legal Status of Singapore Women*, which discusses the rights of single and married women, including their property rights; marriage and citizenship rights; punishments for sex offenses; and the labor laws affecting female employees [28]. The newly formed Association of Women for Action and Research (AWARE) takes one further step by launching research projects and holding forums covering important aspects of women's lives and experiences, such as careers, sexual harassment, portrayal in the media, and women's legal status.

The government, for its part, is increasing its assistance. Nevertheless, in addition to promoting and sponsoring quality child care, urging employers to adopt flexible work schedules, and speeding up the introduction of full-day primary and secondary schooling, it should take the lead in changing attitudes by appointing more women as top-level public administrators, removing the withholding of legal status from foreign spouses of Singapore women and their offspring, and granting female civil servants the right to equal benefits—a milestone yet to be achieved following the equal-pay legislation provided by the Women's Charter.

Conclusions and future scenario

A future scenerio for female managers in Singapore may include the following developments:

1. A gradual increase in female managers is anticipated in all sectors of the economy because of increases in women's enrollment in the university and colleges.

2. More female administrators will be recruited in the public sector and in the sunrise industries, though women will continue to occupy positions in the predominantly female niches of these industries.

3. A disproportionate number of female managers will continue to be single. However, with improvements in child-care services and the introduction of more flexible work schedules, more career mothers can be expected to assume managerial positions in the years to come.

4. An increasing number of female managers will identify with their occupational achievement, and will continue the fight for equality in the organization.

5. Barriers to mobility for women will persist in companies characterized by a predominantly male-dominated power structure and in traditional industrial sectors such as construction, marine industries, and oil refining.

6. Besides working hard and persevering, women who formulate clear career goals and develop strategies for their achievment, who take risks in assuming line responsibility and actively solicit mentorship from senior management, may have a better chance of achieving senior management positions than their more traditionally oriented women counterparts.

Notes

1. Heng Chee Chan (1975) "Notes on the Mobilization of Women into the Economy and Politics of Singapore." Occasional paper from the Institute of Southeast Asian Studies, Singapore.

2. E. R. Singson (1985) "Women in Executive Positions." Paper presented at the 1985 Congress on Women in Decision Making, the Singapore Business and Professional Women's Association, 22–23 September.

3. Kuan Yew Lee (1986) "Keeping Our Bearings in the Midst of Rapid Changes." Talk given at a meeting, organized jointly by the Democratic Socialist Club and the Political Association of the university, at the National University of Singapore, 12 December.

4. Singson (1985) Op. cit.

References

1. Lebra, J., and Paulson, J. (1980) *Chinese Women in Southeast Asia.* Singapore: Times Books International.
2. Singapore Department of Statistics (1970) *Report on the Census of Population.* Vol. II. Singapore: Ministry of Labour.
3. Pang Eng Fong (1982) *Education, Manpower and Development in Singapore.* Singapore: Singapore University Press.
4. Lim, L. Y. C. (1982) *Women in the Singapore Economy.* Singapore: National University of Singapore, Economic Research Centre, Occasional Paper Series. Singapore: Chopman Publishers.
5. Saw Swee Hock (1984) *The Labour Force of Singapore* (Census Monograph No. 3). Singapore: Department of Statistics.
6. "1979: The Second Industrial Revolution." In *The First 25 Years. Sunday Monitor* National Day Special, 5 August 1984.
7. Lee Soon Ann (1982) "Singapore as a Newly Industrializing Country." *AIESEC Business Executive.* Vol. 1. Singapore: AIESEC [International Association of Students of Economics and Management]. Pp. 6–11.
8. Singapore Ministry of Trade & Industry (1986) *The Singapore Economy: New Directions.* Singapore: Ministry of Trade & Industry.
9. Singapore Ministry of Labour (1983) *1983 Singapore Yearbook of Labour Statistics.* Singapore: Ministry of Labour, Research and Statistics Division.
10. Singapore National Productivity Council (1985) *Report of Task Force on Female Participation in the Labour Force.* Singapore: National Productivity Council, Committee on Productivity in the Manufacturing Sector.
11. Singapore Ministry of Social Affairs (1984) *Report on National Survey on Married Women, Their Role in the Family and Society.* Singapore: Ministry of Social Affairs.
12. *1984 Graduate Employment Survey. National University of Singapore.* Singapore: Applied Research Corporation.
13. Ling Sing Chee (1981) "The Singapore Woman Manager and Administrator." *Commentary* 5(1), 47–52.
14. Deyo, F. C., and Chen, P. S. J. (1976) *Female Labour Force Participation and Earnings in Singapore.* Bangkok: Clearing House for Social Development in Asia.
15. *A Salute to Singapore.* Singapore: The Times of Singapore (Pte) Ltd., November 1984.
16. Tan, J. (1985) "Less Emphasis on Language in Bid to Attract More Bright Students—NUS Changes Entry Rules." *The Straits Times*, 23 January, p. 1.
17. Tan, J. (1985) "Why Top Students Did Not Opt for NUS." *The Straits Times*, 24 January, p. 44.
18. National University of Singapore (1980/81–1983/84) *Annual Reports.* Singapore: National University of Singapore.
19. Arasu, S., and Ooi, S. (1984) "Women Who Have Risen High." *The Sunday Times* [of Singapore], 4 November, p. 19.
20. Pang Eng Fong and Sean, L. (1975) *A Report on the 1975 Employment Survey of University of Singapore Graduates.* Singapore: University of Singapore.
21. Tan, A. (1984) "Women Urged to Take High-tech Road." *The Straits Times*, 12 November, p. 19.
22. Ong, P. (1985) "When a Woman Climbs the Ranks." *The Sunday Times*, 30 June, p. 3.

23. *Getting to Know the ASEAN Woman Managers* (A study funded by the Canadian International Development Agency). Manila: Asian Institute of Management Press, 1987.

24. Lai Ah Eng and Ng Shui Meng (1985) "Women's Decade of Uneven Gains." *The Sunday Times*, 23 June, p. 19.

25. Gretchen, M. (1984) "A Look at Asian Women's Lot." *The Straits Times*, 22 June, p. 4.

26. Wong Ai Kwei (1983) "Married Women Go Back to Work—More Now Find the Time after Employing Foreign Maids: Survey." *The Straits Times*, 29 September, p. 1.

27. Chew, A. (1984) "A Background Paper on Married Women in the Workforce." In *National Employers' Symposium on Working Parents: Work and Family Responsibilities—The Role of Employers* (Organized jointly by the American Business Council; the British Business Association; the German Business Group; the Japanese Chamber of Commerce & Industry, Singapore; the Singapore Federation of Chambers of Commerce & Industry; the Singapore Manufacturers' Association; and the Singapore National Employers' Federation. Held 1–2 October in Singapore). Singapore: Singapore National Employers' Federation. P. 165.

28. Singapore Association of Women Lawyers (1986) *The Legal Status of Singapore Women*. Singapore: Singapore Association of Women Lawyers.

5

Virginia R. Crockett

Women in Management in Indonesia

In Indonesia, much lip service is paid to the popular assumption that educated women have access to a wide variety of career choices. Although this seems to be the case, they also face serious obstacles to upward mobility. As expected, the data reviewed here confirm that white-collar Indonesian women are under-represented in managerial positions, even though they are more highly educated than men. They are especially scarce in the private sector. Factors constraining and facilitating women's entry into management positions and their advancement within the management ranks are discussed. As Indonesia faces a continuing demand for skilled managers, it seems likely that educated women will find more doors opening for them, albeit more often in government than in business.

In Jakarta, the capital city of Indonesia, a glossy, expensive magazine called *Eksekutif* [Executive] profiles a different career woman each month. Accompanied by stylish photographs, the articles generally feature women in glamorous jobs such as actress and model, or entrepreneurs and professionals such as boutique owners and fashion designers. Some managerial women are, however, found among those interviewed in a special issue on career women. The following translations describe the career paths of four such women.

> *Retnowati Abdulgani: Progress through Perseverance.* Retnowati has been chief representative of the Jakarta headquarters of the Overseas Trust Bank Ltd. (OTB), a Chinese bank, since it opened in 1982. Her father is the well-known statesman and diplomat Roeslan Abdulgani. She graduated from the University of Indonesia with a law degree in 1969, then followed her family to New York, where her father was posted with the United Nations. In 1971, she earned an M.B.A.

degree from New York University. She intended to become a diplomat like her father, but went into banking instead because of the higher potential salary ("I'm a pragmatic person"). In New York she worked for Chase Manhattan, Citibank, and Bank of America. Before accepting her present position at OTB, she was marketing manager for American Express in Jakarta, the only Indonesian to be hired as a part of AMEX international staff. She moved to OTB because she felt she had advanced as far as possible at AMEX, with little likelihood of ever becoming general manager.

Asked about Indonesian women managers, she mentioned the conflict between the roles of housewife and career woman and the need for an understanding husband. She added that female managers often run the risk of being misunderstood in carrying out their duties. For example, meeting a male boss at the airport late at night and taking him to his hotel caused people to stare at her entering a hotel with a foreign man, whereas they wouldn't have looked twice at a man. In working with clients, staff members have often mistaken her male assistant for her boss. "Women are simply [considered] second class. . .Indonesian men don't have much tolerance for women working," she comments.

However, she thinks gender is not really an issue in top management. In her position as chief representative, she says she has never had a problem presenting her ideas in meetings. "In fact, I'm considered tough in presenting my opinion." In order to get where she is today, "I had to dare to take risks," she concluded [1].

Tity Samhani Koesoemo Dardo. From 1976 to 1982, Tity worked on the management team of the Jakarta Hilton Hotel. Another diplomat's daughter, she lived for twenty years overseas while growing up. She studied political science at the Sorbonne, because she wanted to follow her father into the foreign service. Upon graduation, she worked for the European Economic Community in Brussels, and then for the United Nations in New York. She returned to Jakarta when offered a position as assistant manager in the newly opened Jakarta Hilton. After two months, she was promoted to assistant banquet manager, then, after one year, to public-relations manager, second in command after the general manager.

Tity affirms that women are often challenged to prove themselves. She tells of one guest who refused to deal with her when he learned she was a woman and insisted on meeting with the general manager instead. She says that the risk of working is that not everyone understands why a woman wants to work in a hotel or in business. Tity resigned her position after marrying in 1982, since she felt it would be impossible to fulfill two such important responsibilities. However, she now teaches at the tourism institute of the city of Jakarta [2].

Shanti L. Poesposoetjipto. At age 36, Shanti is general manager of computer data processing and acting coordinator of finance and administration at the Soedarpo Corporation. She is also the director of P. T. Ista Indonesia, a subsidiary of Soedarpo, and director of P. T. Sumber Daya Praweda Informatika. She is the eldest daughter of Soedarpo Sastrosatomo, a prominent Indonesian businessman since 1952. As such, she is apparently being groomed to succeed him.

Shanti was brought up in Jakarta and sent to the University of Munich to study engineering. She also took management courses in anticipation of working in the

family business. Three weeks after graduation, in 1974, she began working as the departmental manager of data-processing services, a position she held from 1974 to 1983. In that capacity, she headed two divisions, computer services and computer equipment, with 90 and 60 employees, respectively. From 1984 to 1986 she was responsible for improving the financial administration, with 500 employees under her.

The interviewer questioned Shanti about being a female manager. As a manager of so many employees, she doesn't agree that male employees dislike female bosses. When asked, she is unable to give a picture of wage discrimination ("This problem is still rather hidden; people don't talk about it"). In her experience, male tolerance toward women is very high. She thinks the problems women have in management rest more with women's attitudes. Shanti understands why women resign from work even after high achievement, since happiness for Indonesian women is based on spiritual values such as building a family [2].

Mrs. Dradjat Sumitro. "We may have plans, but our destiny is not in our hands." Since her husband passed away thirteen years ago, Mrs. Sumitro [a more mature woman than Shanti or Tity and therefore, according to Indonesian custom, referred to by her husband's name rather than her own] has been both mother and father to her four children. She is the export-import manager in the Bank of Tokyo-Jakarta, but privately she admits she would rather stay at home. She worked ten years in the Bank of Indonesia, from 1955 to 1965. "At that time I was just working to kill time while being a companion to my husband and educating my children." In fact, she gave up working after her third and fourth children, twins, were born. However, in the 1960s, when Jakarta bustled with plans to open foreign branches, Mrs. Sumitro wanted to work again. Beginning as a clerk in the export-import division of the Bank of Tokyo, she had been working for three years when her husband died. She was promoted to supervisor, then assistant manager, after two years.

Since 1980 she has been a manager, in charge of ten employees, a position previously held by a Japanese male national. Ideally, she would like to be promoted again, but has not pursued the idea. Her present position appears to be the highest one for women in the bank's organizational structure. Comments the deputy general manager, her immediate supervisor: "Mrs. Sumitro is obviously a *senior manager*; right now she is the only woman among 13 managers here."

In her current position, Mrs. Sumitro says she feels no discrimination. Yet, she mentions the conflict between career and household: the career must come first. She agrees that female bosses are considered the "mothers" of their staff. Commenting on her own situation, she concludes that "women must be prepared to support themselves" [2].

These profiles describe four managerial women considered successful by their peers, the very small group of elite, influential women centered in the capital city. The editor-in-chief of *Eksekutif* is one of this group, and with the monthly profiles is clearly attempting to present role models to the young, aspiring, career women among its readers. How typical are these women? Where are educated Indonesian

women in the labor force, compared with men, particularly in the managerial ranks? What are their characteristics? Do they differ from those of Indonesian women and from male managers in some important ways?

This study attempts to answer these questions by examining the participation of women in the labor force, particularly those in white-collar occupations such as "administrator" in the government and private sectors, and the sociodemographic composition of those managerial occupations. The focus is Jakarta, the dominant city, and other urban areas.

Differences in the economic activities of men and women are influenced by a complex combination of demographic, socioeconomic, and cultural factors. In order to understand the role of Indonesian women in management, I first review the context in which it has developed: current economic and demographic conditions, indigenous management and entrepreneurship, and women's work roles and status.

Next, I present labor-force participation rates of educated women and compare men's and women's representation in white-collar occupations. The sociodemographic background (including age, sex, marital status, migrant status, and education) of government and private-sector administrators is then described, in order to explore the possible explanations for women's present position in management.

The context: Economic development, management, and women in Indonesia

Economic and demographic background[1]

Indonesia is an influential member of the Association of Southeast Asian Nations (ASEAN) and the Organization of Petroleum Exporting Countries (OPEC). It is the fifth largest nation in the world, with a population of 165.5 million in 1985 [3. P. 72; 4. P. 2], the majority embracing Islam, with a strong underlay of Hinduism. Indonesia's five main islands—Sumatra, Java, Kalimantan (Borneo), Sulawesi (the Celebes), and West Irian—extend 3,200 miles across the equator in an archipelago populated by 300 ethnic groups.[2] Fittingly, the national motto is "Unity in Diversity."[3] From 1970 to 1978, Indonesia's real per capita gross domestic product (GDP) grew at the rapid rate of 5.9 percent [3. P. 74], fueled, to a large extent, by oil production. Since 1965, under President Suharto's leadership, foreign investment and joint ventures have been encouraged by various government policies.

Despite the rapid growth in the 1970s, by 1982–1984 the rate had slowed to 2.7 percent [3. P. 74], largely because of the world slump in oil prices. Indonesia's economy faces many obstacles to growth. There are a bottom-heavy age structure—over two-thirds of the population is under fifteen years of age [4. P. 1]—and a high population growth rate (2.3 percent per annum), which has resulted in a rapidly increasing labor force.[4]

Job generation is a major dilemma for Indonesia's economic policy planners. A per capita income of only $600 places Indonesia among the group of "lesser-developed countries" (LDCs) [5]. Income distribution is quite uneven, with the upper 20 percent of the population in Java receiving double its share of income in the 1960s [6] and strong indications of an increasing gap in the 1970s [7. P. 89]. Over half of all Indonesians work in subsistence or plantation agriculture [4. Pp. 3,222].

Despite the incentives of the Suharto government for private-sector development, the Indonesian economy remains highly centralized and closely controlled by the dominant state enterprises and the influential military units. Three hundred and fifty years of Dutch economic guidance, particularly the emphasis on agricultural rather than manufacturing production, have taken their toll.[5] In 1980, manufacturing represented only 9 percent of the total labor force. As Indonesia slowly urbanizes, the labor force in the cities is absorbed into the tertiary sector: in 1980, 37 percent were in personal services and 25 percent in trade [4. Pp. 216,222]. Much of the tertiary sector is characterized by small-scale, impermanent, and low-capital businesses, dubbed the "informal" sector [10,11]. In fact, the majority of Indonesian firms are small, and are usually family-owned [12. P. 68]. Large and medium-size industries in Java employ fewer than one-fourth of those in manufacturing [13].

Nevertheless, the estimated annual need for new managers in Indonesia ranges from 26,000 (according to a World Bank study by Sihombing [1]) to 100,000 (according to a University of Indonesia Management Institute study by Sutoyo [5]). Where will they be found?

Management in Indonesia:
Colonialism, ethnicity, and Pancasila

The development of the Indonesian managerial ranks has been strongly influenced by three factors: Dutch colonial policies on education and

administration, the legal and cultural constraints on various ethnic groups in relation to business activity, and the postwar government's involvement in the private sector.

During the period of Dutch colonialism (1619–1942), the Dutch held the higher-level management positions in government and the largest business concerns. The Javanese were employed mostly as lower-level civil servants. Traditionally, the Javanese nobility preferred government service, as they considered trade fit more for commoners and foreigners, such as the Chinese, the Arabs, or other ethnic groups from the Outer Islands [14. Pp. 117,123].[6] And the Dutch did not encourage the Javanese and other Indonesians to engage in business; in fact, there were various legal restrictions on such involvement.[7]

Instead, immigrant Chinese and the descendants of the Arab merchants who helped bring Islam to Indonesia became active businessmen and traders in Indonesian cities [15. Pp. 11 ff.; 18. P. 29]. They were granted the privilege of conducting business in some cases in which the indigenous Indonesians were not [21]. Discussions of entrepreneurship in Indonesia therefore often focus on the Chinese, a minority of approximately 10 percent that exerts great influence on the nation's economy despite partial assimilation[8] and periodic purges during times of political unrest [16,22,23].

The development of entrepreneurial and managerial expertise among the indigenous Indonesian population [*pribumi*] was hampered not only by the traditional values of the Javanese nobility, or the *priyayi* class, but also by the educational policies of the Dutch. Very few high schools were open to Indonesians, and those wishing a university education had to travel to Holland.[9]

Not surprisingly, when most of the Dutch involuntarily relinquished their management positions in Indonesia at the end of the revolution in 1949, they left a vacuum that the untrained Indonesians found difficult to fill. Initially, most management training was conducted on the job [24. Pp. 223–25]. Although colleges began to provide courses in business management in the 1950s (mostly within departments of economics), only very recently has business become a formal course of study.[10] At least three private institutes in Jakarta now offer the M.B.A. degree,[11] but relatively few Indonesians have received M.B.A.s from these institutes since 1982 [1], and the Indonesian M.B.A. is not yet accredited by the government [25]. Traditionally, the elite, especially the wealthy Javanese and Chinese business families, have sent their sons and daughters overseas to earn degrees in business or technical

disciplines. A typical example is Shanti Poesposoetjipto, of the Soedarpo Corporation, who was profiled in *Eksekutif.*

The Indonesian Ministry of Education has succeeded in vastly expanding educational opportunities in the past 35 years; nevertheless, by 1980 only 6 percent of the adult population had graduated from high school, and only 0.7 percent from a tertiary institution (i.e., academy or university) [4. Pp. 57,270]. The proportionally small group of Indonesian managers and administrators is found in urban areas, where it represents just 0.5 percent of the labor force. In 1980 there were about 20 times more managers in cities than in rural areas.

Administrators and managers in the public and private sectors are drawn from this tiny pool of high-school and university graduates, the upper ranks of the military, Chinese business families, and the aristocratic class of the Javanese [*priyayi*] and certain other influential ethnic groups that constitute the Indonesian elite. Indonesian society is highly stratified and hierarchical. Social status and class have traditionally been based on hereditary nobility and land ownership; but, more recently, educational attainment and wealth have begun to play a part as well. Members of these privileged groups have the easiest access to higher education and value it greatly. The ubiquitous Indonesian name cards typically list all degrees and titles earned.

Thus, the elite tend to be highly educated (particularly those in the postwar age groups), and Indonesians with university degrees are nearly always members of these upper classes. A small, but growing, middle class is propelled by education, although usually the average level attained is high-school graduation rather than university.[12]

Since there is little indigenous management science per se, Indonesians have been influenced by Japanese, European, and U.S. management advice [5,27]. Yet, in practice, Indonesian social and cultural values are also consciously incorporated into management. In particular, Indonesians frequently debate the relationship between management and *Pancasila*, the five-part state philosophy, which stresses belief in one Supreme Being, democracy, state unity, humanism, and social justice.[13] The government and the military exert a strong influence. Many key industries are dominated by state enterprises, and retired military officers hold many government and business posts [5].

Hofstede's [32] attitudinal survey of Indonesian employees of a multinational corporation identified several work-related values, which he uses to describe typical Indonesian organizational behavior as:

(1) characterized by patron–client relationships ("strongly collectivist");

(2) hierarchical and paternalistic, with ascribed instead of achieved status ("high power distance");

(3) highly tolerant of uncertainty; able to "muddle through" unstructured situations by negotiation; valuing mystical predictions and maintenance of tradition; and fatalistic ("below average uncertainty avoidance");

(4) also characterized by low social acceptance of assertive and competitive behavior and by disapproval of ego motives ("slightly below average masculinity").

Where do women fit into what we know about Indonesian management? Does the Indonesian style of organizational behavior facilitate or hinder their upward mobility? These are difficult questions to answer, as little or no analysis of female managers per se has been made.[14] Yet women's work roles have been extensively studied in Indonesia, and several national surveys and censuses have collected detailed labor-force data that can be used to trace the extent of women's involvement in Indonesian management.

Indonesian women's economic roles

Indonesian women, especially those in the dominant Javanese ethnic group, have traditionally been active labor-force participants and influential financial decision-makers within the family. They have participated visibly and vocally in the tumultuous events of national, political, and economic development, particularly since the First Indonesian Women's Congress, in 1928 [40]. There are, however, significant class differences in female work and autonomy, which may be traced to the influence of customary law [*adat*] and the two dominant religions of Hinduism and Islam.

Traditional adat. In most of Indonesia's ethnic groups, customary law provided women with a rather strong economic position relative to property rights and inheritance [41. Pp. 152–55]. For example, in Java, a married woman retained the right to her own property [42. P. 184]. However, other *adat* concerning marriage, in combination with Islamic law and Hindu custom, placed restrictions on women. For instance, arranged marriages at young ages were common, especially among the upper class.

Women's economic role in the family has been very influential,

particularly among Javanese peasants, the dominant ethnic group in Indonesia (representing 60 percent of the population).[15] Javanese women are the financial decision-makers in the family [44. P. 51; 46. P. 123]. Rural women's labor-force participation rates, because of involvement in agricultural and marketing activities, have always been rather high—e.g., in 1980, over 40 percent of rural women aged 15 through 49 were working [4. P. 146]. Market trading activities in Javanese villages and towns have been dominated by women [43], although by the 1970s this dominance appeared to be eroding [47]. Female earnings constitute a substantial proportion of total family income: up to one-half among the lower classes [45].[16]

Historically, Chinese women have also been actively involved in family businesses, albeit in supportive roles. Unfortunately, very little has been written about Chinese women in business, and the available demographic data do not identify Chinese separately.[17]

Javanese noblewomen and the Indonesian women's movement.[18] The adoption of Hinduism (c. 1400) and, subsequently, of Islam (c. 1600) greatly affected the position of women in the aristocratic class. In accordance with the tenets of these religions, Javanese *priyayi* and noblewomen of other ethnic groups began to be secluded from public life, although they did not wear the veil.

The *priyayi* view of women stresses the roles of wife and mother. A women achieves high social status through the rank of her husband, whose position is reinforced by his wife's serving as a gracious ornament at his side. Although the tradition of seclusion prevented most from playing public roles, some upper-class women in colonial and precolonial times also achieved status and income through other means, as monarchs, special elite female bodyguards to the Javanese sultans, traders of batik and jewelry, and office workers during the Japanese occupation [14,34,42,50].

However, Dutch colonial rule sustained the cloistered status of Indonesian noblewomen by providing civil service appointments for their husbands with high enough wages or access to indirect income (i.e., through perquisites and commissions) so that any economic contributions of the wives were generally not crucial to maintaining the family's social position [34].

The upper-class Indonesian woman's aspiration for independence is personified by the Javanese noblewoman Raden Adjeng Kartini. Her brief life at the turn of the century was devoted to developing education-

al opportunities for women. She saw education as the alternative to being bound, ignorant, in a "golden cage" through early arranged marriages [51. Pp. 78,119]. Acclaimed for starting vocational training for women (especially teachers), she is considered *the* pioneer of the Indonesian women's movement. An annual "Kartini Day" celebrates the progress women have made over the past century. True to her aristocratic upbringing, R. A. Kartini envisioned women of her class working only in certain types of occupations: "If I choose to work, it would have to be at something fitting! It is only work for pleasure which would not be a disgrace to my noble and highly placed family"(R. A. Kartini, in H. Geertz [46. P. 42]).

The girls' schools set up, following Kartini's example, opened the door for Indonesian women to become vocal agents of change in society. Women's organizations proliferated during the 1920s. Initial issues of concern were rights for women in areas such as education and marriage, but the women's movement was soon diverted into the national struggle for independence from colonial rule, in which they played an active role.

Since the revolution, upper-class women, in particular, have been quite visible in political and public affairs. A proportion of seats in the national parliament is reserved for special functional groups, including women (who are allocated under ten percent) [41. P. 166]. There have been several female cabinet ministers [40]. Ikatan Wanita Pengusaha Indonesia (IWAPI), the Organization of Indonesian Businesswomen, is an active branch of the Indonesian Chamber of Commerce. Other professional associations for women have been formed, but about one-third of the women's organizations are actually wives' auxiliaries of men's professional groups, such as the "Military Wives" (PERSIT). The platforms of the women's organizations have focused on so-called "female" concerns of maternal and child health, family planning, marriage law reform, education and vocational training (for teachers especially), and political representation for women.

On the whole, the effect of traditional Indonesian customs on women's involvement in economic life has been positive. Peasant women have played a more visible part in the labor force, but upper-class women have benefited from involvement in such "refined" occupations as batik trading and teaching and from their leadership roles in women's organizations.

Educated women workers and
managers in urban centers

This section deals with educated women's work in urban areas, where business and government are concentrated. It is based primarily on detailed data gathered in the 1976 Intercensal Survey (SUPAS II). First, I shall describe the factors influencing educated women's involvement in the labor force, then compare gender differences in occupational status that are not explained by educational levels, and, finally, describe the sociodemographic composition of the managerial class, in order to show what types of Indonesian women become managers.

Female labor-force
participation rates[19]

In Indonesia the patterns for educated women described by the data on labor-force participation reveal some interesting contrasts. Urban educated women are an exclusive group, fewer than two percent of urban women ever attending academy or university and only 14 percent graduating from high school [4. Pp. 47 ff., 67 ff.]. The most highly educated women have the highest economic activity rates (75 percent in 1976) [26. P. 111].[20]

Both literacy and education levels of women have surged dramatically since independence, and at a faster rate than those of men. However, women are still half as likely as men to be highly educated [4. Pp. 47 ff.,87]. With this rapid improvement in women's educational levels, and the evidence that the most highly educated women have the highest economic activity rates, we can expect an increase in female labor-force participation and in potential female managers.

There are important differences in labor-force participation between the middle and the upper classes. Middle-class women typically have a high-school education. Although single middle-class women may work (in teaching or sales) up to marriage, the usual pattern is for them then to opt for full-time domestic responsibilities rather than remain in the formal labor force. However, many of these women conduct some informal, service-based business or trade out of their homes to supplement the family income. They also concentrate on "status-production work," such as membership in women's auxiliary organizations (e.g., "Air Force Wives") [39. Pp. 188 ff.]. Upper-class women —those from noble, wealthy, or high-ranking military families—are more like-

ly to have paid employment, in the professions, civil service, and in family businesses. Higher levels of education partially explain this difference, as well as the competitive advantage in seeking white-collar jobs afforded elite women by virtue of their position in the power structure.

Marriage and motherhood are highly valued and are upheld by the teachings of Islam. Yet divorce is common, particularly among the dominant Javanese.[21] It is less acceptable and therefore less common among the urban elite than the rural poor.[22] Not surprisingly, educated urban women who are single are much more likely to work than those who are married (in 1976, about one-half versus fewer than one-third [26. P. 108]).[23]

In Indonesia, female migrants, defined here as those who move from the village to the city or from town to town, have been assumed to follow husbands or fathers. Although the data show that this is not true for young rural women, who mostly move to find work,[24] it does appear to be the case for educated women. Their migration rate is low [26. P. 108], and among the educated, nonmigrants display higher economic activity rates than recent migrants.[25] Another explanation for this pattern is that the types of jobs the educated migrants seek are more competitive: the level of unemployment for women rises with the level of education [35]. Women with more urban experience have better chances of success in finding white-collar employment.

Not unexpectedly, far more women who are household heads work than those who are not[26]; and given the high value placed on motherhood, educated women with no children are twice as likely to hold jobs [26. P. 108]. Despite the extensive availability of inexpensive child care, Indonesian upper-class women are reluctant to rely solely on domestics, who generally have village backgrounds and little formal education, to bring up their children.

The interplay between religion and culture is complex. On the whole, fewer women from areas dominated by Christians and orthodox Moslems—West Java, Jakarta, and the outer islands—tend to work outside the home than those from Central and East Java, where *abangan*, or nominal, Islam reigns. Among the educated, those from Central Java are still the most likely to work, although the differences are not dramatic [52].[27]

In summary, women with a college education are more likely to be in the labor force than high-school graduates or even the least-educated women, who presumably need to work to survive. This difference is

partially explained by the age and marital composition of the educated group. The most-educated women are more apt to be young and single, and single women are more likely to work than married women.

Some other reasons why college-educated women represent the greatest proportion of those employed are the influence of Western feminist values among the very cosmopolitan upper class, the competitive advantage afforded them by their higher levels of education and, probably, their elite family connections, or the need for additional income to maintain high-status life-styles. The high level of economic activity among unattached, independent women (household heads, unmarried women, and those with no children) indicates that marriage, motherhood, and career are still not easily combined.

Women managers in business
and government: Who are they?

Although virtually no studies have been made of women in management, Indonesians writing on the subject in the business magazine *Eksekutif* have commented:

> Finding executive women who occupy high-level management positions in business in Jakarta does not appear to be an easy task. It seems that most women in management hold dual functions: as owner/founder and manager of the enterprise. Even if there are some professional managers, they usually hold less visible positions such as office administrator. [53]

Business and management are regarded as a male domain [2].

> Why don't women ever reach the top management positions? Some people say that there is a kind of *invisible ceiling* for female careers in professional management. One extreme says that it's women's fault, as they are not determined enough and choose family over career; the opposite view says that this situation is the result of sex discrimination. In any case, it is clear that over the past decade women have become a potential source to fill executive vacancies in business management. [54]

Do the available data support or refute these popular impressions? In what ways do women in management differ from other working women? How do female managers compare with their male counterparts?

Are there any important variations in the characteristics of managerial women in business and those in government?[28]

The most common occupations for urban workers are production for men (32 percent) and sales for women (34 percent).[29] Educated women are most likely to be teachers (37 percent), whereas educated men are most often government administrators (36 percent) (See Table 1). The second most common occupation for educated women is also government service (21 percent). Over eighty percent of educated women are employed in white-collar occupations, compared with two-thirds of educated men.[30] However, almost twice as many educated men as women are administrators (40 percent versus 23 percent). The proportion of all educated workers employed as managers in the private sector is quite small, yet four times as many men as women occupy these positions of authority.

Among the educated, single women are more likely to be administrators than those who have ever been married (28 percent compared with 20 percent), whereas the opposite holds true for men. A striking 37 percent of all ever-married educated men aged 25–44 are government administrators.[31] This reflects the dominance of the state in economic life and indicates that management positions and marriage are obviously complementary for educated men, but much less so for their female colleagues.

Educated women are underrepresented in managerial positions. Nearly one in five educated urban workers were female in 1976, yet only one in eight managerial positions were filled by women. The gap was more marked for private-sector managers, of whom only 6 percent were women (Table 2).

More women in management are single than their male colleagues or any other category of white-collar women. In 1976, nearly 39 percent of female administrators were single, compared with 11.8 percent of men (and 25 percent of businesswomen versus under 6 percent of businessmen), even in the 25–44-year group, by which age most Indonesians have made the marriage decision (Table 3). Women in administrative positions obviously do not combine work and marriage as easily as men. Interestingly, women in the private sector are more often married than other white-collar women (as are men). This partially reflects women's involvement in family businesses.

Female workers are much younger than their male counterparts.[32] This is particularly the case among educated white-collar workers, 1 in 3 women being under 25 compared with 1 in 8 men. In fact, female

Table 1

Percentage Distribution of White-collar Occupations among the Economically Active Population, Aged 25–44, by Sex, Education, and Marital Status: Urban Indonesia, 1976

	Women Educated[a], and 25–44 years old			Men Educated[a], and 25–44 years old		
	Total	Single	Ever married[b]	Total	Single	Ever married[b]
White-collar, total (number)	**100** (754)	**100** (209)	**100** (545)	**100** (2,734)	**100** (396)	**100** (2,338)
Professional, technical, & related	**49.1**	**34.2**	**55.6**	**17.8**	**16.8**	**17.9**
Teachers	37.4	27.5	41.7	11.4	9.9	11.7
Medical assistants	8.0	3.6	9.9	0.8	0.6	0.8
Doctors, dentists	0.7	0.7	0.7	0.5	0.0	0.5
Professionals NEC[c]	3.1	2.4	3.3	5.1	6.3	4.9

Administrators, managers, & related workers	**22.5**	**28.1**	**20.0**	**39.5**	**28.7**	**41.5**
Government	21.1	27.0	18.5	35.8	27.4	37.4
Private	1.4	1.2	1.5	3.7	1.3	4.1
Clerical & related	**9.0**	**10.9**	**8.2**	**9.6**	**11.4**	**9.3**
General clerical	6.4	8.3	5.6	6.3	7.2	6.1
Bookkeepers	0.5	0.8	0.3	0.2	0.5	0.2
Secretaries, typists	1.7	1.9	1.6	1.9	2.0	1.9
Clerical NEC[c]	0.5	—	0.7	1.2	1.7	1.2
Sales workers	**7.7**	**6.3**	**8.3**	**12.8**	**16.1**	**12.2**
Proprietors	0.4	0.4	0.5	1.5	1.6	1.5
Other sales	7.3	5.9	7.8	11.3	14.5	10.6
Service workers	**4.3**	**6.9**	**3.1**	**2.6**	**4.1**	**2.3**
Proprietors	0.1	—	0.2	0.1	—	0.1
Other service	4.2	6.9	2.9	2.5	4.1	2.2
Other workers	**7.6**	**13.6**	**5.1**	**17.9**	**23.6**	**17.6**

Source: 1976 SUPAS II sample tape, Indonesia Central Bureau of Statistics. See also note 28 and reference 55.
[a] Educated equals high school and above.
[b] Ever married includes those currently married, the divorced, and the widowed.
[c] NEC = not elsewhere classified.
Column totals do not always equal 100.0 because of rounding off from two decimal places. Total sample size: 9,541 women, 26,146 men.

Table 2

Percentage of Females among Educated White-collar Workers, Aged 25–44, by Marital Status: Urban Indonesia, 1976

	Educated[a] and 25–44 years old		
	Total	Single	Ever married[b]
All occupations	**18.8**	**29.8**	**16.2**
(number)	(909)	(269)	(640)
White-collar occupations	**21.6**	**34.6**	**18.9**
(number)	(754)	(209)	(545)
Administrators, managers, & related workers	**12.2**	**28.2**	**8.9**
Government	12.8	28.2	9.4
Private	6.3	30.0	4.9
Professional, technical, & related	**39.0**	**48.5**	**37.1**
Teachers	42.6	54.6	40.1
Medical assistants	67.4	75.0	66.3
Doctors, dentists	20.0	33.3	18.2
Professionals NEC[c]	12.4	14.7	11.9
Clerical & related	**17.6**	**27.1**	**15.0**

Source: 1976 SUPAS II sample tape, Indonesia Central Bureau of Statistics. See also note 28 and reference 55.
[a]Educated equals high school and above.
[b]Ever married includes those currently married, the divorced, and the widowed.
[c]NEC = not elsewhere classified.
Total sample size: 9,541 women, 26,146 men.

government administrators (and clerical workers) display the youngest age curve among educated women, only about one-twentieth being older than 44. This is probably due to a combination of factors, including the tendency of these better-off women to leave their positions upon marriage and the birth of children and the growth in the entry of new female labor-force participants into the civil service. The young age structure of this group also indicates that women are clustered at the lower levels of administration. In contrast, many more mature, educated women are represented in business and the professions, with, respectively, over one-fourth and nearly one-half older than 44.

Unlike in most other white-collar jobs, the age structure for business managers is quite similar for both sexes. The few women employed in private-sector management have probably gained their positions through many years of work experience, high educational attainment, and/or family ties.

Table 3

Percentages of Single Persons among Educated White-collar Workers, Aged 25–44, by Gender: Urban Indonesia, 1976

	Educated[a] and 25–44 years old	
	Men	Women
All occupations	**16.2**	**30.3**
(number)	(634)	(269)
White-collar occupations	**14.5**	**27.7**
(number)	(396)	(209)
Administrators, managers, & related workers	**11.8**	**38.0**
Government	12.4	38.8
Private	5.8	25.6
Professional, technical, & related	**15.3**	**21.1**
Teachers	14.0	22.3
Medical assistants	12.4	13.8
Doctors, dentists	0.6	29.7
Professionals NEC[b]	19.9	23.9
Clerical & related	**19.2**	**36.8**

Source: 1976 SUPAS II sample tape, Indonesia Central Bureau of Statistics. See also note 28 and reference 55.
[a]Educated equals high school and above.
[b]NEC = not elsewhere classified.
Total sample size: 9,541 women, 26,146 men.

their male counterparts.[33] However, among white-collar workers, the reverse is generally true (Table 4). About half of the men, in contrast to two-thirds of the women, in white-collar jobs are highly educated. Women obviously have to be more highly qualified than men in order to obtain government administrative positions, in spite of the civil-service rules basing selection on educational degrees and entrance exams [56]. Among private-sector managers, the men are better educated. Apparently, women in business rely on family connections or other factors more strongly than educational certification to compete with men for their positions. Yet, women managers have far more education than women civil servants (80 percent compared with 60 percent).

The data show that women in management differ from their male colleagues in several important aspects. They are generally younger, more likely to be single, and more highly educated. Women administrators in business and government each contrast differently with other

Table 4

Percentage of Educated[a] among White-collar Workers, Aged 25–44, by Gender: Urban Indonesia, 1976

	Workers aged 25–44 years	
	Men	Women
All occupations	**27.6**	**19.6**
(number)	(3,939)	(909)
White-collar occupations	**58.4**	**69.9**
(number)	(2,734)	(754)
Administrators, managers, & related workers	**53.0**	**60.2**
Government	50.9	59.3
Private	89.2	79.5
Professional, technical, & related	**78.7**	**77.9**
Teachers	86.4	80.7
Medical assistants	51.9	66.3
Doctors, dentists	100.0	100.0
Professionals NEC[b]	69.0	76.2
Clerical & related	**50.2**	**69.1**

Source: 1976 SUPAS II sample tape, Indonesia Central Bureau of Statistics. See also note 28 and reference 55.
[a]Educated equals high school and above.
[b]NEC = not elsewhere classified.
Total sample size: 9,541 women, 26,146 men.

and somewhat less educated whereas a typical woman executive is likely to be older, more highly educated, and less often single. She is also a rare creature, as yet barely represented in the managerial ranks.

Discussion and conclusions

In Indonesia, much lip service is paid to the popular assumption that educated women have access to a wide variety of career choices. Although this seems to be the case, they face serious obstacles to upward mobility.

The rather pessimistic observations on women in management made by Indonesians writing in *Eksekutif* [2,53,54] are confirmed by the data. White-collar Indonesian women are underrepresented in managerial positions, even though they are more highly educated than men.

entry into managerial positions is more difficult for women in the absence of the formal selection criteria used by the civil service [56]. Faced with this barrier, those in business apparently become entrepreneurs and managers in family enterprises or small companies rather than executives in corporations.

As Indonesia faces further challenges to growth and a continued demand for skilled managers, educated women may find more doors opening for them. As the case studies highlight, however, there are a number of constraints on women's filling these positions. The principal obstacles are the cultural value placed upon wifely duty [*kodrat wanita*], the Indonesian style of organizational behavior, and the stereotypes held about women in management.

Chief among the sociocultural constraints is the conflict between the roles of wife/mother and career woman. All of the women profiled here cite this as a recognized problem in their own work histories. The hotel executive resigned her position upon marriage because of this conflict. Although she worked again after marrying, it was in the more traditional female domain of teaching. Given the strength of the cultural value attached to marriage and motherhood, it is not surprising that female managers are more likely to be single.

The Indonesian style of organizational behavior described by Hofstede [32] also serves to inhibit women's upward mobility. His so-called "femininity" value affects women more deeply than men. Indonesian society discourages ego motives, self-advancement, and individual competitiveness; mutual aid [*gotong royong*] and collective achievement are the standard. For women the negative effect of this value is especially strong if home life appears neglected in the process.

Furthermore, the high value placed on patron–client relationships ("strongly collectivist"), ascribed status ("high power distance"), and maintenance of tradition ("below average uncertainty avoidance") means that the privileged women who are well connected to the traditional power structure by virtue of class (e.g., nobility involved in government and the military) or wealth (e.g., the Chinese business families) are most likely to succeed. Except for Mrs. Sumitro, the women profiled in the case studies were all members of this elite group. The middle-class woman dependent upon educational attainment for entry into managerial positions and upon individual ability for advancement is at a disadvantage.

The many preconceptions held by Indonesians about women in management also hamper their increasing participation in such functions.

Some recent articles in the popular business periodicals have summarized Indonesian images of women in management. Chief among the beliefs are [2,33,54]:

1. Men are intellectually superior.
2. Men are emotionally more stable than women.
3. Men value achievement, promotion, and "meaningful work" more highly.
4. Men are more determined than women.
5. Successful managers have masculine attributes.
6. Women are more interested in husbands and children than careers.
7. Men are more creative.
8. Men are better decision makers.

A trenchant anecdote about the Indonesian Businesswomen's Association (IWAPI) illustrates the impact of these preconceptions. The popular slang for its acronym is "Iwak Papi-Papi," which means, roughly, "bait for the big daddies," referring to the stereotype that the main function of women in business is to do favors for male power brokers.

These attitudes are reflected in the profiles. As chief representative for OTB, Retnowati Abdulgani is considered tough in presenting her opinions—i.e., not like a traditional female. Tellingly, she uses this to support her view that gender is not an issue in top management. The hotel executive, Tity Koesoemo Dardo, had a male guest refuse to deal with her because she was a woman. Mrs. Sumitro is the only woman among 13 managers, and has no hope of advancement. The underrepresentation of educated women in managerial occupations is indirect evidence of job discrimination based on such attitudes.

Although there are no employment policies that overtly discriminate against women, there is evidence that employers' attitudes do serve to exclude them. Protective labor laws (e.g., maternity and menstruation leaves) may be used as justifications for not hiring women; employment advertisements frequently specify gender.[34] Certainly the clichés about women in management are used as excuses for denying women access to managerial positions.

On the other hand, there are some positive forces facilitating women's move into management. There is an increasing pool of educated women. The most highly educated women are the most likely to work and to seek challenging jobs. The traditionally strong economic role of women in influential ethnic groups such as the Javanese and the Chi-

nese further supports this movement. It is reinforced by the importation of Western cultural values emphasizing managerial roles for women. The role models presented by strong female leaders and highlighted in the popular press will gradually help change attitudes, despite the fact that they give some mixed signals concerning the desirability of pursuing career goals. Women's organizations are a ready vehicle for change: already experienced in promoting concerns such as marriage-law changes, education, and maternal and child health, some are beginning to turn their attention to employment issues.

A recent study of women in civil service [56] provides evidence of significant improvement in their position over the past ten years (1974–1984) [56].[35] The number of women working in government has more than doubled since 1974, and the proportion of civil servants who are women has jumped from 18 percent to nearly 30 percent. Most encouraging is their advancement into higher levels within government. In 1974, most women were employed in the lowest of the four broad official classifications (level I), in which only proof of elementary-school graduation is required. By 1984, the majority were found in level II, which requires a college degree or the equivalent. This is remarkable progress.

Unfortunately, no empirical studies can be located on women managers in the private sector. Considering their dissimilarity to women in government, it is likely that they have not recorded such rapid gains.

Given the positive factors influencing women's upward mobility, women should continue to make steady inroads into administration, especially in the public sector and as entrepreneurs. However, they probably will be stopped by "invisible barriers" before they reach the top unless such constraints as the high priority given to marriage and motherhood and the negative stereotypes of female managers are removed.

Notes

1. All figures are drawn from the 1980 census unless otherwise noted.
2. National Development Information Office (n.d.) "Indonesia: A Profile." Jakarta: National Development Information Office. P. 3.
3. In reality, just a few ethnic groups are dominant, because of history and numerical strength. In particular, the Javanese account for over 60 percent of the total population. The island of Java cradles the national capital, Jakarta, which was also the Dutch colonial seat of power, under the name "Batavia." Jakarta is the largest city in Indonesia. In 1980, it had over six million residents and accounted for nearly twenty percent of the total urban population [4. Pp. 19–25]. As the Indonesian government is highly centralized and exerts a strong influence on the private sector, Jakarta is also the

economic center of the nation. Traditional Javanese political structure reinforces this centralization of power. The precolonial Hinduized kingdoms focused on the sultan, who represented the center of both spiritual and political power. The Javanese nobility, or *priyayi*, formed the core of the revolutionary movement, and have been extremely influential in all spheres of national life ever since.

4. It should be noted, however, that the Indonesian government has succeeded in steadily reducing this rate through its widespread family-planning program, with projections of 1.6% for 1985–1990 and 1.9% for 2010–2015 [3. P. 72].

5. After the Dutch colonial government took over from the Dutch East India Company (VOC) in the nineteenth century, it introduced the Cultivation System (*Cultuurstelsel*), a deliberate policy of forced cultivation of a narrow range of export crops (sugar, tea, coffee, indigo, and rubber). Liberal reforms in the colonial motherland during the late nineteenth and early twentieth centuries replaced the Cultivation System with direct taxation and led to a plethora of private and government plantations using coolie labor. Indigenous manufacturing was not encouraged, since the Dutch saw Indonesia as a viable market for their infant manufacturing sector. Indonesia gained its independence after World War II, as the Dutch attempted to return following the Japanese occupation. See Geertz [8] for a detailed analysis of this policy and its economic effects; see White [9] for an excellent review of Dutch economic policy in Indonesia.

6. This attitude stemmed from the "golden age" of Javanese history and from the traditional Hindu caste system, in which traders held lower status than noblemen, scholars, and warriors. The inland, Hinduized kingdoms ruled by virtue of their control over the fertile rice paddies of upland Java; trade was conducted at the periphery, through the small, northern, coastal sultanates, which eventually converted to Islam and rose to dominate Java just as the Dutch took control. See also Geertz [15] for a discussion of the contrasting values of the *priyayi* ("princes") and those engaged in business ("peddlers").

7. See Wertheim [16], Furnivall [17], Boeke [18,19], and Schrieke [20] for classic treatments of the social and economic conditions under Dutch colonialism.

8. Use of Bahasa Indonesia, the national language, rather than Chinese, is common; it is illegal to post signs using Chinese characters. Many Chinese Indonesians have assumed Javanese or Indonesian names; they are no longer enumerated as a distinct ethnic group in official data collection.

9. For instance, Mohammad Hatta, a key leader of the Indonesian Revolution and the nation's first vice-president, studied economics—and, incidentally, revolution—in the colonial motherland.

10. During the '50s and '60s, a Ph.D. in Economics—preferably from the University of California at Berkeley—was the ticket to success, particularly for those who plotted the path of the nation's economic growth through the series of five-year development plans. The M.B.A. degree is now apparently becoming the talisman, as Indonesia's economy faces further challenges to growth.

11. Institut Manajemen Prasetya Mulya (IMPM); Institut Pengembangan Manajemen Indonesia (IPMI); and Institut Pendidikan dan Pembinaan Manajemen (IPPM).

12. Rahardja and Hull [26] distinguish a middle class by equating six to nine years of schooling with "middle class" and more than ten years of schooling with "upper class." Unfortunately, this level of detail is only rarely presented in published research, and was not tabulated on the SUPAS II tape on which the present analysis is based. (See note 27 below.)

13. *Pancasila*, the "Five Principles" declared in the 1945 Indonesian Constitution, consist of: (1) belief in one Supreme Being, (2) humanism, (3) unity of the state,

(4) democracy, and (5) social justice [5]. See references [5,28–31] for examples of the debate about Indonesian management development.

14. Some popular articles in the Indonesian media have discussed female managers briefly, e.g., [2,33]; and several studies of educated Indonesian woman touch peripherally on the issue, e.g., [26,34–39]; M. Oey (1980) "Issues in the Labor Force Participation of Female Migrants in Indonesian Cities" (paper prepared for the Intermediate Cities in Asia Meeting, East-West Population Institute, Honolulu, Hawaii, 16–28 July); and H. Papanek (1979) "Implications of Development for Women in Indonesia: Selected Research and Policy Issues" (paper presented at the Eighth Annual Conference on Indonesian Studies, Center for South and Southeast Asia Studies, University of California, Berkeley, 2–5 August).

15. Dewey [43], Jay [44], Stoler [45], and Geertz [46] have published some significant studies.

16. V. J. Hull (1979) " A Woman's Place. . .: Social Class Variations in Women's Work Patterns in a Javanese Village" (Working Paper Series, No. 21). Jakarta: Population Studies Center, Gadjah Mada University.

17. Rather, ethnicity is inferred by provincial birthplace. This is generally an accurate assumption for indigenous Indonesians, but does not work for identifying the Chinese, most of whom have been born in Indonesia and are quite assimilated, speaking only Indonesian. Panglaykim and Palmer [48] and Willmott [22], describing successful Chinese firms, show how a wife assisted her husband in the store, took over for him while he was on business trips, and trained her son to take over after she was widowed. While her son was young, she gave active control of the business to a brother. Another woman relative supported the family business by investing capital.

18. Some selected articles, among numerous writings on this topic, are those by Douglas [40], Wilner [42], KOWANI [40], and Ismail [49].

19. Female labor-force participation rates in the following discussion are age-standardized rates unless otherwise noted.

20. Female labor-force participation rates are probably underestimated by standard measures, primarily because women's involvement in unenumerated "informal sector" activities is underreported. Although several studies have addressed this measurement problem (e.g., V. R. Crockett [1983] "Female Migrant Workers in Urban Indonesa" [unpublished M.A. thesis in geography, University of Hawaii at Manoa], and Oey, op. cit. [note 14]), no consensus has yet been reached on whether this pattern would persist if informal sector participation by women could be accurately measured.

21. Papanek, op. cit. (note 14).

22. Y. Rahardjo and V. Hull (n.d.) "Employment patterns of Educated Women in Indonesian Cities" (mimeographed). Canberra, Australia: Department of Demography, Australian National University.

23. Educated women were defined as high school, university, and academy graduates aged 15+.

24. Crockett, op. cit. (note 20).

25. However, the rates are not broken down into the higher levels of education (college vs. high school), which has shown a "J" curve, i.e., the most highly educated are the most likely to work. It is possible that a higher percentage of the college-educated are recent migrants.

26. N. M. Shah and P. C. Smith (1981) "Issues in the Labour Force Participation of Migrant Women in Five Asian countries." Paper prepared for the Annual Meeting of the Population Association of America, Washington, DC, 26–28 March. Table 5.

27. With few exceptions, members of each one of the 300 diverse ethnic groups in Indonesia tend to embrace the same religion. Javanese are almost universally Moslem.

Other dominant groups from the outer islands are Christians; Balinese are Hindu; Chinese are usually Buddhist, Confucian, or Christian. Within the Javanese, the strength of Islamic beliefs varies widely, however, one important group professing orthodoxy and a large majority adhering to a less strict version tempered by Hinduism (Islam *abangan*).

28. This section is based on data from the unweighted sample population subset of SUPAS II (second phase of the Indonesian Central Bureau of Statistics' three-stage 1976 Intercensal Survey), which is composed of 26,112 men and 9,541 women aged 10 and over who were working during the year before the survey and who were living in urban areas. Similarly detailed occupational data have not been published for the 1980 Census or subsequent labor-force surveys. Therefore, the 1976 data, though somewhat out of date, are the best available for this type of analysis.

The Indonesian Central Bureau of Statistics generously made the SUPAS II computer tape available to the East-West Center's Population Institute (EWPI) for this and other analyses.

Data are also drawn from tables made using the SUPAS II tape for a study of occupational segregation in Southeast Asia (see P. C. Smith and V. R. Crockett [1980] "Some Demographic Dimensions of Occupations: Research Implications from an Urban Thailand Case Study." Paper prepared for the Intermediate Cities in Asia Meeting, East-West Population Institute, Honolulu, Hawaii, 16–28 July; and P. C. Smith [1981] "Migration, Sex, and Occupations in Urban Indonesia and Thailand" [Working Paper, No. 21]. Honolulu: East-West Population Institute). The occupational distribution is based on a 38-category scheme drawn from the 109-category, or 3-digit, classification of occupations (see Smith and Crockett, op. cit.), which is a more meaningful level of detail than that available in the published tables [55]. The three broad International Standard Classification of Occupations (ISCO) groupings of professional, administrative, and clerical workers have been broken down into ten white-collar occupations (Central Bureau of Statistics of Indonesia [1971] [*International Standard Classification of Occupations and International Standard Industrial Classification for Processing of the 1971 Population Census Results*]. Jakarta: Biro Pusat Statistik). These ten are clearly more "education intensive" than other jobs in urban Indonesia: in Jakarta in 1971, these workers had an average schooling of seven to nine years, in contrast to all others, who had an average of less than four years [11. P. 75]. Of the 10 white-collar jobs, 2 in particular, "Administrative, government" (4,425 men and 668 women) and "Administrative, private" (303 men and 23 women), are the most clearly managerial.

Note that these administrative groupings cut across the standard occupational groupings. "Administrative, government" excludes "Administrative & Managerial Workers," which was blank on the tape, and includes "Government Executive Officials" (from Major Group 3, "Clerical & Related Workers) and military officers (category 04 from Group 1, "Professional, Technical & Related Workers"). "Administrators, Private" includes General Managers, Production Managers, and Managers Not Elsewhere Classified.

29. Tabular data are available from the author.

30. Tabular data are available from the author.

31. The term *ever married* refers to the combined group of married, widowed, and divorced. The age group 25–44 is selected as being old enough to have completed all levels of schooling and young enough to have had the opportunity to do so during the postindependence era.

32. Tabular data are available from the author.

33. The education variable used here is a composite of two questions: "level

currently or last attended'' and ''highest class ever/currently attended.'' Based on these, five levels of education, ranging from ''never attended'' to ''high school and above,'' are tabulated. Unfortunately, for the purpose of this analysis of elite women, the higher levels of education were not tabulated separately in the EWPI printouts. As the review of labor-force participation rates shows, there are important differences in work patterns between women who are high-school graduates and those who have completed university education.

34. Rahardjo and Hull, op. cit. (note 22).

35. Note that the total group of civil servants discussed in Logsdon's study is broader than the government administrators defined in the SUPAS data set, including nonadministrative categories such as elementary-school teachers.

References

1. Sihombing, C. (1984) ''Embrio MBA Indonesia'' [The Embryo Indonesian MBA]. *Eksekutif*, December, pp. 48–62.

2. Hatta, H. (1984) ''Wanita Dan Manajemen: Masalah Kualitas dan Kesempatan'' [Women and Management: A Problem of Quality and Opportunity]. *Eksekutif*, December, pp. 30–32, 83.

3. Morrison, C. E. (1987) (Ed.) *Asia-Pacific Report, 1987–88: Trends, Issues, Challenges*. Honolulu: East-West Center.

4. Indonesia, Biro Pusat Statistik [Central Bureau of Statistics] (1982) *Population of Indonesia*, Serie S, Number 2: *Results of the 1980 Population Census*. Jakarta: Biro Pusat Statistik.

5. Sutoyo, H. (1985) ''Management Philosophy, Culture and Education in Indonesia.'' *Majalah Managemen & Usahawan Indonesia*, September-October, pp. 41–44.

6. King, D. Y., and Weldon, P. D. (1978) *Income Distribution and Levels of Living in Java, 1963–1970*. New York: Agricultural Development Council Teaching & Research Forum reprint.

7. World Bank (1980) *Indonesia: Employment and Income Distribution in Indonesia* (a World Bank Country Study). Washington, DC: The World Bank East Asia and Pacific Regional Office.

8. Geertz, C. (1963) *Agricultural Involution: The Process of Ecological Change in Indonesia*. Berkeley: University of California Press.

9. White, B. (1973) ''Demand for Labor and Population Growth in Colonial Java.'' *Human Ecology*, *1*(3), 217–35.

10. McGee, T. (1978) ''An Invitation to the 'Ball': Dress Formal or Informal?'' In P. J. Rimmer, D. W. Drakakis-Smith, and T. G. McGee (Eds.), *Food, Shelter and Transport in Southeast Asia and the Pacific*. Canberra: Australian National University (Publication HG/12, Research School of Pacific Studies). Pp. 3–27.

11. Sethuraman, S. V. (1976) *Jakarta: Urban Development and Employment*. Geneva: International Labour Office.

12. Panglaykim, J. (1977) *Indonesia's Economic and Business Relations with ASEAN and Japan*. Jakarta: Yayasan Proklamasi, Centre for Strategic and International Studies.

13. Jones, G. (1984) ''Links between Urbanization and Sectoral Shifts in Employment in Java.'' *Bulletin of Indonesian Economic Studies*, *20*(3), 120–57.

14. Soewondo, N. (1968) *Kedudukan Wanita Dalam Hukum Dan Masyarakat* [The Position of Women in Law and Society]. Jakarta: Timun Mas NV.

15. Geertz, C. (1963) *Peddlers and Princes: Social Change and Economic Modernization in Two Indonesian Towns*. Chicago: University of Chicago Press.

16. Wertheim, W. F. (1956) *Indonesian Society in Transition: A Study of Social Change*. The Hague: W. van Hoeve.

17. Furnivall, J. S. (1939) *Netherlands India: A Study of Plural Economy*. Cambridge: Cambridge University Press.

18. Boeke, J. H. (1946) *The Evolution of the Netherlands Indies Economy*. New York: Netherlands and Netherlands Indies Council, Institute of Pacific Relations.

19. Boeke, J. H. (1953) *Economics and Economic Policy of Dual Societies*. New York: International Secretariat, Institute of Pacific Relations.

20. Schrieke, B. (1955) *Indonesian Sociological Studies: Selected Writings* (2 vols.). Bandung, Indonesia: "Sumur Bandung."

21. Crissman, L. W. (1977) "A Discussion of Ethnicity and Its Relation to Commerce." *Southeast Asian Journal of Social Science*, 5(102), 96–110.

22. Willmott, D. E. (1960) *The Chinese of Semarang: A Changing Minority Community in Indonesia*. Ithaca, NY: Cornell University Press.

23. Williams, L. (1952) "Chinese Entrepreneurs in Indonesia." *Explorations in Entrepreneurial History*, 5(1)(15 October).

24. Hawkins, E. D. (1971) "Labor in Developing Countries: Indonesia" In B. Glassburner (Ed.), *The Economy of Indonesia: Selected Readings*. Ithaca, NY, and London: Cornell University Press. Pp. 196–250.

25. "Quo Vadis MBA Indonesia?" *Eksekutif*, 1987, January, pp. 37–39.

26. Rahardjo, J., and Hull, V. (1984) "Employment Patterns of Educated Women in Indonesian Cities." In G. W. Jones (Ed.), *Women in the Urban and Industrial Workforce: South and Southeast Asia* (Development Studies Centre Monograph No. 33). Canberra: The Australian National University. Pp. 101–126.

27. "Pilihan Kita: Marlene Setiyadi, Saya Manusia Kerja" [Our Choice: Marlene Setiyadi, I'm a Working Person]. *Eksekutif*, 1983, February, pp. 43–47.

28. Marbun, B. (Ed.) (1979) *Konsep Manajemen Indonesia* [Indonesian Management Concepts] (LPPM Seri Manajemen No. 54). Jakarta: Lembaga Pendidikan dan Pembinaan Manajemen.

29. Marbun, B. N., and Bambang, Ks. (1980) *Praktek dan Pengalaman Manajemen Indonesia* [Indonesian Management Practice and Experience] (LPPM Seri Manajemen No. 53). Jakarta: Lembaga Pendidikan dan Pembinaan Manajemen.

30. Panglaykim, J. (1964) *Kaum Manager Indonesia Kekuatan Sosial Jang Revolusionair* [Indonesian Managers, a Revolutionary Social Power]. Jakarta: Lembaga Management Fakultas Ekonomi Universitas Indonesia.

31. Subroto, and Sadli, M. (Eds.) (1964/65) *Bahan Seminar Management, Djilid I* [Management Seminar Materials, Part I]. Jakarta: Universitas Indonesia, Jajasan Badan Penerbit.

32. Hofstede, G. (1979) *Cultural Pitfalls for Dutch Expatriates in Indonesia* (2nd ed.). Deventer: Twijnstra Gudde International.

33. *Manajamen: Majalah Para Manajer dan Eksekutif Indonesia* [Management: The Magazine for Indonesian Managers and Executives]. Published by LPPM.

34. Rahardjo, Y. (1975) "Beberapa Dilemma Wanita Bekerdja"[Some Dilemmas of Working Women]. *Prisma*, 5 (October), 45–51.

35. Oey, M. (1975) "Beberapa Catatan Demografis Tentang Kemajuan Wanita Indonesia" [Some Demographic Notes on the Progress of Indonesian Women]. *Prisma*, 5(October), 11–18.

36. Oey, M. (1979) "Rising Expectations but Limited Opportunities for Women in Indonesia." In R. Jahan and H. Papanek (Eds.), *Women and Development: Perspectives from South and Southeast Asia*. Dacca: Bangladesh Institute of Law and International Affairs. Pp. 233-52.

37. Rahardjo, Y., et al. (1980) *Wanita Kota Jakarta: Kehidupan Keluargo dan Keluarga Berencana* [Women in the City of Jakarta: Family Life and Family Planning]. Jakarta: Gadjah Mada University Press.

38. Papanek, H. (1976) "Jakarta Middle Class Women: Modernization, Employment, and Family Life." In G. Davis (Ed.), *What Is Modern Indonesian Culture?* (S.E.A. Series No. 52) (Papers presented at the Conference on Indonesian Studies, 29 July-1 August, 1976 [ISSI, Madison, WI]). Athens, OH: University Center for International Studies. Pp. 108-134.

39. Papanek, H. (1979) "Development Planning For Women: The Implications of Women's Work." In J. Rounaq and H. Papanek (Eds.), *Women and Development: Perspectives from South and Southeast Asia*. Dacca: Bangladesh Institute of Law and International Affairs. Pp. 171-201.

40. Kongres Wanita Indonesia (KOWANI) [Indonesian Women's Congress] (1980) *The Role of Women in Development: The Indonesian Experience*. Jakarta: KOWANI.

41. Douglas, S. A. (1962) "Women in Indonesian Politics: The Myth of Functional Interest." In S. A. Chipp and J. J. Green (Eds.), *Asian Women in Transition*. University Park, PA, and London: Pennsylvania State University Press. Pp. 152-81.

42. Willner, A. R. (1980) "Expanding Women's Horizons in Indonesia: Toward Maximum Equality with Minimum Conflict." In S. A. Chipp and J. J. Green (Eds.), *Asian Women in Transition*. University Park, PA, and London: Pennsylvania State University Press. Pp. 182-90.

43. Dewey, A. (1962) *Peasant Marketing in Java*. New York: The Free Press.

44. Jay, R. (1969) *Javanese Villagers: Social Relations in Rural Modjokuto*. Cambridge, MA: M.I.T. Press.

45. Stoler, A. (1977) "Class Structure and Female Autonomy in Rural Java." In Wellesley Editorial Committee (Eds.), *Women and National Development: The Complexities of Change*. Chicago: University of Chicago Press. Pp. 74-92.

46. Geertz, H. (1961) *The Javanese Family: A Study of Kinship and Socialization*. New York: The Free Press.

47. Chandler, G. (1985) "Wanita Pedagang di Pasar Desa Di Jawa" [Rural Market Woman in Java]. *Prisma, 14*(10), 50-58.

48. Panglaykim, J., and Palmer, I. (1970) "Study of Entrepreneurship in Developing Countries: The Development of One Chinese Concern in Indonesia." *Journal of Southeast Asian Studies, 1*(1), 85-95.

49. Ismail (Mrs.) (1959) "Women's Organizations in Indonesia." *Asian Review, 55*, 303-308.

50. Kumar (1980) "Javanese Court Society and Politics in the Late Eighteenth Century: The Record of a Lady Soldier." Part I: "The Religious, Social and Economic Life of the Court." *Indonesia*, No. 29, pp. 1-46.

51. Kartini, R. A. (1976) *Letters of a Javanese Princess* (translated by Agnes Louise Symmers). Kuala Lumpur: Oxford University Press.

52. Jones, G. W. (1977) "Factors Affecting Labour Force Participation of Females in Jakarta." *Journal of the Malaysian Economic Association, 14*(2), 71-93.

53. Sihombing, C. (1984) "Retnowati Abdulgani: Bertahan Sambil Maju" [Retnowati Abdulgani: Progress through Perseverance]. *Eksekutif*, December, pp. 18–24.

54. "Pilihan Kita: Indira Wati, Kelana Yang Panjang" [Our Choice: Indira Wati, The Far Wanderer]. *Eksekutif*, 1984, February, pp. 43–47.

55. Indonesia, Biro Pusat Statistik [Central Bureau of Statistics] (1976) *1976 Intercensal Population Survey: Indonesian Labor Force* (Technical Report Series, Monograph 2). Jakarta: Biro Pusat Statistik.

56. Logsdon, M. G. (1985) "Pegawai Negeri Sipil Wanita di Indonesia: Sebuah Pengantar Awal" [Women Civil Servants in Indonesia: Some Preliminary Observations]. *Prisma*, *14*(10), 79–87.

6

PATRICIA G. STEINHOFF AND KAZUKO TANAKA

Women Managers in Japan

Women are notably absent from managerial positions in large Japanese corporations because of characteristic features of the Japanese management system. However, large corporations represent less than one percent of all Japanese firms and employ less than one-fifth of the labor force. Women play a much larger managerial role in small and medium-size enterprises, of which more than twenty-five thousand women are company presidents. The backgrounds and career paths of women in managerial positions are examined in light of this central structural feature of the Japanese economy. The authors predict that women will make only limited inroads into large-scale corporate management in the near future, but are optimistic about opportunities for women in small and medium-size enterprises.

At first glance, it would seem that the topic of women managers in Japan could be handled in one sentence: there are none. In fact, there are women in managerial positions in Japan; but finding them requires careful examination of Japan's employment patterns, promotion policies, and economic structure. In this review we shall attempt, first, to locate the women managers in Japan, and then explore who they are and how they achieved their present position. Finally, we shall assess the future prospects for increased participation of women in Japanese management.

The available talent pool:
Training and culture

On the basis of objective, universalistic criteria, Japan possesses an enormous pool of well-educated women with work experience from which managerial talent could potentially be drawn. Japan has had universal, coeducational, primary education for nearly a century. Since the end of World War II, educational levels for both sexes have risen

steadily until, at present, about 95 percent of all young people complete high school, and one-third go on to higher education. This represents a considerably higher rate of high-school completion than that in the United States, and a comparable rate of postsecondary education.

Japan has had a relatively high proportion of women in the labor force since at least the early part of this century. The main shift from the early part of the century to the 1970s was the steady movement of working women from the status of family worker to wage earner.[1] Women now constitute 39.7 percent of the labor force. Although the transition from family worker to wage earner continues, 20 percent of women in the labor force were still counted as family workers in 1986 [1].

Less than a century ago, Japan's economy was overwhelmingly agricultural, and women worked alongside men in the fields. In the early stages of industrialization, women were sent to work in the textile industry and other light industries; they formed the absolute majority of factory workers through the 1920s [2]. Later, women were heavily utilized in the war economy that propelled Japan to a higher level of industrialization during the 1930s and 1940s. Even in the prewar period, small numbers of women with relatively high education also worked in various kinds of white-collar occupations.

Virtually all young women in postwar Japan join the labor force after they complete their schooling. They work for several years until marriage, and often continue until their first pregnancy. Over ninety percent of Japanese women marry before the age of 35, and the overwhelming majority of married women also become mothers. Compared with most other countries, there is astonishing uniformity in the age range within which marriage and parenthood take place. Fertility is also highly controlled, with a low illegitimacy rate and an average number of children per family that is now well below replacement [3. P. 6].

As postwar Japan developed into a major industrial power during the 1960s, the nonworking wife became a status symbol of economic success. What had once been a luxury of elite women was now within reach for a growing segment of the middle and working class. There arose a cultural ideal of the middle-class, white-collar, salaried man, working in a large company, whose wife devoted all her time to her home and the rearing of her children. Such women were expected to utilize their education and skills in managing the home, and were given substantial control over the household economy [4].

Initially, there may have been some economic advantage to this arrangement, in that the full-time mother closely supervised the education of elementary-school children and thus gave them an edge in the meritocratic educational system that determines the social status of the next generation. As the educational competition intensified, however, families shifted to outside tutors and commercial cram schools, and the mother's role became simply to provide emotional support and encouragement to the studying child. The nonworking wife thus became primarily a status display for middle-class households.

Despite its importance as a cultural image, the ideal of the nonworking wife has never represented an actual life-style for the hundreds of thousands of women who participate in the operation of family businesses. During the 1960s and 1970s, it became common for housewives to do piecework at home, in order to supplement the family income, while maintaining the image of the nonworking housewife. Over the past decade, however, married women have been returning to the labor force outside the home more openly, and at present, half of all married women work [5. P. 37].

Married women who return to the labor force after a break in employment are usually employed in lower-status positions than those they occupied before marriage. Such women are generally classified as part-time workers, who have no employment security, no opportunity for advancement, and no fringe benefits, as opposed to the "permanent" or "regular" workers, who enjoy all of these advantages. About eleven percent of all employees, and 22 percent of all women employees, fall into this category. In the past 20 years, the number of part-time workers has tripled, and their proportion of the labor force has doubled. The trend is much stronger for women, who by 1985 constituted 70.7 percent of all part-time workers. The number of women part-time workers is six times what it was 20 years ago, and their proportion of the female labor force has nearly tripled [1].

Japan has a double-peaked (M) curve of female employment by age, with the overwhelming majority of young, unmarried women in the labor force, a drop in labor-force participation during the early years of marriage and childbearing, and a gradual return to the labor force of growing numbers of older, married women. The bottom of the M has gradually been rising, but is still much lower than in the United States. Because of this demographic pattern of female labor-force participation, coupled with the reality that most women cannot return to the same type of job they left, relatively few women remain in a career

track long enough to attain a management-level position in a large corporation.

Employment and promotion
in large organizations

The barriers against placing women in managerial positions in large companies stem not only from family ideals in the larger society but also from the strictures of the permanent employment system, another cultural ideal that finds its major expression in large corporations.

In both the public and the private sector, large organizations in Japan hire only entry-level white-collar employees and expect to retain them until retirement in their mid-fifties. Incoming, permanent, white-collar employees are generally employed fresh out of school, with no previous work experience. Management-track employees normally have four-year college degrees, but no specialized graduate training. New employees are given considerable in-company training during their first year on the job. Thereafter, they are moved around to various parts of the company to develop their knowledge and skills and receive continuing in-service training over the years.

Most companies would prefer to send an employee for graduate training, if it becomes necessary, rather than hire someone who already has obtained it on his own. In effect, the company grooms employees for managerial positions by providing a wide range of internal career-development opportunities. To a certain extent, all career employees in a hiring-year cohort receive the same opportunities, but specific assignments are made on the basis of the company's view of each individual's potential.

Virtually all promotions are internal, and are carefully graded by seniority. Thus, after about eight years of service, all permanent employees who entered the company in the same year become eligible for promotion: all attain the rank of *kakarichō*, although some are placed in more-important posts than others. Most will eventually receive a second promotion in rank to *kachō*, about five to six years later. Only a small proportion of these will later become *buchō*, or department heads. The highest-rank promotions are given to people near or even past the formal retirement age. The situation is usually managed so that no one from the same age cohort and rank who is not promoted remains in service.

The Japanese system of organization and management features a

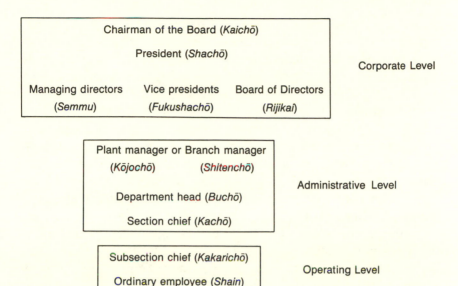

Japanese management levels. Ranks above plant manager or branch manager are considered to be corporate management; section chief to plant manager, administrative-level management. Subsection chiefs are not considered part of management, but may have direct supervisory responsibilities. The latter distinction is related to union membership, which generally includes all permanent employees below section chief.

narrow span of control, with an average of 5–15 people under one direct supervisor. The consequent abundance of supervisory positions, plus the practice of foisting excess managers off onto lower-ranked subsidiaries, makes it possible to provide sufficient positions in the main administrative ranks for the entire age cohort.

Large Japanese bureaucracies, both corporate and governmental, have a relatively standardized rank structure of administrative levels, as shown in the diagram. All persons at the rank of section head (*kachō*) or above are considered to be managers who participate in decision making. Management studies sometimes also include the sub-section-head level (*kakarichō*), the first supervisory-level position, from which appointments to section head are made.

Virtually all employees are rotated within the company at about three-year intervals. Although they fall at the same rank level, these assignments can vary considerably in the amount of responsibility and opportunity they provide. This means that the actual managerial responsibility a person is given may not be reflected in formal rank or

even in compensation, which is heavily determined by rank and seniority. At the same time, the range of experience an employee accumulates and the opportunities to develop and display one's skills weigh heavily in the employee's future placement in a developing managerial career.

The seniority-based promotion system creates an attractive and predictable management career track for permanent employees. It is precisely this package that makes white-collar, entry-level positions in large corporations and government among the most prized commodities in the society. This, in turn, fuels incredible competition for entry into the relatively small number of elite universities from which the major corporate employers and the national government hire their permanent employees.

In the private sector, virtually all who acquire these coveted entry-level positions with a guaranteed promotion ladder are men. Their secure promotion opportunities are preserved, however, primarily by the hiring of large numbers of educated women to fill out the bottom of the employment pyramid at the white-collar rank of ordinary employee.

Young, single women are hired with the expectation that they will "retire" into marriage and motherhood within a few years without being promoted to a higher rank. Because the company does not intend to promote these women, they are often hired at lower educational levels (high school or two-year rather than four-year degrees) or from lower-ranked four-year colleges than are men employed by the same company. The forced retirement of female employees is often helped along by management's urging young, white-collar employees to marry at the appropriate age, preferably to an eligible person in the same company. When two employees marry, nepotism rules are invoked; and, of course, the wife is the one who retires. Although it is against the law to force a woman to retire because of marriage or pregnancy, nepotism is an acceptable reason. Personal social pressures effectively eliminate most of the remaining young women from the white-collar managerial pool soon after they marry.

Until recently, women have generally cooperated with this system. Families traditionally have encouraged women to get the type and level of education that will equip them to marry managers, rather than to become managers themselves. Although the competition for university entrance is open and meritocratic, women still do not compete in great numbers for entry into the elite coeducational institutions. When they do enter, they tend not to go into the "male" disciplines of economics,

law, and engineering, from which companies are more likely to hire. Yet there are some eligible women with the same qualifications as the men; and in some cases they are hired for entry-level positions in large corporations.

Japanese management culture and women

Much has been made of Japan's unique managerial culture as another barrier to women. Japanese white-collar employees are expected to work long hours, and to be available until late at night when there are special work demands. Women members of a work group are also expected to stay late when the work requires it. They may make excuses to leave early, which the men could never do, but this is considered evidence of their weaker commitment to the company. Legal restrictions on women's night work have recently been removed, so this can no longer be used as a reason to exclude women from managerial positions.

Japanese managerial style also mixes work and play to a greater degree than is found in other countries. Co-workers are expected to socialize together regularly after work, which often means bar-hopping until late at night. Managers take their subordinates drinking in order to break down the status barriers and permit employees to speak more freely about problems at work and at home. Some women are accepted as full co-workers and invited to join in these activities. Although evening socializing in small restaurants and bars remains heavily male oriented, it is quite possible nowadays for women to participate as part of the group.

The problem thus is not so much an absolute sex barrier as it is a matter of time commitment and personal style. A married woman with home and family responsibilities in the evening would be very hard-pressed to meet these work demands. A single woman or one whose husband had similar work hours could do so more easily. A mother with young children at home could maintain such a managerial life-style only if she had resident child care. Many women would not be comfortable with the evening socializing required of Japanese managers; some men do not like it either, and it also affects their careers.

Another important aspect of Japanese managerial culture is a consensus-oriented decision-making style that aims to avoid conflict after the decision is made by anticipating resistance and negotiating beforehand. This encourages a managerial style based on teamwork, and

leaders who listen and are sensitive to the feelings of others. Ironically, the qualities required of good Japanese male managers are the same qualities that are often held in American management research to be feminine characteristics disadvantageous to success. (In fact, when Japanese managers complain that they have difficulty finding American men who can fit into their overseas operations, the authors have recommended that they try American women.) There is thus no inherent reason why Japanese women would have difficulty handling the decision-making aspects of management, given similar opportunities to develop their skills in the work group. Even in the home, Japanese women are expected to be competent managers and good negotiators, using a similar style of consensus decision-making.

Utilization of women
in large organizations

A new equal employment opportunity law, which went into effect on 1 April 1986, is intended to improve the promotion opportunities of woman employees. Unfortunately, it has weak enforcement provisions and does not effectively address the problem of differential hiring. It has, however, prompted some new research on the actual status of women in large organizations.

Large firms

A 1986 survey of 321 large firms by the Labor Administration Research Institute found that 79.9 percent of the firms professed to treat men and women equally with regard to promotion, and that the larger the firm, the greater the support for women's promotion opportunities [6]. This is a substantial increase from a 1984 study by the Women's Bureau, in which only 56.3 percent of companies reported that they offered promotion opportunities to women [7]. In the more recent study, however, only 1.2 percent of the companies surveyed had any women above the rank of division manager (*buchō*). Just 4.1 percent of the companies had women up to the level of division manager, but about one-fifth (21.6%) had women in positions up to section head (*kachō*), and slightly more (22.8%) had women in the lowest-level supervisory position, subsection head (*kakarichō*) [6].

Given the system of age-graded internal promotion, the figures suggest that it will be a very long time before women are well repre-

sented in corporate management. A major mechanism for blocking women from the promotion ladder is to exclude them from transfers to branch officer or posts far away from their homes, which means they are unable to acquire the range of experience needed for promotion to a mangerial position. About two-thirds of the firms surveyed currently do this, and most intend to continue the practice despite the new law [6].

In 1979, as part of the background research for the new law, a Cabinet-level commission surveyed all companies listed on the stock exchange and special corporations in the three major urban centers of Tokyo, Osaka, and Nagoya that were capitalized at over ¥ 500 million [8]. The 1,497 companies surveyed had an average work force of 3,321 and an average of 242 persons in decision-making positions.

The study found that women constituted about a quarter (23.3%) of the work force in these large companies, but only 0.3 percent of those in decision-making positions. Nine-tenths (89.5%) of the companies had no women at all in decision-making positions, and most of the remainder (7.8%) had only one or two women in such positions. Fewer than one percent (0.7%) of the companies had 10 or more women in decision-making posts [8. P. 5].

In the entire sample of 1,497 companies, employing almost five million people, the study was able to identify fewer than a thousand women in managerial positions. Two-thirds of the 996 women managers found by the study (66.5%) were at the section-head (*kachō*) level. Seven percent were department heads (*buchō*), and only 1.6 percent were corporate officers [8. P. 5].

In a companion study conducted in 1981, the same Cabinet-level commission surveyed women in decision-making positions in associations, organizations, unions, and cooperatives, institutions that fell outside the purview of the earlier study. Eighty-five percent of these institutions had no women in decision-making positions, and only 5 percent had more than one woman [9. P. 11]. Women make up 40.1 percent of the work force, but only 0.5 percent of management in these organizations, an even greater disparity than in corporations listed on the stock exchange. [9. P. 19].

The public sector

The situation of women in the public sector is similar. Local, prefectural, and national levels of government all hire permanent white-collar

employees directly out of school. Like private corporations, they hire both men and women, but expect to retain the men until retirement in their mid-fifties and to lose many of the women within a few years. However, government is not quite as free as the private sector to discriminate against women, because the laws governing the hiring and promotion of public employees provide some protection. Women schoolteachers, for example, routinely work until the mandatory retirement age, even if they marry and have children. Many are promoted to grade-level or discipline supervisor, and some achieve the rank of principal.

Even in the regular administrative areas of the public sector, it is now difficult for government not to hire women for permanent positions if they have competitive qualifications. Once hired, they have at least a claim to equal treatment, but they may not receive it. Although the numbers are still small, there are women in managerial positions at all three levels of government. In the national government, only 0.7 percent of managers at the *kachō* level, and 0.8 percent at the *buchō* level, are women. At the prefectural level the numbers are about the same. These numbers reflect the government's resistance to hiring women in the upper career tracks in earlier years.

Although one still needs a magnifying glass to read these numbers, 0.8 percent women managers in government is more than twice the 0.3 percent women managers in large corporations. Observing that there may be somewhat more opportunity in the public sector, some highly talented and ambitious young women have begun directing their aspirations toward government, where the door is slightly ajar, rather than toward private industry, where it remains essentially closed.

Enterprise scale in the Japanese economy

It is clear that women managers are rare in the corporate world, and barely more visible in government. To stop at this point, however, would seriously distort the actual situation of women managers in Japan. In fact, there are women in managerial positions just about everywhere in Japan except in the largest corporations. To get a proper perspective on the situation, the overall pattern of firm size in Japan must be examined in more detail.

In general, Japanese firms are much smaller than their American counterparts. Instead of having one giant corporation under central control with a proliferation of divisions, the Japanese tend to have

smaller separate companies interlocked into tight vertical networks. The overall group of companies may be as large as a giant American conglomerate, but it is actually made up of many, sometimes several hundred, separate companies, ranging in size from large corporations listed on the stock exchange down to tiny firms employing fewer than five people. In manufacturing, the firms are linked through subcontracting relationships; in service and merchandising, they are linked in distribution networks.

The definition of a large company varies by industry: 300 employees and capitalization at ¥ 100 million in manufacturing; 100 or more employees and capitalization at ¥ 30 million in wholesale firms; and 50 employees and capitalization at ¥ 10 million in retail enterprises. Even with these rather generous definitions, only 0.6 percent of all Japanese corporations meet the definition of a large company. The overwhelming majority of firms (99.4%) are small or of medium size, and together they employ 81.1 percent of all private-sector employees in the Japanese labor force. Three-quarters of all working women are employed in small or medium-size enterprises. Moreover, most of the growth in female labor-force participation in recent years has been in this area [10].

Thus, it is not surprising that women in managerial positions are most often found in small and medium-size enterprises. Nearly two and a half million Japanese women run their own (nonagricultural) businesses, most of which have fewer than five employees [1]. Yet, in 1984, there were 25,447 women serving as presidents of companies with 5 or more employees, a 10.5 percent increase over the previous year [11. P. 82]. Although the measures are not exactly comparable, they do suggest that the smaller the firm, the more likely it is to be run by a woman.

In a 1983 study of 37 small retail businesses in a single commercial neighborhood, Steinhoff[2] found women heavily involved in running nearly all of the shops, but in varying capacities. Some shops were owned and run by women whose husbands worked as salaried men. A few women had inherited a business, including one daughter-in-law who had been brought into the family to take over her mother-in-law's shop. The majority were family businesses run jointly by husband and wife, often with each spouse running a branch store in a different location. In the few businesses large enough to have nonfamily employees, the wife was the major supervisor and decision maker in daily operations.

Komatsu [11. P. 82] sees three factors behind the rapid increase in women company presidents. The first is the general changes—e.g., smaller family size, reduced household work, and women's recognition that they can do what used to be defined as men's work—that are pushing women out of the home and into more external activities. Second, the structural problems involved in penetrating the existing corporate system force women to act on their own. Third, leisure and volunteer activities are giving rise to new types of enterprises that women can develop.

A 1986 popular magazine article lists the ten most common types of enterprises run by a woman president. At the top of the list are companies that retail women's or children's clothing (1,591). Real estate agencies (803) are second, followed by retail kimono and bedding stores (749). Fourth on the list are inns and hotels (710); construction (694) outranks restaurants (639) and bars and cabarets (639). The remaining three types in the top ten are retail fuel companies (495), general retail stores (415), and barber and beauty shops (400). The 1985 annual income of the top 200 companies with woman presidents ranged from a photo typesetting machine company, with earnings of $25 million, down to a petrochemical company earning under $1 million, in 1985 dollars [11]. These figures for the top 200 companies suggest that the overwhelming majority of companies headed by women are quite small.

Background and characteristics
of women managers

The Prime Minister's Office studies of women in decision-making positions in large corporations provide the most reliable data on the most invisible category of women managers. The educational levels of women managers were surprisingly low for contemporary Japan: about one-third had only middle-school education, and another third, high-school education. Only 16.6 percent had 4-year college degrees, and fewer than one percent had a graduate degree. Their average age was 49.8 years, yet about two-thirds of the women in decision-making positions were unmarried. They had worked for the same company for an average of 28.6 years [8. Pp. 8–11].

It is clear from these findings that the women who did attain managerial positions in large corporations did not do so through the white-collar-employee route that is now the norm for such companies. These

women managers may be located in traditionally female occupations such as nursing or working as telephone operators or in businesses connected with women's apparel, from which it is possible to rise to mid-level supervisory positions. Another possibility is that some large companies in domestic product areas may have grown from small and medium-sized enterprises during the past three decades, promoting some long-term female employees in the process.

A second conclusion that may be drawn from these findings is that women who have achieved managerial rank in large corporations have done so after long service to the company, largely at the expense of marriage and motherhood. This is consistent with the inference that women in management may be located primarily in traditionally female occupations. In contrast to the usual pattern of female employment in large companies, such occupations provide an alternative to the long-term economic security of marriage, and eventually reward the competent and experienced unmarried employee with some opportunity for promotion. The general absence of married women with children among the ranks of corporate management also attests to the management culture barriers discussed earlier.

Takagi and Nakamura [12] conducted a questionnaire study, for the Japanese Association of Women Executives (JAWE), that included 66 women in positions ranging from section chief to corporate officer. Over half the women in the study were from corporations having more than a thousand employees. Two-thirds were college graduates, and another 13 percent were junior-college graduates. The average age of the managers was 45. Slightly over one-half of the women in the JAWE study were married, and the great majority of those (86%) had children. Three-fourths reported that their husbands were quite cooperative about their work [12. P. 19].

These results differ considerably from the Prime Minister's Office survey. The JAWE study sample included relatively more women with high managerial rank, and their mean age was younger; but it also included managers in smaller companies. The differences may be an artifact of the sample, or they may reflect future trends.

Several other recent studies of women managers in small and medium-size companies report results similar to the JAWE study [10,11,13]. The picture that emerges from these various studies is that women managers are generally not highly educated, although college training seems increasingly to be the norm. Among women who work their way up from employee to managerial status, those with appropri-

ate professional qualifications can be promoted to central managerial posts, but women without qualifications rarely rise higher than chief of a secretarial or accounting section.

Women managers in small and medium-size enterprises are more likely to be married and have children, although the possibility of combined roles may be increasing in larger firms as well. Women in management appear to come from families that encourage women to work and study. A substantial minority have working mothers as role models. Their fathers tend to be in professional or managerial occupations that offer role models for their daughters, and also possibly the capital to help realize their ambitions.

Career paths of women managers

Using life history interviewing methods, Nohata [14] found a variety of career patterns among Japanese women managers. This supports the view that women achieve managerial positions by working around the dominant male career pattern, rather than competing within it. American studies have also found that women often take routes different from those of men to achieve the same managerial positions.

The JAWE study did not trace career paths directly, but the survey results provide some indication of women managers' experiences and attitudes. Although only about half reported that becoming a manager had been an important goal for them, the overwhelming majority (87%) found it advantageous to be one. About a third of them had decided while they were still students that they would continue working. Another 16.7 percent decided after they began to work, but 28.8 percent decided only after they had discovered how interesting the work was. Over ninety percent had decided to continue working before they married or had a child [12. P. 18]. These findings suggest that the women achieved managerial status because of special ability and circumstance, unlike Japanaese men, who are directed toward such careers from childhood.

The women managers believed firmly that there was no difference in ability between male and female managers, but that women were at a disadvantage in the world of business. They agreed overwhelmingly that being able to handle male–female issues in business cleverly was an essential skill for women managers. Over two-thirds reported that there were many people available to help them in their careers, suggesting that these women had been able to acquire a network of patrons and

allies just as male managers do [12. Pp. 20–21].

Almost half of the women managers had changed jobs at some point in the past. Furthermore, only half said they were willing to transfer to a different office if their job required it [12. P. 19]. Their unwillingness to make internal transfers coincides with the general policy of large companies not to transfer women, but the record suggests these women may have resolved the problem in the past by changing jobs. Such flexibility about leaving an employer works to women's disadvantage in the largest companies, but may open up opportunities for them in smaller firms that can use their experience.

If effective career strategies for women within larger corporations remain murky, the picture is somewhat clearer and easier to evaluate for women who are actually running or heading smaller firms. The heads of Japanese companies are customarily divided into three types: founders, relatives of founders, or employees who have worked their way up. This categorization reflects the traditional family-enterprise orientation of Japanese society. Founders are generally characterized as dynamic and aggressive entrepreneurs who maintain firm personal control over the enterprise; successors tend to rely more heavily on staff; employees who work their way up tend to have a more bureaucratic, team-oriented, managerial style.

A Keio research group found that each of these three categories required further specification in order to reflect the actual career paths of women who inherited family businesses or began their own with prior managerial experience ranging from zero to years of full partnership. Older women were more likely to have been thrust into a managerial role by circumstances, whereas younger women were more likely to have achieved it by the accumulation of relevant experiences. The study also found that women managers placed more value on realization of their ideals and self-actualization than on social and monetary success. They were therefore more likely to maintain their enterprise at an appropriate size with a good rate of profit rather than risk expansion [10].

Women managers were not necessarily supportive of increased opportunity for other women. Many women managers in their late fifties or older did not treat female employees as they treated male employees, and they often imposed the same constraints on female employees as the large corporations do. Regardless of age, women managers made heavy use of middle-aged, part-time, female workers [10. Pp. 82–100].

Most women founders in the Esso-sponsored study by Komatsu [11] said they would appoint women to managerial posts the same as men, and would consider appointing a woman to succeed them. Successors, on the other hand, said they would consider appointing women only to certain areas of work. Attitudes toward managerial posts for women also varied sharply by industry, support for women's advancement being more common among presidents of service and retail businesses, and more-negative attitudes toward women prevailing in manufacturing. Opinion was also sharply divided by age, younger women presidents favoring managerial opportunities for women, and women over 55 being sharply opposed [15. P. 5].

Although the distinction in attitudes between founders and successors could be interpreted as an indication that attitudes toward women in management become more discriminatory as a company matures, generational differences must be taken into account, since in both studies women successors tended to be older than women founders. Women under fifty who were educated in the postwar era have fundamentally different attitudes toward women's achievement, which are less likely to change as they grow older, or as the companies they manage mature. It seems highly unlikely that the next generation of women successors will be as conservative as the present one.

Prospects for the future

There is some indication that large companies are beginning to offer more promotion opportunities to women. In a recent study, primarily of companies listed on the stock exchange, 64 percent said they would promote women college graduates if they had the same abilities as men. The larger the company, the greater the professed support for promotion of qualified women. When asked what they thought of the current trend for women to work for a longer period of time, 84 percent of the companies said it was acceptable if the woman was strongly motivated; but only 6 percent of the companies found the trend desirable [16]. The distinction implied here between broad support for the unusually motivated career woman and continuing resistance to offering career opportunities to all women is reflected in a recent proposal by a committee of the Kantō Managers Association. Charged with formulating a response to the new Equal Opportunity Law, the committee suggested that companies create a two-track system that would offer promotion opportunities to highly qualified and motivated women, but leave intact the present system of high turnover positions for most women. The com-

mittee said it was not economically feasible for companies to offer management training opportunities to all women employees.[3]

Overall, the studies reviewed here suggest that opportunities for women in management are likely to increase in the future, but not as rapidly in the large corporations, from which women are currently most sharply excluded. For a very limited number of unusually qualified women, opportunities may expand; but women who seek careers in large bureaucracies probably will continue to find somewhat more opportunity for advancement in the public sector.[4]

Small and medium-size enterprises, in which three-quarters of all women are employed, represent a dynamic growth area for women with managerial ambitions. Because there is greater job mobility in these smaller-scale enterprises, there may be considerable movement into such firms by women with previous experience in large corporations. This would include both women who leave to start their own firms and women who are hired by existing firms because of their skills and experience.

As more educated women with work experience either remain in the labor force through the childbearing years or return after only a few years' absence, cultural images of the working married woman are likely to change, as they have elsewhere. The middle-class status symbol of a nonworking wife, a relatively recent, postwar addition to Japanese culture, already shows signs of decline.

The proportion of new women employees who seek promotion has more than doubled in the past two years, from 12.5 percent in 1984 to 28.4 percent in 1986.[5] In the same two years, there have appeared two new magazines aimed at Japanese career-oriented women. Whether such women will find an environment in which to realize their desires is problematic, as sex roles are now in transition in Japan.

The owners of small family businesses in Japan now encourage their sons to get a higher education and to move into the more prestigious world of the white-collar "salaryman." Fewer expect that their children will take over the family firm, with its traditional pattern of participation by the wife. The same families also envision their daughters as the nonworking wives of salaried employees. Thus, the middle-class pattern of the white-collar "salaryman" with his nonworking wife remains a cultural ideal of upward mobility for the children of small-business families, although most will not make it into the large corporations.

At the same time, there is increasing evidence that nonworking, middle-class housewives married to "salarymen" now encourage their

daughters to prepare for careers outside the home. It is not at all clear, however, that the same mothers are rearing their sons to accommodate a wife with a career. To the extent that the Japanese corporate world continues to freeze women out of managerial positions and to expect that a male manager will have a nonworking wife as a personal support system, these differing parental encouragements point toward both domestic and workplace conflict in the future.

Much of this potential for conflict is likely to be defused, however, by the dynamism and fluidity of the small and medium-size enterprise sector. Despite long-standing predictions, this sector does not seem to be decreasing in size or significance in the Japanese economy. Moreover, despite the elitism of the Japanese education system and large corporations, a great deal of talent still flows into small and medium-size enterprises. If that is the sector that accommodates women's growing career aspirations, still more talent will find its way there.

In sum, the future appears to offer increasing opportunities for women in management in Japan, but there will still be some glaring blank spots. Ambitious young Japanese women will have to seek out opportunities for advancement shrewdly, and pick their mates carefully.

Acknowledgments

The authors wish to thank Fumiko Tsukada for research assistance, and the Japan Endowment Fund, University of Hawaii, for making that assistance possible.

Notes

1. Kazuko Tanaka (1976) "Female Labor Force Participation in Japan." Unpublished paper, University of Hawaii.
2. P. G. Steinhoff (1983) Unpublished data.
3. Kantō Managers Association (1986) "Danjo Koyō Kikai Kintō Hō to Kore Kara no Koyō Kanri no Hōkō" [The Equal Employment Opportunity Law and the Future Direction of Employee Management]. Tokyo: Kantō Managers Association.
4. For Japanese women with good foreign-language skills, there may be more opportunity for advancement in foreign companies. No data on this are available, however, and this sector remains a very small part of the overall employment picture.
5. Taiyō Kōbe Bank Management Consulting Office (1986) "Mō Sugu Shakaijin: Shinnyū Shain no Ishiki Chōsa" [Soon They'll Be Full Members of Society: Attitude Survey of New Employees]. Kobe: Taiyō Kōbe Bank Management Consulting Office.

References

1. Women's Bureau (1986) *Fujin Rōdō no Jitsujō* [The Actual Condition of Women Workers, 1986]. Tokyo: Printing Office, Ministry of Finance.
2. Saxonhouse, G. (1976) "Country Girls and Communication among

Competitors in the Japanese Cotton-spinning Industry.'' In H. Patrick (Ed.), *Japanese Industrialization and Its Social Consequences*. Berkeley, CA: University of California Press.

3. Coleman, S. (1983) *Family Planning in Japanese Society; Traditional Birth Control in a Modern Urban Culture*. Princeton, NJ: Princeton University Press.

4. Vogel, E. (1968) *Japan's New Middle Class*. Berkeley, CA: University of California Press.

5. Sugawara, M. (1985) "Josei Kanrishoku no Hikari to Kage" [Light and Shadows of Women Managers]. In H. Hara and A. Sugiyama (Eds.), *Hataraku Onnatachi no Jidai* [Working Women's Era]. Tokyo: Nihon Hōsōshuppankyō-kai.

6. Labor Administration Research Institute (1986) *Danjo Koyō Kikai Kintō Hō ni Taisuru Kigyō no Taiō Jōkyō o Miru* [A Look at How Enterprises Have Responded to the Equal Employment Opportunity Law]. Tokyo: Labor Administration Research Institute.

7. Women's Bureau (1984) *Joshi Rōdōsha no Koyōkanri ni Kansuru Chōsa* [Research on Employment Management of Women Workers]. Tokyo: Women's Bureau.

8. Prime Minister's Office, Women's Section (1979) *Fujin no Hōshinketteisanka jōkyōchōsa Hōkokusho* [Report of Research on the Conditions of Women's Participation in Decision Making]. Tokyo: Prime Minister's Office.

9. Prime Minister's Office, Women's Section (1981) *Fujin no Hōshinketteisanka jōkyōchōsa Hōkokusho (Kaisha igai no hōjin, hōjin de nai dantai)* [Report of Research on the Conditions of Women's Participation in Decision Making (Corporations Other than Companies, and Unincorporated Associations)]. Tokyo: Prime Minister's Office.

10. Iwao, S., Hara, H., and Muramatsu, Y. (1982) "Chūshōkigyō ni okeru Josei Keieisha no Seichōreki Seikatsu Keieikan—Tonai 42 sha (42 mei) no Mensetsuchōsa ni motozuku Jireikenkyū" [The Career, Living Conditions, and Management Attitudes of Women Managers in Small and Medium-sized Enterprises—Research Based on Interviews with 42 Companies (42 Persons) in Tokyo]. *Soshiki kōdō kenkyū, 9,* 1–120.

11. Komatsu, M. (1986) "Joseishachō wa Kigyō Shakai wo kō kaeru" [Women Presidents—How They Are Changing Industry and Society]. *Shūkan Diamond,* 11 February, pp. 82–87.

12. Takagi, H., and Nakamura, N. (1986) *Joseikanrishoku no Yaruki to Nōryoku soshite Shinshutsu* [Women Managers' Desires, Talent, and Advancement]. Tokyo: Japanese Association of Women Executives.

13. Hirano, T. (1981) "Josei no Shokugyo Keisei to Kankyō" [The Structure and Circumstances of Women's Work]. *Musashino Joshidaigaku Kiyō, 16,* 59–74.

14. Nohata, M. (1986) "Joseiyakushokusha no Career Keiseikatei to Soku-shinshoyōin." [Factors and Process of Career Formation of Managerial Women]. *Shakaigaku Hyoron, 34,* 438–56.

15. Komatsu, M. (1984) "Joseikeieisha no Ningenzō—Sogyōsha no Seishindojō wo Saguru" [A Human Picture of Women Managers—Searching for the Spirit of Founders]. *Josei no tame no Esso Kenkyū shōreiseido Kenkyūhōkokushū Esso Sekiyu Kabushikigaisha, 3,* 3–6.

16. Japan Manpower Administration Research Institute (1986) *Shōrai Arubeki Jinji Kanri wo Kangaeru tame no Kiso Chōsa 1985* [1985 Research for Consideration of Desirable Manpower Management in the Future]. Tokyo: Japan Manpower Administration Research Institute.

7

Jean R. Renshaw

Women in Management in the Pacific Islands: Exploring Pacific Stereotypes

> It is in the Pacific and East Asia where we will see things
> happening in the next century, because the next century will be the
> "Century of the Pacific."
> —Mike Mansfield, U.S. Ambassador to Japan,
> in a speech before the Japan-American Society,
> Hawaii, January 1986

*International economics, international business, and government policy are
bringing the Pacific to the forefront of public affairs. The 21st century has been
called the "Pacific Century." Unfortunately, many people know little about
the Pacific region. This chapter provides a brief description of characteristics
of that region and explores its stereotypes of the role of women in management.
Data from the island nation of Fiji are used to illustrate social, economic, and
cultural factors affecting women's participation in management, leadership,
and decision making in the Pacific islands.*

Not only futurists but a growing number of business and political
leaders are turning their attention to the nations of the Pacific. The 21st
century is likely to see a profound shift in emphasis from the Atlantic
(Europe) to the Pacific. The term *Pacific drift* has been used to indicate
this shift in focus. The Pacific is also where more than half the world's
people live. It is the world's most rapidly growing and dynamic eco-
nomic region. The United States now does more business with Pacific
than with Atlantic nations. Headlines about the U.S. trade deficit, the
economic resurgence of Japan and Korea, and the reentry of China into

world markets contribute to increased international awareness of the Pacific.

The analysis presented here of the emerging role of women in management in the New Pacific will be limited to the Island Pacific, data from the nation of Fiji being used to illustrate the dynamics of change and development in the emerging nations of the region. Trends and factors contributing to women's increasing participation in management and decision making will be examined, and the intertwined nature of physical, sociological, and psychological factors will be considered.

The term *Pacific* has different meanings depending upon one's perspective. In Australia, the Pacific may refer to New Zealand, Australia, and the islands of the South Pacific; for a New Yorker, it may mean Hawaii, Japan, and perhaps Korea and China. Some terms commonly used to describe different groupings of nations within the Pacific/Asia region are Pacific Rim, Pacific Basin, and Insular or Island Pacific. *Pacific Rim* refers to the large continental land masses and nations defining the ocean's perimeters; these include the United States, Australia, South and Central America, Canada, Japan, Korea, China, etc. The *Insular Pacific*, or the *Island Pacific*, denotes the islands within that perimeter, the geographic focus of this paper. The term *Pacific Basin* is vague, and is commonly used for both Pacific Rim and/or Island Pacific.

The area encompassed by the Pacific Ocean is greater than all of the world's land areas combined, occupying one-third of the globe's surface. Within the Pacific region there are about 25,000 islands, comprising only a little more than 1 million square miles, but set in a sea area of over 55 million square miles, including vast distances with no land areas. By continental standards, the island nations are small, in both physical size and population, and have in common the problems of isolation and smallness, which include limited resources and difficulties in transportation and communication. The total population of this vast area is 4.8 million. The State of Hawaii has a population of about 965,000, which is 150 percent greater than the population of the second largest nation, Fiji (619,000). The largest nation, Papua New Guinea, has a population of almost three million.

The prehistoric migrations and settlements of the islands are thought to have been from Asia, when the land masses were closer together. By some 40,000 to 50,000 years ago, populations of hunters and gatherers had managed to reach Australia and New Guinea from southeast Asia. The cultures developed in each of the islands, made possible by the

relative isolation of the islands once they were settled, are rich, complex, and varied. The Pacific region can be divided into three main cultural areas: Melanesia, Polynesia, and Micronesia. There are distinct cultural, linguistic, and racial differences among them; and their traditional views of gender roles, status, and power continue to influence women's present-day ability to move into positions of management and decision making.

Melanesia, the "black islands," from the word *melanin*, the dark pigmentation of the skin, includes the islands of New Guinea, the Solomons, New Caledonia, and Vanuatu. Fiji, because of the diversity of its islands, can be considered either Melanesian or Polynesian, some of the islands having been settled by Polynesians and others by Melanesians. Fiji uses this flexibility to its advantage when regional political groupings are being formed. In Melanesia, the ruggedness of the terrain has kept people separated into smaller groups, and land has played less of a role in determining social position than is the case in other societies. Leaders, or chiefs, in Melanesian cultures are literally called "big *men*," and their status is achieved rather than inherited. These cultures tend to define status by achievement in ways that exclude women.

Micronesia, the "tiny islands," lies north of Melanesia; it includes more than 2,000 islands, which are mostly atoll formations. Polynesia, meaning "many islands," covers the largest geographic area, with the greatest distances between islands; it extends from Hawaii, in the north, to Easter Island, in the southeast, and New Zealand, in the southwest.

In Polynesian and Micronesian societies, status and land are related to birth. Polynesian societies generally are organized around bilateral descent and primogeniture: descent is traced back to a founding ancestor, and the first-born child, whether a boy or a girl, has the highest rank in the family. The genealogies, which are transmitted through oral tradition, are traced through the ancestor of highest rank, whether male or female, in each generation. Status in Micronesian society is also inherited, but is passed through the mother to the eldest male child.

Although the traditional inheritance of status and land has become diluted, deeply held beliefs associated with traditions still influence these societies. The roles of women in a given culture today reflect these traditional status attributions, i.e., whether the status of chief is given to males and females, only to males, through the father, or to males through the mother. In Fiji, for example, the chief's line normal-

ly passes to the first born, whether male or female. The chiefly system is still strong in Fiji and influences the ability of Fijian women to become managers and leaders.

Later influences came from Western colonizing nations, including Spain and Portugal, the Netherlands, England, France, and the United States. With the numerous external cultural influences came a blurring of traditional cultural lines, but they are still operative in most of the island nations. In terms of gender roles, some women from Micronesian and Polynesian cultures maintain that the Western influence, with its patriarchal systems in religion and government, has contributed to a decrease in the status of women.

The nations of the South Pacific are developing countries, many of them just beginning to evolve from subsistence economies. All are recently independent nations engaged in establishing governments and economies to support their people, and most of them are dependent on development assistance for survival.

Women in management in the Pacific

Pacific nations vary widely in the participation of women in employment and in management. The variables have some relationship to the traditional cultures found in each country, the values of the colonizing nations, and current social and economic conditions. As noted above, Melanesian countries have different expectations with regard to gender roles than the Polynesian and Micronesian countries, Melanesian women having traditionally derived their status or rank from men whereas Polynesian and Micronesian women have had varying degrees of direct access to status and land. This is, of course, one of the variables affecting women's movement into management.

The limited resources and relatively small size of the Pacific nations mean that effective use of all resources is extremely important. Women are an important and underutilized resource throughout the Pacific region.

Table 1 indicates labor-force participation and the percentage of women in major occupational groups in the island nations of the Pacific; the United States is included for comparison. As with all such data, one must be careful in drawing conclusions. For example, the category "administrative and managerial" usually, but not always, includes women in secretarial positions in this Pacific region; in reality, there are very few women in managerial roles. The professional, technical,

Table 1

Female Labor-force Participation: South Pacific Nations and the United States

	Census year	Number of adult females	Number in labor force	Partici- pation rate, %	Major occupational groups containing more than 20% of the female labor force
Micronesia					
Guam	1970	21,311	6,867	32	Professional, technical, and related workers; clerical
Trust Territory of the Pacific Islands (New nations of Micronesia)	1970	23,810	3,042	13	Professional, technical, and related workers; clerical, service
Polynesia					
American Samoa	1970	7,075	1,854	26	Professional, technical, and related workers; production and related workers
Cook Island	1976	4,498	1,424	32	Professional, technical, and related workers; production and related workers
French Polynesia	1977	36,928	12,310	33	Clerical; service (sports, entertainment, etc.)
Kiribati	1978	17,188	1,420	8	Commerce; community services
New Caledonia	1976	38,637	15,818	41	Agricultural and related workers

Niue	1976	1,082	278	26	Professional, technical, and related workers; production and related workers
Tonga	1976	21,446	3,042	13	Professional, technical, and related workers
Tuvalu	1979	3,025	2,565	85	Professional, technical, and related workers; clerical (cash economy workers only)
Wallis and Futuna	1968	2,416	2,008	83	Agricultural and related workers
Western Samoa	1976	38,438	6,336	16	Agricultural and related workers
Melanesia					
Fiji	1976	172,055	29,470	17	Professional, technical, and related workers; agricultural and related workers
Papua New Guinea	1971	785,318	161,947	21	Agricultural and related workers (including farmers and plantation workers)
Solomon Islands	1976	48,777	3,803	8	Professional, technical, and related workers; agricultural and related workers
Vanuatu	1972	4,101	1,980	48	Service
United States	1984	93,000,000	50,000,000	54	Managerial and professional specialties; technical, sales, and administrative support
Hawaii	1980	347,000	198,000	57	Service

Source: Development Studies Centre, The Australian National University, Canberra (1985) *Women in Development in the South Pacific.* U.S. Department of Labor, Office of the Secretary, Women's Bureau, July 1985, *The UN Decade for Women, 1976-1985: Employment in the United States.*

and related category includes teachers, most of whom in the elementary and secondary schools are women.

The developing nations, at least nominally, recognize their need to use the talents of women as an important resource. All of them have made some public commitment to this goal, but action toward this end is largely lacking. Fiji's Development Plan, 1981–1985, recommends the establishment of "women's interest officers" in the villages to implement social and economic development plans. Other countries have made varying degrees of public commitment to the goal of utilizing women; some have minimally mentioned women only in the country's Action Plan for the United Nations International Year for Women.

Because of their traditional cultural roles, women bring different and important perspectives to management and decision-making processes, and it is vital for women to be involved in those processes in the Pacific. In all Pacific island countries, women traditionally have had responsibility for the home and family, often including growing food to feed the family. These family-centered responsibilities frequently expand to include village and community responsibilities—for example, when women recognize the need and press for a new village well to improve community life and health.

In the 1960s, the development literature began to refer to the importance of women in the development and management process and pointed out their neglect by development planners. Boserup's book *Women's Role in Economic Development* (1970) set forth many of the issues and consequences of neglecting women's roles. The 1970s were a time for reports and recommendations on how to integrate women into the management and development process. (See the United Nations Development Program's long list of such reports, including "Guidelines on the Integration of Women in Development" [1977].) Study groups at all levels examined and reported on the relevant problems; their work culminated in the International Decade for Women.

The 1980s may be the decade for action—a time for women to move beyond the sex-role stereotyping that has prevented them from participating fully in the development of their families, communities, nation—and their own lives. The South Pacific Commission, the oldest regional forum in the Pacific, met in 1980 to consider the needs of women in the South Pacific, but no women had been invited to the deliberations. The women of Papua New Guinea, where the meetings were being held, insisted that they be allowed to speak. Their input changed the deliberations, forcing the participants to include more

issues of actual concern to women and families.

Even the smallest nations must face global issues. South Pacific women, because of nuclear testing and the dumping of nuclear waste in the Pacific, are very aware of the dangers of nuclear pollution and the proliferation of nuclear waste. They have deep concerns about the meaning and direction of "development" in their countries; but many constraints prevent their full participation in decision making concerning ways of improving the lives of their families, villages, and nations.

The nation of Fiji

Fiji, a pivotal nation in the Pacific region, is one of the oldest independent nations in the Pacific (1970). The location of the regional university, the University of the South Pacific, in its capital, Suva, makes Fiji an educational center for English-speaking nations, and has attracted other regional businesses and government agencies, such as the United Nations, the South Pacific Commission's Community Education and Training Centre, the South Pacific Economic Commission, and the American Embassy for the Pacific islands region. Its gross development product per person ($941) is the highest among the independent Pacific nations, as is its literacy rate, estimated in 1978 at 79 percent. In 1981, 95 percent of children aged 6 to 13 in Fiji were in school.

Britain left an ethnic legacy of Indian citizens in Fiji. Indians were brought to work on the plantations, and now outnumber the native Fijians: 50 percent of Fiji's population are Indians; 44 percent, Fijians; 4 percent, Europeans, Chinese, or people of part-European ancestry; and 2 percent, other Pacific Islanders. Only the native Fijians are called "Fijian"; the others are referred to as "citizens of Fiji." Fiji's total population is scattered among approximately 330 islands, ranging in size from 10,000 square kilometers for the main island of Viti Levu, where the capital city of Suva is located, to tiny islets a few meters in circumference.

The first and most important function of women in Fiji is to bear and rear children, and children are loved by all. Fijian women have a history of being educated; current school enrollments at the primary and secondary levels show roughly equal participation by boys and girls. Although women have an important role in Fijian culture, are physically and psychologically powerful, and are valued by their culture, they are not encouraged to participate actively in spheres outside the traditional ones of home and family.

From its Polynesian roots, Fiji has a system of hereditary high chiefs. The chiefs trace their descent from the Polynesians' arrival in the islands, which they estimate to be about eleven generations ago. Important for women in management is the fact that both male and female children inherit the rank of chief. *Ratu* is the male term for chief, and *Adi*, the female one. The mother's rank as chief is the determining one if hers is the higher. A proportion of the national governing senate is, at the present time, reserved for the council of chiefs. The prime minister, Ratu Mara, holds the rank of chief, as does his wife, Adi Lala, and apparently her rank is higher than his—an interesting dilemma.

The important social units are the family, the clan, or *mataqali*, and the village, for which one chief has responsibility. For native Fijians, their village of origin is important throughout their lives; when they move to a city, they maintain ties with their villages. Even those who have lived all their lives in the city have strong roots and ties in their village. Important decisions for individuals, families, and the nation are subjects for the village council; and although younger Fijians may rebel against them, the decisions of the councils are still influential in decision making.

A Fijian's responsibility to the family seems almost limitless. A system of *kerikeri*, in which ''what's yours is mine'' when a family member is in need, prevails.

In terms of employment outside the home, women constitute a small percentage of the paid work force throughout the Island Pacific (see Tables 2 and 3). With the exception of the tiny islands of Tuvalu, Wallis, and Futuna, an average of 24 percent of women in all the Pacific islands work in paid labor. The participation rate in Fiji is about 17 percent. (Again, it is necessary to be cautious about statistics and their meaning, but for Fiji, the figure of 17 percent of women in paid employment is consistent with United Nations and Fiji Development Plan data.) However, the percentage of administrative and managerial positions held by women in Fiji is less than one percent. The percentage of women both in paid employment and in management has increased steadily since independence. It is important to bear in mind that Fijian men, because they lived under colonial rule, were not a part of the governing body, or of top management, before independence, and that they are now reluctant to share their newly gained power with women.

Management training and education provide one indicator of the pool of women moving from lower levels into management. When I

Table 2 Females as a Percentage of the Workers in Major Occupational Groups

Country	Census year	Professional, technical, and related workers	Administrative and managerial	Clerical	Sales	Service	Agricultural, forestry, fishery, and related workers	Production, transport, equipment operators, laborers, and related workers	Workers not classified	All workers
American Samoa	1970	42	17	52	67	49	14	28	0	36
Cook Islands	1976	43	13	47	52	42	1	22	44	28
Fiji	1976	38	8	40	23	45	9	2	32	17
French Polynesia	1977	44	7	55	49	68	11	6	17	29
Guam	1970	46	20	64	65	43	12	5	0	31
Kiribati	1979	36	1	37	30	31	2	3	50	21
New Caledonia	1976	48	6	58	50	29	41	7	13	34
Niue	1976	48	4	36	42	47	21	13	42	29
Papua New Guinea	1971	29	7	38	25	24	39	6	36	31
Solomon Islands	1976	23	4	20	15	25	22	4	8	17
Tonga	1976	37	——— 34 ———	*	47	17	1	5	46	16
Trust Territory of the Pacific Islands	1970	22	13	49	62	40	20	6	0	23
Tuvalu	1979	49	13	47	51	40	3	0	0	29
Vanuatu	1972	38	2	47	49	79	16	2	8	28
Wallis and Futuna	1969	0	——— 57 ———	31	*	54	6	12	53	
Western Samoa	1976	48	11	40	53	51	7	6	42	17
United States	1984	49	34	80	48	61	15	26	0	44

Source: Development Studies Centre, The Australian National University, *Women in Development in the South Pacific*, August 1984; U.S. Department of Labor, Bureau of Labor Statistics, 1984.
*Aggregated in source.

Table 3

Employment in Fiji: Distribution by Sex and Occupational Type

	Total	Females	
		Number	%
Total economically active	175,473	29,460	17
Occupational classification			
Professional, technical, and related workers	12,649	4,772	38
Administrative, managerial	1,656	127	8
Clerical and related workers	11,452	4,556	40
Sales workers	9,222	2,098	23
Service workers	11,429	5,126	45
Agricultural, animal husbandry, and forestry workers and fishermen	76,144	6,595	9
Production and related workers, transport, equipment operators, and laborers	38,680	1,701	4
Workers not classifiable by occupation, unemployed	14,241	4,485	31

Source: Government of Fiji 1976 Census Report.

was a lecturer and consultant at the University of the South Pacific in 1981–1982, only one or two women participated in workshops for senior managers. At less-senior levels of training, there were more women. My observations are substantiated by data from the Fiji National Training Council, whose senior executive seminars had no women participants; and only 4 of 52 participants (8 percent) in seminars for middle management, and 9 of 129 participants (7 percent) in seminars for supervisors were women. But the number of women in mid-level management training is slowly increasing, and more women undergraduates are enrolling in "administrative" subjects at the university.

Enrollment at the University of the South Pacific in 1968, its first year, was 154 students, of whom 31 (20 percent) were women. In 1981, the total enrollment was 1,690 and included 598 women (35 percent). A cadre of women with management training is developing. The pressure to find appropriate career positions that will allow advancement of these bright, capable, ambitious women is beginning to be felt as more of them reach middle management.

Successful women in the Pacific Islands

> I think that women may at times shy away from trying to be a success in their field. It's because they feel that it is the men's domain and probably not in keeping with the view of what a woman should be. There are so many historic, socioeconomic, and cultural factors that restrict women from being a success. Anyway, a woman being a success is often seen as someone who is a deviant—too intelligent, too masculine, too religious, etc. (Excerpt from an interview with a South Pacific woman leader, Suva, Fiji, 1981)

Even in societies in which public achievement and management roles are not encouraged for women, some women do "make it," as illustrated vividly by the Pacific island nations.

Let us look at a sample of South Pacific women who have successfully made a place for themselves in management, in either commerce, government, education, or voluntary organizations. From their experiences, examination of their career paths, and an assessment of the factors that have contributed to or impeded their progress, we may discover ways in which other women may be helped to advance to positions as managers and leaders. The research builds on data from Fiji on barriers and opportunities for women in management in the Pacific region, and it raises questions for further study.

The criteria of success for including women in this research came from within the culture. The women in the sample were nominated by at least two people as being "successful" or "achieving." These nominations came from a variety of sources in business, journalism, the university, and government. Table 3 shows a total of 127 women in administration and management in Fiji. If one assumes that fewer than half of these were Fijian, given the population mix, then that leaves a total population of Fijian women managers of about 60—hence, all are known. Nominations of 20 women came from at least two different sources; and of these, 18 agreed to participate in the research, which required a substantial commitment of time from very busy women. One of the two who declined to participate left for advanced training in Australia, and the other had an illness in her extended family.

The sample of 18 women provided rich data, which were augmented by reading, discussion, and observation. A great variety of sources proved useful, among them seminars with high-school students and a national workshop for principals during my original sojourn in Fiji. Subsequent trips throughout the region, attendance at Pacific regional

women's meetings, seminars in New Zealand and Australia, and later visits to Fiji provided further insights.

The women interviewed ranged in age from 26 to 70 years, and in occupations, from personnel manager for a multinational company to a regional village youth worker, and from a physicist, who later became a senior government civil servant, to the owner/manager of a combination restaurant and small art gallery. Three were in business, seven in education, five in government, and three in international organizations. The roles of the seven in education varied from teacher/trainer to a lawyer serving in university administration, a university lecturer, and the principal of an elementary school. The oldest woman, who was 70, was a retired teacher who continued to work with both young and old in her capacity as president of an international women's organization. She traveled widely and frequently, keeping so busy that it was difficult for her to schedule time for an interview.

Although all the women had homes within the general area of Suva, the capital city, they all told me about their villages, indicating their strong bonds and roots therein. Only two were originally from the same village.

At the time of the research, 11 of the women were married, 4, separated, and 3, single. Being single is not as uncommon for women in Fiji as one might imagine. Most women do marry, but identification with the family and village make it possible for an unmarried woman to lead a full life. All of the extended family or clan share and enjoy responsibility for the care of children. The married women in the sample had an average of three children; one woman had seven, four had four, and two had no children. Among the women who were separated, two had no children, one had one child, and one had four children. The families of origin of the women had an average of six children, indicating that family size may be decreasing, a finding corroborated by United Nations data.

When asked to comment on women and success, all but two of the women mentioned the family and being able to provide for it as an important measure of success. "Provide for" meant not only financial support but also education, including instilling in the young a sense of responsibility for the village and broader community. All but one included support by their families as an important contribution to their success; this did not necessarily mean just a supportive husband, but included a broader definition of family aid, encompassing early parental and sibling support and later child care, support, and affirmation

from their extended families.

As previously noted, women's role in Fiji is centered on the family and home. Publicly successful women are deviants, in the sociological sense of not conforming to the accepted norms of behavior. All the women in this sample are achieving outside the home in addition to within the domestic sphere, and to that extent, they are deviant. The woman quoted at the beginning of this section recognized this very well.

The fundamental question is what has made these women capable of tolerating this state of deviance and successfully moving into new areas. Three common factors emerged from the research as contributing to their ability to transcend the society's traditional sex-role strictures: (*1*) membership in the chiefly class; (*2*) descent from mixed racial groups, i.e., Fijian and some other race in their ancestry; and (*3*) religious affiliation and beliefs. Each of the women had at least one of these factors operating in her life, and several had two.

The chiefly class

Being born into a family of chiefs has many implications for a child in Fiji. It does not mean that the child is isolated from other children: the village children all play together. But it is clear, very early, that certain behaviors and responsibilities are expected of children whose families rank as chiefs. Moreover, as one of the women said, girls in such families are sometimes protected from some of the negative conditioning of female children. For example, it is customary in the villages for women and children to wait to eat until the men have finished. This particular woman spent much of her childhood in the village with her grandparents, and she always ate with her grandfather, the *Ratu*, and therefore never learned that girls usually came second. Her grandfather discussed village concerns and issues with her at the dinner table; and she, as the eldest of 13 children, knew very early that family and village decisions were important group concerns for which she would some day have responsibility. All the children would have responsibilities for the family and the village; but as the eldest girl, she would have the most responsibility for the family. The eldest sister is the arbitrator for children's issues before they are brought to others, and throughout life is the person who first listens to family concerns.

Chiefly class and royalty are strange concepts to Americans, whose heritage includes rebellion against class and inherited status. However,

the values of the chiefly class, which children are taught and which form an important part of their early socialization, offer important elements of success. These values include: (*1*) leadership; (*2*) responsibility; (*3*) humility, as opposed to arrogance; (*4*) resourcefulness; (*5*) ability to communicate with and, especially, to listen as people bring their problems; and (*6*) honesty.

As the women discussed these values, it became clear that both males and females in the chiefly families are socialized to recognize their leadership role. They have a responsibility to take care of the members of their family and their village. They must be able to listen well to the problems of their people and communicate their understanding to others when necessary. They must learn to be resourceful as well as responsible. At its best, this is ideal conditioning and education for leadership, with its incumbent responsibilities, abilities, and duties. Many of the women in this sample received early socialization and education of this kind.

The conditioning was most powerful when both mother and father were of the chiefly class. Mothers tended to enforce the values most strongly. Several women commented that they felt these values were changing and being lost in the modern world. But for each of the women interviewed, these principles had been an important part of her socialization; one said that the precepts were "drilled into children from their earliest memory."

With this socialization, it is not surprising that these women, as adults, do what needs to be done, even if it includes nonconformity to the sex-role stereotypes of domesticity. Their feelings of responsibility require them to respond to observed needs, and their conditioning as leaders means that they assume that they not only can but must make things happen. This chiefly conditioning is extremely powerful because it is built into the very framework of the culture. Management training courses attempt to instill in managers many of the same principles, but the process can never compare with such lifelong conditioning, supported by an immediate social group.

Mixed race

Five of the women had a mixed racial heritage, Chinese or European ancestry being combined with Fijian. Three had a non-Fijian parent, and two had grandparents of a different racial origin. As these women described their attitudes toward success and their early socialization, it

became evident that the messages and conditioning they had received from two or more cultures had given them an opportunity to recognize that there was more than one way to arrange one's life; the prevailing social norms and stereotypes could be seen as less controlling and rigid. Like members of the chiefly class, their marginality gave them an expanded perspective.

Combined with this recognition of other values was an urge to prove themselves as good as, or better than, people of the prevailing culture. In the colonial era, a concomitant of mixed ancestry was often access to more than one educational system. In each of these women the non-Fijian, or outsider, parent had instilled a strong ethic and a total commitment to the family's "making it." Both boys and girls were expected to uphold the honor of the family. Like chiefly status, the mixed racial heritage mitigated the impact of local cultural norms.

Religion

Four of the women stressed religion as an important factor in their ability to succeed. One described the strength given her by her religious beliefs: "I can do anything through the Christ-Spirit." The conviction that all is possible with the help of God was central to their belief system. Christianity was the Western religion brought to Fiji, starting with the London Missionary Society and Methodist missionaries, and later including the Catholic Church. There were no Buddhists, Hindus, or Jews in the sample, so the generalizations about religion apply only to Christianity. These women received multiple messages about what was acceptable from both the dominant Fijian culture and from their "Western" religion, which allowed them to have alternative perspectives.

Combined with their sense of the possibility of achievement was a strong sense of duty and moral responsibility to care for their fellowman. The word *man* as used in this context was only one indication of the patriarchal nature of the Western religious structure. However, the duty to achieve and to contribute to their society was the stronger message; the belief that they had a moral obligation to do so was more powerful than the sex-role stereotyping of both culture and religion.

Although the women citing religion as a factor in their success were in traditionally feminine fields—education and nursing—they did not hesitate to assume leadership roles in their organizations when they felt it was necessary to achieve their goals. The retired schoolteacher was a

good example of this, as she now exerted influence nationally and internationally. Like those of chiefly status and mixed racial heritage, these women had a self-image that fostered achievement; they assumed that they could accomplish the necessary tasks. They also had opportunities, at an early age, to practice leadership and receive support for their accomplishments in projects for the church and charity.

Conclusions

Having examined the forces in Fijian culture that support women's successful movement into management, leadership, and decision making, let us now consider some implications for the Pacific region and explore possible ways of facilitating the success of other women.

First, it is clear that the broader culture must at least allow for, even though it may not necessarily encourage, the possibility of women in leadership positions. In Fiji, this possibility is strongly supported by a traditional system that confers status and responsibility on both women and men. The current economic picture and scarcity of skilled human resources further help to open new possibilities for women.

Second, individual women must somehow have or acquire a concept of themselves as achievers or leaders. One important factor common to the women in the sample was early socialization that fostered self-confidence and a belief that they could do what needed to be done. This self-confidence was combined with equally strong impressions that they had a duty and a responsibility to use their abilities for the common good. Each had a strong sense of responsibility toward family and community, and this extended to national and international concerns when a relationship to the common good was perceived.

Another important characteristic, a more subtle one, has to do with being able to step slightly outside the powerful prevailing norms of one's own culture and imagine different ways of accomplishing goals. For these successful women, this meant not being completely trapped in the traditional, cultural, sex-role stereotypes, either by being born into a chiefly family or having mixed racial ancestry or a strongly religious socialization. This ability to be slightly outside the cultural norms, or "deviant," must be combined with a sufficiently strong sense of identification with a subgroup, whether it be family, clan, or church, so that, though "deviant," one does not feel cut off from the culture. This was true of each of the women in the sample, for different reasons. A strong membership in, or identification with, accepted

groups—family, village, or church—gave these women external support and a network upon which to draw as they developed the ability to act and achieve.

In addition, all these women had opportunities to observe and practice leadership skills—in their villages, as members of the chiefly family, in the church, in the case of those for whom religion was important, and/or in their home/work setting. The practice of leading and identification with the group reinforced self-confidence, which was crucial as they later encountered resistances.

Each of the women saw family support as important in her success. Their family support, however, did not prevent them from moving beyond the home to achieve in other areas. They were quite aware of their deviance from the accepted norms for women. Successful Pacific women are deviant: they do not fit the accepted norms of the culture. For women in the Pacific to become managers and display leadership, at this period in history, requires both internal strength and external support and encouragement. As the number of successful women managers grows, they will be considered less deviant; for there is strength in numbers, as women worldwide are discovering.

This Pacific research indicates that women's successful movement into management requires education and training that support a self-image of achievement, success, and leadership. In addition to the skills of management, self-confidence and perseverance are essential. Training and opportunities to practice leadership skills are also required. Social networks supporting new roles for women are needed. The women in this sample, in common with women all over the world, said they needed peers and colleagues who understood their dilemmas and with whom they could acquire and share information. Communication and support networks at the local, national, and international levels are vital. Women moving beyond stereotypes into decision-making and leadership roles need colleagues, both male and female, who can help create a vision of collaboration and success.

Bibliography

Boserup, E. (1970) *Woman's Role in Economic Development*. New York: St. Martin's Press.

Carter, J. (1980) *Fiji Handbook*. Sydney, Australia: Pacific Publications.

Development Studies Centre (1985) *Women in Development in the South Pacific: Barriers and Opportunities* (Conference proceedings, Vila, Vanuatu). Canberra: Development Studies Centre, Australian National University.

Hawkins, B. (1981) "Strike One for the Pacific Women." *South Pacific Islands*

Business News, *7*(12), 39–41.

Kiste, R. (1984) "Oceania: An Overview." In F. Bunge and M. Cooke (Eds.), *Oceania: A Regional Study* (Foreign Areas Study, American University). Washington, DC: Superintendent of Documents, U.S. Government Printing Office.

Renshaw, J. (1983) "Beyond Sex Role Stereotypes." Paper presented before the Association for the Advancement of Policy in Development conference on "International Development, Women, and the '80s," held in Washington, DC, in November 1983.

Schoeffel, P., and Kikau, E. (1980) "Women's Work in Fiji: An Historical Perspective." *Review* (Suva, Fiji), *1*(2), 20–28.

Siwatibau, S., Sofield, C., Agar, J., Lechte, R., and Simmons, D. (1984) *Women in Development Planning in Fiji*. Kuala Lumpur, Malaysia: Asia Pacific Development Centre.

South Pacific Commission (1980) *South Pacific Economies, 1978: Statistical Summary*. Noumea, New Caledonia, October 1980.

"Women in Business: A Strong Call for a Greater Role." *South Pacific Islands Business News*, *5*(10), 33–34.

United Nations (1973) *Report of the Interregional Meeting of Experts on the Integration of Women in Development* (19–28 June 1972). New York: United Nations.

United Nations Development Programs (1980) *Rural Women's Participation in Development*. New York: United Nations.

8

ARIANE BERTHOIN ANTAL AND
CAMILLA KREBSBACH-GNATH

Women in Management: Unused Resources in the Federal Republic of Germany

Women still play such a minor role in management in the Federal Republic of Germany that a search for the reasons must examine a wide variety of factors. This chapter looks at the position of women in management today and discusses the impacts of different barriers to their career development. It reviews the consequences of socioeconomic, educational, sociopsychological, and systemic characteristics of German business and society for the recruitment and promotion of women in management and considers the implications of emerging trends in politics, both national and international, and among the women in management themselves.

Facts and figures

German women in management are still very few and far between: the sparsity of facts and figures on them reflects the lack of attention they have received so far in business and social science research. Only quite recently have German media and research given the topic more attention,[1] yet the information and results are mostly individualistic or biographical (see, for example, Metz [1] and Edding [2]). This paper therefore draws on and interprets the meager data base to describe the situation of women in management in the Federal Republic of Germany today, to understand the contributing factors, and to develop a sense of future directions.

Compared with other European countries and the United States, the percentage of women in managing positions in West Germany is very small, and has not changed significantly over the past 20 years[2]: only

1.5 percent of the leading positions in West German firms are held by women, and even those are clustered in "female domains." Ten percent of all German personnel directors are women; in the area of finance and general administration, they hold 6 percent of the leading positions; in distribution, only 2 percent [3].

It is interesting to note that no general statements can be made about the types of sectors or companies in which women have achieved higher management positions. A survey conducted recently by a leading German weekly newspaper, *Die Zeit*, reveals no clear pattern [4] (see the table).

The overview of selected major German corporations in the table shows that the total number of women employed by a company is not a reliable indicator of the proportion of women managers. For example, although women constitute only 5.4 percent of employees in the German Railways, they hold 17 percent of management positions.[3] In contrast, in the major retail chains, where a high percentage of the employees are women, there are few women managers. In Karstadt, only 1 of every 3,550 female employees is in management.

An equal-opportunity policy in a company does not seem to be a good predictor of the actual opportunities for women in management. The unions and their companies, for example, which are ideologically committed to equality, do not have particularly good records: in the Deutsche Gewerkschaftsbund (DGB: German Association of Trade Unions), in which 55 percent of the employees are female, only 3 of the ranking officials are women.

The example of IBM, however, shows how effective active efforts to promote women can be in Germany. IBM introduced its worldwide equal-opportunity program into Germany in 1976 and established a full-time office for it in 1982. It is too early to assess the impacts of this office; but a comparison of data over almost a decade indicates an improvement. Although the proportion of women employed by IBM Germany has remained relatively constant during this period (1976—1,690; 1985—1,790), the percentage of women in management has increased. In 1976, 1.6 percent of senior managers and 3.3 percent of middle managers were women; in 1985, the figures had risen to 3.2 percent and 7.1 percent, respectively.

Not only are women in management scarce but even the small number who are in this elite class do not receive the same pay as their male counterparts: their salaries are roughly 20 percent lower than those of male managers [3]. The bigger the company, the higher the female

Representation of Women in Selected Major German Companies

Company	Sector	Employees in FRG	Female employees	Senior managers	Senior female managers
Bundesbahn	German Railway	283,959	15,288	420	72
Siemens	Appliances	194,292	52,721	3,505	19
Volkswagen	Automobiles	117,210	14,210	290	0
Bayer	Chemicals & pharmaceuticals	61,908	10,508	4,731	142
Karstadt	Department stores	58,420	39,060	567	11
BASF	Chemicals & pharmaceuticals	51,959	7,965	2,025	13
BMW	Automobiles	44,692	6,224	260	3
Thyssen	Steel	40,671	3,024	661	1
Deutsche Bank	Bank	38,760	19,692	2,780	50
Audi	Automobiles	35,056	5,304	383	2
Krupp	Steel	30,937	4,977	704	n.a.
Unilever	Food & chemicals	29,252	9,324	2,066	70
IBM	Electronics	27,507	4,644	2,827	90
Dresdner Bank	Bank	26,079	12,471	1,100	12
Henkel	Chemicals	16,138	4,318	883	14
Nixdorf	Computers	14,215	3,782	500	0
Springer	Publishers	11,422	2,934	268	4
Bertelsmann	Publishers	10,818	4,659	546	10
Schering	Chemicals & pharmaceuticals	10,397	3,357	795	42
Reemtsma	Cigarettes	9,167	2,267	189	0
Shell	Oil	4,129	496	124	0
Gewerkschaftsbund	Federation of unions	2,164	1,191	36	3

Source: M. Jungblut (1985) "Wer wagt sich auf die Karriereleiter?" *Die Zeit*, No. 37, 6 September, p. 15.
Figures given by the companies based on their definition of "manager."
n.a. = not available.

manager's rank and the better her qualifications, the higher is her salary. Nevertheless, the income gap persists, and increases with the size of the firm. Unfortunately, research has only just begun to document the differentials, and has not yet progressed to examination of how the gap is maintained.

Barriers

Why are there so few women in management in Germany? So little serious work has been done in examining the barriers blocking women's access to, and promotion in, the public and private sectors that the following discussion is based largely on insights gained from research conducted abroad, particularly in the United States, and conjectures about their transferability to the German situation. Four general types of barriers can be identified: socioeconomic, educational, sociopsychological, and systemic. It is essential to recognize that these groups are treated separately only for analytical purposes—the tenacity and strength of their impact in practice are due to their *interaction*. Just as no one single type of factor can be held responsible for the present situation, it will not suffice to work on resolving one aspect of the problem in isolation, hoping that the other aspects will simply follow suit and resolve themselves.

Social, cultural, and economic barriers

Women in management must be understood within the wider context of women's position in the labor market in Germany. It is striking that the proportion of women in the labor force has grown much less rapidly in postwar Germany than in the United States. In fact, compared with their American counterparts, German women began, after the war, to represent a relatively high percentage of the labor force; but the level remained constant, whereas in the United States there was a noteworthy increase in participation, starting from a lower level than in Germany and then significantly surpassing it. In the United States in 1950, women represented 28.9 percent of the labor force and rose to 42.8 percent in 1982; in Germany in 1950, women represented 35.1 percent of the labor force, but by 1980, the percentage had risen to only 38.2 [5,6]. In 1985, women constituted the majority of the population (52 percent), but only 38 percent of the working population in Germany [7].

In light of their proportional participation in the labor market as a whole, it is not surprising that women have not achieved very high levels of representation in management. But, given the positions they held in management after the war, why are the figures so dismal today? Why is their progress "only approximately equal to the speed at which the next Ice Age is approaching" [8]? Two important factors help to explain this question: legislative and infrastructural preconditions.

A review of German legislation regarding women shows that the focus has been primarily on achieving equal treatment of men and women in society in general, and only secondarily on women at work. Just recently have a few initiatives been introduced directed specifically at achieving equal opportunity that could lay the groundwork for significant improvements in career development (e.g., proposals for voluntary positive action plans: see below). It is no coincidence that the law giving husbands the right to prohibit their wives from working was not changed until 1977 [9]. Most measures have traditionally concentrated on such provisions as social security, maternity leave, divorce laws, and health. (For details, see Antal and Krebsbach-Gnath [10].) Clearly, laws are an expression of the culture, and in Germany (as discussed at greater length in the next section) the culture is not yet oriented to women's having a career perspective.

The most important infrastructural provision for women who work is government-subsidized child care. Compared with the United States, child care is heavily subsidized in Germany, a luxury many Americans can only dream of; but there is still a great deal to be desired. More places are needed, and the hours of child-care centers need to be extended to permit parents to work full time if they wish.

A further constraint arises once children enter school: in contrast to schools in the United States and many European countries, most German schools have half-day schedules, so combining family responsibilities and a full-time job remains a serious problem for mothers in general. And considering the long hours and flexibility required of managers, this is a particularly significant difficulty for women seeking to develop a career [11].

Educational barriers

Immediately after the war, because of the absence of men, women had opportunities to enter management positions, as a stopgap measure, it being a time when education, training, and sex simply could not play

the determining roles. Since then, however, it is generally accepted that the level of education and training plays a significant role in shaping opportunities for promotion. The generations that attended *Gymnasium* (college preparatory secondary school) and university in the immediate postwar period are today's top managers, and the students of that period included few women. The earliest available statistics on this issue show that of the 106,449 students registered at German universities in 1949–1950, only 18,850 were women, of whom 5,651 were studying the humanities [12].

The fact that so few women attended the university in the late 1940s and in the 1950s is partly responsible for their absence from managerial ranks among the 50- and 60-year-olds today. Gradual improvements can be observed: in 1960, 23.9 percent of the students in German universities were female; in 1983, their proportion had reached 37.9 percent [13]. Women continue to concentrate in such areas as languages and literature, and some in law and medicine. Gradually, more are moving into economics; very few go into engineering.

It is revealing that the data on students prepared by the official statistics bureau lists the courses of study pursued by men and women separately by sex, and the overlap in priority areas is very small. Engineering is not even listed among the top 20 areas of study in the women's category, but calculation shows that of the total number of students in engineering-related studies in German universities in the fall semester 1983–1984 (135,478), only 4 percent were women [14]. German universities do not offer management studies per se as other countries do; instead, students study "microeconomics" (*Betriebswirtschaftslehre*). The difference is not as great in this area as in engineering, but still significant: of the 63,010 total, 30 percent were women (compared with 1 percent of 10,120 in 1954–55 [15]).

The increase in number of female college graduates and their very gradual expansion into less traditional areas of education more suited to management careers in the public and private sectors give reason to hope that the younger generation of women will achieve higher ranks than their mothers and grandmothers [11. P. 136]. Two notes of caution, however, are in order here.

First, education is no guarantee of employment. In fact, female university graduates are suffering from higher unemployment rates than are male graduates: although only 25 percent of the working population with a university degree are women, they represent 45 percent of the unemployed with a university education.[4]

Second, it is important to recognize that education and training, particularly when obtained outside the company, play a decreasing role as one moves up the hierarchy. As empirical research has shown (see, for example, Hegelheimer [16]), companies rely predominantly on in-firm training, which implies that if selection procedures filter women out from the outset, they will not participate in the training programs designed as a basis for promotion. At the same time, however, it has been shown that the weight placed on such measures of qualification is inversely related to position in the hierarchy: the higher the position, the less significance is attached to such "objective" criteria. The factors that receive more weight in promotion decisions for higher management functions are less objective and are often based on traditional male career patterns, so, in effect, they discriminate against women. Among those listed in the Hegelheimer study are "professional competence, effectiveness, professional experience, length of experience, time with the company, commitment to the job, and professional and regional mobility" [16. P. 62]. To the extent that "objective" factors and qualifications, such as education and training that women can consciously acquire, play a lesser role in decision making, other sociopsychological and systemic factors assume increasing importance and create less easily surmountable barriers to career development for women.

Sociopsychological barriers

The sociopsychological barriers faced by women in management in Germany probably do not differ significantly from those faced by women in comparable Western industrialized cultures.[4] They have to deal with the same kinds of prejudice based on stereotypes, misinformation, fears, and insecurity [19]. Women are not hired or promoted because it is believed that they are not capable of making difficult decisions, or it is argued that the organization's investment will not pay off since it is expected that women will leave after marriage, when children are born, or when their husbands move for business reasons. The mobility of women is automatically assumed to be less than that of men. It is presumed that women are not career oriented, just task oriented. These unspoken beliefs play a subtle role in decision-making processes concerning hiring and promoting women (see, for example, Süssmuth [11. Pp. 135, 138, 145]).

In Germany, as elsewhere, such prejudices are now gradually disap-

pearing with increasing experience. Younger men today who have had more opportunities to work with women as colleagues or superiors tend to hold less prejudiced views than those who have not done so. At the same time, as women achieve higher qualifications, their career motivation increases, which disproves more of the prejudices. Unfortunately, however, since such traditional attitudes have formed the basis for systemic barriers, as discussed below, there are still very few opportunities for exposing male managers to women in management and thus for breaking down stereotypical prejudice.

Systemic barriers

Companies in Germany—through their general personnel policy—have also produced and built up "systemic barriers" that tend to make it more difficult for women to climb the corporate ladder. The image companies project through their advertising, publications (i.e., companies still are a "man's world"), and job advertisements, in particular, discourage women from applying. Despite a law requiring nonsexist job advertising, firms in Germany reveal their preference for male managers in advertisements directed to men. There is no gender-neutral term for "manager" or "supervisor" in German: the commonly used form (reflecting reality) is masculine, and adding the feminine ending must be a conscious decision (e.g., *Leiter/Leiterin*; *Meister/Meisterin*).

Job requirements implicitly fail to acknowledge career breaks[6] and the fact that employees may have children who need caring time from their parents. Critics observe that the economic order of society in general and of business in particular is based on a polarization of roles, the standard requiring managers (males) to focus so exclusively on their job that women must fill the other social and economic roles in society. Such a system assumes that women who take on traditionally male economic roles continue to fill their other roles as well: the individual woman, not the economic business system, is expected to adapt.

"Since a 'unitary' role is demanded of men, women are assigned the 'double' role. This double role cannot fit smoothly into the processes of an economically determined reality, so it keeps women in secondary, lower positions" [20. P. 146]. Women are very often directed to assignments that, in the long run, are dead ends; they are also often "overqualified" for their jobs, and the periods between their promotions, as some companies have acknowledged in expert interviews, tend to be

longer compared with those of their male colleagues [21]. Hidden quotas in favor of men are not the rule, but they still exist in training programs of big companies [21. P. 85].

Except for this last example, these barriers cannot be labeled "open discrimination." They are attitudes that have more or less become a corporate norm, a cornerstone of the corporate culture (see, for example, Assig and Hoss [22. Pp. 32–32]). In order to effect change, awareness of this problem has to be heightened, and new or revised procedures for personnel recruitment, training, and promotion have to be established at all management levels. A first step in this direction is the guidelines developed by the Federal Ministry for Youth, Family, and Health. These guidelines are quite similar to those already developed in the United Kingdom and Canada and to the "Code of Social Practice" written by the European Communities. They suggest special measures for recruiting, training, and continuing education and also give practical advice on developing a sense for the problems faced by female employees. The impact of these guidelines cannot yet be estimated because they were published only in 1985 and were distributed by the ministry for voluntary rather than mandatory application [23].

Political background relevant to promoting (or not promoting) women in management

Until the late 1960s, the political climate in Germany was quite conservative, which implies an interest in maintaining the traditional role of women as mothers and housewives. Working women, especially working mothers, were seen as needing protection rather than promotion; their interests and needs were not treated as issues requiring political action. Unlike in countries such as Sweden or the German Democratic Republic, there were no political trends, societal interests, or economic necessities in West Germany to serve as an impetus to increasing the number of working women. On the contrary, in spite of programmatic statements proclaiming the importance of equal opportunity, the German labor unions have always concentrated on bargaining for wages and salary levels sufficient to support a family, so that the social goal of one-income families has remained a determining factor in their bargaining policy [24]. Industry has not sought to exert pressure on women to enter the work force because when more labor was needed than was currently available, foreign workers were brought in from other European countries.[7]

Unlike women in other countries, German women have not pushed very hard to enter the labor market because of either financial necessity or ideology. On the one hand, the social security system provides relative security in Germany, so that even unmarried or divorced mothers are not absolutely forced to work. On the other hand, the relative lack of political attention to actively promoting women's interests in the labor market is not unrelated to the nature of the women's movement in Germany, which has never really emphasized such issues.

The women's movement in Germany has its roots primarily in the students' movement of the 1960s, and did not come into its own until the early 1970s, when it disassociated itself from the broader students' movement [25. P. 90]. Since then, it has concentrated on such issues as health (particularly abortion), research and education (women's studies), peace, and local self-help organizations. Because of these varied, issue-specific focuses and the fact that they have been pursued in a very decentralized fashion, the women's movement has not "been able to . . . unite to translate [its] new knowledge into effective political pressure" [17. P. 135].

To date there are no real equivalents in Germany of such American political action organizations as NOW (National Organization for Women) or WEAL (Women's Equity Action League). The issues relating to equality at work in general have received very little attention from groups in the women's movement, and the concerns of women in management, in particular, have, if recognized at all, been considered too marginal and elitist to warrant support. Although the significance of these issues is gradually being understood, particularly as the need for women in decision-making positions to influence policymaking in all social institutions is being recognized, promoting women's careers, specifically women in management, will probably remain a "nonissue" or an issue of very low priority for the German women's movement as a whole.

A number of factors serve to explain the lack of progress with regard to the qualitative status of women in the labor market. As indicated above, improvement in the qualification of women through education and training has been very slow, so women lack one of the main prerequisites for climbing the corporate ladder. Moreover, there have been few role models for younger women to follow. As already mentioned, after World War II, a considerable number of women occupied top management positions and nontraditional positions in German industry, particularly in family-owned small and medium-size businesses.

But since this was usually due to the fact that they inherited these positions—in the absence of men after the war—no shift in values from the traditional social structure ensued, because this placement of women was generally seen as a temporary, stopgap solution to a demographic problem [26. P. 132].

In times of low economic growth and high unemployment, the fact that the concept of women's careers has not yet made significant progress in replacing the traditional concept of women at work as an interim measure (until marriage or because of demographic shifts) is particularly important. Until the idea that women are long-term partners in all ranks of the labor market is thoroughly culturally accepted *and* correspondingly legally anchored, they will always be hired less often and fired more often as a means of dealing with unemployment. Unless corrective steps are taken, it is anticipated that "the small gains made by women in management in the late 60s and 70s can neither be expanded nor maintained. Women are usually replaced by men, and the achievement of improved qualifications will change little" [11. P. 136].

Outlook for the future

What can be expected in the next ten years? Will more women move into more-qualified, better-paid, more-varied positions in the foreseeable future? There is some political action being taken at a number of different levels that give cause for optimism.

The major German political parties are awakening to the power of the female vote; the "gender gap" discovered in the United States is making itself felt in Germany as well. Although the conservative coalition currently in power is basing its policy primarily on appeals to traditional family values and roles, seeking to encourage women to remain at home, it is also trying to appeal to working women (see, for example, [27. Pp. 34–48]). As mentioned above, the Federal Ministry for Youth, Family, and Health recently commissioned the Battelle Institute in Frankfurt to develop a set of guidelines for equal-opportunity measures for use in the public and private sectors [23]. In this, as in other areas of business–government relations, the mood remains antiregulatory, so such guidelines are submitted purely for voluntary application. In fact, the conservative coalition interprets the equal-rights article of the constitution as prohibiting the passing of mandatory affirmative action legislation.

The Social Democrats (currently in the opposition at the federal level) are more actively promoting the introduction of mandatory measures and, particularly in states in which they are in the majority, are exploring the possibilities of affirmative action programs. The Green Party took a major leap in 1984 when it elected an all-women governing board at the national parliamentary level (see, for example, Klein and Michalik [28]).[8] In addition, it proposed an antidiscrimination law in November 1985.

The traditional parties have had occasional women at the ministerial level, and the pressure from women in the party and in the electorate to make women more visible in political organs is growing. The long-term effects of their representation are twofold: they serve as role models for other women and accustom the German people to seeing women in positions of leadership and, at the same time, they integrate women's issues and concerns into the established political system, take them out of their marginal positions, and legitimize their significance.

Not just domestic factors give hope for improvement: the impact of external factors must also be taken into consideration. There are two such main sources of external influence on West German policy toward women: other industrialized countries, particularly the United States and Sweden, and international organizations, particularly the European Communities.

The experience of other countries in seeking to deal with problems of women in the labor market do not go unnoticed in Germany. The highest visibility is achieved by developments in the United States and Sweden. Policymakers and activists in Germany observe the issues that emerge in these countries and the experiments conducted to resolve them. The discussion of affirmative action programs, for example, has been influenced both positively and negatively by reports from the United States: supporters point to the increase in the 1970s and '80s in the number of women in higher positions and in areas in which they have traditionally been underrepresented; opponents cite studies criticizing the bureaucratic side effects and weaknesses of affirmative action and point to instances in which it is now being dropped in the United States. At the same time, Germans, conservatives as well as liberals, are proud of the achievements of their social-welfare state and feel that in many ways the social net they have developed is better than what the American system offers its citizens.

Second is the influence of international organizations. West Germany became a signatory to the United Nations' resolution against all

forms of discrimination against women in 1980—although it took another four years for the concomitant law to be passed by the federal parliament. In the short run, the impact of this move is symbolic rather than real, but exactly such symbolism is needed to prepare the groundwork for long-term changes in attitudes and in the law.

The European Community has a much more direct and regular impact. For example, the law on equal opportunity passed in 1980 in Germany was set in motion by the 1975 directive of the European Communities requiring such legislation in all of the member countries. The same is true of the new law on *parental* vs. *maternal* leave. The European Parliament is becoming an increasingly vociferous and progressive proponent of equal treatment for men and women. This can be explained by a number of factors. Women are playing a far greater role in the European Parliament than in the German national parliament. In the former, 19.75 percent of the currently elected representatives are women, and in the latter, only 10 percent [29. P. 8]. These women at the European level are particularly effective because they are chairing various policy committees [29. P. 29] and because they are actively collaborating on relevant issues with women from other countries across party lines. Furthermore, they have recognized the importance of sharing information about national and international initiatives and disseminating it at the local level to mobilize activities in the member countries.[9]

An additional reason why members of the European Parliament and the Commission of the European Communities are able to promote such progressive measures for equal opportunity is clearly that they are freer to take such bold steps than are their counterparts at the national or state level, who are more directly subject to the pressure of the electorate and other interest groups and who, if the measure they propose is passed, must ensure its funding and implementation. The directives developed by the European Community are not implemented directly by the Community, but rather are passed on to the member countries with the stipulation that they be integrated into national legislation. The Community then monitors the actions of the countries and rebukes them if action is not taken or is unsatisfactory, and cases can be brought before the European Court of Justice.

Clearly, the impact is not via such sanctions, but rather via the impetus provided by the idea. When the European Parliament pushes a proposal, when an issue is taken up by the European Commission, the idea gains legitimacy and life at the national level if it is picked up there

by the relevant activists, within or outside government [30. P. 142]. The symbolic value of European Community actions in such cases is worth as much as, if not more than, its legal power.

It is to be hoped that, in the foreseeable future, one more source of influence promoting women in management will emerge: the women in management themselves. One instrument in this process is networking at the national and at the international level. This was started years ago. The Verein berufstätiger Frauen (Association of Working Women) is probably the oldest example of such a network. The WiB (Women in Business) Club in Hamburg, the Frankfurt-Forum (network of foreign and German women managers) in Frankfurt, and the German Section of the EWMD (European Women's Management Development network) initiated activities just recently. But, probably because of their objectives—mutual support and information—these represent more informal and unofficial activities than those of a political pressure group. "Self-help" groups have been a traditional form of action for women in Germany, but have usually been restricted to the "female" domains of health, culture, and charity. Now women are using this tool, with which they have experience, to deal with a new challenge: careers.

Acknowledgments

The authors wish to thank Nancy Adler, Dafna Izraeli, and anonymous reviewers for helpful comments on an earlier draft of this paper.

Notes

1. Sonja Bischoff's recent study confirms the trends discussed here. See "Capital-Enquête: Frauen als Führungskräfte." *Capital: Das deutsche Wirtschaftsmagazin*, 12/86, pp. 284-98.

2. This assessment holds true even given the—yet unsolved—statistical difficulties of defining the group of leading employees/managers; such an agreement on definitions seems to be necessary in order to make valid intercompany, intercountry, or even intercultural comparisons.

3. The figures may be upwardly biased by the way in which "manager" is defined.

4. SPD-Bundestagsfraktion (1985) "Frauen auf dem Marsch durch die Positionen? Höchste Zeit für Frauenförderplane." Background paper distributed at a public hearing of the SPD on 2–3 April, in Bonn.

5. One interesting difference was found by Judith Buber Agassi in changes in men's attitudes toward women's roles in Israel, the northeastern United States, and the Federal Republic of Germany. Although it was generally true that "the more education they [men] have, the more likely they are to be progressive on the issues of women's roles, the exception was the men of West Germany, who do not seem to have profited

from the women's movement. They like their wives to go to work, but still hold firmly to the notion that women should put their family duties first and should have less responsible paid jobs than men. These attitudes are so prevalent among educated German men that German women will have to make a concerted effort to educate them'' (see the discussion following H.-B. Schöpp-Schilling's [17] contribution to the work edited by J. Farley [18]).

6. The maternity leave referred to earlier was introduced in the physical and social interests of women and to encourage an increase in the birthrate in Germany (which is extremely low); any impact it might have on career possibilities is largely incidental.

7. The jobs filled by such foreign workers were almost exclusively unqualified manufacturing positions. They did not really represent a serious option for women, often being in heavy industries and offering little opportunity for learning and promotion (see also the discussion following H.-B. Schöpp-Schilling's contribution [17] to the Farley work [18]).

8. Although one of the purposes of this move (to provide an impetus for placing women in visible leadership positions) appears to have had some effect, it is not yet clear whether the claim that women will have a substantive impact on the direction of policy has been met. No definitive study of the policy content and decision-making style of the 1984–1985 period has yet been conducted.

9. Of very great value in this process is the newsletter published, in the languages of the member countries, by the Commission of the European Communities.

References

1. Metz. G. (1985) *Frauen die es geschafft haben*. Dusseldorf and Vienna: Econ Verlag.

2. Edding, C. (1983) *Einbruch in den Herrenclub*. Reinbek (FRG): Roro Verlag.

3. "Frauen im Management: selten, tüchtig, unterbezahlt." *Wirtschaftswoche*, No. 18 (26 April 1985), p. 70.

4. Jungblut, M. (1985) "Wer wagt sich auf die Karriereleiter?" *Die Zeit*, No. 37 (6 September), p. 15.

5. OECD (1985) *The Integration of Women into the Economy*. Paris: OECD. P. 14.

6. Commission of the European Communities (1984) *Women and Men of Europe in 1983*. Supplement No. 16 to *Women of Europe* (October).

7. Der Bundesminister für Jugend, Familie und Gesundheit (Ed.) (1984) *Frauen in der Bundesrepublik Deutschland*. Bonn.

8. "Bienen auf der Galeere." *Der Spiegel*, No. 39 (23 September 1985), p. 74.

9. Nölleke, B. (1985) *In alle Richtungen zugleich: Denkstrukturen von Frauen*. Munich: Verlag Frauenoffensive.

10. Antal, A. B., and Krebsbach-Gnath, C. " Working Women in West Germany." *Equal Opportunities International*. In press.

11. Süssmuth, R. (1983) "Frauen in Führungspositionen." In C. Bernadoni and V. Werner (Eds.), *Der vergeudete Reichtum: Über die Partizipation von Frauen im öffentlichen Leben*. Bonn: Deutsche UNESCO-Kommission. Pp. 135–48.

12. Statistisches Bundesamt (1952) *Statistisches Jahrbuch für die Bundesrepublik Deutschland*. Vol. 1. Stuttgart: W. Kohlhammer Verlag.

13. Der Bundesminister für Bildung und Wissenschaft (Ed.) (1984/1985)

Grund- und Strukturdaten. Bonn. P. 115.

14. Statistisches Bundesamt (1985) *Statistisches Jahrbuch für die Bundesrepublik Deutschland.* Vol. 34. Stuttgart: W. Kohlhammer Verlag.

15. Statistiches Bundesamt (1956) *Statistisches Jahrbuch für die Bundesrepublik Deutschland.* Vol. 5. Stuttgart: W. Kohlhammer Verlag.

16. Hegelheimer, B. (1982) *In-firm Training and Career Prospects for Women in the Federal Republic of Germany.* Berlin: CEDEFOP.

17. Schöpp-Schilling, H.-B. (1985) "Federal Republic of Germany." In J. Farley (Ed.), *Women Workers in Fifteen Countries.* Ithaca, NY: New York State School of Industrial and Labor Relations, Cornell University. Pp. 124–35.

18. Farley, J. (Ed.) (1985) *Women Workers in Fifteen Countries.* Ithaca, NY: New York State School of Industrial and Labor Relations, Cornell University.

19. Werner, V., and Bernardoni, C. (1986) *Die Bedeutung des beruflichen Aufstiegs von Frauen für den gesellschaftlichen Wandel am Ende des 20. Jahrhunderts.* Bonn: Deutsche UNESCO-Kommission.

20. Beck-Gernsheim, E. (1980) *Das halbierte Leben. Männerwelt Beruf-Frauenwelt Familie.* Frankfurt/Main: Fischer Taschenbuch Verlag.

21. Krebsbach-Gnath, C., and Schmid-Jörg, I. (1985) *Wissenschaftliche Begleituntersuchung zu Frauenfördermassnahmen.* Bonn.

22. Assig, D., and Hoss, M. (1985) "Ziel: Karriere." *Psychologie Heute*, December, pp. 32–37.

23. Der Bundesminister für Jugend, Familie und Gesundheit (Ed.) (1985) *Leitfaden zur Frauenförderung in Betrieben: Die Durchsetzung der Gleichberechtigung als Chance für die Personalpolitik.* Bonn.

24. Pinl, C. (1978) "Viel Trost und wenig Taten—die Frauenpolitik der Gewerkschaften." In Dokumentationsgruppe der Sommeruniversität E.V. (Ed.), *Frauen als bezahlte und unbezahlte Arbeitskräfte.* Berlin: Dokumentationsgruppe. Pp. 282–89.

25. Schenk, H. (1983) "Frauenbewegung." In J. Beyer, F. Lamott, and B. Meyer (Eds.), *Frauenhandlexikon.* Munich: C. H. Beck. Pp. 85–91.

26. Merkl, P. (1976) "The Politics of Sex: West Germany." in L. B. Iglitzin and R. A. Ross (Eds.), *Women in the World. A Comparative Study.* Santa Barbara, CA: Clio Publishers.

27. "Frauendefizit im Management. Zweifel sind berechtigt." *Wirtschaftswoche*, No. 12 (15 March 1985), p. 70

28. Klein, A., and Michalik, R. (1985) "Frauenvorstand—feministischer Coup oder nur ein Vorstand ohne Männer?" *Beiträge zur feministischen Theorie und Praxis*, No. 13, pp. 128–44.

29. Commission of the European Communities (1984) *Women of Europe*, No. 36 (August).

30. Warner, H. (1984) "EC Social Policy in Practice: Community Action on Behalf of Women and Its Impact on the Member States." *Journal of Common Market Studies*, XXIII(2), 142–267.

9

ANNE BLOCHET-BARDET, LUCIENNE GILLIOZ,
DANIELLE GOERG, AND
MARYVONNE GOGNALONS-NICOLET

Swiss Women in Management: The Quest for Professional Equality

This chapter reviews the situation of unequal opportunities for women in Swiss management. The differences in the extent of women's representation in the various economic branches is explained by the proportion of women employed in the branch and the importance of centrality of the branch in the Swiss economy. The smaller the proportion of women in a particular branch and the more central the branch in the economy, the smaller is the proportion of women managers. The price women managers pay within the realm of the family is demonstrated and discussed, with specific reference to the canton of Geneva.

It is commonly believed that opportunities for the promotion of professional women increase with development of the service sector. With 56 percent of the working population in the tertiary sector, Switzerland occupies a median position among Western societies insofar as the development of services is concerned. During the last decade (1970–1980) there has been a considerable growth of activities in this sector (+25 percent). Seventy-one percent of the female labor force is employed in the tertiary sector. In the city of Geneva, which is the special focus of this study, 75 percent of the total labor force and 87 percent of the female labor force are employed in the tertiary sector.

The economic structure is, however, only one determinant of the position of professional women; the state of gender relationships is another. Switzerland is rather conservative in terms of the rights of

This article was translated from the French by Hana Costa and Toni van Moppes and was edited and revised by Maureen Davis.

women and their place in society:

—It was one of the last countries to grant women the right to vote at the federal level (1971). One canton still denies women the right to vote on cantonal matters (Appenzell Rhodes-Extérieures).

—The proportion of women among university students is one of the lowest in Europe (34 percent), just above that of Turkey [1].

—Only 2.3 percent of full university professors are women [2].

—Abortion is illegal.

With regard to the proportion of women in the working population, Switzerland occupies a median position, with 36.1 percent in 1980 (USA, 42.3 percent; France, 38.9 percent; Federal Republic of Germany, 38.2 percent; Great Britain, 38.7 percent; Italy, 33.6 percent [3]). As in most of the Western countries, women's labor-force participation increased slightly between 1970 and 1980.

During the last decade there have been a number of studies relating to various aspects of women's status in Swiss society and covering a number of different domains [4–7]. A common finding is that women are concentrated in the least prestigious occupations and at the lower levels of the organizational and institutional hierarchies. At the top they are conspicuous only by their absence.

This paper traces the inequalities between men and women in management. It examines gender differences in access to management positions and the factors constraining women's opportunities for advancement. Data are drawn from two sources: the 1980 Federal Census, and a representative study of the 40–65-year-old population of Geneva.[1] The sample of women managers in the Geneva study is small (N=20), so it is not possible to generalize from the findings to the total population; however, on the basis of our familiarity with the subject and data from supporting sources, we believe the findings to be not untypical of the situation of Swiss women in management.

Women and power: A certain incompatibility

The French term *cadres*, used to indicate positions of authority and responsibility, corresponds to the English term *managers* and refers to a variety of positions at different hierarchical levels. The Swiss statistical classification uses two terms to refer to the notion of manager: (*1*) *directeurs* (masculine) or *directrices* (feminine) (directors), applied to the highest positions in the hierarchy, and *employé(e)s supérieur(e)s*, designating middle-level managers. In the

Table 1

Proportion of Women Managers by Economic Sector and Hierarchical Level

Sector	Global population (male and female)	% women	% women among directors	% women among middle-level managers
Primary sector	191,255	26.4	2.0	9.2
Secondary sector	1,197,248	22.7	2.4	6.3
Tertiary sector	1,650,697	46.9	5.4	17.7

Source: 1980 Swiss federal census [8].

Geneva survey (of the 40–65-year-old population), the term *manager* also includes those with a university education who are working in the liberal professions.

Women in Switzerland represent 36 percent of the labor force, but their proportion among management is very small and decreases as the position becomes more senior. Although there was considerable growth in the number of managers between 1970 and 1980 (+53 percent), the proportion of women increased only slightly: among directors, from 4.0 percent to 4.2 percent, and among middle-level managers, from 11.2 percent to 14.2 percent. The proportion of women managers varies by economic sector and branch, the greatest proportion of directors and middle-level managers being in the tertiary sector. Even there, however, the proportion of women among directors is only 5.4 percent.

When we examine the distribution of women managers among the different economic branches of the tertiary sector, the disparities are even more evident. The proportion of women directors ranges from 0.7 percent in banking and insurance to 23.6 percent in religous associations and community organizations.

The most common hypothesis is that as the proportion of women employed in a sector or branch increases, so does the proportion of women directors. In fact, it can be seen that the most "feminized" branches—health and health care, social services, hotels and restaurants, and education, all of which are considered female domains—are among those with the highest proportion of women managers. However, the correlation between the proportion of women employed in a branch and the proportion of women directors is not high (Kendall Correlation Coefficient, 0.49, $P < 0.05$). Some branches, although

Table 2

Proportion of Women Managers by Branch of Economic Activity and Hierarchical Level, Tertiary Sector

Branch	Global population	% women	% women among directors	% women among middle-level managers
Trade, property management, rentals	418,577	49.7	5.0	18.0
Transportation and communications	183,349	21.4	3.2	6.0
Health, health care	158,100	73.3	7.4	32.6
Hotels, restaurants	147,029	60.0	15.7	61.9
Banking, insurance	135,276	41.4	0.7	5.1
Other services:				
Education	132,402	51.9	10.5	20.9
Legal, technical, economic consulting	121,122	34.6	2.8	10.4
Civil services, judiciary, defense	104,747	27.7	3.3	5.3
Repair services	60,324	9.4	2.0	6.8
Social services	38,647	72.7	18.1	49.7
Arts, leisure	31,564	42.2	9.1	25.1
Paid domestic work	26,224	97.2	—	—
Religious associations, community organizations	15,938	44.2	23.6	5.6
Cleaning services	12,569	55.2	8.8	28.7
Diplomatic services, international organizations	9,803	49.0	4.2	16.5
Research services	9,491	28.9	3.1	5.1

Source: 1980 Swiss federal census.

employing a relatively large proportion of women, tend to be closed to women managers. For example, banking and insurance are similar to arts and leisure in the proportion of women employed (42 percent), but offer very different opportunities for women in management: in banking and insurance, women represent only 0.7 percent of the directors and 5.1 percent of the middle-level managers; in arts and leisure enterprises, the respective proportions arc 9.1 percent and 25.1 percent.

Thus, the hypothesis that the number of women managers depends on the feminization of the economic branch only partially explains the observed variations. To examine the sources of variance further, we have constructed an index to measure the accessibility of an economic branch to women independently of its degree of feminization. The differences between the proportion of women among directors and the proportion of women employed have been rated for each branch of the services. When the two proportions are equal, the index is 100. The smaller the fraction, the greater are the difficulties in entering management. The branches are ranked according to their degree of accessibility. The results are presented in Table 3.

The least accessible branches for women directors are banking and insurance, followed by the legal, technical, and economic consulting services and the diplomatic services and international organizations. In contrast, the branches most accessible to women directors are religious associations,[2] hotels and restaurants, and social services. What distinguishes the two groups of branches at the extremes of the index? We contend it is their degree of financial power, of economic or political influence, in addition to the rewards they offer to managers. For example, the highest managerial salaries are paid in the banking and insurance branches and in legal, technical, and economic consulting services [9]. Thus, there appears to be an inverse relationship between women's accessibility to the top level of an economic branch and its centrality in Swiss society.

The absence of women in managerial positions has been acknowledged during the last few years in some public and private settings. The federal government recently created a Bureau de la Condition Féminine. One of its functions is the promotion of women into high levels of the government hierarchy. The private sector has also made some modest attempts in the same direction, such as work-related discussion groups and reports on the situation of women. The seriousness of these measures and their likely effects can be questioned, however.

Table 3

Index of Accessibility by Economic Branch (Tertiary Sector)

Branch	Index of accessibility[a] (Women directors)[b]
Banking, insurance	1.7
Legal, technical, economic consulting	8.1
Diplomatic services, international organizations	8.6
Trade, property management, rentals	10.1
Health and health care	10.1
Research	10.7
Civil services, judiciary, defense	11.9
Transportation, communications	15.0
Cleaning	15.9
Education	20.2
Repair services	21.3
Arts, leisure	21.6
Social services	24.9
Hotels, restaurants	26.2
Religious associations, community groups	53.4

[a]Index of accessibility: 100 × (proportion of women among directors divided by proportion of women among employed population).
[b]Insofar as middle-level managers are concerned, the ranking of the economic branches is approximately the same.

Geneva women and men in management: Unequal situations

Since the Second World War, Geneva has enjoyed economic prosperity, marked by the growth of services to the detriment of the secondary sector. The effects of the world economic crisis have not been strongly felt in Geneva, where unemployment is low (about 1 percent). These good economic conditions could be presumed to offer a particularly favorable situation for the promotion of working women.

Although a large number of the female population of Geneva is engaged in the service sector, the proportion of women among directors is still very low (6.5 percent), even if slightly higher than the Swiss average. In middle-level management, women account for 20 percent, a little more than the national average.

Sectors and branches of economic activities

Relatively important differences can be observed among economic sectors and branches with regard to the sex ratio of managers. These

Table 4

Managers' Monthly Income by Sex

Income	Men (n = 138), %	Women (n = 18), %
< 4,000 SFR.	0.7	16.6
4,000–5,999	8.7	38.9
6,000–7,999	29.0	17.67
8,000–9,999	20.3	11.1
10,000 and over	41.3	17.6
	100.0	100.0

Source: 1985 Geneva survey of population 40–65 years old.

variations represent the same tendencies and are explained by the same factors— feminization of the branch and unequal accessibility according to the importance of the branch—as those noted for the total Swiss population. However, women managers in Geneva have greater access to the branches of the rapidly expanding public tertiary sector: health and health care and education, in which women represent about one-fifth of all directors.

Working conditions and monthly incomes

Women in management differ from men in terms of the number of hours worked per week and monthly income. The majority of women (65 percent) work 40–42 hours a week, whereas 50 percent of the men work more than 43 hours weekly. More than 40 percent of male managers, but only 17.6 percent of female managers, earn a monthly income of SFR. 10,000 or more; on the other hand, 55.5 percent of women and only 9.4 percent of men earn less than SFR. 6,000. These data support what has previously been stated about inequalities in salary by branch of economic activity (Table 4).

Socioeconomic background

It is commonly argued that to hold an equivalent professional position, women must have additional social resources. Results from the Geneva survey support this contention. In top-level managerial positions women are of higher socioeconomic origins: 63.2 percent of the women, compared with 49.7 percent of the men, had fathers at the same profes-

Table 5

Managers' Fathers' Profession

Fathers' profession	Men (n = 141), %	Women (n = 19), %
Liberal professions; top and middle-level managers	49.7	63.2
White-collar positions	32.6	15.8
Farmers	6.4	5.2
Blue-collar positions	11.3	15.8
	100.0	100.0

Source: 1985 Geneva survey of population 40–65 years old.

sional level. However, male managers' fathers more often had white-collar jobs than did women managers' fathers (see Table 5).

More women managers' mothers had paid employment (63.2 percent) than did men's mothers (50.4 percent). Identification with a working mother allows a daughter to follow a professional career pattern. This probably constitutes an important advantage. Furthermore, this high percentage of working mothers is significant considering that, at the time, few middle-class women had paid work.

Family life: The price to pay

It is in the family realm that women managers pay the highest price. Today it is generally recognized that marriage constitutes an advantage for men who want to make a career, but a real handicap for women who have the same ambitions. Not only does marriage provide men with logistic support (housework and emotional security) but it also constitutes a guarantee of stability and reliability in the eyes of employers. In contrast, women, once married and, especially, with children, considerably increase their domestic burden and multiply the obstacles to building a career.

This explains why the family situations of male managers and female managers are very different. According to the federal census, most women managers in Geneva (61.6 percent) are not, or are no longer, married. On the other hand, the great majority of men managers (86.3 percent) are married. The high frequency of divorced (21.8 percent) and of never married (30.1 percent) female managers should be noted (Table 6).

Table 6

Managers' Marital Status

Marital status	Men (n = 4,626), %	Women (n = 289), %
Single	6.4	30.1
Divorced	6.0	21.8
Widowed	1.3	9.7
Married	86.3	38.4
	100.0	100.0

Source: Swiss federal census of population 1980/Geneva [10].

Similarly, Geneva women managers in the 40–65-year age group seem to live alone more often than men: 25.0 percent are alone, and 10.0 percent are alone with one or more children, against, respectively, 5.6 percent and 1.4 percent of men. On the contrary, men in seven cases of ten live within a family with one or more children, whereas this is the case for only four of ten women.

Thus, women pay a high price for their entrance to managerial posts. Insofar as reproduction is concerned, the Geneva survey shows that 30 percent of female managers have no children, compared with 15 percent of male managers. The mean number of children is 1.89 for male and 1.35 for female managers. During middle age, the mean number of children still living at home with their parents is 1.10 for male managers and 0.35 for female managers. The data show that family life and management are far less compatible for women than for men.

Conclusions

Women's underrepresentation in managerial positions, especially at the top of the professional hierarchy, indicates that the rapid growth of the service sector and a sound economic situation do not constitute sufficient conditions to assure fair opportunities for them. Contrary to the claims of some authors (e.g., Badinter [11]), the march toward equality is not an unrelenting force, since power relationships between the sexes still exist and influence the effects of economic, technical, and social changes. As a matter of fact, women's accessibility to top positions depends on the overall state of gender relationships in the spheres of the economy, education, politics, the family, etc. In a sexist society, the social forces that keep women in inferior positions are subtle and

complex and penetrate all aspects of a woman's career.

This study suggests that women pay a high price for their entry into the world of management. Whereas men integrate, apparently without any problem and to their advantage, professional and family life, women, in many cases, find marriage and professional responsibilities incompatible. The question may be asked: Is the overall price that women managers have to pay too high? In other words: Is it really worth it? As women researchers, also concerned with social policy, how do we tackle this problem?

The answer is not easy. Two dangers have to be avoided:

1. To push women toward a career at all costs and to make them accept the rules of the male world would be to make them deny a part of themselves, their way of being, and their desires.

2. To urge them to escape from an aggressive and competitive male world and find refuge in positions to which they are considered to be better adapted would be to risk restricting women to ghettos and avoiding positive exchanges between the female and the male subcultures.

Opportunities for women need to be expanded, and male-reserved territories, to be abolished. This, however, should not be dissociated from the necessary, larger, social changes, a major one being more equal distribution of professional and domestic responsibilities. Without this basic condition, women pursuing careers are condemned either to sacrificing their family life or to assuming a double load. Men clearly also have much to gain from a readjustment of their involvement in their professions and their families: an increase in the quality of their lives.

Notes

1. M. Nicolet-Gognalons (1986) "Ages, cycle de la vie et période dite du milieu de la vie" (Mimeographed, No. 3972.082). Geneva: Fonds National Suisse de la Recherche Scientifique.

2. The high rate of women managers in the religious associations is probably due to their roles in convents and congregations in which the person in charge is necessarily a woman.

References

1. UNESCO (1984) *Statistical Yearbook*. Paris: UNESCO.

2. Office fédéral de la statistique (1985) "Université et éducation—Recueil statistique." *Etudes statistiques*. Vol. 15. Berne: Office fédéral de la statistique.

3. *L'Observateur de l'OCDE* (1983), No. 121 (March).

4. Held, T., and Levy, R. (1975) *Femme, famille et société*. Vevey: Delta.

5. Commission fédérale pour les questions féminines (1982) *La situation de la femme en Suisse*. Berne: Commission fédérale pour les questions féminines.

6. Gillioz, L., and Goerg, D. (1982) "L'impa-science des femmes." *Revue suisse de sociologie, 8*(2), 373–97.

7. Ballmer-Cao, Thanh-Huyen (1982) " Nos réprésentantes dans la politique: Quelques informations préliminaires sur le projet de recherche L'Elite politique féminine en Suisse." *Questions au féminin*, No. 2.

8. Office fédéral de la statistique (1985) "Recensement fédéral de la population 1980. Suisse activité économique." *Statistiques de la Suisse*. Vol. 9. Berne: Office fédéral de la statistique.

9. "Sprung über den Graben Beträchtliche Unterschiede zwischen Branchen und Regionen." *Schweizerische Handelszeitung*, October 1986.

10. Office fédéral de la statistique (1985) "Recensement fédéral de la population 1980. Canton de Genève." *Statistiques de la Suisse*. Vol. 22. Berne: Office fédéral de la statistique.

11. Badinter, E. (1986) *L'un est l'autre*. Paris: Odile Jacob.

10

Valerie Hammond

Women in Management in Great Britain

Women now constitute 44.8 percent of the employed labor force in Great Britain. They hold around 10 percent of general management posts, 16 percent of other managerial positions, and 20 percent of professional and related posts supporting management.

There are many different career paths and entry points to management in Britain and less reliance than in many other countries on a business degree as a qualification. This lack of clarity of career paths creates both opportunities and obstacles. Women managers are not evenly distributed, but are concentrated in traditional areas of women's work and at more junior levels. The number of women in the top posts is nominal, but there are signs of change.

Some employers offer employment conditions and training designed to meet the specific needs of women managers and professionals who want to combine family and career. There is an indication that pay differentials between men and women are decreasing. There are initiatives (some sponsored by the government) to encourage opportunities for women in public life. Training and development programs are increasingly offered to help women take advantage of the climate of opportunity, and women's networks are playing a positive role in this endeavor. The improvements take place against a background of weak legislation for equal opportunity, and sustained effort will be required to maintain and increase women's share of management posts.

There is a long tradition in Britain of women who work outside the home. In the nineteenth and early twentieth centuries, this was a reflection of the industrialization of work previously done at home or in "cottage" industries such as weaving, making pottery, and so on. During the two world wars, women proved themselves able to perform a wide variety of technical work, both skilled and unskilled, but the work tended to be supervised or managed by men. There was a well-defined concept of "women's work," and this was regarded as a "job" rather than a "career." It was accepted that women would give up work on marriage or on the birth of the first child so that, before World War

II, only 10 percent of married women were economically active.

These concepts were challenged out of necessity, both because the level of pay was generally low, so that many families felt the need for two incomes, and because of women's own need for financial independence. Women now constitute 44.8 percent of the employed labor force [1]. They usually continue to work after marriage: 64 percent in 1984 [2]. This due in part to the tradition of part-time employment. For example, in September 1986, nearly 42 percent [3] of the women in employment worked part time, i.e., fewer than 30 hours a week. Women now form an essential part of the labor force in Britain, and they are engaged in most types of work, including management.

The route to management

The route to management in Britain is far from clear. Entry may be via a management training scheme, direct into an executive role, or through promotion from more junior jobs within the organization. In some sectors, entry is via examination; in others, a variety of selection procedures, from simple interviews to assessment centers, are the norm. People enter their management careers from a wide range of backgrounds, in terms of both experience and education. Business degrees have a limited currency: they do not automatically provide a passport to management. Trainee managers direct from the university are as likely to have an arts or science degree as a business one; British industry still tends to be skeptical about the value of a degree, and often prefers to recruit more widely. Many British managers do not have degrees, but they have usually gained professional qualifications appropriate to their functional specialization.

This diffuse approach to entry is a mixed blessing for women who aspire to be managers. On the one hand, it allows them considerable scope for using personal initiative in applying for jobs. On the other hand, it means that women have no clear path to follow: since their life patterns still tend to differ from men's and there are few female role models, each woman has to create her own learning. Also, this approach gives selectors considerable scope for practicing discrimination, often unintended. The criteria can change, and provide almost no guidelines on what one needs to do in order to be accepted.

Even when women are successful in gaining entry to a management career, it is still common to find that the organization has fairly rigid and prescribed notions about the way a woman's career should develop.

At British Rail, for example, women were accepted in the management trainee scheme, but directed toward administration or personnel rather than into line management. This has far-reaching consequences for women's long-term progress since the route to top management in British Rail is usually via increasing responsibility in line management.

Women have had to challenge these restrictions and insist on wider options at very early stages in their careers. This has not been easy. Young women are pleased to have been accepted for training, especially in times of high unemployment, and they are not keen to take issue with the selectors. Also, young women are not always aware of the consequences of these early choices, and a staff role can seem very attractive at that stage.

At Marks and Spencer, one of Britain's most successful retail chains, men management trainees in the stores were habitually routed into store management, women trainees, into staff management. Staff management is rewarding, and promotion entails as much mobility as store management, but the career path for staff managers is more limited. The company is now trying to open store management to women and to make the boundaries between the two careers less rigid.

National Westminster Bank is an example of an organization that has looked closely at the "coded messages" it sends to new recruits. Although the Bank was not aware of the messages, the results were evident in that there were scarcely any women in management posts even though large numbers of women were recruited. There were a number of routes to management, and these were open to people who joined straight from school or from university, providing they attained the appropriate banking qualification. In the past, however, girls received less encouragement from the bank to study for these examinations, and therefore were seldom promoted to management. This has now been changed, and the bank offers one of the most farsighted programs for encouraging the development of its women employees.

Distribution of women in management positions in Britain

Today in Britain, 15 percent of all those holding full-time management or related posts are women. The statistics are difficult to unravel, as they combine several occupational groupings. However, as shown in Table 1, women currently hold around 10 percent of all posts defined as "general management," 16 percent of other managerial positions, and

Table 1

Women in Britain in Selected Occupational Categories, 1986 Compared with 1975

	Women working full time as % of all employees in the category	Women working part time as % of all employees in the category	Women as % of all employees in the category	
	1986	1986	1986	1975
General management	5.8	4.6	10.4	9.7
Managerial posts (excluding general management)	15.0	1.4	16.4	10.9
Professional and related supporting management and administration positions	18.2	2.1	20.3	12.0
Total, all management occupations above	15.2	2.2	17.4	11.3

Source: New Earnings Survey 1986, Part E, Table 138 [4]. *New Earnings Survey 1975*, Part E, Table 138 [5].

Note: New Earnings Survey data are taken from an employed sample of 165,606 men and women, of whom 18,135 (14,975 men and 3,160 women) were in management and related posts.

20 percent of professional posts that support management and administration.

The classification ''general management'' includes top managers in national government and other non trade organizations plus general, central, and divisional managers in trading organizations. In 1975, women held 9.7 percent of these posts [5], and there is current concern that the proportion of women has not increased significantly when compared with the situation in other grades (see below).

The ''managerial'' classification includes all other managers, for example, those in production, distribution, offices, shops, hotels, and catering. There remains a tendency for women to become managers in the sectors in which they predominate as employees. Nevertheless, women increased their share of these functional management jobs by 5.5 percent in the period 1975–1986.

The classification ''professional and related supporting management and administration'' is a wide one that includes managers, officers, and executives working in personnel and industrial relations, marketing and sales, and advertising and public relations; general administrators in national and local government; and others working in

quite different professions, such as the law. The number of women working in these functions increased by 7.7 percent between 1975 and 1986.

Occupational distribution
of women managers

Although the number of women in management has increased, especially at the more junior levels, women in management positions are still a minority. Women managers are not distributed evenly through the different employment sectors, but are concentrated in traditional areas of women's work, e.g., retail distribution, hotel and catering, and public administration. Nevertheless, women in Great Britain are increasingly entering management in nontraditional sectors such as banking, insurance, and manufacturing.

The geographic distribution of working women is biased toward London and the south of the country. This reflects the job situation in the country as a whole, but there appears to be a tendency for traditional attitudes toward women and work to be more strongly held the further one travels from the capital.

Education, qualifications, and training

Women are increasingly choosing to have a university education. In the years between 1975 and 1982, the number of women full-time undergraduates rose from 74,585 (35.3 percent of all undergraduates) to 101,450 (40.6 percent). During the 1970s and early 1980s, this was part of a general increase in undergraduates; but since 1982, the number of men has declined whereas women have continued to register for university education, and have increased their share of places to 41.5 percent in 1984/1985 [6].

At postgraduate level, both the total number of students and the number of male students declined steadily between 1975 and 1982, but there has been a recovery since then. However, the number of women registering for postgraduate studies has shown a steady increase, from 13,083 in 1975 to 15,560 in 1984/1985. The effect has been to increase women's share of postgraduate places from 26.3 percent to 31.8 percent over this period.

The proportion of women studying social, administrative, and business subjects (i.e., sociology, psychology, law, accountancy, geogra-

phy, and economics as well as business studies) at university increased by nearly 10 percent over 10 years, so that in 1984/1985 women constituted 45.4 percent of students at undergraduate level and 34.6 percent at postgraduate level studying these subjects. But, as previously mentioned, entry to management in Britain is not necessarily by this route. For example, among women who entered management or administrative posts in 1984, 20 percent studied geography; 15 percent, French; 17 percent, history; and 13 percent, law [7]. To put the figures into perspective, the total number of M.B.A.s awarded each year in the country as a whole numbers about a thousand; and even though more women than previously (18 percent of the M.B.A. population [8]) are studying for this qualification, the impact of women M.B.A.s on industry is slight.

In Britain, membership in a professional institution is often as important, or more important, than a university degree in terms of advancing in a career. The most respected institutions, and the ones most difficult to enter, are those that admit members only by examination after a course of professional study. In the past this often reflected a desire to prevent women from becoming members of such institutions. This situation is changing, and more women are applying for membership in professional institutions, registering to study, and taking the required examinations in order to be professionally qualified.

Table 2 shows women's participation in selected professional institutes in order of share of total membership. Women's membership in the British Institute of Management is particularly low at 3.2 percent, but the Institute now has a campaign to attract more women. At the more senior level, the Institute of Directors estimates that no more than 2.0 percent of its members are women. This is in part a reflection of the very small number of women who hold directorships. In 1986, the number of women listed in the Directory of Directors, which covers 1,500 United Kingdom companies, was 1,500, or only 2.9 percent of the total membership.

In most professional institutes, women have a relatively low profile, and there is rarely a women's section or any formal lobby for women within the institutes. On the other hand, women have established their own groups, e.g., Women in Management, Women in Banking, and these groups are increasingly having more formal links with the relevant professional institute. There is some reciprocity in these arrangements. The institutes benefit because the women's groups actively

Table 2

Women's Membership in Selected Management and Professional Institutions[a]

Professional institute	Total number of members	Number of women members	Women as % of total
Hotel Catering and Institutional Management Association	22,944	10,957	47.8
Institute of Personnel Management	26,266	10,758	41.0
Institute of Health Service Administrators	5,909	2,292	38.8
Institute of Bankers	111,381	21,370	19.2
The Chartered Insurance Institute[b]	62,893	8,834	14.0
The Law Society (Solicitors)[b]	44,837	6,262	14.0
Royal Town Planning Institute	9,924	1,231	12.4
Institute of Chemical Engineers[c]	16,796	822	5.0
The Rating and Valuation Association[d]	4,955	510	10.3
Association of Certified Accountants	28,309	2,831	10.0
Institute of Chartered Accountants of England and Wales[e]	82,135	5,716	7.0
Institute of Marketing	20,633	1,207	5.8
British Institute of Management	74,268	2,407	3.2
Chartered Institute of Building[e]	27,297	192	0.7

Source: *Women and Men in Britain: A Statistical Profile* [9].

[a]Latest available figures as of January 1986 unless otherwise stated.
[b]As of December 1984.
[c]As of October 1985.
[d]As of February 1986.
[e]As of December 1985.

support and promote membership of the professional body, e.g., by holding joint events, and thus help to increase the number of women in professional membership. The women's groups, in turn, benefit from closer association with the professional body.

Although women generally have access to technical or professional training—the basic skills needed to do the job—they less frequently attend management development programs that provide the broader

development that is essential for promotion to general management. These are, typically, short executive programs that are embedded in corporate culture and are paid for by the company. It is most unusual for any individual to be accepted as a self-sponsored candidate. Women are less likely than their male colleagues to be nominated by their companies to attend such programs. Those who are nominated are likely to be part of a very small minority in the program. Women are less likely to receive informal coaching and counseling in their company; and because they are a small minority, they are more likely to be deprived of peer-group experiences they can either fully share or understand. Women who do attend management courses frequently learn about them on their own and bring them to the attention of their companies, whereas their male colleagues are sent to such courses as part of the general development process.

Some organizations still impose a form of "seriousness of intention" test on women and require a certain period of service before offering them development opportunities, which has the effect of slowing promotion. Several studies, including one conducted by the Ashridge Management College [10], have indicated that women typically remain on each step of the promotion ladder longer than men.

Initiatives for equal opportunity

To overcome this situation, a number of organizations, particularly those in the banking sector, in which there has been strong competition for competent management entrants, have introduced career-development programs specifically for women employees. These frequently involve participation in "women only" courses at an early stage, active support and encouragement to attain appropriate qualifications, and career guidance and counseling. In these organizations, women are encouraged to manage their careers, and the organizations demonstrate their commitment through the introduction of career-break and re-entry schemes.

One of the first organizations to do this was the National Westminster Bank, in which, since 1982, women who have achieved management status are allowed a career break for child-rearing of up to five years. During this period the women are required to participate in training to keep up to date with the banking practices and to work for at least two weeks a year in a relief capacity. Provided these conditions are met, the women are guaranteed a management position at their

previous level when they return to full-time work. Similar schemes have been introduced in the other major banks, and the insurance sector is following suit. The impetus is an economic one, as the banks need to attract an increased number of high-caliber applicants and believe this approach will make them more attractive employers to women. Now, other sectors in which a similar shortage exists, for example, high-tech engineering, are experimenting with career-break options that include retraining possibilities.

Recognizing that men need help to work more effectively with women, the leaders in this type of approach work with men in the company as well. There is also a trend for training that brings women and men together to work through issues. The Civil Service has been a leader in offering this type of program to staff. In July 1983 the Civil Service Staff College introduced a course to train women and men to work together [11]. The course is in two parts and lasts for seven and a half days. On average, three such courses are offered each year, the object being to work more directly on the male–female dimension in organizations.

There is, in fact, a great deal of experimentation with nontraditional forms of development, particularly variations of self-development processes. In 1985 the Manpower Services Commission (the U.K. Government training agency) sponsored a pilot series of self-development groups for women managers [12]. Briefly, funds were provided to cover approximately 50 hours of facilitating skills for self-development groups of women managers. The women were responsible for determining the objectives and plans for their groups: how often they would meet, what issues would be tackled, and so on. Although the facilitators offered frameworks when they thought this would be helpful, it was the women who chose the processes. Sixteen groups were run experimentally, members in different groups being drawn from public- and private-sector organizations. Six groups were open to "all comers," and participants worked on their own time, usually in the evenings or on weekends. The majority, however, were "in-house," all participants being drawn from within one organization. In these cases the organization had to cope with a situation in which it supported, often financially, the formation of the group, but could not dictate, or even be privy to, the work of the group.

Motives for organizational support varied widely. In one organization, for example, self-development groups were already in operation, but were attended almost exclusively by men. A women's group was

seen as a logical extension, offering choice and encouraging more participation by women. Another organization experienced very high labor turnover among its women managers and thought the self-development process might help identify the cause and arrest the process. It met with success in that "demotivating" aspects of the work were tackled by the group and, although several members had been on the point of resigning, the support and ideas exchanged during meetings encouraged them all to stay and resolve the issue.

The project for self-development of women managers is only one of a number of initiatives funded in full or in part by the Manpower Services Commission (MSC). Within its overall responsibility for stimulating training and employment, the MSC has a small unit that focuses specifically on women's training needs. Skills training is delivered through its Training Division, and a specialist unit concentrates on funding innovative activities. Usually these are small-scale investigations or action research projects. The objective is to generate learning and materials that can be disseminated widely through publications, or often by events organized by the Co-ordinating Group for Women and Training. Researchers and trainers are linked into the overall scene and to the wider community through *Women and Training News*, which is distributed free to anyone, companies or individuals, with an interest in women's training and development. Since the Co-ordinating Group was established in 1979, it has placed particular emphasis on women in management, in the belief that such a focus will also benefit women at other levels in the organization.

Developing a personal management style

Writers and observers of management trends frequently refer to the need for managers to have a more involving, participative style, a "transforming" kind of leadership that helps people to find more in themselves to contribute than they thought possible. In Hugh Marlow's terms [13], this is the "ferryman," or woman, one of whose key skills is the ability to impart to the team the route by which the organization should move from the present to the achievement of tomorrow's goals. Similar ideas are expressed by Bradford and Cohen [14], who describe the model of the all-knowing manager, the "heroic" leader, as "severely outdated and inadequate." They describe instead the role of "manager-as-developer," a person who asks how problems can be solved in a way that further develops the commitment and capabilities

of staff. The increasing acceptance of this style suggests that more women may be suited to the emerging predominant style, which integrates logic and rationality with care, concern, and intuition. This is in line with Sargent's "androgynous" manager [15], in which the masculine and feminine qualities in each individual are blended to the best effect.

In the development of training for women, the trend in Britain is to help them to identify and enhance their own individual management style, to be unafraid to use intuition and trust, and to create good, open communications so as to motivate and carry staff forward. Building confidence in personal style is one of the basic tenets behind a new program developed at Ashridge Management College: Business Leadership for Women. In this program women who are already managers are given diagnostic frameworks and techniques to enable them to develop effective styles of leadership with which they feel comfortable. They are encouraged to be more aware of, and to enhance, their existing style while experimenting with a range of other styles to increase their repertoire and be more flexible and able to respond to the demands of the situation.

This approach, which takes into account a reevaluation of organization needs as well as personal development, underlies many of the programs offered throughout the country by organizations such as The Industrial Society (an independent body that works to improve relations between all employees and managements) and by continuing education efforts such as the Women and Work Units at the University of Aston and the Manchester Institute of Science and Technology.

Getting to the top

Among members of the boards of Britain's top 100 companies, as defined by turnover in *The Times 1000* [16], there are no women chief executives. Among the more than a thousand directors of these companies, there are only nine women. Two of these are full-time executives; the others hold nonexecutive posts and work in a part-time capacity on these boards, although some are employed as executives in other organizations. Several of these women seem to owe their appointment to family connections, and might be regarded as token appointments or as evidence of the British class system in operation.

It is important for Britain to address the situation of women in top jobs partly because the figures suggest that women are not maintaining

their share of these posts, and because there is a need to provide role models with relevant experience for the middle and junior managers who are now climbing up through the ranks. Many of the women who have achieved top positions have recently retired, or will do so shortly; for demographic reasons associated with the postwar "baby boom" and women's return to temporary domesticity, there is a missing generation. There is therefore a need to foster an awareness among senior managers, who are almost entirely men, that women are part of the pool of promotable talent.

A current focus of attention is to encourage the appointment of more women to the boards of companies and to the various statutory bodies and tribunals that are established by government departments. The pressure for this move comes from groups as diverse as the Fawcett Society, a long-established group for women's rights; the 300 Group, which is campaigning for women of all parties to stand for election as members of Parliament, with the aim of achieving 50 percent representation in the House of Commons (as opposed to 6.3 percent after the 1987 election); the Institute of Directors; and some government ministers, particularly those concerned with employment and small business.

Since 1983, the Management and Personnel Department of the Cabinet Office has published information on the number of women appointed to public bodies. The situation varies among departments. For example, women were appointed to 30.8 percent of public appointments available through the Home Office, but to only 3.2 percent of posts available through the Ministry of Agriculture, Fisheries, and Food. Overall, women were the recipients of 18.5 percent of such appointments in 1985, the most recent year for which figures are available.

In 1987 a major achievement by the Women's National Commission (WNC), the official body of advisers to the government on women's matters, has been to secure the publication of details of all 40,000 public appointments. This includes information about the government department that has responsibility for the appointment as well as the date on which it falls due. Such information was not previously available, and appointments were made in a manner that, perhaps unintentionally, appeared to be secretive.

An alternative strategy to getting to the top in existing organizations is being adopted by the increasing numbers of British women who become self-employed or start their own business. This is part of a

general trend, but the rate of increase between the years 1975 and 1985 was 76.5 percent for women compared with 23.8 percent for men [2]. By the end of 1985, there were 625,000 women and 1,918,000 men in self-employment.

The government is now actively encouraging women entrepreneurs. For example, the Minister for Small Business has been actively recruiting existing entrepreneurs to act as advisers to others just starting up. Support has also been given to training for women and for staff in government enterprise agencies and elsewhere to make them more receptive to business ideas put forward by women. Banks, for example, tend to react cautiously, and it is not uncommon for women entrepreneurs to have their requests for business loans rejected. Perhaps the most spectacular example is Anita Roddick, who was turned down for a loan in 1976, but used a £4,000 overdraft to found the highly successful Body Shop franchise chain, selling natural cosmetics and toiletries in plain plastic containers. In 1986 Roddick had 250 shops and pretax profits of more than £3 million.

Women themselves have, with the help of banks and government, established the Women's National Enterprise Agency and other similar information organizations to help women set up their own businesses.

Earnings

There are few available data on which to base detailed comparisons of the earnings of men and women in comparable management positions. However, a recently published salary survey commissioned by the British Institute of Management indicates that women in the same position as men are, on average, paid less [17]. The survey was based on the experiences of 356 companies, with more than 21,000 executives, and revealed that at several middle and senior management grades, women are paid up to £3,000 less a year than men. At more senior levels, the gap widens; at director level, it is around £11,000 (i.e., the average for women at this level is £29,965, whereas for men it is £41,007). However, the survey also shows that women are, on average, 6 years younger than men in comparable positions and that, during the year, women averaged a pay increase of 9.4 percent, compared with 7.8 percent for men. These two factors, age and rate of salary increase, suggest that companies are recognizing and promoting women. This is supported in the survey by the fact that 55 percent of the companies reported that they now have one or more women execu-

tives whereas this was the case for only 49 percent a year earlier.

Job segregation by sex still exists, and the fact that women achieve management positions in sectors in which women predominate means that unofficial pay differentials are perpetuated. Such anomalies may be reduced through the workings of the amendment to the Equal Pay Act of 1984 to take account of work of equal value. However, as each case has to be fought in isolation (as opposed to the concept of "class action" in the United States), progress is slow, and claims are rare: only one, by a cook at the Cammel Laird Shipyard, has come to judgment.

In occupations for which figures are readily available—in the Civil Service, for example—it is clear that there are still far higher proportions of men than women in the better-paid grades. In the Civil Service, 74.9 percent of the women are employed as clerical assistants, the grade that has the lowest rates of pay. Women hold only 2.6 percent of posts at the highest rank (Permanent Secretary) and 10 percent of those at the next level (Principal), and constitute 42.6 percent of the entry grade for management (executive officers).

Women managers and their families

The typical career/life plan as experienced by many women in Britain includes a short break for child-rearing. Statutory provisions for maternity leave enable full-time employees who have worked continuously for 2 years up to the 14th week before confinement to take 18 weeks' paid leave and a further 11 weeks' unpaid leave, with a right to return to work.

An increasing number of organizations offer extended leave to employees in identified categories with the right to return to a job at the same level. This is usually unpaid leave, although a retainer fee is sometimes paid as a contribution toward the cost of subscriptions to professional institutes, attending conferences, etc. The amount of time differs among organizations, from one year in some Local Authorities to five years in the Marconi Company and in the National Westminster Bank.

The banks, and now engineering companies as well, in which there is also pressure on human resources, have taken the lead in developing formal, published policies on career breaks. In other sectors a woman employee frequently has to negotiate her own arrangement. However, the amount of time taken for career breaks has been decreasing for all

women, including those in management and the professions [19]. There is no tradition of provision of child care by the state, and the need for geographic mobility precludes the use of members of an extended family. There is, however, a widespread tradition of registered child-minders and an increased supply of trained nannies, partly as a result of the difficult employment situation. High-earning women managers have shown themselves willing to spend significantly on these forms of child care, on either a daily or a residential basis, despite the fact that such expenditure does not qualify for tax relief. This solution, however, is not without its problems, as there is relatively little stability in the "nanny market."

Child care is a continuing concern for several years since children do not generally start school until five years of age (some, of course, do attend kindergarten on a fee-paying basis at a earlier age). The typical school day for young children is from 9 a.m. to 3 p.m., with the possibility of the child's returning home for lunch. Education authorities are currently debating the feasibility of changing the school day to the European system of an early start and lunchtime finish. If implemented, this will increase the pressure on parents, who will have to deliver the children to school at an earlier hour and arrange child care for the whole of the afternoon.

Dual careers

It is becoming more difficult for companies to overlook the real implications of dual careers. Professionals, both women and men, are likely to have spouses who also work in a professional capacity. This compounds the difficulty with regard to geographic mobility, which is often a requirement of promotion. The most favored solution in Britain is to encourage employees to take more responsibility for managing their careers and personal development plans. One result is that there is a small but growing band of long-distance commuters, partners who work in different parts of the country, or even in different countries of Europe.

Managing dual careers is not the only partnership issue for women managers. Among wives who are also full-time employees, approximately one in seven earns as much as, or more than, her husband. Popular surveys frequently show this to be a cause for concern to the women, who fear the stress this brings to the relationship. Working out new patterns for relationships that are mutually satisfying and can

withstand the comments of family and friends who are accustomed to traditional roles is a challenge for many couples. Work on the "No Barriers Here?" [20] follow-up project, which was carried out by Ashridge Management College to study the way men and women work together, suggests that women can often find support from male colleagues who have similar concerns.

External systems

Women managers in Britain are increasingly forming and developing their own contacts and networks. In most cases this is handled on a personal, usually informal, basis; but some companies are establishing, or are tacitly supporting, in-house groups for women. These may be large, and linked into the mainstream organization. Women in BP, for example, have their own program of speakers and carry out projects concerned with women's development, whereas Women in Rank Xerox is very informal and independent, just five to ten senior women who make a point of keeping in touch. External networks also attract company support. These include organizations such as Women in Management and The European Women's Management Development Network, which offer an information and training base to members.

Whereas previously almost all networks were based in London, a recent development is the growth of locally based networks for women managers. This is a good indication that women are breaking into management and other senior positions in more parts of the country and are creating their own support systems.

Summary and conclusions

More women are coming into management in Britain, and companies are starting to realize this. Recognition of the need and potential for women's management development is therefore growing. It is essential that women be properly trained and developed for higher levels of management; unless this need is met, the early investment companies make in introducing women into management will be wasted. For the foreseeable future, it will be necessary to continue to make some particular provision for training women, over and above including them in general management programs, to ensure that they will be able to benefit fully from such training.

Training, by itself, will clearly not increase the number of women in

senior management. To achieve this, women and organizations need to address wider issues concerned with structures, cultures, and social customs. Entry and promotion criteria will need to be expressed openly and clearly, so that women can prepare themselves and apply for senior posts and for appointments in a wider range of management areas. At the same time, recruiters and management development specialists need to be open to a wider range of possibilities and to recognize that leadership potential may be signaled in many different ways.

The indication that the salary gap is narrowing between women and men in management posts will need to be followed closely, as will the career progression of women who are now being appointed to senior positions. There are still very few women directors, but the number of women entrepreneurs and professionally qualified managers is growing. These women, as individuals and through the emergence of relevant networks, offer the possibility of role models and mentoring relationships to women in lower positions.

In the absence of any government initiative with regard to child care, some employers are leading the way, e.g., designing employment options to enable women to combine a family and a career. For most women, however, this remains an issue to be tackled on an individual basis, as is the growing issue of managing dual careers within the family unit.

There is a climate of opportunity for women in management in Britain today, but sustained pressure and action within organizations and by individuals will be required if women are to increase their share of management jobs substantially.

References

1. "GB Labour Force Survey, Revised Results." *Employment Gazette*, May 1987. London: HSMO.
2. "GB Employees in Employment: Historical Supplement No. 1, Table 1.1." *Employment Gazette*, February 1987, pp. 4–5. London: HSMO.
3. "GB Employment: Working Population, Table 1.1." *Employment Gazette*, February 1987, p. S9. London: HSMO.
4. *New Earnings Survey*, 1986, Part E, Table 138. London: HSMO.
5. *New Earnings Survey*, 1975, Part E, Table 138. London: HSMO.
6. "Students and Staff." *University Statistics*, 1984–85, Vol. 1, Table 1. London: HSMO.
7. Tarsh, J. (1986) "The Labour Market for New Graduates." *Employment Gazette*, October, p. 427. London: HSMO.
8. Forrester, P. G. (1986) *The British MBA*. Bedford: Cranfield Press.
9. Equal Opportunity Commission (EOC) (1986) "Women's Membership of

Selected Management and Professional Institutions." *Women and Men in Britain: A Statistical Profile*. London: EOC/HMSO.

10. Ashridge Management College (1980) *Employee Potential: Issues in the Development of Women*. London: Manpower Services Commission and the Institute of Personnel Management.

11. Glucklich, P. (1985) "Reflections on Training Men and Women to Work Together." *Management Education and Development, 16,* Part 2, pp. 224–29.

12. Boydell, T., Pedler, M., and Hammond, V. (1986) *A Guide to Self-development Groups for Women Managers*. Sheffield: Sheffield City Polytechnic and the Manpower Services Commission.

13. Marlow, H. (1984) *Success: Individual, Corporate and National*. London: Institute of Personnel Management.

14. Bradford, D. L., and Cohen, A. R. (1984) *Managing for Excellence*. New York: Wiley.

15. Sargent, A. (1983) *The Androgynous Manager: Blending Male and Female Styles for Today's Organizations*. New York: American Management Association.

16. Allen, M. (1986) *The Times 1000 1986–87*. London: Times Books.

17. British Institute of Management (1987) *BIM National Management Salary Survey*. London: Remuneration Economics.

18. *New Earnings Survey*, 1985, Part A, Tables 8 and 9. London: HSMO.

19. Martin, J., and Roberts, C. (1984) *Women and Employment, A Lifetime Perspective*. London: HMSO.

20. Manpower Services Commission (1981) *No Barriers Here?* Sheffield: Manpower Services Commission.

11

Dafna N. Izraeli

Women's Movement into Management in Israel

This study examines recent trends in women's entry into management in Israel. It identifies four macrolevel developments that have been conducive to women's attaining managerial positions during the last decade—the demand for educated workers, the entry of management into academe, increased levels of managerial differentiation, and changed social norms—and traces the demographic patterns associated with these developments. The main contention is that during the last decade, women entered managerial positions in economic branches in which structural and economic changes created new opportunities and resulted in a decreased level of competition among men for managerial positions.

This hypothesis was tested with data from Labor Force Surveys for 1975 and 1982, three measures of decreased competition being used. The findings support the hypothesis. However, although market forces led to an increase in the number of women managers, they did not result in a decreased level of sex segregation of the occupations. Women's underrepresentation, especially at the more senior levels, needs to be understood within the framework of the rocesses of both managerial and familial reproduction, and the impact of these processes on women in Israel is analyzed.

People do not usually begin their occupational careers as managers: they are generally promoted to managerial positions from lower levels in the hierarchy. In this respect, management is more than an occupation; it is a location in the formal hierarchy of authority and command. Managers congregate at the apex of organizational structures. Access to more of such benefits as economic rewards, social deference, power and autonomy, and challenging work—and to symbolic benefits such as bigger and newer cars, personal secretaries, and the right to privacy— frequently requires moving up the ladder [1]. The relevance of study of women's entry into managerial roles therefore extends beyond the

problem of desegregation of a traditionally male occupation. It speaks to the more general issue of the sex stratification of organizations and the sex structure of the distribution of valued resources within them.

This study examines recent trends in women's entry into management in Israel. It identifies three macrolevel developments that have been conducive to women's attaining managerial positions during the last decade. It then tests the impact of these developments on women's movement into and through the occupation of manager.

The main contention of this study is that during the last decade, women entered managerial positions in economic branches in which structural and economic changes created new opportunities and resulted in a decreased level of competition among men for managerial positions. When competition drops, gatekeepers become less selective and are more willing to experiment with candidates who do not meet all the social criteria, including that of being male. Women, in turn, are encouraged by the more realistic prospects of promotion, and are more likely to act to advance their own careers [2. Pp. 4–7]. I conclude that the macrolevel developments and market forces have been insufficient to overcome the barriers to women's advancement into management. Although there was an impressive increase in the absolute number of women managers during the last decade, there was no significant change in the level of sex segregation of the occupation.

The factors that impede women's access to positions of power have been well documented. (For reviews see references [3–6].) This study examines the constraining impact of two factors that are unique to Israel as a modern, industrialized, democratic society: the role of the military in the reproduction of managerial elites, and the role of a family-centered culture in the structuring of women's occupational opportunity. I suggest that women's continued absence from more senior-level positions must be understood within the framework of the processes of both managerial and familial reproduction and their impact on women.

The setting

During the 1970s the absolute number of women managers in Israel increased by more than 65 percent. Many of the conditions that explain a similar development in the United States, however, are not applicable to Israel.

In the United States, changes in the laws and the creation of affirmative action programs impelled business and educational institutions to

open their ranks to women [7. Pp. 6–8]. These changes gave organiza-
tions incentives to seek, recruit, train, and promote women, and gave
women incentives to invest in training and make the commitments
necessary for their advancement. The trend toward delayed marriage
and/or childbirth and a decline in female fertility, by freeing women to
compete for jobs in time-intensive occupations, made undertaking such
commitments possible. Among the causes of fertility reduction were
"the declining value imputed by society to other people's children and
the resulting efforts by governmental authorities to make birth control
possible" [8. P. 57].

None of these developments occurred in Israel. There is no specific
law that prohibits discrimination in assignment or promotion. Legisla-
tion in Israel is essentially protective in nature [9],[1] and the main thrust
of social policy is concern for the working woman in her role as mother
and housewife; her role as worker gets much less attention [10. P. 51].
Moreover, demographic trends for the country as a whole do not indi-
cate a change in marital and childbearing patterns [11]. Using com-
parative data from other countries, Peres and Katz [12. P. 688] demon-
strate that although Israel is a modern society by cultural, economic,
and political criteria, its high marriage rate and low divorce rate resem-
ble those of traditional and predominantly agrarian societies, and its
birthrate falls midway between that of European and Middle Eastern
countries.

Despite the rapid industrialization that took place in Israel during the
1960s and the 1970s, the marriage, divorce, and birth rates remained
remarkably stable [12. P. 689], and so did the average age of first
marriage for women—around 22.9 years [13. P. 84]. Between 1975 and
1981, however, the average age at marriage increased by nine months
for women and by eight months for men. Family in general and children
in particular are highly valued. Young women perceive motherhood
and homemaking as normatively more salient than being employed
[14].

Peres and Katz [15] found that even among the more modern women
(educated, secular, Jewish women of European-American origin), the
number of children desired and the fertility rate had a significant
impact on employment, including whether a woman would take a part-
time or full-time job. They concluded that the mandate of the tradition-
al female role remained a powerful force in women's employment
decisions.

From the data in Table 1 we observe that the marital status of women

Table 1

Percentage Distribution of Israeli Managers and of Women Employees by Marital Status, 1975 and 1982

	Year	Single	Married	Widowed or divorced
Women	1975	15.7	71.4	12.9
managers	1982	12.4	75.2	12.4
Women employees (Age 30 or				
more years)	1982	8.3	79.7	12.0
Men	1975	3.6	93.8	2.4
managers	1982	5.3	92.6	2.0

managers is not significantly different from that of the total female labor force aged 30 or more. Between 1975 and 1982 (the period with which this paper is concerned), the proportion of married women managers even increased. Compared with other major occupational categories, a larger proportion of women managers and administrators have no children under age 14 living at home [16. P. 286]. The paucity of small children in the home reflects more the tendency to enter management at a later stage in the life cycle than a preference for a career over parental functions.

Despite the high commitment to family life in Israel and the lack of affirmative action legislation, there has been a significant increase in the number of women managers in recent years. Explaining and assessing that development and identifying the patterns of entry are the major tasks of this study.

Who is a manager?

According to the Israel Central Bureau of Statistics, in 1983 there were some 62,950 managers and administrators; 7,400, or 11.8 percent of them, were women [17. P. 366]. In 1973 there were 35,000 managers and administrators, of whom 2,450, or 7 percent, were women [17. P. 366]. There is cause to suspect, however, that there is a downward bias in the reported number of managers and administrators that is an artifact of categorical definitions. For example, in the United States, 11 percent of the labor force is classified as executive, administrative, or managerial [18. P. 38], compared with only 4.7 percent in Israel [17. P.

366]. In the United States, however, 11.5 percent of all managers are employed in mining and manufacturing [18. P. 40], compared with 34.5 percent in Israel [16. P. 216]. The first difference suggests that many persons classified as managers in the United States are "defined out" of the category in Israel, and the second, that there is a definitional bias in favor of industries in which there are relatively few women managers compared with other economic branches.

For the purpose of this study, therefore, the definition of the category of manager has been expanded to include a larger number of occupational categories in which coordinating and managing the work of others are a major component.[2] The data throughout this study, unless otherwise stated, are based on this broader definition.

Socioeconomic developments and their impact on women: Getting a foothold on the rungs of the managerial ladder

A number of macrolevel developments that crystallized toward the end of the 1960s created favorable conditions for women to get a foothold on the rungs of the managerial ladder. Three of these are discussed below: the demand for workers, the elevation of management to an academic discipline, and increased organizational differentiation. A fourth development, the changes that occurred in social norms regarding women's employment, although important in its consequences, is not specifically addressed in this study.

Demand for workers

The rise in the standard of living and the expansion of financial, public, and community services following the 1967 war were accompanied by a demand for more workers [19]. Although Arabs from the administered territories met the need for additional unskilled labor, there remained a shortage of qualified males to fill the new clerical, administrative, and professional positions. At the same time, a number of factors reduced the rate of growth of the Jewish male civilian labor force. The expansion of the professional army and the extension of compulsory military service from two to three years (and for women from one-and-a-half to two years) siphoned off potential labor; the increase in university registration extended the moratorium on labor-force participation; and the aging of the population further curtailed

the pool of available labor. (Oppenheimer [20] has indicated that similar conditions prevailed in the United States: a shortage of the preferred kind of labor—males—which predisposed employers to experiment with hiring female substitutes.) Successful experience with women in positions of responsibility reinforced readiness to employ them. The fact that military reserve service, currently up to 45 days a year until approximately the age of 55, is required of men increases the attractiveness of women to employers.

Management as an academic discipline

Until the 1960s, the development of a cadre of skilled managers was discouraged by the overriding importance given to political considerations. The Mapai (Labor) Party, which was the dominant political force in the country from the mid-thirties until 1977, sought to consolidate its political control of the economy through a policy of strategic selection and placement of personnel in the public and labor-owned sectors of the economy. Political appointment extended to middle and even lower levels of management [21]. Active female party members, who were few to begin with, tended to be routed to managerial positions through the women's sector—i.e., the party's women's organizations and affiliated welfare services [22].

A decline in the power of the party/state to mediate job placement and a push on the part of business and management to emphasize "market" criteria in general (including technocratic criteria for management positions), in order to carve out and strengthen their position, were among the factors that led to considerable depoliticization of the economy, which, in turn, facilitated growing recognition of the technical requirements of management. Moreover, the increased demand for technically qualified managers led to a closer link between various sectors of the economy and the educational system. Management as an occupation entered academe; university education came to be regarded as necessary cultural capital, especially for those just entering management. Training in any even tangentially related discipline was considered an asset; the demand was not necessarily for a degree in management, but for proof of relevant higher education.

The upward drift in educational requirements for administrative and managerial positions is reflected in the changing job descriptions in the civil service. A survey of job descriptions over the last 20 years reveals that positions for which a high-school diploma was sufficient in the

early 1960s required a first, or even a second, university degree by the end of the 1970s. In 1975, years of education for male managers averaged 12.2, and for female managers, 13.1; in 1982, the figures were 12.7 and 13.6 years, respectively. During that 7-year period, the average age of the men dropped from 52.8 years to 44.7, and of the women, from 47.7 years to 41.5, reflecting the recruitment of new managers from among younger people, primarily those with some university education.

These processes were accompanied by rapid expansion of the universities and of the number and proportion of female students. The first M.B.A. program was established at Hebrew University in about 1960. Today, all six Israeli universities grant degrees in management, and there are a number of institutions with diploma-granting programs. Between 1965 and 1982, the university student body grew by 300 percent, and the proportion of female students increased from 42 percent in 1971 to 47 percent in 1981. Between 1973 and 1982, the proportion of female students in management and business administration increased from 12.4 percent to 21 percent. In 1982 women constituted 50 percent of the students in the social sciences, 39 percent of those in law, 36 percent of those in mathematics, statistics, and computers, and 13 percent of those in engineering [13].

The entry of management into academe and the new focus on professional knowledge and expertise, in contrast to the emphasis on personal leadership qualities and ascriptive criteria (including the charisma attached to being male), gave women the possibility of developing a legitimate basis for their managerial authority. The universities supplied credentials of competence and authority based on expertise. The fact that 37 percent of the female managers, compared with 27 percent of the male managers, have 13 or more years of education reflects the greater importance of accreditation for women than for men. The establishment of institutions with universal criteria for entry and advancement provided women with an opportunity to accumulate cultural capital independent of the workplace, but transferable to it [23].

Organizational differentiation
and specialization

The development of a cadre of skilled managers had been impeded by an overall government policy that subsidized enterprises regardless of their productivity, emphasizing, instead, their function as providers of

work for new immigrants [21. P. 135]. By the mid–1960s, the economy had integrated the nearly doubled labor force into productive employment [24. P. 93]. The military victory of 1967 marked the end of a two-year recession that led both to a search for foreign markets and to a heightened awareness of the need for more skilled managers to compete effectively in foreign markets [19,25].

These developments, plus the introduction of more-advanced technology, resulted in an increase in staff functions and new managerial specializations in a number of economic branches. Organizational growth, especially in the finance and business services branch, caused an increase in the number of middle-level supervisory positions. Organizations in public and community services, which employ large numbers of women in professions such as teaching, nursing, and social work, became somewhat more decentralized and introduced new supervisory and administrative positions.

In the 1960s, most of the managers with university training were either engineers—particularly in industry—or economists employed extensively in public administration. When Barad and Weinshall [26] looked for a sample of women for their pioneering study of women managers, they selected them from the lists of women graduates in engineering and economics, on the assumption that these were the ones most likely to be in the managerial recruitment pool. During the 1970s there was an accelerating demand for managers to specialize in such areas as marketing, public relations, organizational research and development, and human resources development—relatively new specializations with as yet no clear sex label or institutionalized status sequences [27]. The new specializations drew potential candidates from a wide catchment area, including niches that contained a high proportion of women, e.g., lower-level clerical workers and university graduates in the humanities and social sciences. Work with computers was another new area receptive to women, whose early entry was assisted by opportunities for computer training given them in the army since the early 1970s. (For the impact of the army on women's civilian occupations, see Izraeli [28].)

Some hypotheses

I have reviewed a number of developments that I contend created congenial conditions for women's advancement into managerial positions. Using cross-sectional data, I shall consider the impact of these

developments on women's movement into and within management. Four hypotheses have guided my analysis.

Female labor-force and task continuity

Those at higher levels in organizational hierarchies are generally re- cruited from among those who have served at lower levels. A major constraint on the advancement of women is their relative absence from the labor pools from which managers are recruited [29]. An increase in the number of women available at lower levels increases their represen- tation in recruitment pools and thus the *possibility* of their advancement to higher levels. Also, there is greater acceptability of women as man- agers supervising other women. Moreover, it may be suggested that pressure from women to rise in the ranks (especially once their family obligations decline) is greater where there are more of them. Third, all other things being equal, female-intensive labor forces are found in (and cause) lower overall wage levels, thus making it more difficult to sustain the privileged rewards attractive to men at higher levels in the hierarchy. I expected, therefore, that the proportion of women manag- ers would be greater in economic branches in which the proportion of women employed was greater.

The availability of a group in the human resources pool makes it feasible to promote members of that group. The probability that they will in fact be promoted to managerial positions, however, depends on the nature of the linkage between lower and upper levels of the hierar- chy.

Offe's [30] distinction between situations of "task continuity" and "task discontinuity" is here instructive. Task continuity exists where people at higher levels of the organization are familiar with the work of those at the bottom, generally because those who manage the work are recruited from among those who carry it out. In situations of task discontinuity, those at the top do not have the same skills as those at the bottom, and are recruited from sources other than from among those at the lower levels who perform the major tasks of the organization. The recruitment of production managers from a pool of engineers rather than from among production workers is an example of task discontinu- ity; the recruitment of school principals from the pool of teachers illustrates task continuity or, in other words, a continuous occupational hierarchy.

The stronger the link between tasks performed at the bottom and the

requirements of task performance at the top, the stronger the impact of women's presence in the labor force on their participation in managerial positions. Our hypothesis, then, may be refined as follows:

Hypothesis 1: Economic branches in which there is a larger proportion of women at the lower levels and in which the situation is one of task continuity have a greater proportion of female managers than ones in which either (or both) of these two conditions does not exist.

The effects of sex proportion

A number of recent studies provide empirical support for Kanter's [1] contention that the proportion of women in a group or organization has a significant impact on social interaction [31–34]. According to Kanter, many of the debilitating effects of performance pressures observed in groups in which women constitute only a very small proportion of the membership decrease significantly as the sex ratio becomes less skewed. Women's achievements are greater [31]. Moreover, they are less likely to be trapped in stereotypical roles and are apt to feel more influential [32] when they constitute a greater proportion of the members than when they are part of male-dominated groups.

Study findings suggest that units or occupational groups within organizations that have a higher proportion of women are more "female friendly" in the sense that they provide conditions more favorable for women's successful performance and integration into the group and/or organization. It might therefore be expected that the proportion of women managers present in an occupation or economic branch would have an impact on the rate of increase in the number of women managers over time, that branches with a higher proportion of women managers in 1975 would have a greater proportional increase in women managers between 1975 and 1982 than those with a lower proportion of women managers.

Hypothesis 2: The contribution of women to the net growth in the managerial labor force will be greater in economic branches in which the proportion of women managers is greater.

Expansion of opportunity

A rapid growth in the demand for managers may impel gatekeepers to increase the managerial market by expanding the boundaries of existing labor pools to include nontraditional recruits. Assuming there are occu-

pationally qualified women available, the increased demand will create new opportunities for women. Successful experience with women in management reinforces readiness to promote other women to managerial positions, and the presence of female role models and the expansion of the boundaries of recruitment provide incentives for women to seek advancement.

Hypothesis 3: The proportionate increase in women managers is greater in economic branches in which the proportionate growth in the total managerial labor force is greater.

Occupational differentiation

In addition to market forces of supply and demand, another factor associated with women's movement out of sex-segregated occupations is the creation of new occupations, or of specializations within existing occupations, that initially either have no sex label or have characteristics perceived to make them "suitable for women" [23]. In other words, it was hypothesized that the rise of new specializations within management and the process of increasing differentiation of the field created employment niches more receptive to women's entry than the more-traditional managerial enclaves had been.

Hypothesis 4: The proportionate increase in women managers is greater in economic branches in which the rate of occupational differentiation of management is greater.

Findings

The hypotheses were tested with unpublished Labor Force Survey data collected by the Israel Central Bureau of Statistics for the two years 1975 and 1982.[3] Table 2 presents the distribution of managers among occupational subcategories for these two years. The subcategories "general managers" and "administrators" in the public sector are those used by the Central Bureau of Statistics in defining managers and administrators and refer generally to senior-level managers in relatively large organizations. The other three subcategories—school principals and supervisors, supervising clerks and inspectors, and working proprietors or owner-managers—were added for the purpose of this analysis.[4] Clerical supervisors are primarily lower- and middle-level managers; owner-managers include proprietors in the retail, wholesale, restaurant, and hotel trades.

Table 2

Distribution of Israeli Managers by Occupational Subcategory and Sex, 1975 and 1982

Occupation	Total	1975 Women	% women	Total	1982 Women	% women
Total	97,200	12,021	12.4	130,800	20,842	15.9
General managers	28,391	1,737	6.2	46,257	4,815	10.4
Administrators in public sector	6,297	667	10.6	7,244	750	10.4
Owner-managers: retail, wholesale lodging	45,061	5,420	12.0	48,811	6,922	14.2
School principals and supervisors	3,878	1,110	28.6	5,497	2,237	40.7
Clerical supervisors	13,573	3,087	22.7	22,990	6,118	26.6

Hypothesis 1 predicts a relationship between the proportion of women among the total employed in an economic branch and the proportion of women among total managers in that branch. Table 3 lists the economic branches in ascending order of proportion of women employed in the branch (column 1). We observe that, with one exception (government and local authorities administration), the larger the proportion of women employed in a branch, the larger the proportion of women managers in that branch. The ratio of women employed to women managers is two or three to one. In government and local authorities administration, there is an unusually large proportion of managers compared with those employed, which may be explained by the fact that 62 percent of the managers in this branch are "clerical supervisors"—that is, lower- and middle-level managers—whereas all other branches have from a minimum of 1 percent (commerce) to a maximum of 38 percent (agriculture) in that subcategory and a larger proportion of more-senior managers.

The branch with the greatest hierarchical continuity is education services, in which 71 percent of the managers are school principals and supervisors promoted from the ranks of teachers. In the recruitment pool for school principals and supervisors, women have a strong competitive advantage over men in terms of numbers and qualifications. The scarcity of men is enhanced by the fact that they are concentrated in

Table 3

Percentage of Women of Total Employed and of All Managers in Israel and Contribution of Women to Net Growth in Managers in 1975 and 1982, by Economic Branch

Economic branch	Women as % of employed[a] 1982	Women as % of all managers[b] 1975	1982	% contribution of women to net growth, [c] 1975–1982
Total	36.6	12.4	15.9	26.3
Agriculture, utilities, construction, & transportation[d]	15.8	3.9	9.1	24.1
Industry	24.3	2.3	7.0	12.3
Commerce, restaurants, & hotels	34.8	11.8	13.6	29.3
Finance & business services	49.1	15.4	18.1	20.4
Personal & other services	47.8	18.7	24.1	43.7
Government & local authorities administration[e]	34.7	21.4	26.2	44.3
Health & welfare services[e]	72.6	20.4	26.8	44.5
Education services[e]	72.1	30.8	40.4	53.6

[a]Number of women employed divided by total number employed.
[b]Number of women managers divided by total number of managers.
[c]Number of women managers in 1982 minus number of women managers in 1975 divided by total managers in 1982 minus total managers in 1975.
[d]Four smaller economic branches were combined all of which had relatively few women employed in them and few women managers: agriculture, forestry, and fishing; electricity and water; construction and transportation; storage and communication. This applies also to Tables 4 and 5.
[e]These three subbranches of "public and community services" were disaggregated because of the large proportion of women managers in them. This applies also to Tables 4 and 5.

the sex-segregated, religiously orthodox, school system, in which men and women do not compete for the same jobs.

In Israel, heads of social welfare agencies were, until the mid-seventies, frequently recruited from pools of other than social workers, including schoolteachers and principals, youth-movement leaders, and party functionaries. Pressure from the union of social workers was one of the factors that made being a trained social worker a necessary requirement for promotion, which increased the task continuity of the

Table 4

Percentage Growth from 1975 to 1982 in Total Managerial Labor Force and in Female Managerial Labor Force in Israel, by Economic Branch

Economic branch	Growth in managerial labor force, 1975–1982, %[a]	Growth in female managerial labor force, 1975–1982, %[b]
Total	35	73
Finance & business services	116	154
Industry	89	213
Education services	72	126
Health & welfare services	36	80
Agriculture, utilities, construction, & transportation	35	213
Personal & other services	28	65
Government & local authorities administration	27	56
Commerce, restaurants, & hotels	11	28

[a]Total managers in 1982 minus total in 1975 divided by total in 1975.
[b]Female managers in 1982 minus female managers in 1975 divided by female managers 1975.

occupation, as reflected in the growth in proportion of managers in the health and welfare services. This example reflects the fact that the definition of continuity is social, not technical; it is the outcome of a struggle among contending groups (male and female, among others) concerning determination of acceptable qualifications for filling top positions.

Hypothesis 2 predicts a relationship between the proportion of women managers in a particular branch in 1975 and the rate of increase in women managers, here measured as the proportion of women's contribution to the net growth in managers between 1975 and 1982. Comparing columns 2 and 4 in Table 3, we observe a definite pattern, women making a significantly greater contribution to net growth in the four economic branches in which they constitute a relatively larger proportion of the managers. Therefore, this hypothesis is supported.

Hypothesis 3 predicts a relationship between the growth in the total managerial labor force and the growth of the female managerial labor force. The association between the two columns in Table 4 is clear; there is only one anomaly: agriculture, utilities, construction, and transportation, in which the number of women managers employed

Table 5

Managers as Percent of All Employees, Increase in Managers as Percent of All Employed, and Percent Increase in Total Female Managers in Israel, 1975 and 1982, by Economic Branch

Economic branch	Managers as % of all employed[a]		Increase in managers as % of all employed[b]	% increase in female managers[c]
	1975	1982		
Total	8.7	10.1	16	73
Industry	3.9	6.8	74	213
Finance & business services	8.3	11.4	37	154
Agriculture, utilities, construction, & transportation	4.4	5.9	34	213
Education services	3.5	4.4	26	126
Health & welfare services	5.0	5.9	18	80
Government & local authorities administration	11.1	12.0	9	56
Personal & other services	1.6	1.7	6	64
Commerce, restaurants, & hotels	36.1	34.9	-3	28

[a]Total number of managers divided by total number employed for each year.
[b]Number of managers in 1982 minus number in 1975 divided by number in 1975.
[c]Number of female managers in 1982 minus number in 1975 divided by number in 1975.

more than doubled although the number of total managers increased by only 35 percent, a finding for which we have no explanation.

Hypothesis 4 predicts a relationship between rate of occupational differentiation (specialization) and rate of increase in the proportion of female managers. Rate of occupational differentiation was measured by comparing the ratio of managers to total employed in 1975 and the ratio of managers to total employed in 1982 (columns 1 and 2 of Table 5). Column 3 in Table 5 presents the proportionate growth in that ratio. Growth in proportion of managers to those employed reflects the process of specialization among managers.

Support for this assumption was found in the case of the industrial branch, which had the highest rate of differentiation (Table 5, column 3) and in which 75 percent of the increase in managers took place among the subcategory "other managers." According to Central Bureau of Statistics data [35. P. 180; 16. P. 214], the majority of new "other managers" came from specializations such as marketing, public relations, and personnel [36. P. 38]. Comparing the figures in

columns 3 and 4 of Table 5, we observe a relationship between the two measures. Generally, greater differentiation is associated with a greater proportionate increase in female managers. An alternative or additional explanation may be that the spread of academic training in management makes it necessary to call jobs "managerial" in order to attract graduates; the proliferation of new managerial titles, then, may reflect a downgrading in the new positions that are allocated to women.

Discussion

The major argument of the present analysis is that, given the absence of external intervention and the centrality of family life, any change in women's access to managerial positions in Israel required an improvement in their competitive position vis-à-vis men as a result of changes in the structure of the occupation and in market conditions. The data generally support my hypotheses. The proportion of women managers was greater in economic branches with high task continuity and a greater proportion of women employees. Moreover, women made a greater contribution to net increase in managers where the proportion of women managers was greater.

The most impressive gains women made in attaining managerial positions were in education services, in which, in the last decade, the proportion of males in the managerial recruitment pools (teachers) dropped severely. They also contributed over 40 percent to the net increase in managers in the three public and community services subbranches (education services, health and welfare services, and public administration), in which women constitute the majority of employees. The proportionate increase in women managers was greater in economic branches with greater growth in the managerial labor force and in the rate of occupational differentiation. Women made gains in the category "other managers" primarily in the newly emerged specializations in which high demand and lack of a clear sex label improved their competitive edge.

How are we to assess the gains made? Two points need to be emphasized. First, the major gains made by women have been into lower- or, to a lesser extent, middle-level managerial positions, the supervisory subcategory. They concentrate in staff rather than line positions. Although no systematic data are available concerning the managerial level of women in the economy, anecdotal evidence suggests that there are very few in senior positions. For example, in one of Israel's three

largest banks, women constitute approximately 50 percent of the employees but only 13.7 percent of the "signing" officers, the great divide between lower- and higher-level employees. The great majority of the women are in staff positions; whereas 32 percent of the men are signing officers, only 4.5 percent of the women hold that title.

Women constitute only 3 percent (120 of 4,000) of the members of the Israel Management Center. In the recently formed senior marketing managers' club at the Center, not one of the handful of female candidates who applied was considered senior enough to qualify for membership. In the civil service, women constitute 51 percent of the employed: 20 percent of those in the top five grades of the professional hierarchy (high task continuity), and only 11 percent of those in the top five grades of the administrative hierarchy.

Perhaps more important is the fact that the level of sex segregation in management did not change during the period studied. Segregation is measured by comparing the proportion of women managers with their proportion in the labor force. The latter grew from 32.6 percent to 36.9 percent, and the former from 12.4 percent to 15.9 percent. In other words, whereas the proportion of women in the labor force grew by 4.3 percentage points, their proportion among managers grew by 3.5 points, suggesting that management has become an even somewhat more sex-segregated occupation. The proportion of women in Israeli management in 1982 was equivalent to that in the United States in 1960 (15.6 percent) and 1970 (16 percent), before enactment of affirmative action legislation, and considerably lower than that in the United States in 1982—28 percent.[5] In the absence of affirmative action legislation, such macrolevel developments as the increased demand for managers, greater specialization, academic preparation for the occupation, and an increased supply of technically qualified women were insufficient to impact significantly on the constraints women faced in attaining managerial jobs, particularly at more-senior levels.

The military and the reproduction of elites

To understand why women were constrained from accumulating social capital to improve their competitive edge and from exploiting the opportunities market forces opened up during the period under investigation, we need to consider the issue of women in management within the framework of the processes of managerial reproduction, or even within the more general framework of elite reproduction [37. P. 186].

This perspective is reflected in the above analysis of the role of the Labor Party and, later, of the universities as processors of aspirants to managerial positions. The kibbutz is another important recruitment pool for elite positions. Kibbutz members are disproportionately represented in the senior managerial positions within the labor-owned economy, which employs approximately 25 percent of the civilian labor force. These managers are selected primarily from such roles as kibbutz secretary, treasurer, or head of an economic branch, positions rarely filled by women.

The dominant elite-producing institution in Israel, however, is the Israel Defence Forces (IDF). Military policy, which prohibits women from participating in combat, and the structural arrangements that emanate from that policy virtually exclude women from the process of elite reproduction.

Rein [10. P. 67] points out that in 1954, Moshe Dayan, as Chief of Staff, drew up a plan to facilitate the retirement of army officers at the age of 40 and bribed reluctant "pensioners" with the top jobs in society. She quotes Shabtai Teveth [38. P. 223], noted authority on Dayan, who writes:

> Dayan's concept had a far-reaching influence on Israeli society. His "Double life" plan let loose into civilian life forty year old ex-officers— talented, ambitious, vital men at the height of their powers. The economy began wooing these pensioners with offers of top-level positions, so much so that the profile of Israeli society assumed an increasingly military aspect. . . .

Initially drawn into the public and semipublic sector, after 1973, officers were increasingly recruited into the economic enterprises of the private sector as well.[6]

The dynamics and functions of homosocial reproduction have been analyzed by a number of researchers [1,3,39–41]. The diffusion of military personnel throughout the managerial elite is self-reinforcing: those already in management posts seek other officers with whom they share a leadership culture and on whom they can rely for support.

Yariv,[7] who studied 146 retired male lieutenant-colonels and colonels, found considerable continuity in the officers' two careers: those who had served in combat units were later employed as general managers, whereas those who had had office jobs were later employed in functional or staff positions. It should be added, however, that at some time in their careers, even senior officers with desk jobs generally do a

stint in a combat role, which is considered a necessary qualification for promotion to the higher ranks. The process of their transition to the civilian market is facilitated by preretirement opportunities to acquire university accreditation. The training both provides needed expertise and skills and functions as a resocialization mechanism for adjusting to the different reality of civilian organizational life. Thus, an officer develops an alternative career while still serving in the army [42].

In 1979, an employment office for retiring senior officers was established. The fact that officers today face greater difficulties finding suitable employment in the civilian market reflects in large measure processes such as the increase in supply of officers and the contraction of market opportunities in recent years, but does not contradict the fact that a high proportion of senior positions are filled each year by retiring officers.[8]

Becoming an officer enhances a woman's self-image and achievement motivation [43]. It also increases the likelihood of her getting a managerial job.[9] As a management reproduction mechanism, however, the system works primarily for men, not for women. The single most important reason is that although women undergo compulsory military service, they do not take part in combat. Consequently, they are not exposed to the same intensive training and experience that are believed to contribute to the development of the special leadership skills and authoritative personality of the Israeli officer. This fact sets a ceiling on women's upward mobility within the armed forces.

Their exclusion from the core activities of military life and from the locales in which these are carried out severely limits women's opportunities for gaining (relevant) visibility: for establishing connections with the "old boy" network so instrumental for postarmy positioning; for becoming effective bearers of the most valued national symbols—those associated with duty; and for moving to the senior ranks that provide training, experience, and social capital highly valued in the civilian market. The highest-ranking woman, including the head of the Women's Corps, is a colonel; and there is only a handful of colonels. There are no women in the two ranks below chief-of-staff. Few women achieve ranks above those that are acquired routinely with time and satisfactory performance and attain those that for men serve as accreditation for direct access to the most senior positions in the economy.

Women officers serve primarily in the Women's Corps, in which they are assigned to welfare and social services roles, or in the general army, in which they serve largely in administrative and professional

positions. As noncombat officers, by definition they play secondary roles [44].[10]

Family-centeredness as a disincentive
for seeking managerial roles

Israel is a family-centered society. The family is the focus of all important national, religious, and personal celebrations.

> Social interaction is built on the assumption that adults are paired off at the beginning of their twenties and continue to live as couples. There are no social or cultural patterns for singles—men or women. . . . Children are considered extremely important for the wholeness of the family and for the personal happiness of the individual. [14. P. 2]

The divorce rate in Israel is about one-fourth that in the United States; approximately 97 percent of the population marry by age 40, and the average family has 3 children [12]. Although valued by both sexes, the family impacts differently on men's and women's occupational roles. In a study of men and women in middle-level and high-ranking jobs, Gafni[11] found no sex difference in relative importance attributed to career and family. Her data show, however, that for women there is a significant negative correlation between relative importance attributed to family and preference for a job that entails making decisions and exerting authority ($r=0.32$, $P \leq 0.001$), aspirations for a more-senior managerial position ($r=0.26$, $P \leq 0.001$), perceived chances for advancing to a more-senior position ($r=0.26$, $P \leq 0.001$), and belief that she is qualified for a senior managerial position ($r=0.23$, $P \leq 0.001$). None of these correlations is significant for men.

Working women in Israel use a number of strategies to cope with what Coser and Coser [45. Pp. 91–92] term the "conflict of allegiance" that arises because there is a normative expectation that a woman will give priority to her family. They gravitate toward part-time jobs and jobs that are synchronized with the children's school schedule, such as teaching, or that have flexible working hours, such as nursing or social work. Even within the professions, women tend to concentrate in specializations or locales that permit control over timetables. For example, with the exception of pediatrics, 83.4 percent of women doctors specialize in areas that have been rated by independent judges as high in permitting time control, compared with 38 percent of men doctors who specialize in such areas.[12] Congenial and fixed working

hours are among the major attractions of the civil service, in which women constitute 84 percent of the pharmacists and 53 percent of the lawyers [46. P. 194], compared with 46.2 percent and 40.6 percent, respectively, in the labor force [16. P. 210]. In two studies of educated respondents, women cited convenient working hours as a preferred job characteristic significantly more often than men [47].[13] In short, caught in the "greedy" institution of the family [45], women cope by avoiding demanding or "greedy" occupations.

Management has none of the characteristics that make it easy for a woman to juggle her multiple roles. It is resistant to part-time work. Only 21.4 percent of female administrators and managers work part time (less than 25 hours a week), compared with 47.3 percent of female academic workers and 47.1 percent of other professional and technical workers [13. P. 373]. Although managers generally have more discretion in determining their work schedules than do lower-level employees, their work load is less predictable and more likely to expand beyond official work hours. In addition, working overtime has important symbolic value as an expression of one's commitment to the organization.[14] In this sense, the managerial role intrudes more sharply into the domestic time sphere than do other occupational roles and is likely to elicit resentment from spouse and offspring and arouse guilt in the mother. This may explain why only 50 percent of female administrators and managers who are not single have children at home under the age of 14, compared with 67.5 percent of academic and professional workers and 73.7 percent of other professional and technical workers [48. P. 174].

The managerial role produces another form of conflict, which I call "responsibility overload." This refers to the psychological strain experienced as a result of having to cope with two jobs in both of which the person has major responsibility for the performance of others over whom she or he has limited control. The married woman is also manager in her home. She need not produce all the goods and services herself, but she is accountable for them. It is this quality of responsibility in managerial work that makes psychological departmentalization difficult and creates a sense of overload. A recent study[15] of stress among Israeli managers reports that women believe a successful career and successful family life are incompatible.

Given the "greediness" of women's domestic roles and of managerial jobs, the latter have had less appeal for married women than other professions. This sentiment is captured in the oft-repeated response to

the question "Do you want to become a manager?"— "What do I need it for?" The implication is that the transaction costs of being a manager are potentially greater than the foreseeable benefits. This sentiment is shared by male managers, the gatekeepers to the managerial suite, who presume that the mother of small children is a poor bet as a candidate for a senior managerial position [49].

The Golda Meir effect

Management also has its Golda Meirs—the token women who support the illusion that social mobility applies equally to all who meet the requisites of the managerial role. Tokenism, or "the Golda Meir effect," sustains the myth that any woman who is competent and strongly motivated can advance to a key position in the economy.[16] It encourages the denial of exclusionary practices, legitimates the *status quo*, and impedes the process by which systemic and cumulative discrimination may come to be defined as a structural and political problem [51]. "Where the claims of a theory prove to be unfounded but, nevertheless, are still widely accepted, one may speak of restraining myths" [52]. The widely held belief in the existence of equal opportunity for (competent and motivated) women in Israel and in the innately natural and voluntary character of women's family roles as they are played on the Israeli scene are such restraining myths, in that they have an inhibiting impact on the development of Israeli women's consciousness, a necessary precondition for social change.

Although there appears to be growing awareness, especially among women in Israel, of the inequity of the division of labor in the family and of discrimination in the labor market [53], the absence of women from positions of power and prestige is still generally considered a personal rather than a political issue. Even the efforts of the powerful women's organizations are directed more toward helping women become assertive than toward making claims against the political system for a greater share of power.

Considering that educated women were the economy's major source of new workers during the 1970s, one may expect a gradual growth in the proportion of women moving into lower- and middle-level managerial positions. In addition, there are early indications of delayed marital age and an increasing divorce rate among urban, postarmy, university-educated women—a population that may elect to enter "greedy" occupations. The proportion of women in management, especially in more-

senior positions, however, is not likely to change significantly until women, with the assistance of the powerful women's organizations, move beyond "treating the victim" and begin treating the social structure by transforming equal opportunity for promotion into a political issue.

Acknowledgments

I wish to express my sincere appreciation to my colleagues for their helpful criticisms and insights given at various stages in the development of this study: Judy Lorber, Kalman Gaier, Michael Shalev, Ellen Boneparth, Rivka Bar-Yosef, Yoram Zeira, and Debbie Bernstein. I owe a special debt of gratitude to the late Linda Keller Brown, who encouraged me to undertake this project, and to Zohar Karti, who was my mentor on the subject of women in Israel.

Notes

1. Raday [9. P. 92] distinguishes between restrictive protection, which is paternalistic and limits a woman's freedom to choose (such as compulsory earlier retirement for women), and protection, which reinforces stereotypes (such as granting workers maternal rights rather than parental rights and thus reinforces sex stereotypes by its presumption that the home and child care are the primary responsibility of the mother rather than of both parents).

2. The broader definition of managers and administrators includes: managers and administrators in governmental and municipal services; other managers; school principals and school supervisors; supervising clerks and inspectors in transport and communication services; and working proprietors in retail and wholesale businesses and trades and in lodging and catering services. Not included are first-line supervisors in industry and agriculture, who are today considered more part of production than of management and for whom movement into management is not likely without the person's leaving the job and acquiring additional training.

3. The hypotheses were tested on data from labor-force surveys conducted by the Central Bureau of Statistics in 1975 and 1982. This data base has two limitations. First, the data span a period of only seven years, which makes trends more difficult to identify. The time span was dictated by the fact that in 1972 the definitions of occupational titles were changed, making that a base year for comparison; the earliest raw data using the new titles available to the researcher were for 1975. The second limitation is that labor surveys are based on four quarterly random samples of 12,000 persons each. When occupations were disaggregated to the extent necessary for this analysis, the small number of persons in many subgroups constrained the use of sophisticated analytical techniques.

4. In 1982, general managers were found in all economic branches, but the greatest concentration was in industry (in which they constituted 40 percent of all managers), followed by finance (19 percent). The vast majority of school principals and supervisors were employed in education services (87 percent). Most administrators in

the public sector were employed by government and local authorities (57 percent), followed by public health and welfare services (25 percent). Almost all owner-managers were employed in the commercial branch (98 percent). Clerical supervisors were found in all economic branches, but the largest concentration was in public administration (37 percent), followed by agriculture and associated branches (25 percent) and finance (18 percent).

5. L. Keller Brown (1981) "Female Managers in the United States and in Europe: Corporate Boards, M.B.A. Credentials, and the Image/Illusion of Progress." See page 265 in the present volume.

6. D. Yariv (1980) "Integration of Zahal Officers (Pensioners) into the Civilian Economy and Continuity between the Military Career and the Civilian Career." M.A. thesis. Faculty of Management, Tel Aviv University.

7. Ibid.

8. There are three reasons why retiring officers currently face greater difficulty obtaining suitable employment than was the case a decade ago. First, the number of retired officers has increased at a faster rate than have available managerial jobs. Second, some highly visible unsuccessful experiences with retiring officers in civilian jobs have made employers somewhat wary. Third (and related to the two previous points), where specific expertise is required, having served as an officer is no longer sufficient qualification.

9. Y. Har-Gad (1984) "The Status of Women in Managerial Positions in Israel." M.B.A. thesis. Faculty of Management, Tel Aviv University.

10. What women officers do when they retire has not been studied. In terms of their visibility, the majority disappear from public life. The most-senior ones have, in recent years, tended to be routed into the female economy of the women's organizations or into peripheral jobs in the public sector. Exceptions to the rule are instructive, and there are a few. Common to them are the facts that they served in the general army, not in the Women's Corps, and that they rose to senior ranks in a professional career path.

Dvora Tomer, for example, joined the professional army following compulsory military training and simultaneously completed her degree in economics. She rose to the position of deputy to the financial advisor to the General Chief of Staff and deputy head of the Department of Budgets in the Ministry of Defence, with the rank of colonel. She was then persuaded to become Commander of the Women's Corps, in which capacity she served for three years and then retired to civilian life. She became a senior manager in a large bank and, within three years of her retirement, became general manager of one of its subsidiaries. The case of Dvora Tomer, the token woman in the system, is often cited as evidence of the opportunities available to women with the proper qualifications and commitment.

11. Y. Gafni (1981) "The Readiness of Women and Men in Israel to Accept Top Management Positions." M.A. thesis. Department of Political Science, Bar-Ilan University.

12. H. Zimmer and N. Halperin (1978) "The Distribution of Women among Medical Specialties in Israel." Unpublished seminar paper (in Hebrew). Department of Labor Studies, Tel Aviv University.

13. Gafni, op. cit.

14. A signing officer in one of Israel's large financial institutions has described what she calls the bank's "afternoon culture": " At headquarters, the offices of the department line both sides of a long corridor. In the rooms on the right sit the managers—all men. In the rooms on the left sit the secretaries—all women. A female assistant and the man who delivers the mail and runs errands also sit on the right. During the day the managers are in their offices, speaking on the phone and dictating letters to their

secretaries. At 3 p.m., the offices on the left empty out—only the secretary on duty remains. Then the managers come out of their offices and visit one another. That's also when all the meetings are held. I get called to headquarters about once a week and make a special point never to miss a meeting because I know that this is when the really important information is exchanged. After the official meeting is over, most managers linger on and gossip or give one another tips on issues of current interest. They rarely leave the office before six in the evening. That's the ritual of the afternoon culture of the managers at headquarters.''

15. D. Etzioni (1984) "Burning Out in Management: A Comparison of Women and Men in Matched Organizational Positions.'' Paper presented at the Second International Interdisciplinary Congress on Women, Groningen, the Netherlands, 16–21 April.

16. As a role model for women, Golda Meir is problematic. She divorced her husband and, according to her autobiography [50], neglected her children and spent most of their childhood in guilt and self-recrimination for inadequacies as a mother. As a politician and national leader, she was a success; as a woman, she was a failure. More than representing the possibilities for achievement, she represents the high cost that women, but not men, must pay in Israeli society to achieve positions of power and prestige. (I am grateful to Judy Lorber for pointing out to me the "catch" in the Golda Meir effect.)

References

1. Kanter, R. M. (1977) *Men and Women of the Corporation*. New York: Basic Books.

2. Diamond, I. (1977) *Sex Roles in the State House*. New Haven, CT: Yale University Press.

3. Lipman-Blumen, J. (1984) *Gender Roles and Power*. Englewood Cliffs, NJ: Prentice-Hall.

4. Martin, Y. N., Harrison, D., and Dinitto, D. (1983) "Advancement for Women in Hierarchical Organizations: A Multilevel Analysis of Problems and Prospects.'' *Journal of Applied Behavioral Science, 19*(1), 19–33.

5. Coser, R. L. (1981) "Where Have All the Women Gone? Like the Sediment of a Good Wine, They Have Sunk to the Bottom.'' In C. F. Epstein and R. L. Coser (Eds.), *Access to Power: Cross-national Studies of Women and Elites*. London: Allen & Unwin. Pp. 16–33.

6. Brown, L. Keller (1981) *The Woman Manager in the United States*. Washington, DC: Business and Professional Women's Foundation.

7. Epstein, C. F. (1981) "Women and Elites: A Cross-national Perspective.'' In C. F. Epstein and R. L. Coser (Eds.), *Access to Power: Cross-national Studies of Women and Elites*. London: Allen & Unwin.

8. Heer, D. M., and Grossbard-Shectman, A. (1981) "The Impact of the Female Marriage Squeeze and the Contraceptive Revolution on Sex Roles and the Women's Liberation Movement in the United States, 1960–1975.'' *Journal of Marriage and the Family, 43*(1), 49–65.

9. Raday, F. (1983) "Equality of Women under Israel Law.'' *Jerusalem Quarterly, 27*, 81–108.

10. Rein, N. (1979) *Daughters of Rachel: Women in Israel*. Harmondsworth: Penguin Books.

11. Peres, Y., and Katz, R. (1984) "Did the Israeli Family Lose Its Character?'' *Israel Social Science Research, 2*(1), 38–43.

12. Peres, Y., and Katz, R. (1981) "Stability and Centrality: The Nuclear Family in Modern Israel." *Social Forces*, 59(3), 687–704.

13. Central Bureau of Statistics (1983) *Statistical Abstract of Israel*, No. 34. Jerusalem: Central Bureau of Statistics.

14. Bar-Yosef, M., Bloom, A., and Levy, T. (1977) *Role Ideology of Young Israeli Women*. Jerusalem: Work and Welfare Research Institute, The Hebrew University.

15. Peres, Y., and Katz, R. (1983) *The Working Mother*. Report of Modi'in Ezrachi Ltd. Tel Aviv: Institute of Research. (In Hebrew)

16. Central Bureau of Statistics (1984) *Labor Force Surveys 1982*. Special Series No. 738. Jerusalem: Central Bureau of Statistics.

17. Central Bureau of Statistics (1984) *Statistical Abstract of Israel*, No. 35. Jerusalem: Central Bureau of Statistics.

18. Bureau of Labor Statistics (1983) *Employment and Earnings*, 30(2). Washington, DC: U.S. Department of Labor.

19. Weinshall, T. D. (1976) "The Industrialization of a Rapidly Developing Country—Israel." In R. Dubin (Ed.), *Handbook of Work, Organization and Society*. Chicago: Rand McNally.

20. Oppenheimer, V. K. (1970) *The Female Labor Force in the United States*. Berkeley, CA: University of California Press.

21. Eisenstadt, S. N. (1967) *Israeli Society*. London: Weidenfeld and Nicolson.

22. Izraeli, D. N. (1981) "The Zionist Women's Movement in Palestine: 1911–1927." *Signs: Journal of Women in Society and Culture*, 7(1), 87–114.

23. Izraeli, D. N. (1983) "Israeli Women in the Labor Force: A Current Appraisal." *Jerusalem Quarterly*, 27, 59–80.

24. Patinkin, D. (1969) "The Progress Toward Economic Independence." In S. N. Eisenstadt, R. Bar-Yosef, and C. Adler (Eds.), *Integration and Development in Israel*. Jerusalem: Israel Universities Press. Pp. 93–106.

25. Radom, M. (1967) *Management Development in Israel*. Tel Aviv: The Israel Management Center and the Department of Industry and Management Engineering of the Technion, Israeli Institute of Technology.

26. Barad, M., and Weinshall, T. (1967) "Women as Managers in Israel." In *Public Administration in Israel and Abroad*. Jerusalem: Israel Institute of Public Administration. Pp. 78–87.

27. Merton, R. K. (1957) *Social Theory and Social Structure* (Rev. ed.). Glencoe, IL: The Free Press.

28. Izraeli, D. N. (1979) "Sex Structure of Occupations: The Israeli Experience." *Sociology of Work and Occupations*, 6(4), 404–429.

29. Ratner, R. S. (1981) *Barriers to Advancement: Promotion of Women and Minorities into Managerial Positions in N.Y. State Government*. Albany, NY: Center for Women in Government.

30. Offe, C. (1976) *Industry and Inequality* (J. Wickham, Trans.). London: Edward Arnold.

31. Spangler, E., Gordon, M. A., and Pipkin, R. M. (1979) "Token Women: An Empirical Test of Kanter's Hypothesis." *American Journal of Sociology*, 84, 160–70.

32. Izraeli, D. N. (1983) "Sex Effects or Structural Effects?: An Empirical Test of Kanter's Theory of Proportions." *Social Forces*, 62(1), 153–65..

33. Izraeli, D. N. (1984) "Attitudinal Effects of Gender Mix in Union Committees." *Industrial and Labor Relations Review*, 37, 212–21.

34. Martin, P. Y. (1985) "Group Sex Composition in Work Organizations: A Structural-Normative Model." *Research in the Sociology of Organizations*, 4, 311–49.

35. Central Bureau of Statistics (1978) *Labor Force Surveys 1976*. Special Series No. 564. Jerusalem: Central Bureau of Statistics.

36. Central Bureau of Statistics (1981) *The Standard Classification of Occupations 1972*. Technical Publications Series, No. 38. Jerusalem: Central Bureau of Statistics.

37. Whitley, R. (1981) "Women, Business School and the Reproduction of Business Elites: Britain and France." In C. Epstein and R. Coser (Eds.), *Access to Power: Cross-national Studies of Women and Elites*. London: Allen & Unwin. Pp. 185–92.

38. Teveth, S. (1972) *Moshe Dayan*. London and Jerusalem: Weidenfeld and Nicolson.

39. Lipman-Blumen, J. (1976) "Toward a Homosocial Theory of Sex Roles: An Explanation of the Sex Segregation of Social Institutions." *Signs: Journal of Women in Society and Culture*, *1*(3), 15–31.

40. Lorber, J. (1979) "Trust, Loyalty and the Place of Women in the Informal Organization of Work." In J. Freeman (Ed.), *Women: A Feminist Perspective* (2nd ed.). Palo Alto, CA: Mayfield.

41. Martin, P. Y. (1980) "Women, Labor Markets and Employing Organizations: A Critical Analysis." In D. Dunkerley (Ed.), *The International Yearbook of Organization Studies*. London: Routledge & Kegan Paul.

42. Perlmutter, A. (1969) *Military and Politics in Israel—Nation-building and Role Expansion*. London: Frank Cass & Co.

43. Bloom, A., and Bar-Yosef, R. (1985) "Israeli Women and Military Service: A Socialization Experience." In M. Safir, M. Mednick, D. Izraeli, and J. Bernard (Eds.), *Women's Worlds: The New Scholarship*. New York: Praeger. Pp. 260–69.

44. Bar-Yosef, R., and Padan-Eisenstark, D. (1977) "Role System under Stress: Sex Roles in War." *Social Problems*, *25*(2), 135–45.

45. Coser, L., and Coser, R. L. (1974) "The Housewife and Her Greedy Family." In L.A. Coser (Ed.), *Greedy Institutions*. New York: The Free Press. Pp. 89–100.

46. Civil Service (1982) *Annual Report No. 32*. Jerusalem: Ministry of Finance.

47. Shapira, R., and Etzioni-Halevi, H. (1974) *Who Are You the Israeli Student?* Tel Aviv: Am Oved. (In Hebrew)

48. Central Bureau of Statistics (1982) *Labor Force Surveys 1980*. Special Series No. 690. Jerusalem: Central Bureau of Statistics.

49. Izraeli, D. N., Banai, M., and Zeira, Y. (1980) "Women Executives in Subsidiaries of Multinational Corporations." *California Management Review*, *22*, 53–54.

50. Meir, G. (1975) *My Life*. London: Future Publications.

51. Apfelbaum, E. (1979) "Relations of Domination and Movements for Liberation: An Analysis of Power between Groups." In W. G. Austin and S. Worschel (Eds.), *The Social Psychology of Intergroup Relations*. Monterey, CA: Brooks/Cole.

52. Hamilton, R. (1975) *Restraining Myths; Critical Studies of United States Social Structure and Politics*. New York: Wiley. Cited by J. Bernard (1981) *The Female World*. London: The Free Press. P. 190.

53. Izraeli, D. N., and Tabory, E. (1986) "The Perception of the Status of Women in Israel as a Social Problem." *Sex Roles: A Journal of Research*, *14*(11–12), 663–78.

12

Ronel Erwee

South African Women: Changing Career Patterns

Although South African managerial women are advancing slowly up the corporate career ladder, many other women are also moving into nontraditional careers such as entrepreneurship. This career advancement is enhanced by the elimination of discriminatory clauses regarding race and sex in labor legislation and a greater willingness of companies to invest in their female human resources. By establishing multiracial women's groups, women are working together to abolish societal and organizational barriers to career growth and to enhance women's quality of life.

Despite the fact that the economy of South Africa is the strongest of all African economies [1], it is currently facing a severe recession. One of the factors contributing to the recession is the relatively low level of productivity. Three reasons for this relatively low productivity can be mentioned: lack of a "productivity consciousness" in South Africa, insufficient education and training of the total population, and inadequate management skills.

The last factor, inadequate management skills, is of particular relevance to this paper. South Africa urgently needs to continue developing an adequate supply of high-quality managerial talent in order to survive the recession. Unfortunately, the country is also suffering from a critical shortage of high-level manpower [2,3]. Visser [4] notes that the ratio between executives and other workers in South Africa is 1 to 52, compared with 1 to 15 in most developed countries.

The manpower problems are exacerbated by the racial division of the society. The white minority, which has the economic and political power, constitutes only 17 percent of the population, yet the majority of executives are white males. There is, however, growing recognition among companies that men and women of all races must be trained to

provide a cadre of future executives. To this end, companies are allocating significant funds to training potential managers of all races, and are encouraged in these efforts by generous government concessions. Companies complain that too little new managerial talent has emerged from their training efforts—particularly among black managers [2].

Despite the increase in employment of women during the past decade, companies claim that there is a lack of suitably qualified women to promote to managerial positions. This scarcity of potential female managers is the result of multiple factors, including labor legislation, companies' employment practices, lack of encouragement, and adequate career guidance.

I shall here focus on three issues: participation trends among women of all races in management and related occupations, problems facing women aspiring to managerial careers, and policy recommendations for better utilization of womanpower in South Africa.

Employment trends

There has been a significant increase in the employment rate of women in South Africa. In 1960, 23 percent of women were in the labor force; by 1980, the proportion had grown to 33 percent. Participation rates vary according to racial group. It is currently 32 percent for black, 38 percent for colored, 26 percent for Asian, and 33 percent for white women [3]. Participation rates for women show certain trends, which are linked to the women's age groups. Participation rates are highest (22 percent) for women in the 20–25-year age group and decline to 14 percent for the 25–35 group. A gradual increase in participation (11 percent) occurs after the age of 35 as women return to the work force after their childbearing years.

According to Van der Walt [3], 55 percent of all working women in South Africa are engaged in four traditionally female occupations: nursing, teaching, and clerical or sales work. Ninety-four percent of all nursing staff are women; and 48 percent of teaching, 56 percent of clerical, and 45 percent of sales positions are occupied by women. The remaining 45 percent of women workers are spread over the remaining occupational categories, e.g., the various professions, all industry- and agriculture-related occupations, other service occupations, etc. Whereas white women have reached a "saturation point" in traditional female occupations [5], there is still room for improvement within the traditional categories for colored and for Asian women. Black women

will have much scope for moving into the traditional careers, as approximately 80 percent were employed as agricultural workers or domestic servants in 1980.

In recent years the proportion of women has increased significantly in the following areas: sciences (1965—4.8 percent; 1981—15.9 percent); physicians, dentists, and veterinarians (1965—3.8 percent; 1981—8.8 percent); paramedical careers (1965—32.9 percent; 1981—47.2 percent); legal careers (1965—2.2 percent; 1981—8.26 percent); other professions, e.g., psychologist, economist (1965—14.4 percent; 1981—23.2 percent); and management and related careers (1965—8.3 percent; 1981—13.8 percent) [3].

Asian women in managerial positions are almost invariably in family businesses and therefore "seldom command the status or salaries commensurate with their responsibilities and capabilities" [6. P. 41]. According to Prekel,[1] the number of black women holding management and administrative positions increased from 20 in 1969 to 751 in 1983. Although this represents a tremendous increase in black women in managerial positions, their number is still relatively small.

By 1981, 56 percent of white women and 4 percent, 13 percent, and 5 percent of colored, Asian, and black women, respectively, had attained more than high-school education [3]; but despite their educational achievements, women do not enter high-level occupations to the extent that their scholastic training permits. Women who embark on a managerial career are less likely than men to obtain further relevant academic qualifications. Mkalipe [7] has quoted reports from the multiracial University of South Africa School of Business Leadership indicating that only 17 percent of the students were women; 2 percent of them were white, and 15 percent, black. Black women are more interested in making use of business courses [7].

Barriers to managerial advancement

Women managers worldwide face a host of problems. Many of the problems reported for American women managers [8–10] are common to South African women managers of all races. This paper deals only with certain salient issues characteristic of South African society.

Cultural and societal problems

Until recently, a major barrier to women's advancement was the status of married women as legal minors [11]. This situation has largely been

rectified for white, colored, and Asian women with the passing of the Matrimonial Property Act in 1984. One of the most important provisions of the Act abolishes the husband's control over his wife's right to negotiate and undertake contractual agreements and therefore endows her with full contractual capacity. This provision does not apply to black women, who are still subject to traditional laws.

According to African tribal tradition, black women are regarded as subordinate to men regardless of their age or educational status. This implies that a woman has to obtain written permission from a male (her father, husband, son, brother-in-law, or other relative) if she wishes to enter employment.[2] It is likely that tradition will remain a powerful barrier for Asian women as well. Permission and approval of fathers, husbands, or other male guardians are still necessary for an Indian woman "to step outside the family for any reason" [6. P. 41]. It is hardly surprising, therefore, that women are conspicuous by their absence among the executives of welfare, educational, political, and labor organizations.

Even if a black woman gains access to a managerial career, like her male counterpart, she faces additional problems. In a comprehensive study of black South African managers (males), Human and Hofmeyer [12] describe black managers as "marginal men" who are

> . . . partially accepted and partially rejected by the white world in which they are expected to perform; they face the psychological burden of not knowing where they stand; they cannot take the knowledge they require for practical competence in routine performance for granted . . . [the black manager] faces discrimination on a social level and encouragement to be individualistic while at the same time being constantly reminded of his ethnic background. [12. P. 102]

These problems are not unique to South Africa, but are generalizable to anyone with a black skin who attempts to function in a white world. The black, colored, or Asian woman aspiring to a managerial career may very likely anticipate experiencing similar status dilemmas and contradictions.

A problem working mothers in South Africa face is the acute shortage of crèches and day-care facilities. Very few companies make day-care facilities available to women; the facilities that do exist are provided primarily by local communities and government agencies. Black women, in particular, face great hardships. In the traditional extended family system that operated in black society, care of relatives' children

was considered part of any family's responsibilities, but the extended family system has disintegrated in urban communities. In the Asian community the extended family system is still operative to some extent. White women have access to relatively more crèches than the others, and, moreover, can employ black domestic workers.

The psychological impact of cultural norms

In the South African culture (as in most other cultures), the traditional female roles are still highly regarded, and such qualities as subservience, supportiveness, and submissiveness meet with approval. Career women therefore often face a conflict since the qualities that make them "acceptable" in traditional terms can undermine their self-confidence and their ability to assert themselves, to assume responsibility and to succeed in a career.

Westaway and Skuy [13] found that in a sample of white adolescent females, more than half had high educational aspirations, but only a minority had high vocational aspirations. This discrepancy between educational and vocational aspirations reflects the prevalent societal attitudes toward girls. Behaviors compatible with success at school are encouraged, whereas high vocational aspirations are discouraged because of the possibly adverse effect such aspirations may have on the more-traditional, "family-nurturing" roles assigned to women.

Once a woman starts climbing the corporate ladder, new problems often emerge. Prekel[3] found that professional women tended to keep on trying to prove themselves and to become too task oriented, appeared aloof and abrupt to co-workers, did not listen effectively, and often "overcommunicated" in trying to prove their point. In this context, one should take into account the structural determinants of women's behavior in organizations. Kanter [8. P. 246] notes that ". . . opportunity, power and relative numbers have the potential to explain a large number of discrete individual responses to organizations." The fact that women in South African companies constitute only a small minority of the managers and have relatively less power and few promotion opportunities may explain some of the dynamics surrounding their roles and the difficulties they experience.

The willingness of women to invest in their careers is illustrated by 1982 and 1984 surveys of professional and managerial women [14]. Most of the women tend to formulate career goals for the next year, or for the next five years. In general, the more highly qualified women

have a longer time perspective regarding their own career development. The respondents describe themselves as "career women": 88 percent take their careers seriously, and would want to continue in them even if there were no financial pressure to do so. These women's positive attitude toward their careers is also reflected in their definition of success. The questionnaire item "Becoming an authority in my profession" achieved the highest proportions of "most important" and "second most important" ratings. The only other success goals to achieve moderate ratings were "Contributing to the welfare of others" and "Being married to a person I love deeply." The majority (81.4 percent) attribute their career advancement to their own efforts rather than to changes in personnel policies of their company or to external sources such as changes in government policies.

Employment legislation

A Study Group on Women in Employment[4] made an intensive survey, in 1978, of labor legislation that contained clauses discriminating against women workers. As a result of prolonged lobbying, a number of bills were amended in 1983. The Manpower Training Amendment Bill prohibits employer discrimination in all aspects of training. The Wage Act Amendment Bill has made discrimination against women in wage agreements illegal. The Conditions of Employment Bill lifted a long-standing ban on women's working nights and overtime. The aim of the Labor Relations Amendment Bill is to provide more stable working conditions and greater protection to workers and to eliminate existing discriminatory clauses [14].

The Wiehahn Commission investigation of South African trade unions led to the Labor Relations Act, which legalizes black trade unions [15]. As a result, the black trade union movement has grown considerably, but only a few black women have become leaders in this area. Black women trade unionists are especially dominant in the retail, clothing, chemical, engineering, and food industries.

A major grievance of married, skilled women employees and businesswomen is the legal discrimination inherent in joint taxation with husbands, which is especially detrimental to the recruitment of higher-level womanpower. The authorities argue that two working people living together have a greater taxable capacity than two people living singly, and therefore want to keep joint taxation. The counterargument is that the incentive for a family member to earn should not be blunted

by tax considerations that depend on the economic position of other members of the family [16].

Employment policies

Women have become legal equals in the workplace during the past few years. The positive changes in legislation are, however, not always implemented by employers. Some employers still practice discrimination, e.g., in relation to pensions and medical benefits.

In 1982 and 1984, surveys were conducted among graduate (university) women in professional/technical and managerial/administrative occupations to determine the employment conditions in their companies [14]. The 1982 sample included only white women managers (n=131), whereas the smaller, 1984 sample (n=30) included both white and black professional women. More than half (52 percent) of the respondents indicated that the company they currently worked for did not plan their employees' long-term career development [14]. Only 34 percent of the respondents reported that their companies had career planning for all employees; the rest offered career planning for males only (8 percent) or for selected groups of women (6 percent).

Moreover, the same organizations (education, commerce, and service) that do not offer career planning are not inclined to have any formal training programs for women employees. The supervisory and management training that does include women is offered by financial and manufacturing institutions and by certain research and service organizations. Most (61 percent) women report that they are able to get financial support from their organizations to attend training seminars offered by other institutions. Reentry training for older women is still rare. The respondents believe that the training opportunities available to women do not meet their needs [14].

The respondents receive the usual benefits from their organizations: a pension, medical insurance, and group (or other) insurance. Maternity leave is usually offered (58 percent); few companies have day-care facilities (11 percent). Only a third of the organizations make housing subsidies available to their women employees whereas almost all male employees receive such subsidies. Most respondents (54 percent) do not think their organization discriminates against them regarding the above-mentioned benefits, although some believe such discrimination exists at their current level (14 percent), at lower levels (14 percent), or at higher levels (18 percent) in the organization.

Half the respondents think that women are not promoted as frequently as men in their organizations, and 39 percent, that it is not always the most task-competent people who are promoted. Many of the companies (41 percent) have no women in top management positions. Those that do (41 percent), are mainly the educational and service institutions, or those with a large proportion of female employees; the rest (18 percent) have women at lower management levels. Although most women (54 percent) think they receive equal pay for equal work, some perceive discrimination at their present level or at higher levels. Only a few (17 percent) state that they do not currently receive equal pay for equal work [14].

The Wage Act Amendment Bill of 1983 makes labor-market discrimination in wages between the sexes illegal, and such practices are being phased out. However, Chitja [17] has noted that in the clothing industry, it is still common practice for a male production manager to be paid more than a female manager. With regard to the differences in productivity level, Mkalipe [7] has found that some companies now prefer black women as workers because of their greater output, which leads to higher productivity.

Accepting the challenges

Despite the barriers to managerial advancement, there are many forces in South African society and strengths within women that can assist them in overcoming obstacles. By identifying and using these forces constructively, a woman can advance in her managerial career.

The social responsibilities of companies

Organizations that have adopted a positive policy of nondiscrimination against women can provide a constructive force for change. There are 400 United States multinational corporations operating in South Africa; of these, only 146 are signatories to the Sullivan Code, which aims to end racial discrimination in U.S. companies operating in South Africa [1]. These 146 foreign multinationals are making a substantial and very direct contribution by providing employees with equal opportunities to secure quality education and community facilities, adequate housing, unrestricted union organization, and the freedom to locate where jobs exist. Schomer [1] notes that the 146 Sullivan signatory companies contributed more than $5.5 million to help educate blacks

who were not their own employees and 5,600 employee days of work in educational institutions. One can only hope that the remaining 254 U.S. multinationals will join the list of Sullivan signatory companies.

The Sullivan Code focuses mainly on improving the employment conditions of black workers as a group. This has a direct, positive influence on the upward mobility of black women in these companies. White women have also benefited indirectly as discriminatory personnel policies have been eliminated. A high-achieving woman will therefore be promoted on merit, race or sex not being taken into account.

The positive example of the U.S. companies has influenced policies in South African companies. The findings of Wagenaar's research [18] indicate a growing awareness of social responsibility among South African business leaders, who believe they can make a significant contribution to the solution of social problems, for example, the training and education of blacks.

Training managers

Human and Hofmeyer [12] have concluded that many South African companies are in a position to invest time, money, and effort in the development of potential black managers, and that the whole problem of black advancement needs further attention. According to these authors, black managers have indicated that their most important training needs are developing cognitive skills and learning such management functions as planning, organizing, problem solving, and control. The research also indicates that the manager's tasks should be clearly defined and that he or she should be given a job or assignment that will allow him or her to develop the necessary managerial competences. Strategies such as those mentioned above may be common practice in the United States. In South Africa, however, many companies do not currently employ such strategies, but are gradually changing their training policies for all managers, regardless of race or sex.

Creating mentors

Many South African companies are debating whether an official management-sponsored mentor system is applicable in their organizations. Nasser [2] and Human and Hofmeyer [12] support the idea that a system in which potential managers are assigned to a mentor could be used in most South African organizations. Schmikl [19] has noted that

the male model of mentorship does not appear to be totally applicable to females, and that there is a dearth of female mentors in most (male-dominated) organizations in South Africa, mainly because of the small number of women in senior management positions. Male managers are reluctant to serve as mentors for women because such a role is unfamiliar to them and, moreover, is often underrated as a personnel-development technique.

The scarcity of mentors for female managers within an organization can, to some extent, be overcome by the use of role models in the broader South African society. In the past, black, colored, and Asian women had few role models to emulate. For example, only 4 of the 21 women nominated for the countrywide "Star Woman of the Year" honor in 1979 were black, though the winner was a black woman trade unionist; and only 3 percent of the 980 women listed in the 1984 *Fair Lady Who's Who* of South African women were black.

Another trend that has emerged is for white women to become more aware of the plight of black women. This has led to the formation of groups such as the Women's Bureau of South Africa, Women for Peace, and the Women's Legal Status Committee. The members of such organizations work together across racial lines to promote cross-cultural understanding and to help identify and solve problems common to all women. These women believe that being female transcends racial divisions. Several business and professional women's clubs have organized seminars on career guidance and advancement in which women of all races share strategies for advancement in organizations.

Career workshops

Because of the interest of women in their careers, the Women's Bureau of South Africa formed a Career Counseling Work Group, which develops (*a*) training courses and workshops aimed at equipping women to meet the demands of higher-level professional and managerial jobs and to develop entrepreneurial and industrial skills, and (*b*) vocational and career counseling methods to meet the needs of women, and application of these methods within companies [20].

Women attending career workshops can be classified according to three groups: young professional women (20–29 years) in the exploration phase of their careers, older professional women (30–39 years) aiming at higher-level management posts, and senior women (age 35–45) who are contemplating a second career. Each of these groups has

unique career development needs that are accommodated in the workshops. The senior professional women often contemplate starting their own businesses, and special workshops on starting a business have been developed by the Women's Bureau of South Africa. This organization is compiling a register of professional women working in offices at home as part of a nationwide Employment Creation Project.

Entrepreneurial managers

Pottas [21] has noted that it is not just white and black male managers who are highly achievement motivated: he found that among large samples of black and white university students, the black students (male and female) were more achievement motivated than their white counterparts. Pottas concludes that these black male and female students are a vast reservoir of potential entrepreneurs.

With more black women seeking avenues and opportunities for self-development, some are now following entrepreneurship as a career. Mkalipe [7] estimates that about 70 percent of small businesses owned by blacks are run by women, although many of them are family concerns that women manage while their husbands work elsewhere. More black women are becoming interested in managing their own shops. Prekel[5] cites as evidence of the activities of black women as entrepreneurs the fact that 30 percent of the members of the National African Federated Chambers of Commerce (NAFCOC) are women. The success of these women as entrepreneurs can be linked to their willingness to enroll in business courses and to the training they receive there. In business courses presented by the NAFCOC for blacks in various parts of the country, more than half the students, on average, are women. These black women entrepreneurs also contribute to the economy by creating new jobs. Mkalipe [7] mentions that for the 143 industrial units erected in Soweto, the Small Business Development Corporation received more than 400 applications, most of which were from women entrepreneurs. These entrepreneurs created more than 300 new work opportunities.

Future trends

In South Africa the growing recognition of the shortage of qualified managerial and professional resources augurs well for women aspiring to managerial careers, as this will create more opportunities for ad-

vancement. Although the numbers of white, black, Asian, and colored women who have moved into management are relatively small, the trend is encouraging.

Many other changes in South African society, such as elimination of discriminatory clauses in labor legislation, changes in the legal status of women, and greater availability of educational opportunities, do support the advancement of women. There is a greater awareness in multinational and South African companies of the aspirations and strengths of men and women of all races and of the problems related to their advancement. There are still barriers to be overcome, such as unequal pay, but women are campaigning against these unfair practices. More women are taking the initiative in planning their own career development and in managing their own small businesses, and are thus creating new role models. Of equal importance is the growing readiness of women to support the career aspirations of other women and to assist in their realization.

Acknowledgment

The author wishes to thank Professor Dafna Izraeli for her comments on an earlier draft of this article.

Notes

1. T. Prekel (1985) "Black Women at Work: Overcoming Double Obstacles." Unpublished research report. Pretoria: School for Business Leadership, University of South Africa.
2. Ibid.
3. Ibid.
4. Study Group on Women in Employment (1978) "Memorandum on Women in Employment." Johannesburg: Unpublished report to the Commission of Inquiry into Labour Legislation.
5. Prekel, op. cit.

References

1. Schomer, H. (1983) "South Africa: Beyond Fair Employment." *Harvard Business Review*, June, pp. 145–56.
2. Nasser, M. E. (1984) "Achievement Training—A Re-assessment of the Technique and Its Impact on the Development of Supervisory and Managerial Talent in RSA." *South African Journal of Business Management*, 15(2), 105–108.
3. Van der Walt, S. (1984) "'n Kwantitatiewe Beeld van die Vrou in die Werksituasie in die RSA." *RSA 2000*, 6(1), 27–35.
4. Visser, J. (1982) "The Contribution of Females to Productivity." *South African Journal of Labour Relations*, 6(3–4), 114–21.

5. Swart, S. (1980) "How the Wiehahn Report Affects Women." In W. D. Pienaar (Ed.), *Women: A Vital Human Resource*. Pretoria: School for Business Leadership, University of South Africa.

6. Bughwan, D. (1984) "Women and Special Indian Problems." In *Women's Bureau Congress Report*. Pretoria: Women's Bureau. Pp. 39–42.

7. Mkalipe, P. (1984) "Black Women in the Labour Market." *RSA 2000*, 6(1), 8–11.

8. Kanter, R. M. (1977) *Men and Women of the Corporation*. New York: Basic Books.

9. Hennig, M., and Jardim, A. (1979) *The Managerial Woman*. London: Pan Books.

10. Josefowitz, N. (1980) *Paths to Power*. Reading, MA: Addison-Wesley.

11. Starke, A. (1984) "Women and the Economy." In *Women's Bureau Congress Report*. Pretoria: Women's Bureau. Pp. 13–15.

12. Human, L., and Hofmeyer, K. (1984) "Black Managers in a White World: Strategy Formulation." *South African Journal of Business Management*, 15(2), 96–104.

13. Westaway, M., and Skuy, M. (1984) "Self-esteem and the Educational and Vocational Aspirations of Adolescent Girls in South Africa." *South African Journal of Psychology*, 14(4), 113-17.

14. Erwee, R. (1984) "Creative Career Development." *RSA 2000*, 6(1), 12–20.

15. Du Preez-Benade (1984) "Women and Trade Unions." In *Women's Bureau Congress Report*. Pretoria: Women's Bureau. Pp. 43–44.

16. Mulholland, S. (1986) "It May Just Be Good." *Financial Mail*, 7 March, p. 51.

17. Chitja, S. (1980) "Women in Industry." In W. D. Pienaar (Ed.), *Women: A Vital Human Resource*. Pretoria: School for Business Leadership, University of South Africa.

18. Wagenaar, C. F. (1979) "Social Responsibility—The Changing Role of Business in South Africa." *South African Journal of Business Management*, 10(3), 93–100.

19. Schmikl, E. D. (1984) "Developing Tomorrow's Managers Today: An Examination of Superior/Subordinate Relationships." *South African Journal of Business Management*, 15(2), 109–115.

20. Van Rooyen, J. (1984) "Developing the Female Labour Force of South Africa: A Challenge." *RSA 2000*, 6(1), 21–16.

21. Pottas, C. D. (1981) "Entrepreneurspotensiaal onder Swart Studente." *Developmental Studies; Southern Africa*, 3(e), 243–61.

13

NANCY J. ADLER

Pacific Basin Managers: A *Gaijin,** Not a Woman

Pacific Rim business is the fastest growing in the world. To remain competitive, no major North American firm dare ignore Asia. Traditionally, very few women have held managerial and executive positions in Asia. Can North American female managers be successful in Asia, or must firms limit their international management positions to men?

To answer this question, 52 women who had held at least one management position in Asia were interviewed. They were overwhelmingly successful. This study describes who the women are, how they were chosen, and their professional experience as female expatriate managers in Asia.

> It doesn't make any difference if you are blue, green, purple, or a frog. If you have the best product at the best price, they'll buy.
>
> —American female manager based in Hong Kong

About the single most uncontroversial, incontrovertible statement to make about women in international management is that there are very few of them. The evidence is both subjective and objective [1. P. 58]. As the international personnel vice-president for a North American company, would you choose to send an American or Canadian woman to Asia as an expatriate manager? Would she succeed? Would it be fair to the company and to the woman to send her to Asia? Would it be wiser not to send her?

International commerce has become vital to North American prosperity. Robert Frederick, chairman of the U.S. National Foreign Trade Council, has stated that 80 percent of United States industry now faces international competition. Already by the beginning of this decade, approximately 70 percent of all U.S. firms were conducting a portion

Gaijin means foreigner (i.e., non-Japanese), either male or female.

This paper is an adaptation of a longer version that appeared in *Human Resource Management*, 1987, 26(2), 169–191.

of their business abroad [2]. Canada provides an even more dramatic example of the importance of international business. By 1980, more than five hundred Canada-based companies had foreign subsidiaries, an increase of more than forty-three percent in just six years [3]. Canadians import nearly one-quarter of all the goods they consume and export a slightly larger proportion of their gross national product. Moreover, foreigners own more than half of Canada's manufacturing capacity [4].

Internationally, Pacific Rim business is the fastest growing in the world. Asian economies, most notably those of the "Four Tigers"— Hong Kong, Korea, Singapore, and Taiwan—have been among the most rapidly developing in recent economic history. At the same time, the People's Republic of China now commands the attention of Western economies, if for no other reason than the size of its potential market; and Japan continues to dominate global economic activity across a widening range of industries. To remain competitive, no major North American firm dare ignore Pacific Rim business.

Along with the globalization of business, stories about women's changing role in society have gained prominence during the last decade. The United Nations Decade for Women emphasized both what needs to be done for women to reach equality and the many changes already under way. Within this pattern of changes, what role do, and will, female managers play in Asia?

One wonders if North American companies should respect Asian countries' apparent cultural norms and send only male managers to those countries. Yet, with the increasing importance of international business, can North American firms afford to limit their personnel selection decisions to one gender? Women's role in international management has become one of the most important questions facing human resources managers of multinational firms. Owing to the economic significance of Pacific Rim business and the apparent dearth of female managers, both local and expatriate, the question assumes particular importance. This chapter examines the role of North American women working in Asia for North American firms. It reports the findings of a series of studies investigating Canadian and U.S. women's role as expatriate managers in Asia.

Do Asians discriminate against women in management?

All cultures differentiate male and female roles, expecting women to behave in certain ways, and men, in others; for women to fill certain

roles, and men, others. In many cultures the traditional female role supports attitudes and behaviors contradictory to those of a manager. Therefore, women in many parts of the world have failed to aspire to become managers, and men have blocked their pursuit of such careers. Asia is no exception. Few Asian women are managers; even fewer have achieved prominence as managers. Using Canada and the Unites States as a point of comparison, let us look at the role women play as managers in a selection of Asian countries.

Already two decades ago in the United States, more than fifteen percent (15.8 percent) of working women held managerial and administrative positions, while in Canada almost ten percent (9.5 percent) held such positions.[1] By 1982, American women occupied over a quarter (27.9 percent) of all managerial and administrative positions [6]. Yet, top management positions still elude women: even in the 1980s, American women represent only 5 percent of top executives [7].

By comparison, the number of female managers in Asia, especially those visible to the international business community, remains infinitessimally small. Female managers are almost nonexistent within the corporate structure and, more broadly, within the leadership ranks of the business sector. Women constitute less than one percent of the senior managers in Southeast Asian corporations.[2] But our North American statistics, focusing primarily on major corporations, have missed some of the involvement of female entrepreneurs and women managing smaller and family-owned Asian companies. For example, Japan has more than twenty-five thousand female company presidents, all of whom manage small to medium-size firms; none are CEOs of multinationals.[3] Similarly, a number of women control major family-owned firms in Thailand and Indonesia, although none hold top positions within corporate structures. Notwithstanding this overlooked involvement, neither the numbers nor the status of Asian women in management equals those of their male counterparts. Why? The reasons are cultural, legal, and economic, with the emphasis varying from each specific Asian nation to another.

Indonesia

In Indonesia, only one in five women (20.8 percent) participates in the paid labor force, compared with 60 percent in Sweden, 53 percent in the United States, 51 percent in Canada, 46.7 percent in Japan, and 45.5 percent in Australia [8]. This compares with a male labor-force

participation rate of over seventy percent in the United states (77 percent), Canada (78.3 percent), Sweden (74 percent), Japan (80 percent), and Australia (79 percent). Although a few Indonesian women hold highly prestigious leadership positions, the vast majority remain outside the corporate and managerial hierarchy.

As in most areas of the world, Indonesian managers come from the ranks of the educated. In Indonesia only 5 percent of the total population has graduated from high school, and fewer than one percent from an academy or university [9]. Although the proportion of those educated is rising rapidly—and considerably faster for women than for men—women remain half as likely as men to be highly educated.[4] Not surprisingly, the highly educated women have the highest labor-force participation rate, government administration being the second most common occupation after teaching in rural areas and sales in urban areas. Yet almost twice as many educated men as women hold such positions. In the private sector, four times as many men as women hold managerial positions.

Japan

Despite Japan's highly acclaimed advanced industrialization, private industry excludes women from most responsible managerial positions [10]. In 1955, the proportion of professionals and managers in the entire female labor force was 3.5 percent, rising to only 8.5 percent by 1977 [11]. By the 1980s, primarily because of women's reentering the work force after rearing their families, the proportion of women working had risen to one of the world's highest, now constituting almost forty percent (39.7 percent) of the work force [12], approximately on a par with Sweden [13,14]. Yet, women continue to hold few managerial positions, especially in major corporations.[5] For example, the 1983 *Who's Who in Japanese Business*, covering the 1,754 major companies listed in Japan's 8 Stock Exchanges, included only 68 women among the 160,764 Japanese managers.[6] Moreover, 50 percent of all Japanese firms have no female managers, and that proportion has remained constant since 1955 [11]. Of the Japanese women who have attained managerial status, almost all work for small or medium-size businesses, not for multinational corporations. Despite recent legal changes, no major increase in the number of women in the latter category is predicted.

While cultural and legal constraints partly explain the role of women

in Japanese management, the lifetime employment system accounts for their absence from major corporations. Culturally, a well-known Confucian saying states: "A woman is to obey her father as daughter, her husband as wife, and her son as aged mother" [11]. Not surprisingly, given this tradition, the Japanese have viewed women neither as authority figures nor as decision makers. Strong cultural norms have made it difficult for Japanese companies to send a woman on domestic or international business trips with a male colleague if not accompanied by a second man. Laws, including the Labor Standards Act, restrict certain positions to men and preclude women from working overtime or at night in many professions.

In general, Japanese society expects women to work until marriage, quit to rear children, and return, only as needed, to low-level and part-time positions after age 40. Thus, by 1985 women constituted a little over seventy percent (70.7 percent) of all part-time workers [12]. Clearly, in Japan, while the home continues to be women's domain, the workplace remains the domain of men. Given this pattern, combined with major Japanese corporations' lifetime employment and promotions sytems, most firms have not considered it worthwhile to develop women for significant management positions. Major corporations generally place women on separate career paths from men, frequently treating them differently in terms of wages, promotion, and retirement. Today, Japanese women seeking managerial careers often must take positions in foreign, rather than Japanese, firms [15].

The People's Republic of China

Although one Chinese saying is that "Women hold up half of the world," numerous other traditional folk sayings and proverbs belittle women and disparage their leadership abilities. For example, when a woman becomes a leader, some Chinese say that it is like "a donkey taking the place of a horse, which can only lead to trouble" [16]. Since the 1970s, the anti-Confucian and Lin Piao campaigns have tried to create more favorable conditions for women by identifying obstacles to redefining women's role and improving their status [17]. The media have reported men's and women's groups "as coming to a new awareness of an old problem through the recognition of their ideological constraints originating in the Confucian principle of male supremacy" [16]. Nevertheless, women are still underrepresented in political and leadership positions, receive unequal pay in rural areas, and are bound

by traditional courtship and marriage customs that maintain work-related gender differentiation and disproportionate shares of household work [16,18].

Given the rapidly changing political and economic environment in China and its increasing openness to international markets, it is difficult to assess the exact proportion of women currently holding managerial and executive positions. My own interviews with female Chinese managers in 1986 confirmed the continued pattern of placing women's primary responsibility in the home, equality at work being most accessible to those in lower positions and those whose children were grown up and thus beyond the need for daily maternal care.[7] Whereas physical labor knows few gender boundaries in the People's Republic of China, access to top managerial positions in industry and government remains largely the domain of men.

India

Although women have been guaranteed constitutional equality and have occupied prominent positions in government since India's independence, in 1947, only recently have they begun to assume managerial positions in business organizations. A limited survey of 33 female executives across a wide range of industries led to the conclusion that Indian women have fewer opportunities for promotion than men; but once promoted, they perform as well as men in executive positions. However, despite the fact that these Indian women believed they could successfully combine the roles of wife and executive, some questioned the appropriateness of continuing to work if they had small children [19].

Singapore

Singapore has been one of the most rapidly developing "newly industrialized countries" in the Pacific Basin. To overcome critical human-resource shortages, the government launched a major campaign, in the early 1980s, to encourage Singaporean women to rejoin the work force. This effort included supporting quality child-care services, flexible work scheduling and incentives, training and retraining programs, and improved societal attitudes toward career women [20]. By 1983, Singaporean women constituted more than a third (35.5 percent) of the labor force and more than a sixth (17.8 percent) of the administrators and

managers (up from 7 percent in 1980). Chan, elsewhere in the present volume, attributes the increases to prosperous economic conditions, the government's development policies encouraging women's participation in the work force, and women's own career aspirations. She views Singapore's rapid growth as an enabling condition, but also notes the 1984 economic downturn's disproportionately adverse effect on women.

The Philippines

Although women from prominent families clearly hold influential positions in Filipino political and economic life, the overall situation for women differs little from that in other Pacific Rim countries. The Philippine Labor Code prohibits discrimination against women with respect to rates of pay and conditions of employment [21]. Yet, while women accounted for approximately a third of the labor force by 1976, less than three percent (2.7 percent) of the working women held administrative or managerial positions in government or business—a figure representing less than one percent of the total managerial positions [22]. Their numbers have not increased.

Philippine society still holds deeply rooted beliefs regarding the role of women at home and at work [23]. Social pressures in Philippine society, in which both men and women frequently support strongly differentiated sex-role stereotypes, make it difficult for a Filipina to choose a career instead of a family or to combine marriage, career, and motherhood successfully [24–26].

Women in international management

Given the culturally mandated scarcity of local female managers in most Asian countries, can female expatriate managers from North American companies function successfully in Asia? More specifically, should Canadian and American companies send women to Japan, Korea, Hong Kong, the Philippines, the People's Republic of China, Singapore, Thailand, India, Pakistan, Malaysia, or Indonesia? Is the experience of local women—i.e., their relative absence from the managerial ranks—the best predictor of success, or lack thereof, for expatriate women?

The research summarized here presents the story of a noun, *woman*, that appears to have gotten mixed up with an adjective, *female*, when

describing managers. The study is the unfolding of a set of assumptions about how Asians would treat North American female managers, based on North Americans' beliefs concerning Asians' treatment of their own women. The problem with the story is that the assumptions have proven to be false, that they fail to reflect reality.

The study

This research on female managers is part of a four-part study on the role of North American women as expatriate managers. In the first part, 686 Canadian and American firms were surveyed concerning the number of women they had sent overseas as expatriate managers. The survey identified over thirteen thousand (13,338) expatriate managers, of whom 402, or 3 percent, were women—that is, 3.3 percent of American and 1.3 percent of Canadian expatriate managers were female. Overall, North American firms send 32 times as many male as female managers overseas [27,28].

Not surprisingly, larger companies send proportionately more women than do smaller companies, with financial institutions leading other industries. However, the 3 percent, although representing significantly fewer than the proportion of North American women in domestic management, should not be viewed as a poor showing, but rather as the beginning of a trend. The vast majority of North American female managers who have ever been sent abroad in expatriate status are currently overseas.

The second, third, and fourth parts of the study attempted to explain why so few North American women work as international managers. Each part was structured around one of the three most common "myths" about women in international management:

Myth 1: Women do not want to be international managers.

Myth 2: Companies refuse to send women overseas.

Myth 3: Foreigners' prejudice against women renders them ineffective, even when they are interested in overseas assignments and succeed in being sent.

These beliefs were labeled "myths" because, although widely held by both men and women, they had never been tested.

Women's interest in international careers

Are women less interested than men in pursuing international careers?

The second part of the study tested this myth by surveying 1,129 graduating M.B.A.s from 7 management schools in the United States, Canada, and Europe. The overwhelming result was an impressive case of no significant difference: male and female M.B.A.s displayed equal interest, or disinterest, in pursuing international careers. Eighty-four percent of the M.B.A.s said they would like an international assignment at some time during their careers. Both males and females, however, agreed that the opportunities were fewer for women than for men, and fewer for women pursuing international compared with domestic managerial careers. Although there may have been a difference in the past, today's male and female M.B.A.s appear equally interested in international work and expatriate positions [29,30].

Corporate resistance to
assigning women overseas

To test the corporate resistance myth, personnel vice-presidents and managers from 60 major North American multinationals were surveyed [31]. According to their responses, over half of the companies (54 percent) hesitate to send women overseas. This is almost four times as many as those hesitating to select women for domestic assignments (54 percent compared with 14 percent). Almost three-fourths (73 percent) believe foreigners are prejudiced against female managers. Similarly, 70 percent believe that women, especially married women in dual-career marriages, would be reluctant to accept, if not totally uninterested in, a foreign assignment. With respect to certain locations, the personnel executives expressed concern about the women's physical safety, the hazards involved in traveling in underdeveloped countries, and, especially in the case of single women, the isolation and potential loneliness. These findings concur with those from a survey of 100 top managers in *Fortune* 500 firms operating overseas in which the majority believed that women faced overwhelming resistance when seeking management positions in international divisions of U.S. firms [2].

Foreigners' reactions to
female expatriate managers

Why do three-quarters of the North American firms believe foreigners are prejudiced against expatriate women managers? Perhaps, owing to

their lack of experience, companies anticipate female expatriates' success, or lack thereof, on the basis of the role and treatment of local women within the particular foreign culture. Perhaps the scarcity of Asian women working as managers has led North American companies to conclude that North American women would not receive the respect necessary to succeed in managerial or professional positions. When interviewed, many international personnel executives declared that it would be fair to neither the woman nor her company to send a female manager to Asia when the treatment of local women suggested that she would have difficulty succeeding. The fundamental question was, and remains, Is this a valid basis for predicting female expatriate managers' effectiveness?

Foreign female managers in Asia

To investigate the third myth, that foreigners' prejudice against women render the latter ineffective as international managers, 52 female expatriate managers were interviewed in 1983 while in Asia or after returning from Asia to North America. Owing to multiple foreign postings, the 52 women represented 61 Asian assignments. The greatest number was based in Hong Kong (34 percent), followed by Japan (25 percent), Singapore (16 percent), the Philippines and Australia (5 percent each), Indonesia and Thailand (4 percent each), and at least one each in Korea, India, Taiwan, and the People's Republic of China. Since most of the women held regional responsibility, they worked throughout Asia rather than just in their country of foreign residence.

Of those working in Asia, financial institutions sent the vast majority (71 percent). Other industries sending more than two women to Asia included publishing (7 percent) and petroleum (6 percent). Those sending one or two women were engaged in advertising, film distribution, service industries (including accounting, law, executive search, and computers), retail food, electronic appliances, pharmaceuticals, office equipment, sporting goods, or soaps and cosmetics.

On average, the female expatriates' assignments lasted 2.5 years (19.7 months), though they ranged from 6 months to 6 years. Salaries in 1983, not counting benefits, varied from U.S.$27,000 to $54,000, averaging $34,500. The female expatriate managers supervised from 0 to 25 subordinates, the average falling between four and five (4.6). Their titles and levels in the organization varied considerably: some held very junior positions, e.g., "trainee" or assistant account man-

ager, while others held quite senior positions, including one regional vice-president. In no case did a female expatriate hold the company's number-one position in the region or in any country.

Female expatriates: Who are they?

As the above description indicates, the female expatriates were fairly junior within their organizations and careers. Their ages ranged from 23 to 41 years, the average being under thirty (28.8). Nearly two-thirds (62 percent) were single; only 3 had children. Five of the women married while overseas—all to other expatriates.

Although the women were considerably younger than the typical male expatriate manager, their age probably does not reflect any systematic discrimination for or against them. Rather, it is an artifact of the relatively high proportion of women sent by financial institutions— an industry that selects fairly junior managers for overseas assignments—and the relatively low proportion in manufacturing, in which international employees are generally quite senior (e.g., country or regional directors).

The women were very well educated and quite internationally experienced. Almost all held graduate degrees, the M.B.A. being the most common. Over three-fourths had had extensive international interests and experience before their present company had sent them overseas. For example, 77 percent had traveled internationally, and almost two-thirds (61 percent) had had an international focus in their studies before joining the company.

On average, the women spoke between two and three languages (average, 2.5), some speaking fluently as many as six. In subjective observations during the interviews, the women, as a group, had excellent social skills and, by Western standards, were very good-looking.

The decision to go overseas

How did the companies and the female managers decide on the overseas transfers? In the majority of cases, the female expatriates were "firsts": only 5 women (10 percent) followed another woman into the international position. Of the 90 percent who were "firsts," almost a fourth (22 percent) represented the first female manager the firm had ever sent abroad. Fourteen percent were the first women sent to Asia, 25 percent were the first sent to the particular country, and 20 percent were the first to fill the specific position. Clearly, neither the women

nor the companies had the luxury of role models; few could follow previously established patterns. Except in the case of a few major New York-based financial institutions, both the women and the companies found themselves experimenting, in hope of uncertain success.

The decision process leading a company to send a female manager to Asia could be described as one of mutual education. In more than four of five cases (83 percent), the woman had initially introduced the idea of an international assignment to her boss and company. In only 6 instances (11 percent) had the company initially suggested the assignment; in another 3 cases (6 percent), the suggestion had been "mutual."

The women had used a number of strategies to "educate" their companies. Many had explored the possibility of an overseas assignment during their original job interview and had eliminated from consideration companies that were totally against the idea. In other cases, women had informally introduced the idea to their bosses and continued to mention it informally "at appropriate moments" until the company ultimately decided to offer them an overseas position. A few women had formally applied for a number of overseas positions before actually being selected.

Some of the female managers admitted to having employed various strategies to make their careers international, primarily attempting to be in the right place at the right time. For example, one woman who foresaw that Hong Kong would be her firm's next major business center arranged to assume responsibility for the Hong Kong desk in New York, leaving the rest of Asia to a male colleague. The strategy paid off: within a year, the company sent her, not her male colleague, to Hong Kong. Overall, the women described themselves as needing to encourage their companies to consider the possibility of giving overseas posts to women in general and themselves in particular. In most cases they claimed that their companies simply had failed to recognize the possibility of giving women overseas assignments, not as having thoroughly considered the idea and then rejected it. Generally speaking, the obstacle was naiveté, not conscious rejection.

Many women confronted some corporate resistance before being sent abroad. For example:

> *Malaysia.* According to one woman being considered for an assignment in Malaysia, "Management assumed that women didn't have the physical stamina to survive in the tropics. They claimed I couldn't hack it."

Thailand. ''My company didn't want to send a woman to that 'horrible part of the world.' They think Bangkok is an excellent place to send single men, but not a woman. They said they would have trouble getting a work permit, which wasn't true.''

Japan and Hong Kong. ''Everyone was more or less curious if it would work. My American boss tried to advise me, 'Don't be upset if it's difficult in Japan and Korea.' The American male manager in Tokyo was also hesitant. Finally, the Chinese boss in Hong Kong said, 'We have to try!' ''

Japan. ''Although I was the best qualified, I was not offered the position in Japan until the senior Japanese manager in Tokyo said, 'We are very flexible in Japan.' Then they sent me.''

A few women described severe company resistance to sending female managers abroad. To these women it seemed that their firms offered them positions overseas only after all potential male candidates for the positions had turned them down. For instance:

Thailand. ''Every advance in responsibility is because the Americans had no choice. I've never been chosen over someone else.''

Japan. ''They never would have considered me. But then the financial manager in Tokyo had a heart attack, and they had to send someone. So they sent me, on a month's notice, as a temporary until they could find a man to fill the permanent position. It worked out, and I stayed.''

Although most of the women had been sent in the same capacity as male expatriates, some companies demonstrated their hesitation by offering temporary or travel assignments rather than true expatriate positions. For instance:

Hong Kong. ''After offering me the job, they hesitated: 'Could a woman work with the Chinese?' So my job was defined as temporary, a one-year position to train a Chinese man to replace me. I succeeded and became permanent.''

This may appear to be a logically cautious strategy, but in reality it tends to create an unfortunate self-fulfilling prophecy. As a number of women reported, if the company was not convinced a women could succeed (and therefore offered her a temporary rather than a permanent

position), this decision itself communicated the company's lack of confidence to foreign colleagues and clients as a lack of commitment. The foreigners then mirrored the home company's behavior by also failing to take the women managers seriously. Assignments became very difficult, or could even fail altogether when companies' initial confidence and commitment were lacking. As one woman in Indonesia said, "It is very important to clients that I am permanent. It increases trust, and that's critical."

Many women claimed that the most difficult hurdle in their international career involved getting sent overseas in the first place, not—as most had anticipated—gaining the respect of foreigners and succeeding once there.

Did it work?
The impact of being female

When describing their actual working experience in Asia, almost all (97 percent) of the North American women said it had been a success; their descriptions were, admittedly, strictly subjective; but a number of more objective indicators suggest that most assignments were, in fact, successful. For example, most firms—after experimenting with their first female expatriate manager—decided to send other women overseas. Moreover, many companies promoted the women on the basis of their overseas performance and/or offered them other international assignments following completion of the first one.

In only two cases did women report experiences of failure: one in Australia, and the other in Singapore. For the first woman, it was her second international posting, after a successful experience in Latin America, and was followed by an equally successful assignment in Singapore. For the second woman, the Singapore assignment was her only overseas posting.

Prior to conducting the interviews, I had expected the women to describe a series of difficulties caused by their being female and a corresponding set of creative solutions to each difficulty. This was not the case. Almost half of the women (42 percent) reported that being female served more as an advantage than a disadvantage; 16 percent found it to have both positive and negative effects; 22 percent saw it as "irrelevant" or neutral; and only 20 percent found it to be primarily negative.

Advantages. The women reported numerous professional advan-

tages to being female. Most frequently they described the advantage of being highly visible. Foreign clients were curious about them, wanted to meet them, and remembered them after the first encounter. It therefore appeared easier for the women than for their male colleagues to gain access to foreign clients' time and attention. The women described this high visibility, accessibility, and memorability with comments such as the following:

> *Japan.* "It's the visibility as an expat, and even more as a woman. I stick in their minds. I know I've gotten more business than my two male colleagues. [My clients] are extra interested in me."

> *Thailand.* "Being a woman is never a detriment. They remembered me better. Fantastic for a marketing position. It's better working with Asians than with the Dutch, British, or Americans."

> *India and Pakistan.* "In India and Pakistan, being a woman helps in marketing and client contact. I got in to see customers because they had never seen a female banker before. . . . Having a female banker adds value to the client."

The female managers also described the advantages of good interpersonal skills and mentioned their belief that men could talk more easily about a wider range of topics with women than with other men. For example:

> *Indonesia.* "I often take advantage of being a woman. I'm more supportive than my male colleagues. . . . [Clients] relax and talk more. And 50 percent of my effectiveness is based on volunteered information."

> *Korea.* "Women are better at treating men sensitively, and they just like you. One of my Korean clients told me, 'I really enjoyed the lunch and working with you.'"

In addition, many of the women described the higher status accorded women in Asia and said that that status was not denied them as foreign female managers. They often felt that they received special treatment that their male colleagues did not receive. Clearly, it was always salient that they were women, but being a woman did not appear to be antithetical to succeeding as a manager.

Hong Kong. "Single female expats travel easier and are treated better. Never hassled. No safety issues. Local offices take better care of you. They meet you, take you through customs, . . . It's the combination of treating you like a lady and a professional."

Japan. "It's an advantage that attracts attention. They are interested in meeting a *gaijin*, a foreign woman. Women attract more clients. On calls to clients, they elevate me, give me more rank. If anything, the problem, for men and women, is youth, not gender."

Moreover, most of the women claimed benefits from a "halo effect." Most of their foreign colleagues and counterparts had never met or previously worked with a female expatriate manager. At the same time, most of the foreign community was highly aware of how unusual it was for American and Canadian firms to send female managers to Asia. Hence, the Asians tended to assume that the women would not have been sent unless they were "the best," and therefore expected them to be "very, very good."

Japan. "Women are better at putting people at ease. It's easier for a woman to convince a man. . . . The traditional woman's role . . . inspires confidence and trust, less suspicion, not threatening. They assumed I must be good if I was sent. They become friends."

Indonesia. "It's easier being a woman here than in any place in the world, including New York City. . . . I never get the comments I got in New York, like 'What is a nice woman like you doing in this job?' "

No impact. Other women found being female to have no impact whatever on their professional life. For the most part, these were women working primarily with the Chinese:

Hong Kong. "There's no difference. They respect professionalism . . . including in Japan. There is no problem in Asia."

Hong Kong. "There are many expat and foreign women in top positions here. If you are good at what you do, they accept you. One Chinese woman told me, 'Americans are always watching you. One mistake and you are done. Chinese take a while to accept you and then stop testing you.' "

Disadvantages. The women also cited a number of disadvantages in being a female expatriate manager. Interestingly enough, the majority

of the disadvantages involved the women's relationship with their home companies, not with their Asian clients. As noted earlier, a major problem involved difficulty in obtaining the foreign assignment in the first place. A subsequent problem involved the limited opportunities and job scope the home company allowed once the woman was overseas. More than half of the female expatriates described difficulty in persuading their home companies to give them latitude equivalent to that given their male colleagues, especially initially. Some companies, out of concern for the women's safety, limited their travel (and thus their region of operation), excluding very remote, rural, and underdeveloped areas. Other companies, as mentioned previously, limited the duration of the women's assignments to six months or a year, rather than the more standard two to three years. For example:

Japan. "My problem is overwhelmingly with Americans. They identify it as a male market . . . geisha girls. . . ."

Thailand (petroleum company). "The Americans wouldn't let me on the drilling rigs, because they said there were no accommodations for a woman. Everyone blames it on something else. They gave me different work. They had me working on the sidelines, not planning and communicating with drilling people. It's the expat Americans, not the Thais, who'll go to someone else before they come to me."

Another disadvantage that some companies placed on the women was limiting them to work only internally with company employees, rather than externally with clients. The companies' often implicit assumption was that their own employees were somehow less prejudiced than were outsiders. Interestingly, the women often found the opposite to be true: they faced more problems within their own organization than externally with clients. One American woman described her situation thus:

Hong Kong. "It was somewhat difficult internally. They feel threatened, hesitant to do what I say, resentful. They assume I don't have the credibility that a man would have. Perhaps it's harder internally than externally because client relationships are one on one, and internally it's more of a group, or perhaps it's harder because they have to live with it longer internally, or perhaps it's because they fear that I'm setting a precedent or because they fear criticism from their peers."

Managing foreign clients' and colleagues' initial expectations proved difficult for many of the women. Some described initial meetings with Asians as "tricky." Since most Asians had previously never met a North American expatriate woman holding a managerial position, there was considerable ambiguity as to who she was, her status, her level of expertise, authority, and responsibilty, and therefore the appropriate form of address and demeanor with respect to her.

> *Hong Kong (Asia Region).* "It took extra time to establish credibility with the Japanese and Chinese. One Japanese manager said to me, 'When I first met you, I thought you would not be any good because you were a woman.' . . . The rest of Asia is O.K."

> *People's Republic of China.* "I speak Chinese, which is a plus. But they'd talk to the men, not to me. They'd assume that I, as a woman, had no authority. The Chinese want to deal only with top-, top-, top-level people, and there is always a man at a higher level."

Since most of the North American women whom Asians had met previously had been male expatriate managers' wives or secretaries, the Asians naturally assumed that the new woman on the scene was not a manager. Hence, the women said, initial conversations often were directed to male colleagues, not to the newly arrived female managers. Senior male colleagues, particularly those from the head office, became very important in redirecting the focus of early discussions back toward the women. If this was well done, old patterns were quickly broken, and smooth ongoing work relationships were established; if this problem was ignored or poorly managed, the challenges to credibility, authority, and responsibility became chronic and undermined the women's potential effectiveness.

The North American women clearly had more difficulty gaining respect from North American and European men working in Asia than from the Asians themselves. Some even suggested that the expatriate community in Asia had attracted many "very traditional" men who were not particularly open to the idea of women in management—whether at home or abroad. For example:

> *Singapore.* "Colonial British don't accept women; very male. There are no women in their management levels. I got less reaction from the Chinese. The Chinese are interested only in whether you can do the job."

Hong Kong. "British men. . .you must continually prove yourself. You can't go to lunch with U.K. expat company men. The senior U.K. guys become uncomfortable, and the younger U.K. guys get confused as to whether the lunch is a social or a business occasion. So I hesitate inviting them. Interaction is just tenuous from both sides."

Hong Kong. "The older men had trouble imagining me with the bank in ten years."

As mentioned earlier, many women described the most difficult aspect of the foreign assignment as getting sent overseas in the first place. Overcoming resistance from North American head offices frequently proved more challenging than gaining foreign clients' and colleagues' respect and acceptance. In most cases, assumptions about Asians' prejudice against female expatriate managers appear to have been exaggerated: the anticipated prejudice and the reality did not match. Why? Perhaps foreigners are not as prejudiced as we think.

The *gaijin* syndrome

Throughout the interviews, one pattern became particularly clear. First and foremost, foreigners are seen as foreigners. Like their male colleagues, female expatriates are seen as foreigners, not as local people. A woman who is a foreigner (a *gaijin*) is not expected to act like the local people. Therefore, the rules governing the behavior of local women that limit their access to management and managerial responsibility do not apply to foreign women. Although women are considered the "culture bearers" in all societies, foreign women in no way assume, or are expected to assume, that role. As one woman in Japan said, "The Japanese are very smart: they can tell that I am not Japanese, and they do not expect me to act as a Japanese woman. They will allow and condone behavior in foreign women that would be absolutely unacceptable in their own women." Similarly, Ranae Hyer, a Tokyo-based personnel vice-president of the Bank of America's Asia Division, said, "Being a foreigner is so weird to the Japanese that the marginal impact of being a woman is nothing. If I were a Japanese woman, I couldn't be doing what I'm doing here. But they know perfectly well that I'm not" [32].

Many interviewees related similar examples of female expatriates' unique status as "foreign women" rather than as women per se. For example:

Japan and Korea. "Japan and Korea are the hardest, but they know that I'm an American woman, and they don't expect me to be like a Japanese or Korean woman. It's possible to be effective even in Japan and Korea if you send a senior woman, with at least three to four years of experience, especially if she's fluent in Japanese."

Japan. "It's the novelty, especially in Japan, Korea, and Pakistan. All of the general managers met with me. . . . It was much easier for me, especially in Osaka. They were charming. They didn't want me to feel bad. They thought I would come back if they gave me business. You see, they could separate me from the local women."

Pakistan. "Will I have problems? No! There is a double standard between expats and local women. The Pakistanis test you, but you enter as a respected person."

Japan. "I don't think the Japanese could work for a Japanese woman, . . . but they just block it out for foreigners."

Hong Kong. "Hong Kong is very cosmopolitan. I'm seen as an expat, not as an Asian, even though I am an Asian American."

It seems that we may have confused the adjective and the noun in predicting Asians' reactions to North American women. We expected the primary descriptor of female expatriate managers to be "woman" and predicted their success on the basis of the success of the Asian women in each country. In fact, the primary descriptor is "foreign," and the best predictor of success is the success of other North Americans in the particular country. *Asians see female expatriates as foreigners who happen to be women, not as women who happen to be foreigners.* The difference is crucial. Given the uncertainty involved in sending women into new areas of the world, our assumptions about the greater salience of gender (male/female) over nationality (foreign/local) have caused us to have false expectations concerning women's potential to succeed as managers in foreign countries.

Recommendations

It is clear from the experience of the women described and quoted in this paper that North American female expatriates can succeed as managers in Asia. In considering them for overseas assignments, both the companies and the women themselves should bear in mind a number

of aspects of such an assignment.

First, do not assume that it will not work. Do not assume that foreigners will treat expatriate female managers the same way they treat their own women. Our assumptions about the salience of gender over nationality have led to totally inaccurate predictions. Therefore, do not confuse adjectives and nouns; do not use the success or failure of local women to predict that of foreign women.

Similarly, do not confuse the role of a spouse with that of a manager. Although the single most common reason for male expatriates' failure and early return from overseas assignments has been the dissatisfaction of their wives, this does not mean that women cannot cope in a foreign environment. The role of the spouse (whether male or female) is much more ambiguous and, consequently, the cross-cultural adjustment is much more demanding than that for the person in the role of employee. Wives (female spouses) have had trouble adjusting, but their situation is not analogous to that of female managers, and therefore is not predictive.

Second, do not assume that a woman will not want to go overseas. Ask her. Although both single and married women need to balance private- and professional-life considerations, many are greatly interested in taking overseas assignments. According to the expressed attitudes of today's graduating M.B.A.s, the number of women interested in working overseas will increase, not decrease, in the next decade.

Given that most expatriate packages have been designed to meet the needs of traditional families (working husband, nonworking wife, and children), companies should be prepared to modify benefits packages to meet the demands of single women and dual-career couples. Such modifications might include increased lead time in announcing assignments, executive search services for the partner in dual-career couples, and payment for "staying connected"—including telephone and airfare expenses—for couples that choose some form of commuting rather than relocating overseas.

Third, give a woman every opportunity to succeed. Accord her full status from the outset—not that of a temporary or experimental expatriate—with the appropriate title to communicate the home office's commitment to her. Do not be surprised if foreign colleages and clients direct their comments to male managers rather than to the new female expatriate in initial meetings, but do not accept such behavior: redirect discussion, where appropriate, to the woman. The foreign colleagues' behavior should not be interpreted as prejudice, but rather as a reaction

to an ambiguous, nontraditional situation.

The female expatriates had a number of suggestions for other women following in their footsteps. First, presume naiveté, not malice. Realize that sending women to Asia is new, perceived as risky, and still fairly poorly understood. In most cases companies and foreigners are operating on the basis of untested assumptions, many of which are faulty, not on the basis of prejudice. The most successful approach is to be gently persistent in "educating" the company to the possibility of sending a woman overseas and granting her the status and support usually accorded male peers in similar situations once sent.

Second, given that expatriating women is perceived as risky, no woman will be sent abroad if she is not seen as technically and professionally excellent. According to the interviewees, beyond being extremely well qualified, it never hurts to arrange to be in the right place at the right time.

Third, for single women, the issue of loneliness, and for married women, the issue of managing a dual-career relationship, must be addressed. Contact with other expatriate women has proven helpful in both cases. For dual-career couples, most women considered it critical that they (*1*) had discussed the possibility of an international assignment with their husbands long before it became a reality, and (*2*) had created options that would work for them as a couple, which, for most couples, meant creating options that had never, or rarely, been tried in their particular company.

Global competition is, and will continue to be, intense in the 1980s and '90s, and companies need every advantage to succeed. The option of limiting international management to one gender is an archaic luxury of the past. There is no doubt that the most successful North American companies will call on both men and women to manage their international operations. The only question is how quickly and how effectively companies will manage the introduction of women into their worldwide managerial work force.

Acknowledgments

I should like to thank the Social Sciences and Humanities Research Council of Canada for its generous support of this research. I owe special thanks to Ellen Bessner and Blossom Shafer for their assistance in all phases of the research and to Dr. Homa Mahmoudhi for her help, creativity, and professional insight in conducting the Asian interviews.

Notes

1. International Labour Office (1970) "Statistical Information on Women's Participation in Economic Activity" (mimeographed). Geneva: International Labour Office. Table VIII. Cited by Galenson [5].

2. E. R. Singson (1985) "Women in Executive Positions." Paper presented at the 1985 Congress on Women in Decision Making, the Singapore Business and Professional Women's Association, 22–23 September.

3. See Steinhoff and Tanaka in the present volume.

4. See Crockett in the present volume.

5. See Steinhoff and Tanaka in the present volume.

6. N. Suzuki and V. Narapareddy (1985) "Problems and Prospects for Female Corporate Executives: A Cross-cultural Perspective." Working paper, University of Illinois at Urbana-Champaign.

7. Interviews were conducted in Tianjin with female managers from all parts of the People's Republic of China in a management seminar sponsored jointly by the PRC's State Economic Commission and the U.S. Department of Commerce.

8. See Chan in the present volume.

References

1. Caulkin, S. (1981) "Women in Management." *Management Today*, February, pp. 80–83.

2. Thal, N. L., and Cateora, P. R. (1979) "Opportunities for Women in International Business." *Business Horizons*, 22(6), 21–27.

3. Dun & Bradstreet Canada (1980) *Canadian Key Business Directory 1980*. Toronto: Dun & Bradstreet Canada Ltd.

4. Dhawan, K. C., Etemad, H., & Wright, R. W. (1981) *International Business: A Canadian Perspective*. Reading, MA: Addison-Wesley.

5. Galenson, M. (1973) *Women and Work: An International Comparison* (ILR Paperback No. 13). Ithaca, NY: New York State School of Industrial and Labor Relations, Cornell University. P. 23, Table 4.

6. U.S. Department of Labor, Bureau of Labor Statistics (1982) "Current Population Survey." In *Employment and Training Report of the President*. Washington, DC: U.S. Government Printing Office.

7. Trafford, A., Avery, R., Thorton, J., Carey, J., Galloway, J., and Sanoff, A. (1984) "She's Come a Long Way—Or Has She?" *U.S. News & World Report*, 6 August, pp. 44–51.

8. Sorrentino, C. (1983) "International Comparisons of Labor Force Participation, 1960–81." *Montly Labor Review*, February, pp. 23–26.

9. Indonesia Biro Pusat Statistic [Central Bureau of Statistics] (1982) *Population of Indonesia*, Series S, Number 2: *Results of 1980 Population Census*. Cited by Crockett in this volume.

10. Dahlby, T. (1977) "In Japan, Women Don't Climb the Corporate Ladder." *The New York Times*, 18 September, Section 3, p. 11.

11. Osako, M. M. (1978) "Dilemmas of Japanese Professional Women." *Social Problems*, 26, 15–25.

12. [Japanese] Women's Bureau (1986) *Fuin Rodo no Jitsujo* [The Actual Condition of Women Workers]. Tokyo: Ministry of Finance Printing Office.

13. Hiroshi, T. (1982) "Working Women in Business Corporations: The Management Viewpoint (Japan). *Japan Quarterly*, 29(July/September), 319–23.

14. Cook, A. H. (1980) *Working Women in Japan: Discrimination, Resistance and Reform*. Ithaca, NY: New York State School of Labor and Industrial Relations, Cornell University.

15. Kaminski, M., and Paiz, J. (1984) "Japanese Women in Management: Where Are They?" *Human Resource Management*, 23(3), 277–92.

16. Croll, E. A. (1977) "A Recent Movement to Redefine the Role and Status of Women. *China Quarterly*, 69, 591–97.

17. "Let All Women Rise Up" (Editorial) (1974) *Jen-min jih-pao*, 8 March.

18. Davin, D. (1976) *Women Work: Women and the Party in Revolutionary China*. London: Oxford University Press. Pp. 53–69, 210–13.

19. Singh, D. (1980) "Women Executives in India. *Management International Review*, 20, August, pp. 53–60.

20. Singapore National Productivity Council, Committee on Productivity in the Manufacturing Sector (1985) *Report of the Task Force on Female Participation in the Labor Force*. Singapore: National Productivity Council.

21. Foz, V. B. (1979) *The Labor Code of the Philippines and Its Implementing Rules and Regulations*. Quezon City: Philippine Law Gazette.

22. Ople, B. F. (1981) *Working Managers, Elites: The Human Spectrum of Development*. Manila: Institute of Labor and Management.

23. Miralao, V. (1980) *Women and Men in Development: Findings from a Pilot Study*. Quezon City: Institute of Philippine Culture.

24. University of the Philippines, Department of Sociology (1977) *Stereotype, Status, and Satisfaction: The Filipina among Filipinos*. Quezon City: University of the Philippines.

25. Castillo, G. T. (1977) *The Filipino Woman as Manpower: The Image and Empirical Reality*. Laguna: University of the Philippines.

26. Gosselin, M. (1984) "Situation des Femmes aux Philippines." *Communiqu'elles*, January, pp. 11–12.

27. Adler, N. J. (1979) "Women as Androgynous Managers: A Conceptualization of the Potential for American Women in International Management." *International Journal of Intercultural Relations*, 3(4), 407–435.

28. Adler, N. J. (1984) "Women in Management: Where Are They?" *California Management Review*, XXVI(4), 78–89.

29. Adler, N. J. (1984) "Women Do Not Want International Careers: And Other Myths about International Management." *Organizational Dynamics*, XIII(2), 66–79.

30. Adler, N. J. (1986) "Do MBAs Want International Careers?" *International Journal of Intercultural Relations*, 10(3), 277–300.

31. Adler, N. J. (1984) "Expecting International Success: Female Managers Overseas." *Columbia Journal of World Business*, XIX(3), 79–85.

32. Morgenthaler, E. (1978) "Women of the World: More U.S. Firms Put Females in Key Posts in Foreign Countries." *Wall Street Journal*, 16 March, pp. 1, 17.

14

Caroline Andrew, Cécile Coderre,
and Ann Denis

Women in Management:
The Canadian Experience

The Relationship of
Professional and Personal Lives

The relationship between the professional and private lives of middle- and senior-level women managers in Canada employed in the public and private sectors is examined. Characteristics of the personal profiles of these managers underline their relatively privileged backgrounds—the occupational and educational levels of their parents and their own high educational levels. The commitment of these managers to their professional work is very strong, but in most cases is combined with a commitment to family and personal lives. In addition, the managers demonstrated a high degree of female solidarity rather than being concerned solely with furthering their individual careers.

Women still hold only a small minority of middle- and senior-level management positions in Canada, although their numbers have increased substantially since the 1970s. The changing lives of women in management and the patterns of the changes within the broader context of the trends in labor-force participation of Canadian women are our subject.

Women's labor-force participation

The female labor-force participation rate in Canada climbed from 36 percent in 1970 [1. Table 1] to 54 percent in 1984 [2. Table; Sect. 1-2]. The increase was greater among married women, rising from 31 percent in 1970 to 54 percent in 1984.

Educational attainment has a strong influence on women's labor-

force participation rates. As Table 1 illustrates, both in 1971 and in 1981, educated women were more likely to be in the labor market than uneducated women. In addition, however, the increase in participation rates over time was considerably greater among the more educated women.

Despite the increase in women's participation in the labor force, their occupational distribution has not greatly changed. Relative to men, they remain concentrated in a small number of occupations. For example, in 1984 one-third of all employed women were in clerical jobs whereas, by contrast, no more than 12 percent of men were in any single major occupational categories [1. Table 24; 2. Table; Sect. 1–11]. In general, therefore, the increase in rates of participation for women took place without basically altering their position within the occupational structure.

Occupations in management

Management as an occupational category has grown significantly since the early 1970s as a result of the development of the tertiary sector, the growth of the state sector, and the increasing bureaucratization of the private sector. Between 1971 and 1984, it is the only occupational category in which the proportion of both the female and the male labor force increased substantially. For women, this increase was from 3 percent to 8 percent, and for men, from 5 percent to 11 percent [1. Table 24; 2. Table; Sect. 1–9; 5. Table 4; 6. Table 1].

Within management the proportion of women rose from 16 percent in 1971, through 25 percent in 1981, to 32 percent in 1984. Although women remain underrepresented, their increase in this occupational category has been considerably greater than their increase in the labor force as a whole.

A more detailed examination of management occupations for 1971 and 1981, however, demonstrates a phenomenon that has been widely observed in the labor force, and not just in Canada: the more senior the position, the lower the percentage of women in it. In 1971 women accounted for 16 percent of all managers and 4 percent of senior management. By 1981 the figures were 25 percent of all managers, but only 9 percent of all senior managers [5. Table 4; 6. Table 1].[1]

In 1971, women managers did not differ significantly from the total labor force in terms of marital status (Table 2) except for senior managers, who were less likely to be single. In 1981, women in all manage-

Table 1

Female Labor-force Participation Rate by Marital and Parental Status and Level of Schooling, Canada, 1971[a] and 1981[b]

	Total		Less than grade 9		High-school diploma		University degree	
	1971	1981	1971	1981	1971[c]	1981	1971	1981
Single	53.4[d]	61.6	38.2	41.8	68.8	71.7	82.5	88.0
Married	35.4		23.6		46.7		55.3	
Husband absent		60.9		30.3		72.1		88.2
Husband present		51.4		30.4		56.1		73.4
No children	35.1		19.3		53.5		69.5	
Husband absent		58.9		26.8		74.3		87.7
Husband present		50.1		20.1		65.6		82.6
Some children, none under age six	41.8		31.7		51.6		53.5	
Husband absent		65.5		36.5		74.3		89.9
Husband present		55.0		38.5		57.9		73.6
Some children, some under age six	27.6		20.7		33.6		37.3	
Husband absent		57.2		27.2		64.0		86.0
Husband present		47.0		34.1		45.0		63.1

[a]Adapted from Armstrong and Armstrong [3. P. 150].
[b]Adapted from Armstrong and Armstrong [4. P. 160].
[c]Includes those with and without diploma who have completed final year of high school.
[d]Of 100% for each cell.

ment categories were less likely to be single than those in the female labor force as a whole. Managerial jobs seem, therefore, to be no more incompatible with marriage than labor-force participation in general—indeed, to be more compatible today than in the 1970s.

Overall, therefore, the 1970s were a time of change for women in management. The sector as a whole expanded considerably, and the place of women within management grew even more rapidly. Women remain marginal at the senior-management levels; but even there, growth has occurred during the past 15 years. In order to understand these changes, it is important to see how Canadian women managers have experienced their work world.

Methodology of the study

A sample of middle- and senior-level women managers in the public and private sectors in Ontario and in Quebec[2] (n = 214) were interviewed to learn about their professional lives and the relationship between their professional and personal lives. In the public sector, our sample came from personnel located in the federal, Ontario, and Quebec civil services. We chose ministries that were relatively comparable in terms of functions, and we included both ministries with economic and noneconomic missions. In the private sector we looked at large companies in finance, sales, and manufacturing, which are the major sectors employing women. Comparable companies with head offices in Montreal and Toronto were chosen.[3]

The degree of cooperation was very high.[4] Only 3 organizations refused to participate; and of the 230 women contacted, only 2 percent did not agree to be interviewed. A further 6 percent could not be interviewed because of scheduling problems. This left us with 214 completed interviews—114 from the public sector, and 100 from the private sector.[5] The interviews took, on average, and hour and a half to two hours and included a mixture of closed and open questions.[6]

Our purpose in this presentation is to establish a general profile of women managers. We were particularly interested in looking at differences between women managers in the public and private sectors, since a number of researchers have stressed differences in career patterns between them [8–12].

We were also interested in observing generational differences, because of the statistics indicating a growing presence of women in management. If this is so, to what extent does it change the kind of

254

Table 2

Percent of Women in Selected Occupations by Marital Status and Age, 1971 and 1981

1971

	Total female labor force			Female labor force aged 44 and under			Female labor force aged 45 and over		
	Single	Married	Other	Single	Married	Other	Single	Married	Other
Total female labor force	32.4	60.0	7.6	39.8	57.2	3.0	15.0	66.4	18.4
All managerial occupations[a]	31.8	57.8	10.4	34.1	59.7	6.2	28.7	55.2	16.1
Middle and senior managerial occupations[b]	35.4	55.0	9.5	36.7	58.1	5.2	33.9	51.2	14.9
Senior managerial occupations[c]	14.6	66.7	19.4	16.5	77.4	6.0	13.5	60.6	25.9

1981

	Total female labor force			Female labor force aged 44 and under			Female labor force aged 45 and over		
	Single	Married	Other	Single	Married	Other	Single	Married	Other
Total female labor force	29.3	62.3	7.5	35.8	61.4	2.9	8.5	69.4	22.1
All managerial occupations[a]	22.4	67.6	10.0	26.0	68.3	5.7	12.6	65.5	21.8
Middle and senior managerial occupations[b]	20.7	69.0	10.4	24.3	69.1	6.6	12.0	68.6	19.4
Senior managerial occupations[c]	18.2	68.9	12.9	23.4	69.9	6.8	9.0	67.3	23.7

Sources: References 7 (Table 3) and 6 (Table 4).

[a]Major group 11 in the Canadian Census, Managerial, Administrative and Related Occupations.
[b]Category 1113, government administrators, and minor groups 113/114, other managers and administrators, Canadian Census.
[c]Category 1130, general managers and other senior officials, Canadian Census.

women to be found in management and the way in which women can and do operate in management positions? To be able to look at questions such as these, we divided the sample into 3 relatively equal age groups: those born in 1941 or before (71 respondents), those born between 1942 and 1947 (73 respondents), and those born in 1948 or later (70 respondents).

Empirically, these two dimensions are interrelated. Respondents from the private sector are younger than those from the public sector. Almost half of the private-sector respondents were born after 1948, whereas this was true for fewer than one-quarter of the public-sector respondents. It is therefore important to be prudent in interpreting differences, since ones that may appear to be linked to differences between public and private sectors may, in fact, also be related to differences in generation.

Profile of the women managers

Half of our sample was born after 1945, the birth dates ranging from 1921 to 1958. In terms of mother tongue, the sample was 38 percent French-speaking, 53 percent English-speaking, and 9 percent other.[7]

A significant characteristic of our sample of women managers is that they come from relatively advantaged backgrounds. This can be seen from the educational levels and occupations of their parents. Women who became middle and senior managers tended to come from family backgrounds that offered a model of high educational attainment, high-status occupations, and paid employment for females.

Looking first at parental levels of education, almost one-third of the fathers and one-fourth of the mothers had a university degree. Indeed, 15 percent of the fathers and 2 percent of the mothers had a postgraduate degree, which is a substantially higher proportion than that for the overall Quebec and Ontario population of the same age group.[8] Respondents working in the public sector were more likely to have had parents with a university education. As Table 3 indicates, significant differences between public- and private-sector respondents existed in relation to the levels of the mothers' education. Thirty-five percent of public-sector respondents had mothers with university education compared with 15 percent of respondents from the private sector. These differences are all the more striking in that the public-sector respondents are older than those from the private sector, and therefore might be expected to have mothers with less education.

Table 3

Parents' Education by Sector of Respondents

	Mother		Father	
	Less than secondary, %	B.A. or more, %	Less than secondary, %	B.A. or more, %
Public	42.5	35.4	35.4	37.2
Private	43.4	15.2	41.7	26.0
Total	42.9	25.9	38.3	32.1

Mothers: $\chi^2 = 14.7$; $P \le 0.002$. Fathers: $\chi^2 = 6.3$; $P \le 0.10$.

Parental occupations also indicate the relatively privileged background of our respondents. Forty percent of the fathers had most recently held positions in management and the professions, and a further 16 percent were in clerical and sales jobs. The most recent employment of 14 percent of the mothers was in professional positions, and of a further 26 percent, in clerical and sales occupations. However, only 60 percent of the mothers worked outside the home.

Almost 70 percent of the mothers of our respondents had been employed before marriage. By the time their respective daughters were 15 years old, 40 percent of the mothers were in the labor force, a rate that is relatively high compared with that of the general Canadian female population [4].[9] Many of the managers in our sample grew up in an environment in which there was a role model of female employment outside the home.

The relatively privileged background of our respondents is also indicated by their own educational levels. Fully 37 percent of the respondents had studied at the postgraduate level; only 10 percent of the respondents had no more than secondary schooling. These high levels of education indicate relatively advantaged social origins.

There were significant differences between the public sector and the private sector in this regard. As Table 4 indicates, 51 percent of the public-sector managers had at least started studies at the postgraduate level, but this is true for fewer than one-fourth of the managers in the private sector.

In many cases, the respondents had continued their studies after having started paid work. Almost half studied some aspect of administration, compared with one-fourth who studied the arts and social sciences, the next most frequent area of study.

If our respondents seem "exceptional" in terms of their socioeco-

Table 4

Educational Level by Sector of Respondents

	B.A. or less, %	Some postgraduate education, %
Public	48.2	51.8
Private	79.0	21.0
Total	62.6	37.4

$\chi^2 = 21.5; P \leq 0.000.$

nomic background, they seem less so in terms of their life-styles. Many of the studies of women in management positions have emphasized the difficulties for women of combining family and professional responsibilities [9,12,13–15]. In our sample, however, the majority of the respondents live within a family; in this, they are not different from the Canadian female labor force as a whole, or from the population of female managers (see Table 2). Among our respondents, 14 percent are single; 50 percent, married[10]; 14 percent, remarried; 19 percent, divorced or separated; and 2 percent, widowed. Moreover, there is very little difference among age groups or between the public and private sectors in this regard.

Our data suggest that children rather than marriage pose career problems for women managers. Fifty percent of our sample report not having had responsibility for children (Table 5). The figure was lowest for the middle-age groups and highest among the youngest group, in which 65 percent had not had responsibility for children; however, it must be recognized that these women were still of child-bearing age. Significant differences exist between public- and private-sector respondents (Table 6), those from the public sector having responsibility for more children.

Orientation toward work

Our respondents indicated a high level of satisfaction in relation to the development of their careers. When asked if they were satisfied with their career development, 52 percent of the respondents replied that they were fully satisfied; 43 percent, that they were satisfied; and only 5 percent, that they were not very satisfied. Nevertheless, when asked at what level they should be, taking into account their experience and

Table 5

Number of Children by Year of Birth of Respondents

Respondents' year of birth	Number of children			
	0 %	1 %	2 %	3 or more %
1941 or earlier	45.1	18.3	19.7	16.9
1942–1947	38.4	24.7	30.1	6.8
1948 or later	65.7	15.7	14.3	4.3
Total	49.5	19.6	21.5	9.3

$\chi^2 = 18.4; P \leq 0.005.$

Table 6

Number of Children by Sector of Respondents

Sector	Number of children			
	0 %	1 %	2 %	3 or more %
Public	40.4	17.5	28.1	14.0
Private	60.0	22.0	14.0	4.0
Total	49.5	19.6	21.5	9.3

$\chi^2 = 15.3; P \leq 0.002.$

aptitudes, 40 percent thought they should be at a higher level (28 percent, 1 level higher, and 12 percent, 2 levels); 58 percent said that they should be at their present level; only 2 percent thought they should be at a lower level.

Respondents were asked where they thought they would be five years hence. The answers were categorized according to the type of movement indicated: vertical (moving up the hierarchy), developmental (content of job continuing to be a challenge—in most cases, the answers did imply an upward movement, but the focus was on the content of the work, not the level); stable (similar to present job); other (complete change of career, retirement, etc.). Almost 40 percent of the sample defined their likely career development in terms of vertical mobility, and another 23 percent, in terms of development. Only 20 percent saw themselves as likely to stay at the same job level.

Not surprisingly, there were age differences. The youngest group was more inclined to see career development in terms of vertical

movement (50 percent, compared with 30 percent of the eldest group of respondents) and less likely to see it as stable.

A similar picture of career commitment emerged from answers to questions about the characteristics considered most and least important to the respondents. The list given in the questionnaire included factors both related and unrelated to work. Among the factors related to work, there were both intrinsic job benefits (atmosphere, interest of work, etc.) and extrinsic ones (possibility for training, job security, etc.). The answers indicated a number of strong trends—the strength of attachment to the work world, the importance of the content of the work, and a desire to combine family and professional ties. Two-thirds of the respondents mentioned interesting work as being one of the two most important factors. The single most popular combination was interesting work and time with family (20 percent of the respondents), followed by interesting work and level of responsibility (12 percent of the respondents). The least important factors were job security, long-term career plans, possibility of training, salary, time with friends, and leisure time (each chosen by between a fifth and a third of the respondents as one of the least important factors). Concern for the content of work and for balancing private and public responsibilities clearly count for these women managers.

Commitment to the work world was part of our respondents' world view from an early age. Two-thirds of the sample indicated that as adolescents they already had planned to work as adults, and 13 percent said that their plans as adolescents had included marriage, children, and paid employment. These replies indicate that nearly 80 percent of the respondents grew up with the idea that as adults they would be working outside the home. Sixteen percent said that they had seen their future in terms of marriage and children, and 5 percent said that they had not had a life plan during their adolescence. When the respondents were specific about the type of employment they had imagined having, it was most often professional.

Female solidarity

Our respondents demonstrated considerably less individualism and more concern for helping others than the literature and the stereotypes would have us believe is true for successful managers [16–18].[11] One particularly interesting aspect of this is the degree of female solidarity shown by our respondents. This was illustrated by the spontaneous

comments of the respondents in explaining why they felt it important, despite very busy schedules, to participate in the study. This female solidarity can also be demonstrated by the answers the respondents gave to three questions: How important is it for women to support each other? Have you served as a mentor for others? and Have you ever given particular support to someone because she was a woman?

The first question measures whether our respondents thought it important for women to support each other. The number of positive replies was impressive: 60 percent of the respondents said that it was very important, and another 30 percent, that it was important. There were no significant differences between age groups or sectors on this question—the importance of women's supporting each other was recognized by all groups. The "Queen Bee" geared to individual success is certainly not the model for our respondents, and this is borne out by their practice, as indicated by their experience in being mentors.

The answers to the questions concerning whether the respondents had been mentors for other people and whether those people were primarily women, men, or both also illustrated, even more clearly, their sense of female solidarity. Eighty-five percent of the respondents said that they had been mentors, with slightly more than 40 percent primarily for women, 37 percent for both, and only 8 percent primarily for men. Considering the fact that most of these women have had mostly male colleagues, this is an interesting finding. It may indicate that these women managers helped women who were in clerical jobs, but it also seems to indicate that they have been particularly concerned with helping their female peers. Once again, there were no significant differences among the respondents in terms of employment sector and age.

Female solidarity was also demonstrated by the answers to the question of whether the respondents had ever given particular support to someone because she was a woman. Twenty-eight percent of the respondents said they had done so often, and 33 percent, sometimes, for a total of slightly over 60 percent who indicated that they had given particular support to women on grounds of gender solidarity. The other respondents were divided more or less equally between those who had not done so and those who stated that they were opposed to doing so.

There were significant differences between public- and private-sector respondents on this question (Table 7). Women from the private sector were less likely to have supported other women because they were women and more likely to be opposed to doing so. This may

Table 7

Particular Support to Women by Sector of Respondents

Sector	Often %	Sometimes %	Never %	Opposed to such support %
Public	31.6	43.0	15.8	8.8
Private	24.5	22.4	23.5	27.6
Total	28.3	33.5	19.3	17.5

$\chi^2 = 20.3$; $P \leq 0.000$.

indicate ideological differences between the sectors, the private sector being more supportive of individualism and equality of opportunity, or it may reflect differences in the functioning of the two sectors and in the positions occupied by women.

Summary and conclusions

Our profile of women managers in Canada dealt both with socioeconomic variables and with elements relating to working conditions and work satisfaction. The socially advantaged background of our respondents was very clear. This supports the view that it is still exceptional in Canada for women to be intermediate- and senior-level managers, and that those who are, tend to come from family backgrounds with a tradition of salaried employment for women, high professional status, and high educational achievement.

There were important differences between managers in the private sector and the public sector. In part, they were socioeconomic differences—public-sector respondents had, for example, mothers with higher levels of education—and in part they were generational, as the public-sector respondents tended to be older than those in the private sector. Managers in the public and private sectors also differed in their reponses to questions relating to support for women.

These differences between sectors should not, however, distract attention from areas of broad agreement among these women managers. The majority display beliefs and behavior that reflect gender solidarity. This strengthens our description of them as interested in their career development, but in a somewhat different way from that portrayed in the prototype of the career-oriented manager. These women managers are committed to their work, but are particularly concerned

with its content and with its offering a constant challenge. A large percentage of the sample combines commitment to work with commitment to family and personal lives. In addition, these women appear to be supportive of other people, particularly of other women, rather than concerned solely with furthering their own careers.

Can we say, as women move increasingly into management, that they are changing the rules of the game in relation to their work world? It is clearly too early to answer this question, but it is certainly worth asking.

Acknowledgments

We should like to thank the women we interviewed, and their employers, for their generous collaboration. We should like to acknowledge with thanks the financial support we have received for this research from the Women and Work Strategic Grants program of the Social Sciences and Humanities Research Council of Canada and from the University of Ottawa. We should also like to thank Nicole Lemire, Andrée Daviau, Béatrice Godard, Hyacinthe Irving, and Nicole Ollivier, who worked as research assistants on this project. Finally, we should like to thank Ginette Rozon, Louise Clément, and Phuong Chi Hoang, of the Faculty Research Secretariat, for the rapidity and quality of their typing assistance.

Notes

1. Determination of the position of women in management requires some manipulation of the census categories. The major category 11 in the Canadian census, administrative and related occupations, is homogeneous in that it includes only positions within large organizations, but it is heterogeneous in terms of the level of managerial responsibility, as it includes administrative support occupations through senior managers. One subcategory includes only senior managers, but excludes those in occupations unique to government. It is also possible to distinguish the subcategories that include all the middle and senior management positions. These distinctions are made in the censuses (Statistics Canada, 1971 and 1981), but not in the quarterly labor-force surveys based on samples (Labour Canada, 1977 and 1986).

2. Ontario and Quebec are the two most populous, and the two most industrial, of the ten Canadian provinces. The large majority of the Quebec population is French-speaking, and of the Ontario population, English-speaking.

3. For budgetary reasons our interviews were limited to women working in Montreal, Quebec, Toronto, and Ottawa-Hull. In the case of the public sector, this included most eligible women—an indication of the high degree of geographic centralization of the public sector in Canada. In the private-sector companies, because of

differences in recruitment and career-development practices between "head office" and "branch," we wished to include women in both. However, our financial constraints permitted inclusion of "branch" representatives only when these were located in one of the above four urban centers.

4. Our research strategy consisted of contacting the companies and ministries and asking for their collaboration. These initial contacts were directed to the vice-president, Human Resources (private sector), or to the deputy minister (public sector). We asked for lists of intermediate and senior women managers, explaining that we would contact these women directly. When lists were provided, we drew random samples. When organizational policies prevented names' being given out, the organizations distributed letters from us describing the project and asking for collaboration, and the women willing to be included contacted us directly.

5. Sixty-six of the public-sector respondents came from ministries with an economic mission, and 47 from those with a noneconomic mission. In the private sector, the distribution was as follows: 43 from the financial sector, 23 from sales, and 35 from manufacturing.

6. All the areas touched on in the questionnaire will not be discussed in this article. The questionnaire included questions about the current job of the respondent and past work experience. Career plans, both past and future, were explored, as was the respondent's experience with mentors, support networks, and organizational plans relating to women's careers within the organization. In terms of the personal dimension, questions were asked about education, family background, patterns of child care, division of responsibilities, and allocation of time for various household activities.

7. Three-fourths of the women interviewed were born in Canada; 11 percent, in Great Britain; 1 percent, in France; and 12 percent, in other countries. By ethnic origin the distribution was as follows: 38 percent French, 40 percent English, and 23 percent "other."

8. A. Denis, C. Andrew, C. Coderre, and N. Lemire (1986) "Interrelations between the Public and Private Lives of Women In Management." Paper presented at the International Sociological Association Meeting, New Delhi.

9. A. Denis (1983) "Women's Paid Employment and Subordination." Paper presented at annual meeting of the Canadian Sociology & Anthropology Association, Vancouver.

10. Includes those cohabiting, as does the married category in the Canadian census.

11. F. H. Giasson (1981) "Perception et actualisation des facteurs de promotion chez les femmes cadres des grandes entreprises québécoises francophones du secteur privé." Doctoral thesis, Montreal: Hautes Etudes Commerciales.

References

1. Labour Canada (1977) *Women in the Labour Force. Facts and Figures* (1976 ed.). Part 1. Ottawa: Labour Canada, Women's Bureau.

2. Labour Canada (1986) *Women in the Labour Force. Facts and Figures* (1985–86 ed.). Ottawa: Labour Canada, Women's Bureau.

3. Armstrong, P., and Armstrong, H. (1978) *The Double Ghetto*. Toronto: McClelland and Stewart.

4. Armstrong, P., and Armstrong, H. (1984) *The Double Ghetto* (2nd ed.). Toronto: McClelland and Stewart.

5. Statistics Canada (1975) "Occupations by Sex Showing Birthplace, Pe-

riod of Immigration and Ethnic Group, Canada and Provinces.'' *1971 Census of Canada* (Cat. 94–734, Vol. 3.3, Bul. 3.3–7). Ottawa: Statistics Canada.

6. Statistics Canada (1983) ''Labor Force-Occupation by Demographic and Educational Characteristics.'' *1981 Census of Canada* (Cat. 92–917, Vol. 1, National Series). Ottawa: Statistics Canada.

7. Statistics Canada (1975) ''Occupations of Females by Marital Status by Age for Canada.'' *1971 Census of Canada* (Cat. 94–733, Vol. 3.3, Bul. 3.3–6). Ottawa: Statistics Canada.

8. Fogarty, M. P., Allen, A. J., Allen, I., and Walters, P. (1971) *Women in Top Jobs: Four Studies in Achievement*. London: Allen and Unwin.

9. Fogarty, M. P., Rapoport, R., and Rapoport, R. N. (1971) *Sex, Career and Family*. London: Allen and Unwin.

10. Fogarty, M. P., Allen, I., and Walters, P. (1981) *Woman in Top Jobs 1968–1979*. London: Heinemann Educational Books.

11. Simard, C. (1983) *L'administration contre les femmes*. Montréal: Boréal-Express.

12. Sales, A., and Bélanger, N. (1985) *Décideurs et Gestionnaires*. Québec: Editeur Officiel du Québec.

13. Hennig, M., and Jardim, A. (1977) *The Managerial Woman*. Garden City, NY: Anchor Press/Doubleday.

14. Hupper-Laufer, J. (1982) *La fémininité neutralisée*. Paris: Flammarion.

15. Jewell, D. O. (Ed.) (1977) *Women and Management: An Expanding Role*. Atlanta: School of Business Administration, Georgia State University.

16. Gordon, F. E., and Strober, M. H. (Eds.) (1975) *Bringing Women into Management*. New York: McGraw-Hill.

17. Rosen, B., and Jerdee, T. H. (1974) ''Sex Stereotyping in the Executive Suite.'' *Harvard Business Review*, *52*, 45–58.

18. Stead, B. A. (1978) *Women in Management*. Englewood Cliffs, NJ: Prentice-Hall.

15

Linda Keller Brown

Female Managers in the United States and in Europe: Corporate Boards, M.B.A. Credentials, and the Image/Illusion of Progress

Is the picture of progress portrayed by the media real or myth? The image presents a skewed perception of the data. The growth in the number of female managers has not been proportional to the overall influx of women into the work force. Within management, women are concentrated in a limited range of job titles. Very few women occupy top positions in business and industry. Two important gains are the increases in women on corporate boards and in business schools. The M.B.A. degree, however, has been losing its value for both men and women. The "gains" must be analyzed carefully to separate image from reality.

The new genre of magazines for working women has projected the look of the 1980s—the successful woman manager: intelligent, attractive, sophisticated, and on the fast track up the corporate ladder. This image in the popular press both reflects and reinforces the belief of many—Americans and Europeans alike—that there has recently been considerable change in the male/female composition of American management and that women are making great gains in attaining managerial positions.

What about this picture of progress? Is it real or a myth? Do the changes that may be under way really point in the direction of greater opportunity for women in management?

The situation in the United States[1]

A precise answer would be that this image presents a skewed perception of the data. At first glance, the increase in the number of women

Table 1

Female Managers, 1900–1982

Year	Number of female managers, officials, and proprietors (except farm)	Female percentage of total managers, officials and proprietors
1900	74,374	4.4
1910	150,067	6.1
1920	190,627	6.8
1930	292,274	8.1
1940	414,472	11.0
1950	699,807	13.6
1960	1,099,000	15.6
1970	1,320,000	16.0
1979	2,587,000	24.6
1980	2,849,859	26.1
1981	3,100,310	27.4
1982	3,218,040	28.0

Sources: D. L. Kaplan and M. C. Casey (1958) *Occupational Trends in the United States, 1900–1950*. Washington, DC: Department of Commerce, Bureau of the Census. Pp. 6–7; U.S. Department of Labor, Bureau of Labor Statistics, *Employment and Earnings*, 1961, *7*(7), xv; 1971, *17*(7), 126; *27*(1), 174; 1981, *28*(1), 180; 1982, *29*(1), 165; 1983, *30*(1), 158. Figures for 1979, 1980, 1981, and 1982 are under a slightly different heading: "Managers and administrators, except farm." All percentages calculated by the author.

managers in the United States over the last three decades appears significant and promising. According to figures published in 1983, covering 1982, women constituted about 28 percent of all "managers and administrators," an increase from about 14 percent in 1947. As can be seen in Table 1, the most significant changes took place in the latter part of the 1970s. In the short period from 1972 to 1979, the number of women in this category increased by 75 percent—and the proportion of women, from 17.5 percent to 24.6 percent of all "managers and administrators." This would *seem* to indicate a pattern of continuing progress. The figures from 1980, 1981, and 1982 also suggest this trend.

To be evaluated fairly, however, these statistics must be analyzed in relation to other measures: (*1*) the participation of women in the entire labor force; and (*2*) the breakdown of specific occupational categories included within the census designation "managers and administrators."

The growth in the number of female managers has not been proportional to the overall influx of women into the work force. The percent-

age of employed women who work in managerial/administrative positions has remained relatively constant. In 1947, 5 percent of all women who worked were managers or administrators. Thirty-five years later (1982), that figure was only 7.44 percent, which does *not* represent substantial progress. This compares with 14.7 percent of the male labor force holding managerial jobs [1,2].[2]

Furthermore, even this statistic of relative stability in the proportion of women workers who become managers/administrators does not reveal the concentration of women in a limited range of job titles within management. Women are most heavily concentrated as a percentage of the managerial labor force in the areas indicated in Table 2.

In examining in detail the statistics on this subject, it is discouraging to see how few women occupy *top* positions in business and industry. The major corporations in the United States are operated by approximately 23,000 male officials and only 250 female counterparts.[3] Among managers earning $40,000 or more in the country's top 50 industrial companies, 400, fewer than 5 percent, are women. The number of women holding the "ultimate power job in America"—that of chief executive officer in those top firms—is zero [3].

The disparity between female and male executives is especially evident when salary is considered. U.S. Census statistics on total money income show that (for 1981, the most recent year available at the time of writing) only 321,000 female managers and administrators earned over $25,000, compared with 4,023,000 males (see Table 3). Of all women managers, 9.26 percent earned $25,000 or more; this compares with 45.9 percent of male managers.

Nevertheless, the gains of women in business—although not as great as the media have implied—are considerable, but not in the areas usually portrayed by the popular press. Two changes at opposite points on the corporate pyramid are especially significant: the increase in companies selecting women for membership on their corporate boards, and the growth in the number of women seeking specialized training for business careers. These patterns are important developments, but they merit careful scrutiny to determine what is image (which may have its own usefulness for women) and what is reality.

The gains and the restrictions on women's achievements in management are reflected in the representation of women on corporate boards of directors. Since the most desirable board candidate is a chief executive officer or a senior executive of another company, female board representation has been linked to the availability of senior female

Table 2

Percentage of Women Managers in Specific Areas

	Percent
Office management	72.6
Building management	52.5
Health administration	50.9
Credit and collection management	48.4
Buying, wholesale and retail trade	43.1
Restaurant, cafeteria, and bar management	40.6
Sales management, department heads, retail trade	39.7

Source: U.S. Department of Labor Statistics (1983) *Employment and Earnings*, *30*(1), 158.

Table 3

Male and Female Managers
with Income over $25,000*

	Women	Men
$25,000–$29,999	157,000	1,176,000
$30,000–$39,999	115,000	1,379,000
$40,000–$49,999	37,000	649,000
$50,000–$59,999	None	333,000
$60,000–$69,999	5,000	191,000
$75,000 and over	7,000	295,000
	321,000	4,023,000

Source: U.S. Department of Commerce, Bureau of the Census (1983) *Money Income of Households, Families and Persons in the United States: 1981*, Series P-60, No. 137, pp. 176–81.
*Total managers and administrators, except farm: 8,765,000 men, 3,407,000 women.

executives. As Table 4 indicates, in 1973 only 10.7 percent of the corporate boards in the United States had *any* women directors. By 1982, this figure had increased to 41.2 percent. Among the prestigious *Fortune* 1300 companies, the figures break down as shown in Table 5.

This is quite a contrast to the situation in other countries. In Europe, for example, the number of female directors is quite small, and is confined primarily to women actually involved in the ownership of the company. In the United States, 22 percent of women directors are in government, law, and nonprofit administration; 25 percent, in educa-

Table 4

Composition of Corporate Boards of Directors

Year	Percentage of boards having any women directors	Percentage of boards having any ethnic minority directors*
1973	10.7	8.9
1974	11.4	10.7
1975	19.5	15.1
1976	21.3	13.6
1977	24.4	13.6
1978	28.0	15.1
1979	36.4	19.2
1981	38.9	17.5
1982	41.2	23.2

Source: Korn/Ferry International (1973–1983) *Board of Directors Annual Study* (First–Tenth). New York: Korn/Ferry.
*Data on minorities included for purposes of comparison.

Table 5

Number of *Fortune* 1300 Companies Having at Least One Woman Director

Category	Number of companies	Percentage of companies
First 500 largest industrials	167	33.4
Second 500 largest industrials	71	14.2
In 300 largest diversified financial, service, and retail firms	158	52.7

Source: F. N. Schwartz (1981) "The New Woman Director." *Directorship*, October.

tion; 23 percent, in business; and 30 percent, in miscellaneous other enterprises, including family-connected interests.

Improvement in the United States may be slowing. Korn/Ferry's 1983 survey of boards of directors [4] reported: "The addition of women and ethnic minority directors has peaked. While the ten-year trend was up dramatically, we have observed that the trend is flattening. Boards will now seek directors with 'operating experience' as the primary requirement." Moreover, one could interpret the U.S. situa-

tion in another way. The statistics above represent the percentage of boards having *any* women directors. In most cases, this was *one* woman director. In 1983, of approximately 16,000 directorships in the *Fortune* 1300 companies, 527 (3.3 percent) were held by women [5]. At this rate, it will take 200 years to attain equal representation in corporate board rooms [6].

The second major change related to women managers is the increase in the number of women earning undergraduate and graduate degrees in business and management. It is hard to realize that as recently as 1963, the Harvard Graduate School of Business did not even admit women to its two-year M.B.A. program [7]. The percentage of business degrees awarded to women has grown substantially in a short time. Most top business schools now have enrollments that are at least one-fourth female. Table 6 charts this dramatic increase in women seeking specialized, business-oriented training. Studies have confirmed that the M.B.A. degree has a positive effect on access for women at the time of job entry, especially for women whose undergraduate degree is in the humanities.

However, the increase in the number of female recipients of business degrees may not prove to be the positive development that it initially appears to be. First, contrary to popular belief, having the same professional credentials as their male counterparts has not, historically, resulted in female managers' having comparable employment prospects and career patterns [8,9].[4] Second, the M.B.A. itself may be changing in value and orientation.

On the first point: women's limited participation in management has been commonly attributed to women's failure to pursue advanced education—or, it is argued, if women have sought degrees, they have done so in the "wrong" subjects, such as English, foreign languages, or library science. It is understandable why, in good faith, someone might believe this; but when this idea is analyzed more closely, it proves incorrect on a number of counts. In many industries, especially heavy manufacturing, the managers at the middle level did not—and still do not—come from Harvard with M.B.A.s: they come up from the shop floor in the operation. In the United States, as in Europe, women have not been, and are not, brought into this promotional chain.

Moreover, if one uses education as an explanation, then, in theory, women managers who have the "right" professional credentials should do as well as male managers. This explanation, however, is not sustained by the evidence in studies of earlier managerial groups.

Table 6

Percentage of Degrees in Business and Management Received by Women

Degree	1969–70	1976–77	1979–80	1980–81	1981–82
B.A.	8.7	23.4	33.6	36.7	39.2
M.A.	3.5	14.3	22.3	25.0	27.8
Ph.D.	1.7	6.3	14.4	14.8	17.7

Sources: U.S. Department of Education, National Center for Education Statistics (1983) *Digest of Education Statistics, 1982*. Surveys of Earned Degrees Conferred. Data for 1981–1982 are calculated from unpublished data from the Survey of Earned Degrees Conferred for those years. Calculations are by the author.

In a retrospective survey of the progress of 6,400 M.B.A.s for a 25-year period beginning in 1947, Steele and Ward [10] found that if beginning salaries reflected opportunities in any way, even females with the credential of an M.B.A. always had less opportunity for management careers than their male counterparts. In 1947, the median starting salary for women M.B.A.s was 83 percent of that for men; in 1969, it was 88 percent. Steele and Ward also found that the women M.B.A.s fell further behind as their careers continued. When they had been out of graduate school for 25 years, the women received only half as much compensation as their male classmates.

Similarly, degrees may facilitate women's entry into corporate positions, but they do not ensure comparable careers. A Columbia University study [11] tracked the careers of 40 pairs of graduates from Columbia's business school between 1969 and 1972. Each pair had nearly identical academic and socioeconomic backgrounds and career goals. One-half of each pair was female, and the other, male. When the M.B.A.s began working—each pair at similar jobs—their average salaries were nearly identical: $12,414 for the women, $13,692 for the men. However, by 1979 the men's salaries, at an average of $48,900 annually, far exceeded the women's at $34,036.

Career-path studies such as these have led researchers to conclude that women's careers (and men's) are affected less by *individual* traits (e.g., educational credentials) than by *structural* variables (e.g., the proportion of women managers within the organization, which affects how women are perceived and responded to, e.g., the dynamics of the organizational environment, especially issues such as access to the power structure). In the United States, the trend in research on women

and management has moved away from intrapsychic/individual explanations toward a social structure paradigm that focuses on the *systemic* factors inhibiting upward mobility of women managers.[5]

This structuralist approach gives a different perspective on current developments in management, such as the second point identified above—the change in the value of the M.B.A. There are certainly many factors involved in the growing disaffection with supposed inadequacies in the M.B.A. and business training in general. However, I should argue that it is not a coincidence that this reassessment is coming at a time of increased involvement of women in management. Sociologists specializing in research on sex typing have frequently pointed out that as occupations become more "female," they lose status.

I venture a prediction: Instead of an M.B.A.'s becoming a path to an executive career for women—that is, a strategy for expanding the number of women in managerial positions because they as individuals earned the right credentials for entrée into the "club"—the M.B.A. itself, for men and women, will lose value. The signs of this decline in status are evident everywhere—articles in the business and popular press, statements of corporate leaders, and discussions in the offices of corporate recruiters. Critics claim that M.B.A.s are obsessed with short-term results rather than long-term success and development; that they are unable to compete in the international marketplace; that they "crunch numbers" instead of manage people; that M.B.A.s are not worth what they are paid.[6]

It is difficult to predict where this indictment of business training will lead and what the effect will be on aspiring women managers. Let us hope that women have not gotten on the "right" credential boat at a time when it is sinking.

As documented above, there have been changes and gains for women, especially in the areas of corporate board participation and the earning of business degrees. Nevertheless, as in the M.B.A. controversy, the "gains" must be analyzed carefully to separate image from reality.

Brief reflections on "credentials" and the situation of the female manager in Europe

Until recently, the pattern for business training in most European countries has been quite different from that in the United States. There has

been no long history of the business school at the undergraduate and graduate levels (e.g., in the United States, the Wharton School of Business is a century old), nor has there been emphasis on the credential of the M.B.A. These are more recent trends in Europe, and the career pathways remain different from those in the United States.

Some of the differences in the training area in Europe are particularly detrimental to women. Absence of the kind of American-style "credentializing" (referred to above) makes advancement for women into management much more difficult than it is in the United States. European women must overcome two obstacles: first, they must be hired by the company; then, they must be selected for the training programs to which companies send their potential future executives. Since so much of the management training in Europe is *after* employment, *after* working in the company, this ex post facto selection process becomes a way of passing over or excluding women. The statistics of male/female participation in the prestigious executive-training programs in Europe record very few women participants, except those who are company owners or future heirs.

Notes

1. For a more extensive discussion of the research findings on this subject, see L. Keller Brown, *The Woman Manager in the United States*. Available from the Business and Professional Women's Supply Service, 11722 Parklawn Drive, Rockville, MD 10852.

2. All percentages calculated by the author.

3. See comments by Ruth Green, of the consulting firm Moore, Manning, and Ernst, Inc., in C. Wyatt (1983) "Wanted: Top Professional." *Working Woman*, December, p. 93.

4. A. Harlan (1978) "A Comparison of Careers for Male and Female MBAs." Working paper. Wellesley, MA: Center for Research on Women, Wellesley College.

5. See, for example, R. M. Kanter (1977) *Men and Women of the Corporation*. New York: Basic Books; and A. Harlan and C. Weiss (1980) *Moving Up: Women in Managerial Careers, Third Progress Report*. Wellesley, MA: Center for Research on Women, Wellesley College.

6. See, for example, C. H. Deutsch (1983) "B-School Blues." *TWA Ambassador*, December, pp. 20–21; and S. Fraker (1983) "Tough Times for MBAs." *Fortune*, 12 December, p. 64.

References

1. U.S. Department of Commerce, Bureau of the Census (1980) *A Statistical Portrait of Women in the United States: 1978*. Washington, DC: U.S. Government Printing Office. Chap. 8.

2. U.S. Department of Labor Statistics (1983) *Employment and Earnings*, 30(1), 157–58.

3. Salamon, J. (1980) "Few Women Get Top Business Jobs Despite Progress of Past Decade." *The Wall Street Journal*, 25 July.

4. Korn/Ferry International (1983) *Board of Directors General Study (Tenth)*. New York: Korn/Ferry International. P. 2.

5. Wyatt, C. (1983) "Wanted: Top Professional." *Working Woman*, December, p. 93.

6. Elgart, L. D. (1983) "Women on Fortune 500 Boards." *California Management Review*, 25(4), 121–27.

7. Robertson, W. (1978) "Women M.B.A.s, Harvard '73." *Fortune*, 17 July, pp. 58–63.

8. Endicott, F. (1979) *The Endicott Report, 1978*. Evanston, IL: Northwestern University, Placement Center.

9. Business and Professional Women's Foundation (1979) *Women in Management*. Washington, DC: Business and Professional Women's Foundation.

10. Steele, J., and Ward, L. (1974) "MBAs: Mobile, Well Situated, Well Paid." *Harvard Business Review*, 52(1), 99–110.

11. Devanna, M. A. (1984) *Male/Female Careers, The First Decade: A Study of MBAs*. New York: Center for Career Research and Human Resources Management, Columbia University.

Index

Abdulgani, Retnowati, 74–75, 94

Achieved status, 13

Adat, 81

Affirmative action programs: in the U.S., 152; in West Germany, 151

Agassi, Judith Buber, 154*n*

Age. *See* Labor force profile

Albeksten, B. H., 32

Andrew, C., 10

Androgynous managers, 178

Antal, A., 10, 11, 145

Anticipatory socialization of heirs, 46

Arabs: in Indonesia, 79; in Israel, 190

Arasu, S., 65

Ascribed status, 13

Asia, 7. *See also* Southeast Asia; *and specific countries*

Asian women in South Africa, 214 family businesses and, 215; marriage and the family and, 217; traditional laws and, 216

Assig, D., 149

Assimilation, 5

Association of Women for Action and Research (AWARE), 70

Assumptions about women's role in management, 4–7. *See also* Sex-role stereotypes

Badinter, E., 165

Bales, R. L., 20

Banking industry: in Great Britain, 14–15, 170, 175–76, 181; international managers in, 233, 235–37; in Israel, 201–2, 209–10*n*; in Japan, 32; in the U.S., 14–15

Barad, M., 193

Bartol, K., 25

Bavelas, A., 21

Belgium, 7

Big business. *See* Large corporations

Black women in South Africa, 214–15, 220, 221; as entrepreneurs, 223; marriage and the family and, 217; traditional laws and, 216

Blochet-Bardet, A., 10, 12

Boards of directors, U.S., 267–70

Boserup, E., 128

Bradford, D. L., 177

British Rail, 170

Business education: in Canada, 52*n*; in France, 49, 52*n*; in Indonesia, 79–80; in Israel, 192; in the U.S., 270–72; in West Germany, 146. *See also* Management training

Businesses. *See* Family businesses; Large corporations

Canada, 41–51, 51–52*n*, 250–62, 262–63*n*; educational background of managers in, 11, 52*n*; entrepreneurs in, 46–47; ethnic issues in, 49–50; founders/owners in, 47; France compared with, 41–52; heirs in, 46–47; labor force profile, 42; middle-level management in, 250–62; professional managers in, 44–45; public/private sector compared in, 250–62; self-made women in, 43–44, 50; sex-role stereotypes in, 44; sponsorship system in, 48–49; upper-level management in, 250–62. *See also*